Bartolomé Esteban Murillo (1617–1682)
Paintings from American Collections

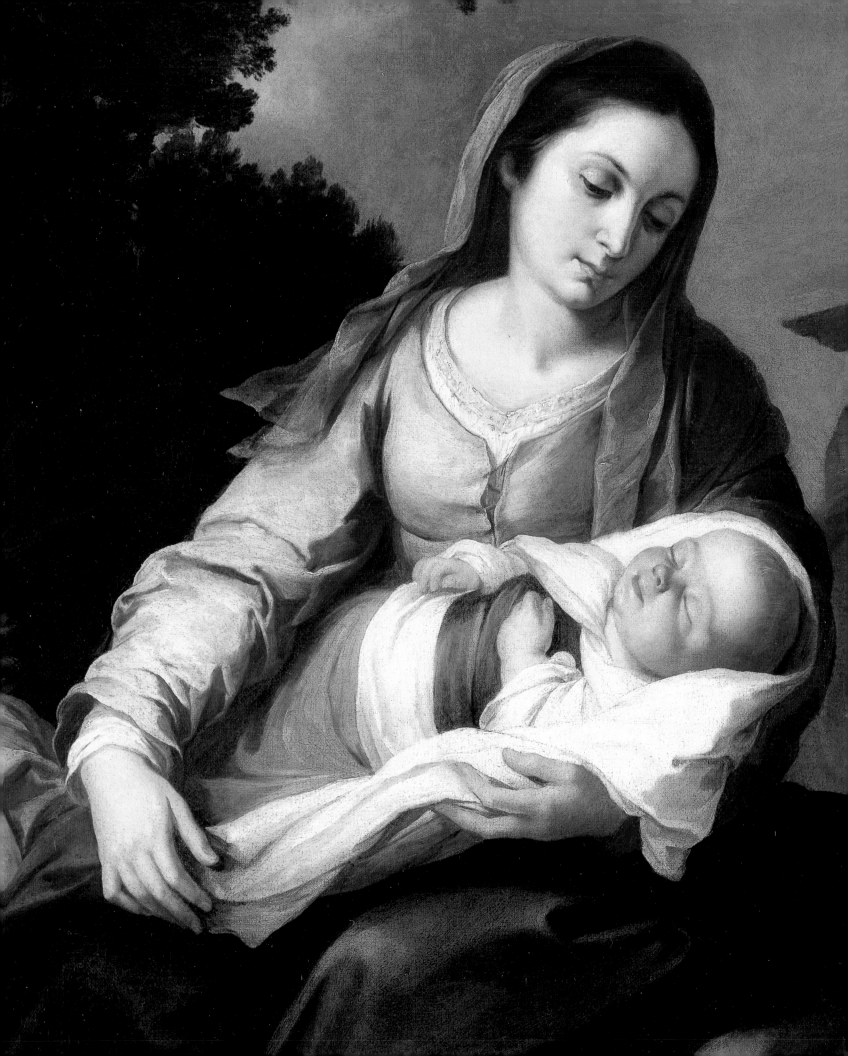

BARTOLOMÉ ESTEBAN MURILLO (1617–1682)

PAINTINGS FROM AMERICAN COLLECTIONS

Suzanne L. Stratton-Pruitt

*with essays by
Jonathan Brown, William B. Jordan,
Peter Cherry, and Claire Barry*

HARRY N. ABRAMS, INC., PUBLISHERS, IN ASSOCIATION WITH THE KIMBELL ART MUSEUM

Editor: ELAINE M. STAINTON
Designer: ANA ROGERS

This publication accompanies the exhibition
BARTOLOMÉ ESTEBAN MURILLO (1617–1682): PAINTINGS FROM AMERICAN COLLECTIONS

EXHIBITION DATES:
Kimbell Art Museum, Fort Worth
March 10–June 16, 2002

Los Angeles County Museum of Art
July 14–October 6, 2002

pp. 2–3: THE FLIGHT INTO EGYPT *(detail). c. 1647–50. The Detroit Institute of Arts (cat. no. 3)*

Library of Congress Control Number: 2001096955
ISBN 0–8109–0390–3 (Abrams: cloth)
ISBN 0–912804–38–6 (Kimbell: paperback)

Printed and bound in Japan
10 9 8 7 6 5 4 3 2 1

 Harry N. Abrams, Inc.
100 Fifth Avenue
New York, N.Y. 10011
www.abramsbooks.com

Abrams is a subsidiary of
 LA MARTINIÈRE
G R O U P E

Contents

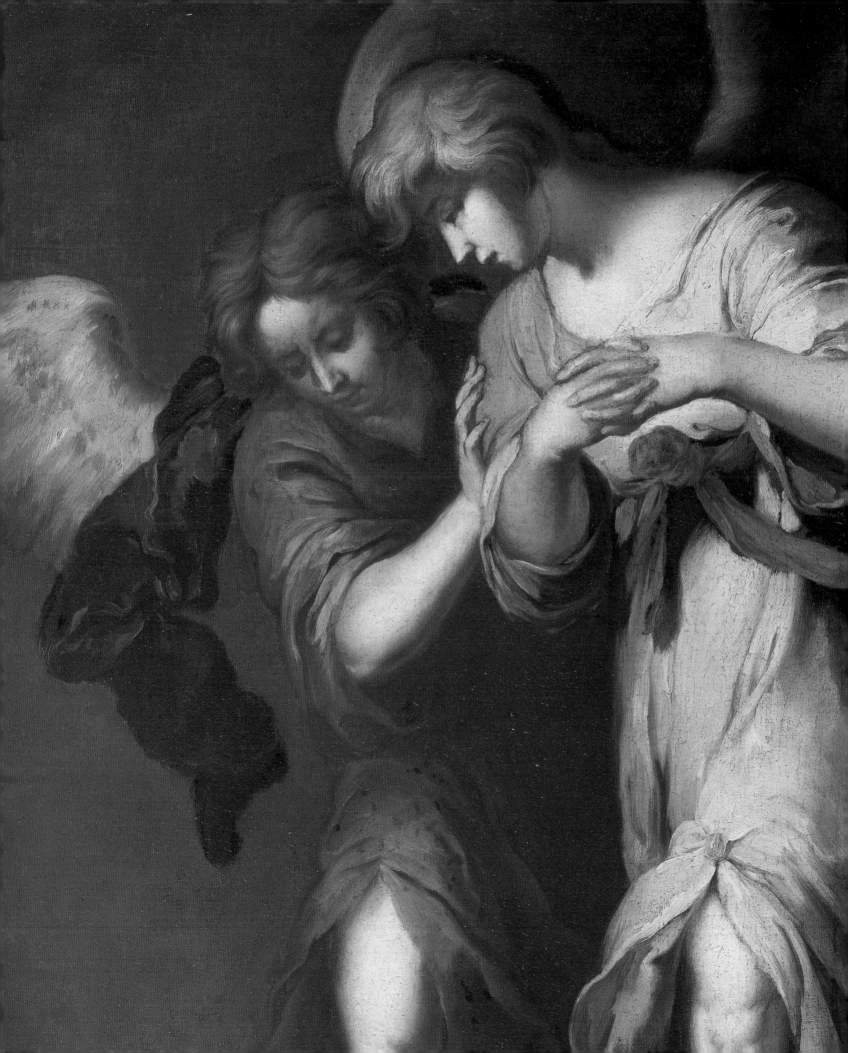

Directors' Foreword

This exhibition was initiated by the Kimbell Art Museum under the directorship of Edmund P. Pillsbury, and developed jointly with the Los Angeles County Museum of Art, initially under the directorship of Graham W. J. Beal. Our special thanks are due to guest curator Suzanne Stratton-Pruitt, whose fine scholarship and judgment have informed the selection and analysis of the works, and illuminated their place in the evolving taste for Spanish art in the United States. From the start, William B. Jordan has also played a critical role in shaping and refining the concept of the exhibition, working in close collaboration on the selection of the works and in undertaking new research for this catalogue. In this latter aspect they were joined by two other distinguished students of Spanish painting, Jonathan Brown and Peter Cherry, as well as the Kimbell's chief conservator of paintings, Claire Barry, who undertook new technical examinations of a number of Murillo's paintings for her essay on his painting method. To all these, we express our thanks for their crucial contributions to the success of the project over the past three years.

On behalf of Dr. Stratton-Pruitt and the other contributors, it is a pleasure to acknowledge the many scholars, curators, conservators, librarians, and other staff from museums around the country and abroad who willingly gave of their time to facilitate this research.

The installation of this exhibition at the Kimbell Art Museum was coordinated by Nancy E. Edwards and at the Los Angeles County Museum of Art by J. Patrice Marandel. The catalogue has been coordinated by the Kimbell's museum editor, Wendy Gottlieb.

Finally, and most importantly, we are especially grateful to the lenders from throughout the United States, both public and private, whose willingness to support this project is the basis of whatever success it may have.

TIMOTHY POTTS
Director
Kimbell Art Museum

ANDREA L. RICH
President and Director
Los Angeles County Museum of Art

Detail of Catalogue No. 12. CHRIST AFTER THE FLAGELLATION, CONSOLED BY ANGELS. *After 1665. Oil on canvas. 44½ x 58 in. (113 x 146 cm). Museum of Fine Arts, Boston, Ernest Wadsworth Longfellow Fund, 53.1*

INTRODUCTION

In early 1633, at the age of fifteen, Bartolomé Esteban Murillo drew up a will in preparation for a trip to America. There is no evidence that he actually embarked for the New World, where some of his family had already emigrated, to be followed later by one of Murillo's sons. But it is an intriguing thought that this quintessentially Spanish artist might easily have made his life across the Atlantic on the continent where this exhibition now celebrates his achievement. Perhaps he would not have become a painter; if he had, he would certainly have become a very *different* one than we see in this exhibition, deprived of the opportunity of seeing Rubens and other Baroque masters at the court of Madrid, as well as his contemporaries in Seville. Better, then, that it was so many of his works that eventually came to America, a rich selection from which this first major showing of his paintings in the United States has been assembled.

The making and breaking of artistic reputations is notoriously unpredictable and often unfair, but few artists can have enjoyed as spectacular a rise and fall from critical acclaim as Murillo. The first extended treatment of the artist's work, by Théophile Gautier in 1864, was in a book whose title succinctly captures the apogee of Murillo's star: *Les Dieux et les demi-dieux de la peinture*. Murillo, at this point, was still among the "dieux," though for some critics his apotheosis was already under threat from Velázquez, a process that accelerated as the century wore on. With the triumph of modernism, El Greco too received greater attention, along with Goya, whose visual and emotional directness assured him center stage in twentieth-century eyes. The eclipse of Murillo's fame by this triad of fellow Spaniards in little more than fifty years was dramatic and almost unanimous. The chocolate boxes on which his works so often appeared were, for many people, just where he belonged.

If there is a key to this sharp reversal in Murillo's critical standing, and his curiously ambivalent reception even today, it may be the difficulty in understanding him as an artistic whole. A devoutly religious man himself, it has from the beginning been hard for some to come to terms with Murillo's blending of the sacred and profane — the dirty soles of the bedraggled prodigal son (cat. no. 18) and the adoring shepherd (Madrid and London 1982: cat. no. 18), the filthy urchins who press around Saint Thomas of Villanueva (cat. no. 19). Justino de Neve, who commissioned devotional paintings from Murillo for his church in Seville, also owned two of Murillo's more decorous genre paintings (London 2001A: cat. nos. 16, 17), but otherwise the markets for these divergent aspects of his works must have been largely mutually exclusive, responding to what were, and remain, very different sentiments and aesthetics. Bringing them together, as Murillo often did, set teeth on edge.

In both sacred and profane subjects, the tenebrism of his early years (fig. 20) gives way to a softer, more embracing light, though here their palettes set the devotional and genre scenes apart. For Murillo, the brilliant light of divine grace has a color, and that color is golden, which explodes in starbursts behind the Virgin and swirls in dense clouds around saints and putti. Street life requires a clearer, whiter light that is scrutinizing rather than atmospheric, a spotlight rather than a stage. Reading these scenes as sympathetic portraits of the destitute victims of famine, earthquake, and plague ties in with Murillo the artist of devout compassion, but there are enough suggestions of more profane meanings, of practices unacceptable to seventeenth-century Spanish religiosity, to have fostered an active debate in alternative interpretations (cat. nos. 31, 32). Here too it proves difficult to hold together a convincing picture of Murillo the man, the artistic storyteller, and the devout Catholic. Needless to say, this seeming moral and artistic multiplicity has increased Murillo's interest to a generation of "new" art historians.

Scholarly interest in Murillo's work was sustained through his denouement in a respectable flow of publications, but it is only in the last twenty-five years that his critical reputation has been fully rehabilitated. This process has been fueled principally by direct visual engagement with his works in exhibitions at Princeton (1976), the National Gallery, London (1981), the Prado, Madrid, and Royal Academy, London (1982–83), and the Louvre, Paris (1983). It is no coincidence that, in addition to Spain, these have taken place in France, Britain, and the United States, where Murillo's works were most actively collected. Vast numbers of his paintings were pillaged by the French in the Peninsular War in the early nineteenth century and then disbursed in a series of spectacular sales in the middle decades of the century. Many fell into British hands, and were subsequently sold to U.S. collectors and museums in the heyday of the transatlantic art trade. In 1883, when the American Charles B. Curtis published his pioneering catalogue of Murillo's work, there were many more of his paintings in Britain (220) than in Spain (128). France, having already lost so much, came a distant third (28); the United States was hardly on the map with only seven. A century later (Angulo 1981) the count of Murillo's total oeuvre was little changed (465 versus 481 in Curtis), but the demographics had shifted dramatically: Spain 228; the United Kingdom 89; France 26; and the United States 54. In the past twenty years the westward traffic in Murillo's works has continued, and, though no accurate count has been made, it may safely be stated that more than one in ten of the artist's works now reside in this country, including examples of all his major subjects, manners, and periods.

Against this background, and the growing interest in the history of collecting over the past thirty years, it was natural that two of the pioneering exhibitions should have focused on the collecting and taste for Murillo's work outside his homeland, as is forthrightly declared in their titles: *The Taste for Spanish Painting in Britain and Ireland* (National Gallery, London) and *Murillo dans les musées français* (Louvre, Paris). The current exhibition again takes its point of departure from Murillo's representation in a particular country, appropriately the last of the three to have collected his work in depth. The taste for Murillo was in each country and era subtly different, as Suzanne Stratton-Pruitt discusses below. The bifurcation of his work into religious and low-life subjects itself somewhat split Murillo's audience in his own day, as does still the heavily Catholic orientation of his devotional subjects in predominately Protestant countries like Britain and the United States. His street scenes were the first to be widely sought after by private collectors and are much the closest to modern taste, but only two found their way into American collections (cat. nos. 31, 32), which generally arrived too late on the scene. Fortunately, these two are among Murillo's supreme achievements in this genre.

It is our hope that this exhibition will contribute to the continuing reappraisal of Murillo's place in Baroque art, begun twenty-five years ago by the groundbreaking exhibition *Murillo and His Drawings*, in Princeton (Brown 1976). The enthusiasm for Murillo's urchins and other intriguingly cryptic scenes of street life remains as strong as ever, as evidenced by the success of the recent exhibition in Dulwich and Munich, *Murillo: Scenes of Childhood*. His religious paintings, on the other hand, continue to suffer from decades of relentless popularization that often pushes his sensitive sentimentality over the borderline of kitsch. Art at this emotively loaded extreme does not fare well in the hands of copyists, let alone mass-market plagiarists. Murillo has here been the victim of his own popularity. Taken on their own terms, however, and shorn of these unwelcome associations, his devotional paintings are unsurpassed in their powers of spiritual evocation and as fine as any in mastery of brushwork and composition. It is these essentially visual qualities that we hope this exhibition will convey more compellingly than has before been possible in this country.

TIMOTHY POTTS

LENDERS TO THE EXHIBITION

Anonymous Lenders 11, 29, 33

The Art Institute of Chicago 6

Cincinnati Art Museum 19

The Cleveland Museum of Art 14, 28

The Detroit Institute of Arts 3

El Paso Museum of Art, Texas 27

Fogg Art Museum, Harvard University Art Museums, Cambridge, Mass. 25

The Hispanic Society of America, New York 17

Kimbell Art Museum, Fort Worth, Texas 31

Krannert Art Museum, University of Illinois, Champaign 22

Los Angeles County Museum of Art 30

Algur H. Meadows Collection, Meadows Museum, Southern Methodist University, Dallas 8, 13, 15, 16, 21

The Metropolitan Museum of Art, New York 23, 26, 34

Museum of Fine Arts, Boston 12

Museum of Fine Arts, Houston 20

National Gallery of Art, Washington, D.C. 18, 32

North Carolina Museum of Art, Raleigh 1

Philadelphia Museum of Art 10

The John and Mable Ringling Museum of Art, Sarasota, Florida 24

San Diego Museum of Art 5

Sterling and Francine Clark Art Institute, Williamstown, Mass. 2

Timken Museum of Art, San Diego 9

Toledo Museum of Art, Ohio 7

Virginia Museum of Fine Arts, Richmond 4

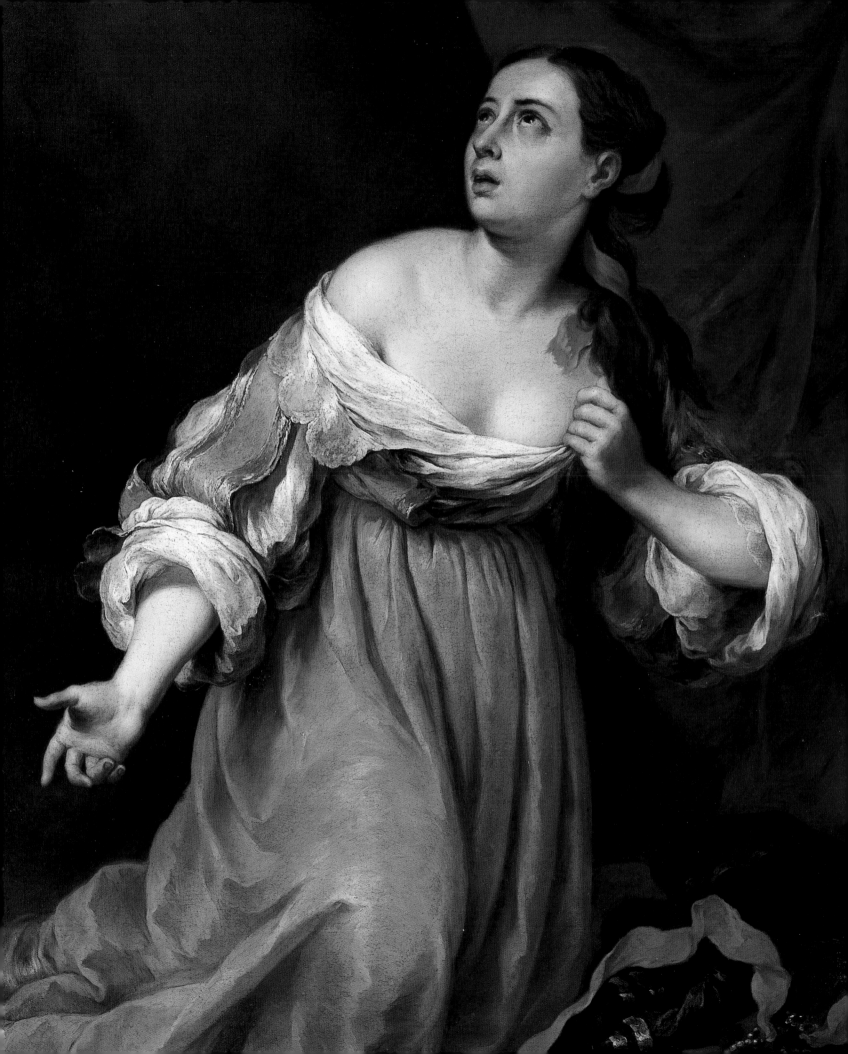

Bartolomé Esteban Murillo, 1617–1682

Suzanne L. Stratton-Pruitt

Bartolomé Esteban Murillo's name appeared in print only twice during his lifetime. His achievements were lauded in a detailed 1666 description of the redecoration of the church of Santa María la Blanca in Seville[1] and, in a history of the city published in 1677, he was called the "Apelles of Seville."[2]

The first biography of the artist was published by Joachim von Sandrart soon after Murillo's death in 1682. Sandrart's inclusion of the Spanish painter in his *Academia nobilissimae artis pictoriae* (Nuremberg, 1683) is a tribute to Murillo's international recognition at the time of his death; however, Sandrart's information was sketchy. In fact, Murillo's first Spanish biographer, Antonio Palomino, in his *Lives of the Eminent Spanish Painters and Sculptors* (1724), criticized Sandrart: "although some foreign authors (like Joachim von Sandrart and an Italian) have said that he went to the Indies as a youth and then to Italy, they were badly informed, . . ."[3] Palomino took particular offense at Sandrart's assumption that a Spanish painter of Murillo's stature must have studied in Italy:

Detail of Catalogue No. 4. Saint Mary Magdalene Renouncing the Worldly Life. *Early 1650s. 65¼ x 42¾ in. (165.7 x 108.6 cm). Virginia Museum of Fine Arts, Richmond, The Adolph D. and Wilkins C. Williams Fund*

The fact is that foreigners do not want to grant the laurels of fame to any Spaniard unless he has passed through the customhouse of Italy, without realizing that Italy has come to Spain in its statues, eminent paintings, prints, and books and that the study of the model (with these antecedents) abounds everywhere. This is apart from the signal men who have come from over there since the days of King Philip II up to the present and have left us their school and their works, as well as from the Spaniards who have gone to Italy and have returned from there well instructed.[4]

Palomino insisted on his own authority about Murillo, "for I overlapped him for almost thirty years, and although I did not have a friendship with him, I knew him and was acquainted with many men who were his friends and used to tell the whole sequence of his fortunes."[5]

Palomino's biography of Murillo would later be expanded (and corrected, in some instances) by the research of Juan Agustín Ceán Bermúdez in his *Diccionario histórico de los más ilustres profesores de las bellas artes en España* (Madrid, 1800) and in Ceán's "letter to a friend," published in 1806.[6] Unfortunately, Murillo was not well served by his early Spanish biographers, for both Palomino and Ceán make assertions that we now know through documentary and other evidence to be inaccurate. In a recent book review, Kenneth Silverman remarked that: "The lives of many great figures are meagerly recorded and make miserable subjects for biography. What is known about Chaucer or Bach, leaving aside their works, can be told in a few pages."[7] The same might be said about Murillo. However, during the nineteenth century meager information was no deterrent to biographers. The few facts provided by Palomino and then imaginatively fleshed out by Ceán Bermúdez were further "enhanced" by the Romantic imagination. But we should not too quickly jettison the myths and legends about Murillo's life and career in favor of the hard facts, because it was Murillo's biography nearly as much as his art that fueled his posthumous fame. In fact, Bartolomé Esteban Murillo was one of the most famous of all western European painters until the twentieth century. The fictive elements that grew up around his life and career were based upon the observations of the first biographers. For example, Palomino wrote that "our Murillo was favored by Heaven not only in the eminence of his ability but also in his natural endowments; he had a good figure and an amiable disposition and was humble and modest, . . ."[8] Ceán Bermúdez elaborated: "Bartolomé Esteban Murillo's amiability corresponded perfectly with the sweetness and style of his paintings. This virtue and other natural gifts he demonstrated in teaching his followers, gently directing them along the correct path that leads to the imitation of nature. . . ."[9]

During the nineteenth century, Murillo himself was increasingly seen through the lens of his art and of his predominantly religious subject matter. His "amiability" became saintliness. The Italian writer Edmondo de Amicis, whose immensely popular guidebook to Spain was translated into English in 1880 and appeared in a number of editions, was among Murillo's most besotted fans: "His canvases make him known as if he had lived with us. He was handsome, good, and pious; many knew not where to touch him; around his crown of glory he wore one of love. He was born to paint the sky."[10] Murillo's much vaunted goodness eventually achieved a certain hyperbolic charm in the 1929 poem by Virginia McCormick:

The good and holy grew beneath his brush,
The poor and sorrowing came at his command;
God on his throne, kind Thomas with his alms,

Such simple folk as all may understand.
The little Jesus on his mother's lap,
And gentle saints with haloes now grown dim;
Murillo was a simple man himself,
I always think Saint Francis looks like him.[11]

Even as recently as 1982, the late Diego Angulo Iñíguez, a distinguished art historian and compiler of the authoritative catalogue raisonné of Murillo's oeuvre, conflated Murillo's life and work. Having recounted the death of Murillo's wife after twenty years of marriage and the fact that only four of their nine children outlived her, Angulo assumed that: "In contrast to his sad and increasingly lonely private life, Murillo's professional career was filled with triumphs. . . . It is almost certain that he compensated for the sadness of his family life by painting a world fashioned in his dreams, inhabited by cherubs playing on a sea of clouds, saints in mystical transport, or the smiling, laughing children of Seville."[12]

Murillo was orphaned at an early age, and, for most of his nineteenth-century biographers, this event went a long way toward explaining the painter's genre scenes: "His low-class life was not vicious, but it was the life of childhood—thoughtless ragamuffins with a tremendous appetite and uncertainty how it was to be satisfied—recollections of his own youth when a few coppers and a melon made him happy as a prince."[13] Similarly: "Murillo had himself known poverty and homelessness. Left an orphan at the age of eleven, he was thrown entirely upon his own resources at nineteen. . . ."[14]

Palomino reported that, following his apprenticeship with the painter Juan del Castillo, Murillo busied himself *pintando de feria* and also that he painted a consignment of works to be sent to the Indies.[15] Ceán Bermúdez assumed that Palomino meant that Murillo painted for the *feria*, or marketplace, in Seville, thus inspiring the imagination of later writers.[16] However, *pintando de feria* may well refer to a little studied aspect of the art trade.[17] Young painters without a clientele traveled to the huge trade fairs such as that at Medina del Campo in Castile, to market their paintings. If Murillo did so, it might account for his seeming to be familiar with art in Madrid before his first documented journey there. However, since there is no way of knowing for sure what Murillo did between his period of apprenticeship and his earliest documented commissions, the intervening years have inspired some especially colorful notions. Even earlier than Ceán, Matthew Pilkington, in his biography of Murillo in his 1770 dictionary of painters, seizing on the word *feria*, went so far as to assert that Juan del Castillo's "subjects were fairs and markets," though Castillo, with whom Murillo served his apprenticeship, very probably never ventured beyond conservative religious themes.[18] And, although Palomino was very dubious about rumors that Murillo had worked for Carlos II, last of the Spanish Habsburgs, Pilkington asserted that the painter was "employed by the king to paint several historical subjects which were later sent to the Pope as a present—the Italians called him a second Veronese."[19]

The favorite notion gleaned from Palomino and Ceán Bermúdez, though, was the idea of Murillo busily at work at the Seville fair. In the *Dictionary of Spanish Painters* published in 1833, A. O'Neil generously describes Murillo as a "historical, landscape, portrait, fruit, flower, and still-life painter in oil and fresco."[20] After his study with Castillo, according to O'Neil, Murillo had "to make preparations for the annual Fair of Seville. He was now unwillingly obliged to quit the more refined appropriation of his pencil, for the coarser labor of painting on serge: however, no lover of art should hold in derision the Fair of Seville, as to its existence we are indebted for many fine Spanish colorists, and, above all, Murillo, their prince."[21]

Murillo's reported activity at the fairs of Seville was supposedly impelled by desperate need. According to O'Neil (and other authors following): "He procured a piece of canvas, perhaps large enough to bear a vessel before the breeze, divided it into many pieces, prepared them to receive color, and represented on their surface all sorts of subjects; such as fruits, garlands, and bouquets of flowers, male and female Saints, beside diverse other objects of monastic interest. . . ." [22] Murillo's presumed creation of works for the art traffic from Seville to the Americas, a market that was in fact quite real, led Ernest Beulé, in 1867, even to specify that Murillo painted pictures of the Virgin of Guadalupe for export to the Americas. [23] So much interest in Murillo's completely undocumented early career in turn stimulated romantic interpretations of his life in art. The most extravagant of all must be the Scottish artist John Phillip's (1817–1867) enormous painting of *The Early Career of Murillo, 1634* (fig. 1), which depicts the elegant young painter surrounded by a cast of characters inspired more by a northern stereotype of Andalusia than by the subjects of Murillo's paintings. An engraving after the British watercolorist W. H. Kearney, *The School of Murillo* (fig. 2), may in turn have suggested to Charles H. Caffin, in 1906, that: "It was the custom to bring paints and brushes to the fair, so that patrons could have the pictures altered to suit their taste; and, as he sat among the stalls, he had plenty of opportunity of studying and sketching the city urchins and beggar boys that lay or frolicked in the sunshine." [24] In Emelyn W. Washburn's 1884 biography of the artist, both the naturalism of Murillo's art, supposedly impelled by his direct study of nature, and the spirituality of his art, attributed to his own character, were drawn together:

We find on his canvas the biography of all the scenes of the market-place, the everyday life of the common people. In his Holy Families we recall the very image of his youth; the earnest, dark-eyed peasant women; the sombre Franciscans; the happy, laughing children. We breathe everywhere the air of Andalusia; we look on its bare hills, the transparent waters, and the valleys that laugh and sing; the gayest flowers, the freshest fields, and the cattle feeding in green nooks; along the road

at every turn you meet a rough shrine, with a figure of the Virgin or Christ, and an inscription calling you to prayers. It is a series of fair pictures it brings before you; but more than all we have the purity of a man who, through all the temptations of an artist's life, has known a higher power than nature,—whose life is a hymn of faith and love.[25]

Beginning with the facts that Palomino and Ceán recounted accurately, scholars have, over the years, added to our information about Murillo's life and career through research in the archives of Seville. The colorful anecdotes related above no longer appear in Diego Angulo Iñíguez's otherwise lovingly detailed biography of the artist published in 1981.[26] We find, after the legends have been pruned away, that Murillo's life is not the stuff of which film scripts are made. Washburn was probably not far off the mark when he wrote, "Murillo's life was the quiet, uneventful career of a simple painter."[27] He was a family man and a friend who enjoyed good relationships with his colleagues and students. He was a well-adjusted, social being who joined religious confraternities and developed a sustaining network of wealthy patrons. But his "quiet, uneventful career" transpired in very interesting times.[28]

Seville (fig. 3) was one of the largest and most cosmopolitan cities in Europe in the late sixteenth century.[29] Trade with Italy, Flanders, and especially, the importation of gold and silver and other precious stuffs from the Spanish American colonies made Sevillian merchants rich, and they built grand palaces and endowed family chapels, convents, and monasteries. However, by the mid-seventeenth century, the picture was not so rosy. The Guadalquivir River silted up, and Cádiz, on the Atlantic Ocean, absorbed the trade from the Americas; bubonic plague ravaged the city in 1649, killing half of its inhabitants; and, in 1652, the poor and hungry of Seville revolted and nearly gained control of the city— all this just as Murillo's career was getting started. Later in Murillo's life, the situation in Seville was not greatly improved, only less dire. In 1677 the city was afflicted by another epidemic. Though it did not prove as disastrous as the earlier plague, it certainly raised the fears of a citizenry whose living consitutuents had a clear and horrible memory of 1649. A famine in 1678 resulted from crop failures. In 1680, an earthquake threatened the collapse of the city's oldest buildings, and the value of money in Spain was deliberately depreciated by the Monarchy—a disaster for Sevillian merchants. Extremes of weather year upon year devastated crops.[30]

Bartolomé Esteban Murillo, the youngest of fourteen children of Gaspar Esteban of Seville, a university-educated barber-surgeon, and his wife, María Pérez, was baptized on January 1, 1618. Gaspar Esteban prospered, held a respected position in Sevillian society, and evidently provided his large family with stability, for all the children were baptized in

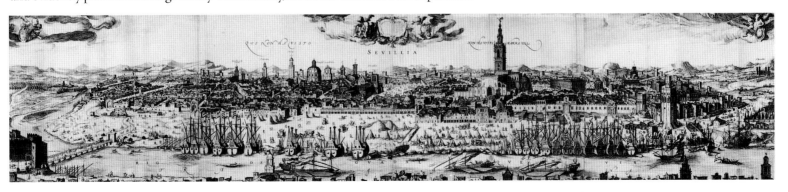

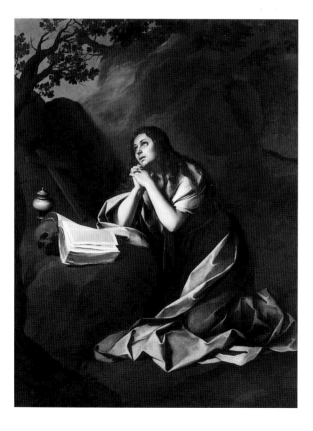

the same parish church of La Magdalena. Murillo's parents died within months of each other in 1627 and 1628 and the boy (who later adopted the surname of his maternal grandmother) became a ward of his older sister, Ana, and her barber-surgeon husband, Juan Agustín Lagares. Though Murillo was thus technically orphaned, he was in no way thrown upon his own resources. Rather, he could count on considerable support from an extensive family network that included artists. An uncle, Antonio Pérez, was a painter: he was married to the daughter of a Sevillian artist, and their daughters were also married to artists. Juan del Castillo, who was related to Murillo on his mother's side, was a prominent Sevillian painter of the time. Although no contract has been discovered, we may take Palomino's word for it that Murillo entered Castillo's studio as an apprentice. He would have done so at about the age of twelve or thirteen, or about 1630. Juan del Castillo (1584–1640), with others of his generation of Sevillian painters, was a workmanlike but provincial artist, who contributed little but the techniques of the trade to his apprentice's future success.

Some members of Murillo's family had emigrated to America. In 1633, with the apparent notion of following them, Murillo drew up a will. We do not know whether he traveled to the Americas or not, but his plan to do so suggests that his apprenticeship was over. He was surely back in Seville by the end of the decade. There are few extant early paintings by Murillo, among them the *Virgin Presenting the Rosary to Saint Dominic* (fig. 4), painted for the Colegio de Santo Tomás. The composition follows a Sevillian type of double-tiers used by Juan del Castillo and others of his generation, and the technique also follows that of Castillo in the application of rather hard-edged, closed contours to the figures of the Virgin Mary and Saint Dominic. However, the softer brushwork, seen in the depiction of the heavenly host, suggests Murillo's early debt to Juan de Roelas, whose fluent combination of both Italian and Flemish elements had refreshed Sevillian painting early in the seventeenth century. The gentle urge toward modernization found in Roelas's work was followed, around 1620, by the forceful naturalism of Velázquez's genre paintings, and Murillo could also have studied contemporary Flemish and Italian paintings in Sevillian private collections. In a painting of Mary Magdalene (fig. 5) that Murillo must have created just before 1640, his training by Juan del Castillo is still evident, but the predominantly brown tonalities indicate his awaking interest in a more naturalistic manner. It is interesting to note that this *Mary Magdalene* was on view in the United States in 1908, even earlier than the two paintings of the same subject included in this exhibition of works by Murillo in American collections (cat. nos. 4 and 5).[31]

Around 1645 Murillo began work on a commission that might seem daunting for such a little-proven young painter: eleven canvases for the Claustro Chico ("small cloister") of the monastery of San Francisco el Grande (see cat. nos. 1 and 2), the largest religious house in Seville. The conservative, somewhat tentative, qualities of Murillo's earliest works seem to be quite suddenly replaced by a confident naturalism and, between the first and the last of the paintings in the series, a clearly discernible move toward a more individual style. Palomino attributed Murillo's newfound strength and originality to a trip to Madrid, "where, with the protection of his compatriot Velázquez (then Painter to the Bedchamber), he saw many times the eminent paintings in the Palace, in El Escorial, and in other royal seats and gentlemen's palaces and copied many from Titian, Rubens, and Van Dyck, so that he greatly improved the quality of his coloring . . . but particularly by seeing the beautiful and grand manner of Velázquez, contact with whom was very profitable to him."[32] Ceán Bermúdez later specified that Murillo left for Madrid in 1643 and returned to Seville in 1645. We know that the painter was in Seville in 1645, the year he married Beatriz Cabrera y Villalobos (who bore him nine children during their

twenty years together) and the year he received the commission from San Francisco el Grande. Like Palomino, Ceán could not explain Murillo's successful handling of this large project without the educational intervention of a sojourn at court: "No one could figure out how and with whom he had learned that new, masterly, and unknown style, since no master or model then found there [Seville] could have taught him. He showed soon afterwards in those paintings the three teachers he had decided to imitate in Madrid. . . . "[33] Ceán identified those "three teachers" as Jusepe de Ribera, Anthony van Dyck, and Velázquez. In reality, however, the paintings for San Francisco reveal nothing of what might have most strongly attracted a young painter to Madrid to study the royal collection famous for paintings of the Venetian Renaissance (Titian and Tintoretto) and the northern Baroque (Rubens and Van Dyck) or even the brilliant painting style Velázquez developed at the court. Palomino himself mentions an alternative to the trip to Madrid: "Because they neither knew his history nor had observed it—as earlier he had not been a man of signal reputation in this art—they said that he had been closeted at home all that time, studying from the model and in this way had acquired his skill; and that is what I heard some painters say in my youth."[34] Indeed, Murillo's sources of inspiration were all to be found "at home" in Seville, and most scholars today discount the supposed stay with Velázquez as legend.[35]

The eleven paintings in the San Francisco series relate miraculous episodes from the lives of Franciscan saints, individuals well known to the residents of the monastery, of course, but not so familiar to the viewer today. Perhaps, however, Saint Juniper and Saint Salvador of Horta were not so widely recognized even in Murillo's time, for each of the paintings includes an inscription identifying the subject. The earliest works in the series, such as *Saint Diego of Alcalá Giving Food to the Poor* (fig. 6), bespeak the naturalistic style of a slightly older generation of Sevillian painters such as Francisco de Zurbarán and Francisco de Herrera the Elder. Not only are the figures in this painting not idealized (as they most surely would have been in the hands of a contemporary Italian artist), they are even homely. As well, and as is true of many of the more complex subjects painted by Zurbarán or Herrera the Elder, the individual figures in Murillo's painting are not well unified into an overall compositional whole. The eye jumps from one to another of the interesting cast of characters, and Saint Diego seems less the center of attention than the food he has provided. However, as the young artist continued work on the series, his sophistication increased step by step. By the time the entire group of paintings for San Francisco was complete, Murillo had found his own "voice," a visual language in which a certain elegance of line and movement tempers blunt realism, as evidenced in the female figures in the *Death of Saint Clare* (fig. 7). Here, not only are the individual figures more graceful than earlier, but Murillo has choreographed their movement so that they approach the cell of the dying Saint Clare in a harmonious, unified composition.

This direction in Murillo's art may be indebted to the example of Alonso Cano, a multitalented artist who worked with distinction as painter, sculptor, and architect. Cano and Velázquez were contemporaries who studied together in the workshop of Francisco Pacheco in Seville and remained lifelong friends. Cano, as Jonathan Brown has pointed out, was the "odd man in Sevillian painting of the 1620s and 1630s,"[36] for most of his work during those years was in sculpture. But Murillo could have studied Cano's *Saint John the Evangelist's Vision of the Heavenly Jerusalem* (fig. 8), painted about 1635–37 for the convent of Santa Paula in Seville. Cano's careful rendering of the anatomy of the angel; its complex, foreshortened pose; and the pastel, translucent colors suggest a study of Italian painting not undertaken by any of Cano's contemporaries. The idealizing qualities in

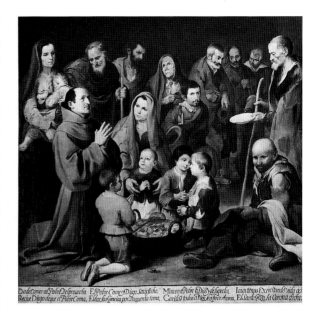

Opposite, top: *Fig. 4. Bartolomé Esteban Murillo.* THE VIRGIN PRESENTING THE ROSARY TO SAINT DOMINIC. *c. 1638–40. Oil on canvas, 6′9½″ x 63¾″ (207 x 162 cm). Archbishop's Palace, Seville*

Opposite, bottom: *Fig. 5. Bartolomé Esteban Murillo.* PENITENT SAINT MARY MAGDALENE. *c. 1639. Oil on canvas, 6′5″ x 57″ (196.2 x 144.8 cm). Matthiesen Fine Art, Ltd., London*

Above: *Fig. 6. Bartolomé Esteban Murillo.* SAINT DIEGO OF ALCALÁ GIVING FOOD TO THE POOR. *1645–46. Oil on canvas, 68⅛ x 72″ (173 x 183 cm). Real Academia de Bellas Artes de San Fernando, Madrid*

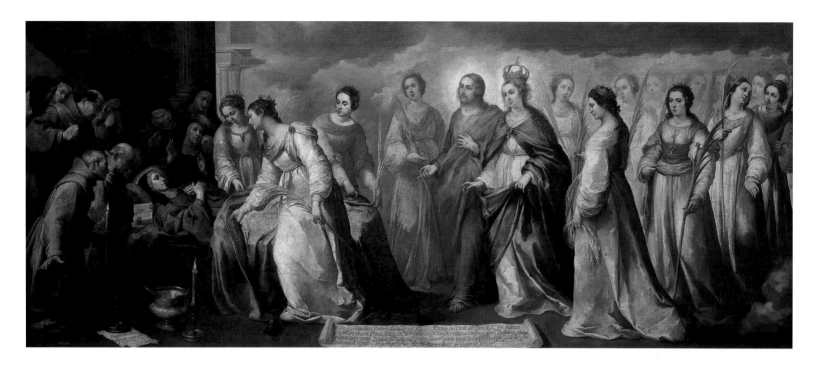

Above: *Fig. 7. Bartolomé Esteban Murillo.* THE DEATH OF SAINT CLARE. *c. 1646. Oil on canvas, 6′2¾″ x 14′8⅝″ (190 x 446 cm). Gemäldegalerie, Dresden*

Opposite, top: *Fig. 8. Alonso Cano.* SAINT JOHN THE EVANGELIST'S VISION OF THE HEAVENLY JERUSALEM. *c. 1635–37. Oil on canvas, 32½ x 17¼″ (82.6 x 43.8 cm). The Wallace Collection, London*

Opposite, bottom: *Fig. 9. Bartolomé Esteban Murillo.* HOLY FAMILY WITH A LITTLE BIRD. *c. 1650. Oil on canvas, 56¾″ x 6′2″ (144 x 188 cm). Museo Nacional del Prado, Madrid*

Cano's paintings might indeed have inspired the gracefulness, later maligned by critics as "sweetness," of Murillo's mature style.

In a 1645 document related to his marriage, Murillo affirmed that he had "all his life been a parishioner of La Magdalena without any notable absence."[37] In the same year he is for the first time documented as a landlord, renting out a house on the plaza San Pablo. Managing a modest collection of rental properties, as Murillo did through the years, was one of the ways artists in Seville assured a regular income, so that a family could be fed in between lucrative commissions. During the next several years babies were born to the young couple and several of them were buried, the family moved a number of times, and Murillo took on an apprentice, fourteen-year-old Manuel Campos, who was to stay with him for six years.

The 1649–50 epidemic of plague caused the city's large number of religious establishments (by 1649 there were nearly seventy monasteries and convents in and around Seville and twenty-eight parish churches) to turn their resources to charitable purposes. As a result, Murillo for a while received no additional large religious commissions, but he continued to build his career. His early *Self-Portrait* (see cat. no. 33) projects the confidence of a young painter on his way up despite the economic and societal devastation around him. Around the same time, he painted the *Holy Family with a Little Bird*, called "El Pajarito" (fig. 9), a work that perfectly exemplifies a type of religious painting that would make Murillo not only a great success among private patrons and collectors in the second half of the seventeenth century, but popular for decades thereafter. Murillo had painted the Holy Family early in his career, in a composition called the *The Two Trinities*, in which the Virgin and Saint Joseph walk on either side of the Christ child, each holding his hand (Nationalmuseum, Stockholm). Above, the threesome is echoed in the heavenly presence of the Trinity: God the Father, the Son, and the Holy Spirit. Thus, the Trinity, an article of faith, is given visual form. Later, Murillo painted the Holy Family again in two versions of the Flight into Egypt (see cat. no. 3). In both these paintings, Murillo relied on a traditional and oft-repeated composition. However, in the *Holy Family with a Little Bird*, Murillo created something quite new, effectively transforming a religious subject, the

Holy Family, into a cozy and reassuring domestic scene unadorned with attendant angels or miraculous light. He so thoroughly made Mary, Joseph, and the Christ child believable that Hans Christian Andersen, visiting the Museo del Prado in the mid-nineteenth century, did not recognize the actual subject matter of the painting: "One more work of Murillo's I must mention, it is so charmingly conceived and so beautifully executed; it represents a little domestic scene: a young mother sits and winds yarn, her husband holds the child, who is raising a little bird high in the air, whilst a little dog shows its cleverness by sitting on his hind-legs and giving his paw."[38] Murillo's tender interpretation moves radically away from the austere naturalism that had generally characterized much of Spanish religious painting since the 1580s. Because his transformation of such images has seemed so effortless, his originality has not, perhaps, been fully credited. In the coming centuries, both Murillo's fans and detractors assumed that his devotional paintings sprang from an easy naturalism. On the positive side:

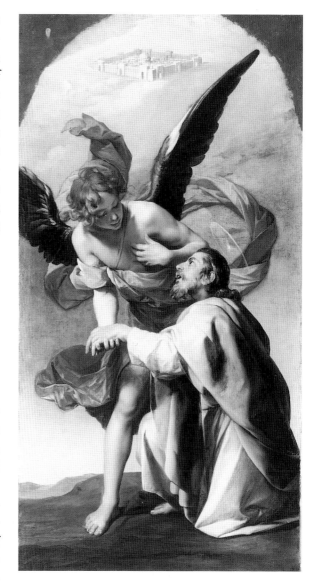

> His paintings picture the natural gaiety of the natives and their delight in mere living. They reveal the sweet kindness and liveliness of their character, and give it a truly lyrical expression. . . . His Madonna, his Christ Child, his saints, were taken direct from the people of his native city. He met them in his walks along the shadow-painted streets and in the sunny squares. He knew them and took them to be as good and as kind as he was himself. [39]

For the critic of Murillo's art, that same ease with the world around him bespoke laziness: "He [Murillo] is a son of the soil, and of a soil so fertile that it assures a living even to the sluggard. So Murillo takes the line of least resistance, adopting without question the style which pleases his patrons, and indolent even when exercising his great natural bent for Realism."[40]

We may be sure that Murillo was not just recording everyday life in seventeenth-century Seville, for painters in the seventeenth century never merely documented their surroundings. Nor should we believe that Murillo's art was shaped by his taking the path of least resistance (although he did not pretend to, never sought to, create an intellectually challenging art). It has often been written that Murillo's art responds to the gentler devotional spirit characteristic of his time: that is, that his paintings reflect a lessening of the severe character of the Catholic religion during the decades immediately following the Council of Trent. The problem with this interpretation is that the only evidence ever used to demonstrate this "kinder, gentler" church is Murillo's oeuvre. Rather than assume that the spiritual tenor of Murillo's paintings, especially those intended for private devotion, is grounded in the nature of contemporary religiosity, we might consider instead whether Murillo simply invented it, creating images of comfort for the faithful, images that held out the promise of salvation through piety and good works, and that offered sweet respite from the real horrors of the plague and grinding poverty and hunger. Certainly, Murillo's particular sensibility for warm, intimate, familial subjects, while often attempted by his followers (and well into the eighteenth century), was not shared at all by his greatest contemporary—and competitor—in Seville, Juan de Valdés Leal. On the contrary, Valdés Leal's work was characterized by an overwrought emotionality that projected a feeling of tension, even anxiety, emotions Murillo seemed at pains to avoid.

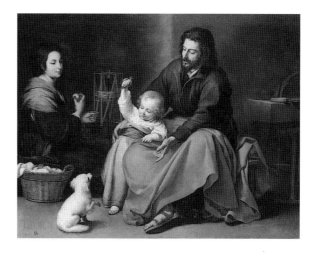

Although Murillo's predecessors in Seville had painted devotional subjects not unlike those he himself created—Francisco de Herrera the Elder's *Saint Joseph and the Christ Child,* of 1645 (Szépmüvészeti Múzeum, Budapest), comes to mind—and although an older

Zurbarán would try to take advantage of the demand for devotional pictures stimulated by Murillo (as, for example, Zurbarán's *Virgin and Child with Saint John the Baptist*, 1658, San Diego Museum of Art), the expansion of this "niche market" was largely in the younger painter's hands. Around 1650 Murillo painted half a dozen versions of the Virgin and child alone, among them the famous version in the Palazzo Pitti (fig. 10), and several versions of the Virgin of the Rosary (Musée Goya, Castres; Museo del Prado, Madrid; Palazzo Pitti, Florence).

As noted earlier, Murillo had painted a Virgin of the Rosary in 1639 (see fig. 4). He became a member of the Brotherhood of the Virgin of the Rosary in 1644, so perhaps paintings of that subject created around 1650 were commissioned by other members of the confraternity. Certainly, during this period, Murillo was cultivating the circle of friends who would supplement the patronage of the arts by Catholic institutions. In 1650 Miguel de Mañara Vicentelo de Leca, who would become one of Murillo's most important patrons, became godfather to the painter's son, José Esteban. The daughter of Murillo's sister and her husband, the couple who had cared for him following the deaths of his parents, married José de Veitia Linaje. Veitia did not directly commission works from Murillo, but his position in the Casa de Contratación (which governed trade with the Indies) and his membership in the Brotherhood of the True Cross could influence those who did. The brotherhood, which had a chapel in the monastery of San Francisco el Grande, numbered among its members wealthy foreign merchants and friends of Veitia who became Murillo's clients. In 1652 Murillo was commissioned by the brotherhood to paint the *Virgin of the Immaculate Conception with Fray Juan de Quirós* (Archbishop's Palace, Seville); the first payment to the artist was made by Veitia. Murillo's connection to Veitia is just one example of the way in which social interaction produced commissions, the kind of connection that would continue to be crucial for Murillo's career.[41] Murillo did not paint a great number of portraits, though he did record to splendid effect the images of a number of his patrons, such as the Fleming Nicolás Omazur and his wife (both Museo del Prado, Madrid). A portrait of Veitia was in the artist's estate.

In contrast, Zurbarán, who had earlier in the century supported a large workshop on the generous commissions from the many religious foundations in Seville, found his support melting away. After the plague, when those institutions turned their resources to feeding the poor rather than adding to their store of paintings, Zurbarán was not able to tap the wealthiest segment of the private sector, as Murillo's connections enabled him to do. Zurbarán's later career depended on consignments of painting for the Americas, some devotional paintings for individual clients, and a sad effort, in the end, to soften his style to simulate that of the ascendant Murillo. Murillo, in fact, soon replaced Zurbarán as the painter of choice of the religious houses. Around 1655, Murillo received a commission from the monastery of San Leandro, the Sevillian home of the Shod Augustinians, who had a special dedication to the two Saints John. For San Leandro, Murillo painted four scenes from the life of Saint John the Baptist (see cat. no. 6) and one depicting Augustine, the titular saint of the convent, washing the feet of Christ (now Museo de Bellas Artes, Valencia). In the quiet solemnity of the narratives in the San Leandro paintings, told with only two or three figures set against a luminous landscape for the sake of legibility, Murillo set a new standard of restrained Baroque grandeur for the decoration of Sevillian religious houses and churches. In 1655, when Juan de Federigui, archdeacon of Carmona and canon of Seville, commissioned Murillo to paint effigies of Saints Isidore and Leander for the cathedral, he described Murillo as "the best painter that there is today in Seville."[42]

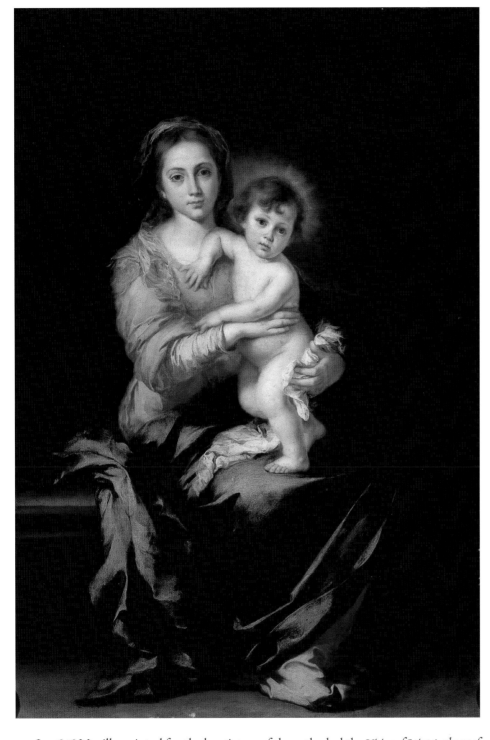

In 1656 Murillo painted for the baptistery of the cathedral the *Vision of Saint Anthony of Padua* (fig. 11), a work of immense scale (measuring more than eighteen by twelve feet, thus preventing it from being removed to France at the time of the Napoleonic invasion) that marks a significant moment in Murillo's stylistic development. The painting is somewhat formulaic in that it is divided, in a tradition of Sevillian painting, into a heavenly and an earthly zone, but it is also Murillo's earliest foray into a "high Baroque" style. The result is the spacious *gloria* in which the Christ child appears surrounded by a host of angels, a heavenly zone filled with movement and the soft, golden light that came to be

Fig. 11. Bartolomé Esteban Murillo.
VISION OF SAINT ANTHONY
OF PADUA. *1656. Oil on canvas,*
18′4⅜″ x 12′3⅝″ (560 x 375 cm).
Seville Cathedral

associated with Murillo as master of epiphany as well as master of realism. The free brush-work and brilliant luminism of this painting were described by Ceán Bermúdez as "la diestra indecision con que se pierden los contornos" ("the skillful indecision with which the contours are lost"), [43] and foretell Murillo's treatment of heavenly space and angelic company in paintings following his visit to Madrid. Certainly, however, there were many paintings in Seville, especially in private collections, that collectively might have stimulated Murillo toward a new monumentality. His own patrons had considerable collections: the Dutch ship owner Joshua van Belle, for example, owned paintings attributed

to Titian, Van Dyck, Rubens, and Veronese.[44] Italian Baroque painters were also represented in Sevillian collections: Francisco Pacheco, in his *Arte de la pintura,* published in 1649, noted his admiration for Guido Reni, whose work Pacheco must have seen in Seville. Even more likely is the possible influence of paintings by Jusepe de Ribera, the Spanish Baroque master whose career largely took place in Naples, but whose works were regularly sent to Spain by his patrons in that Spanish viceroyalty.

Soon after Murillo's *Vision of Saint Anthony* was installed in the cathedral, a commission for another painting of a Franciscan subject was given to Francisco de Herrera the Younger, who had spent time in Madrid and brought with him elements of a new style characterized by dynamic movement and sketchy brushwork (*Stigmatization of Saint Francis,* 1657, Seville Cathedral). Murillo's trip to Madrid in April 1658 may well have been impelled by the evident modernity of Herrera the Younger's painting, to see what Herrera had seen and profited by studying at the court. It was not a long sojourn: by the beginning of December he had returned to Seville. We can be sure, however, that he was able, while in Madrid, to study the royal and noble collections of painting there—two decades later than Palomino and Ceán Bermúdez claimed. This was to have a palpable impact on Murillo's art.

In the years between his creation of the *Vision of Saint Anthony of Padua* for the cathedral and about 1660, Murillo was busy with various independent commissions for religious subjects and portraits. However, the impact of Murillo's trip to Madrid is most clearly evident in the *Birth of the Virgin* (fig. 12), painted in 1660 for the chapel of the Immaculate Conception in the cathedral, or in another work of the same period in an American collection, *The Birth of Saint John the Baptist,* now in the Norton Simon Museum, Pasadena, California (fig. 13). Here, Ceán's description of a style marked by the "skillful indecision with which the contours are lost" is apparent to any careful observer, and here is the beginning of a great underestimation of Murillo by later critics.

Above: *Fig. 12. Bartolomé Esteban Murillo.* The Birth of the Virgin. *1660. Oil on canvas, 70½″ x 11′4⅜″ (179 x 349 cm). Musée du Louvre, Paris*

Below: *Fig. 13. Bartolomé Esteban Murillo.* The Birth of Saint John the Baptist. *c. 1660. Oil on canvas, 57¾″ x 6′2⅛″ (146.7 x 188.3 cm). The Norton Simon Foundation, Pasadena, Calif.*

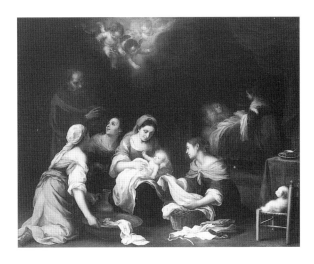

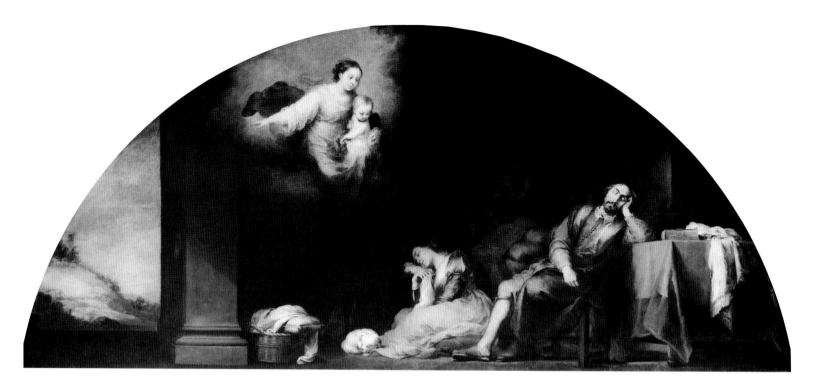

Fig. 14. Bartolomé Esteban Murillo.
THE DREAM OF PATRICIAN
JOHN AND HIS WIFE.
*c. 1662–65. Oil on canvas, 7′7⅜″ x
17′1″ (232 x 522 cm). Museo
Nacional del Prado, Madrid*

Palomino and Ceán Bermúdez categorized Murillo's art as belonging in the camp of masters of color rather than drawing, in a long tradition of contrasting the virtues of *colore vs. disegno*. Palomino understood the matter quite well:

> Thus today, outside of Spain, a picture by Murillo is esteemed more than one by Titian or Van Dyck. That is how much power the flattery of color has to coax the layman's favor! For the truth is that the men who achieved the greatest acclaim have not done so for being the greatest draughtsmen (they earn their well-deserved reputation from the professionals instead), but rather those who have excelled in the good taste of their coloring. We cannot deny that Michelangelo, Raphael, Annibale, and all the Carracci school (without lacking the essentials of coloring) drew better than Titian, Rubens, Van Dyck, Correggio, and our Murillo, but nonetheless it was the latter painters who won popular acclaim, for the superior excellence of what is purest and more transcendental in drawing is not understood by the layman. And since its substance was not lacking in them, and on the other hand they excelled in the more attractive beauty of coloring, they drew to themselves the applause of laymen, who are incomparably more numerous than the entire throng of artists.[45]

Later Murillo critics seem to have forgotten the seriousness of the debate over the relative importance of *colore vs. disegno* during the Renaissance and Baroque periods (even in Spain), so Palomino's words came to be misinterpreted. In a handbook of the history of art popular at the turn of the nineteenth century, the author firmly stated: "Murillo is weak and wanting in distinction as a draftsman." At the same time, however, the author credited Murillo with being "a master of vaporous colour, sometimes silvery, sometimes golden, always suave and caressing. This colour is not merely spread upon his figures, but around them; it is like a nimbus from which they emerge, embellished by its glamour."[46]

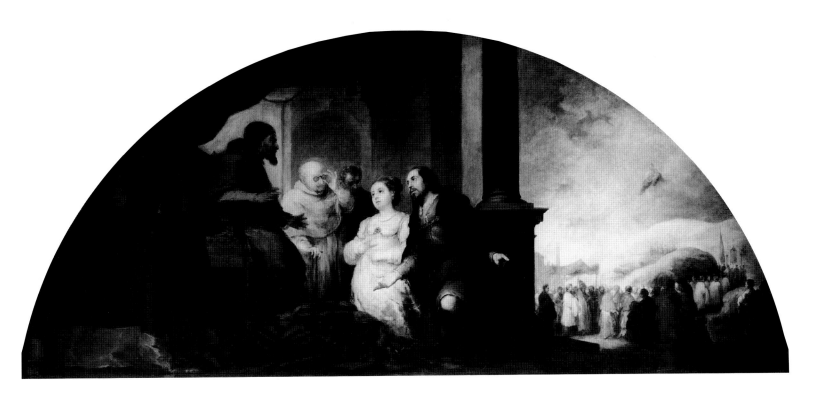

Fig. 15. Bartolomé Esteban Murillo. PATRICIAN JOHN REVEALS HIS DREAM TO POPE LIBERIUS. c. 1662–65. Oil on canvas, 7'7⅜" x 17'1" (232 x 522 cm). Museo Nacional del Prado, Madrid

To state that Murillo could not draw is, of course, patent nonsense. The proof of his being one of the great draftsmen of the Spanish golden age of painting is the large number of beautiful drawings that are an important aspect of his oeuvre.[47] In fact, an academy of art was established in Seville in January 1660 with Murillo and Francisco de Herrera the Younger as its co-presidents and with the principal aim to teach drawing, encouraging students to both copy from works of art and to work directly from models (see essay by Peter Cherry in this catalogue). There can be no doubt that these masters of *colore*, Murillo and Herrera, greatly valued the underlying importance of *disegno* in painting. The loose and sketchy brushwork of Murillo's mature style reflects his authority as an artist who has long since mastered the essentials. Already in 1660, and with more than twenty productive years ahead of him, Murillo has come into his own, a style described by Ceán as "distinguished from others by a general harmony of hues and colors [and by] an indecision of outlines wisely and sweetly lost."[48]

By 1662, Murillo could be described as "a famous painter who is the admiration of Europe, only in Spain, his land, is he unknown and less esteemed," as he was in the document that registered his membership in the lay organization, the Venerable Orden Tercera de San Francisco.[49] Also in 1662 Murillo began work on a major commission that would keep him busy for the next several years: a series of paintings for the church of Santa María la Blanca in Seville. The church, once a synagogue, was refurbished with new marble columns, stucco decoration, and paintings, all at the personal expense of Justino de Neve, a canon of the cathedral who had inherited considerable wealth from his Flemish merchant father. The works for the church were completed in early July 1665, but the grand opening was scheduled for August 5, the feast day of Saint Mary of the Snows. Two large lunettes painted for the crossing narrate the legend of the founding of the church of Santa Maria Maggiore (Santa Maria della Neve) in Rome: the *Dream of Patrician John and His Wife* and *Patrician John Reveals His Dream to Pope Liberius* (figs. 14 and 15).

The Roman patrician and his wife, who pledged their wealth to the service of the Vir-

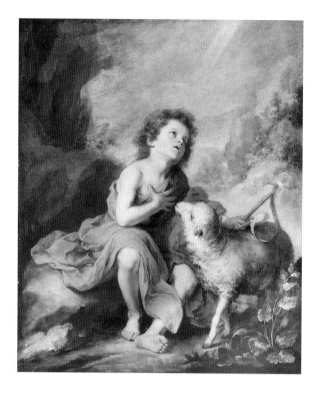

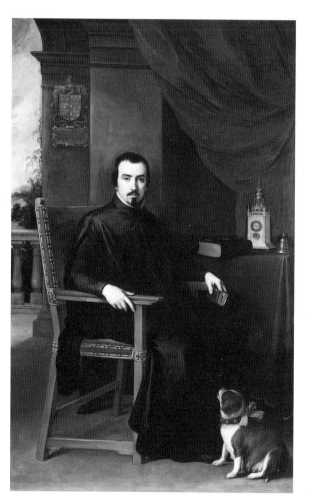

gin, may be seen as paradigms for the person of Justino de Neve himself. In the first painting, the couple are seen asleep, but it is not an ordinary sleep (for they are fully clothed), rather a kind of dream in which the Virgin appears to them. She announces that the plan for the church to be built in her honor will appear outlined in snow on the Esquiline Hill—in August. The couple are seen in the second painting reporting to the pope on their experience, while, to the right, a crowd witnesses the miracle overseen by the Virgin herself. The other two lunettes commissioned by Justino de Neve represent important points of church doctrine: the *Triumph of the Eucharist* (Buscot Park, Oxon) and the *Immaculate Conception of the Virgin* (Musée du Louvre, Paris). The latter reflects the patron's dedication to the Virgin, because the redecoration of the church and its celebrated reopening responded to the 1661 bull issued by the papacy in support of the doctrine of the Immaculate Conception.[50]

Large-scale, narrative paintings such as these require quite different skills on the part of an artist than do smaller devotional images such as those with which Murillo is most often associated. Because they are intended to be viewed at a considerable height and from a considerable distance, compositional clarity and legibility are requisites. In the scene in which the patrician relates his dream to the pope, for example, Murillo demonstrates an easy command of this demanding scale and format. The figures of Patrician John and his wife are centered within the shape of the lunette, and Pope Liberius stands out prominently on the left against a light background. To the right, clearly separated from this interior scene by the imposing architectural elements, a crowd witnesses the miraculous snowfall in a luminous landscape setting.

Murillo had further opportunities to demonstrate his skill as a landscape painter in the settings for the scenes of the life of Jacob (see cat. nos. 13 and 14) that he painted for the marqués de Villamanrique and that were also on display when Santa María la Blanca was inaugurated. These, and paintings by Peter Paul Rubens, Jusepe de Ribera, Luca Cambiaso, the Cavaliere d'Arpino, Artemisia Gentileschi, Orazio Borgianni, and even one attributed to Rembrandt[51] were on view out of doors, for the square in front of the church and the adjacent buildings were decorated with works from private collections. Murillo also provided three pictures for the main temporary altar: an *Immaculate Conception*, an *Infant Saint John,* and a *Good Shepherd*.[52] The latter two subjects, Saint John the Baptist and Christ as children, would become inextricably linked to Murillo's name during the following centuries. His paintings of Christ offering Saint John a drink of water from a shell (fig. 41) and of *Saint John the Baptist as a Child* (fig. 16) became, especially at the turn of the nineteenth century, among the favorite paintings of visitors to the Prado.

Probably around the time of these festivities, Murillo painted the portrait of the sponsor, Justino de Neve (fig. 17), in which the sitter is captured in a traditional pose, seated at his desk within an architectural setting leading out to a grand landscape. The pose and accouterments (an ornate clock on the desk and a faithful dog attentive to his master) lend appropriate grandeur to a generous supporter of religious institutions and patron of the arts. There are few portraits by Murillo extant, but those few (such as cat. no. 34) reveal yet another of the painter's areas of expertise. Murillo's *Portrait of Don Antonio Hurtado at the Hunt* (private collection, Vitoria) perhaps reflects Velázquez's portraits of the king and other members of the royal family in hunting dress, but the inclusion of a pack of hounds, an attendant, and a pile of game lend the composition a Flemish air. Surely Flemish in inspiration is Murillo's use of a frame within the frame and the *vanitas* emblem of the skull in his portrait of Nicolás Omazur (Museo del Prado, Madrid). Ceán Bermúdez

asserted that "un MS. de aquel tiempo" (a document of that time) identified the fictive portrait paintings of Saints Isidore and Leander that Murillo painted for the cathedral as actual portraits of officials of the cathedral community.[53] This suggests, if it is indeed true, that there may be more portraits by Murillo than have been identified, particular individuals depicted as saints (called *retratos al divino*), or among the cast of characters in narrative scenes.

In the late eighteenth century, Antonio Ponz wrote that "the church of the Capuchins is second to none other in Seville in its number of original paintings by Bartolomé Murillo."[54] In 1665 Murillo began work for the "Capuchinos," a commission that included ten paintings for the main altar and eight for individual side altars in the monastery church.[55] In order to fulfill the demands of such a large commission in such a short time (the main altarpiece was completed in 1666), Murillo in some cases relied on a traditional composition, as in his painting of the patron saints of Seville, *Saints Justa and Rufina* (see cat. nos. 15 and 16, fig. 1), and, in some cases, he used a print as a compositional guide. Thus, the *Pietà* (Museo de Bellas Artes, Seville), painted for a side altar, depends on an engraving after a work by Annibale Carracci (Museo e Gallerie Nazionali di Capodimonte, Naples). Both the recycling of iconic images and the use of prints as compositional short-cuts were common practices in the seventeenth century.

The huge main altarpiece created for the Capuchins had as its imposing centerpiece *Saint Francis at the Porciuncula* (Wallraf-Richartz-Museum, Cologne): it is composed similarly to the earlier *Vision of Saint Anthony* but is more complex. The earthbound Saint Francis beholds a heavenly vision of the Virgin Mary, Christ holding the cross, and a numerous crowd of putti. This great Baroque painting was surrounded on the altarpiece by works conceived largely as pairs. *Saint John the Baptist* was paired with standing figures of *Saint Joseph and the Christ Child* (both Museo de Bellas Artes, Seville); *Saints Justa and Rufina* had as its pendant *Saints Bonaventure and Leander* (both Museo de Bellas Artes, Seville); the *Guardian Angel* leading a small child by the hand (now Seville Cathedral) was paired with an image of *Saint Michael* (now lost); and *Saint Anthony of Padua* and *Saint Felix of Cantalicia* were shown adoring the infant Christ child (both Museo de Bellas Artes, Seville). These large-scale paintings were joined by a small image of the Virgin and child (called *La Virgen de la Servilleta* (Museo de Bellas Artes, Seville), and a *Veil of Veronica* (now lost). The entire ensemble was dismantled by the Capuchins at the time of the French invasion in the early nineteenth century and sent to Gibraltar for safekeeping. Following other vicissitudes, most of the paintings found a home when the Seville Museo de Bellas Artes de la Merced opened in 1841.

In 1664, Murillo turned to a commission for paintings for the church of San Agustín. These included *Saint Thomas of Villanueva as a Child Dividing His Clothes among Beggar Boys* (cat. no. 19) and *Saint Thomas of Villanueva Giving Alms to the Poor* (cat. no. 19, fig. 2). Work for the Capuchin monastery was resumed when funding to complete the project became available in 1668. Among the nine large-scale canvases for the side altars extant today is the one Palomino believed to be Murillo's favorite painting, the magisterial *Saint Thomas of Villanueva Distributing Alms* (fig. 18).

During 1667 and 1668, Murillo returned to work for the cathedral, creating portraits of eight saints in roundels and a *Virgin of the Immaculate Conception*, all still in situ in the chapter room. And, in 1667, Murillo undertook one of his most important commissions, this one for his friend Miguel de Mañara—eleven canvases for the newly completed church of the hospital run by the Brotherhood of Charity.

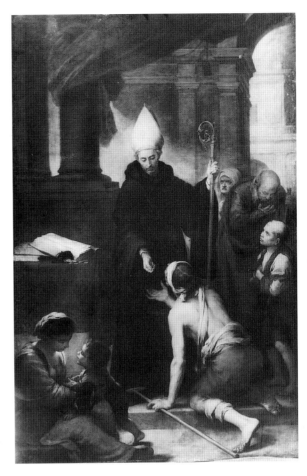

Opposite, top: *Fig. 16. Bartolomé Esteban Murillo.* SAINT JOHN THE BAPTIST AS A CHILD. *1660–65. Oil on canvas, 47⅝ x 39″ (121 x 99 cm). Museo Nacional del Prado, Madrid*

Opposite, bottom: *Fig. 17. Bartolomé Esteban Murillo.* PORTRAIT OF DON JUSTINO DE NEVE. *1665. Oil on canvas, 6′9⅛″ x 51″ (206 x 129.5 cm). National Gallery, London*

Above: *Fig. 18. Bartolomé Esteban Murillo.* SAINT THOMAS OF VILLANUEVA DISTRIBUTING ALMS. *c. 1668. Oil on canvas, 9′3″ x 6′2″ (283 x 188 cm). Museo de Bellas Artes, Seville*

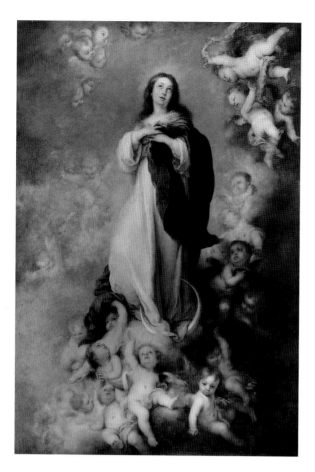

Above: *Fig. 19. Bartolomé Esteban Murillo.* VIRGIN OF THE IMMACULATE CONCEPTION (IMMACULATE CONCEPTION OF LOS VENERABLES, OR THE "SOULT IMMACULATE"). *c. 1678. Oil on canvas, 9′ x 6′2¾″ (274 x 190 cm). Museo Nacional del Prado, Madrid*

Opposite, top: *Fig. 20. Bartolomé Esteban Murillo.* URCHIN HUNTING FLEAS. *c. 1648. Oil on canvas, 54 x 45¼″ (137 x 115 cm). Musée du Louvre, Paris*

Opposite, bottom: *Fig. 21. Bartolomé Esteban Murillo.* THREE BOYS PLAYING DICE. *c. 1675–80. Oil on canvas, 57½ x 42¾″ (146 x 108.5 cm). Bayerische Staatsgemäldesammlungen, Alte Pinakothek, Munich*

The Brotherhood of Charity was founded in 1565 with the mission of burying the poor (one of the seven acts of mercy recognized by the Catholic Church as fulfilling the requirements of "good works"). The plague of 1649 lent this mission a renewed urgency, and the brotherhood expanded its membership, welcoming in 1662 Miguel de Mañara. Mañara had lived carelessly, enjoying his inherited wealth, until the sudden death of his wife in 1661. This event tapped a vein of deep religiosity, and Mañara was converted to a life dedicated to the good works espoused by the Brotherhood of Charity. He directed the organization in the expansion of its activities, built a hospital on the property adjacent the the chapel, and then decided to enlarge and redecorate the chapel. The resulting decorative ensemble of the church of the Caridad is one of the most cogent iconographical programs of religious art created in seventeenth-century Spain.[56]

Mañara's friend Murillo provided most of the paintings for the Caridad, though the first elements of the program were commissioned from Juan de Valdés Leal. His dramatic *memento mori* paintings (*In Ictu Oculi* and *Finis Gloriae Mundi*, 1670–72, Church of the Hospital de la Caridad, Seville) are powerful reminders of the fleeting glories of earthly pursuits. Following that reminder, the visitor to the church is shown the seven acts of mercy. Murillo painted six of these: among them, "clothing the naked" is represented by the *Return of the Prodigal Son* (see cat. no. 18), feeding the hungry by *Feeding of the Five Thousand*, and giving drink to the thirsty by *Moses Striking the Rock*. The seventh of the acts of mercy, burying the dead, was shown on the altar in a sculptural group by Pedro Roldán as the *Entombment of Christ*. Murillo painted two further pictures for side altars, depicting the good works of Saints Elizabeth of Hungary (fig. 92) and John of God. These underline one of the tenets of the Brotherhood of Charity—personal participation in good works.

In 1675 Justino de Neve established, in the Sevillian quarter of Santa Cruz, a charitable foundation dedicated to the care of retired priests—the Hospital de los Venerables Sacerdotes. Murillo painted two important pictures for the hospital, one of the Virgin of the Immaculate Conception (fig. 19), called the "Soult Immaculate" after it was taken from Spain by the French Marshal-General Soult. The other, the *Virgin and Christ Child Giving Bread to Pilgrims* (Szépművészeti Múzeum, Budapest), was originally installed in the refectory of the hospital. Murillo's earlier portrait of Justino de Neve was also installed there.

Despite the demands of these important commissions from the religious orders, the lay brotherhoods, and their well-to-do members, Murillo seems always to have found time to paint individual devotional pictures for his patrons and to create genre paintings to suit the cosmopolitan tastes of his patrons in Seville. The fame of Murillo's genre paintings greatly exceeds their numbers. In fact, the few that are surely by his hand had all left Spain for English and European collections by the early eighteenth century. Some of them seem to be scenes of everyday life in Seville, sensitively reflecting the concerns expressed elsewhere in works commissioned by the charitable orders and brotherhoods. An example is the earliest of these pictures, *Urchin Hunting Fleas* (fig. 20), a poignant image of a boy delousing himself, which has been dated to around 1648. Others are more light-hearted, more "picturesque," such as the *Three Boys Playing Dice* (fig. 21). Still others, such as the ones now in American collections (cat. nos. 31 and 32) are sexually suggestive.[57] These paintings defy easy categorization or interpretation, but, all together they clearly indicate Murillo's familiarity with the broad repertory of genre subjects painted by Dutch and Flemish artists throughout the seventeenth century. As well, their very existence broadens the stereotype of artistic patronage in Seville during Murillo's lifetime. Although

much has been written about the effects of the Counter-Reformation on art, and on the control the church exerted on religious painting to assure decorum and orthodoxy, it is important to remember that ecclesiastical authority was concerned with works of art on public view. The church did not dictate the contents of private collections and, as we have seen, the private collections of Seville were considerable repositories of paintings. There was a large market for pious imagery, to be sure, but also for lightly moralizing, amusing, even erotic paintings—all of which Murillo could provide.

Murillo's last large religious commission was for the main altar of the Capuchin church in Cádiz, which the artist probably began working on in Seville in the fall of 1681. Murillo's sketch for the enormous central canvas representing the *Mystic Marriage of Saint Catherine* is in this exhibition (cat. no. 30). While he was working on the painting, later completed by his assistant, Francisco Meneses Osorio (cat. no. 30, fig. 1), Murillo fell from the scaffolding and sustained serious injuries. He died a few months later, on April 3, 1682, at the age of sixty-four. O'Neil, following Ceán Bermúdez, would write: "This fatal accident has been the only painful circumstance which has ever fallen to the knowledge of any of his biographers to record; for the unsullied tissue of his life has only presented a web clear of infirmity of disposition and character, while the unrolling of his genius constantly dazzled in proportion as it was revealed."[58]

Murillo left both an impressive body of work and what was, for a long time, a confused legacy. His impact on his immediate followers, such as Meneses Osorio, was so profound that many works by them, though often clearly inferior to those of the master, have in the past been carelessly dubbed "Murillos." This was particularly true of the genre paintings that were spun out of the popularity of those few actually by his hand. These were particularly numerous in collections and on the art market during the nineteenth century, when such pictures were in great demand. In fact, the only one of Murillo's disciples who approached the master in genre painting was the gentleman painter and good friend of the artist Pedro Núñez de Villavicencio, who left a small body of quite interesting paintings.[59] Murillo's influence in Seville extended beyond his disciples, though, well into the eighteenth century, when the overwhelming impact of his oeuvre proved debilitating to any chance of originality on the part of a later generation of artists. Moreover, through the export of Sevillian paintings to the Americas, Spanish Colonial painting often bears the imprint of his style. However, Murillo's subtle compositional skills, his use of color and sketchy brushwork, all tended by a sensitive and compassionate eye, proved inimitable in the hands of others.

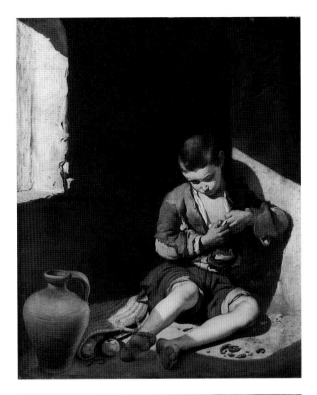

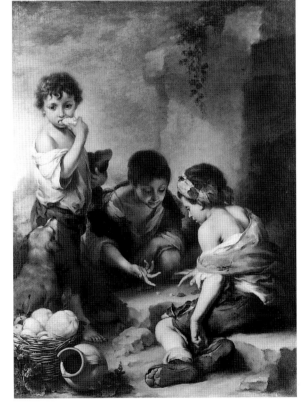

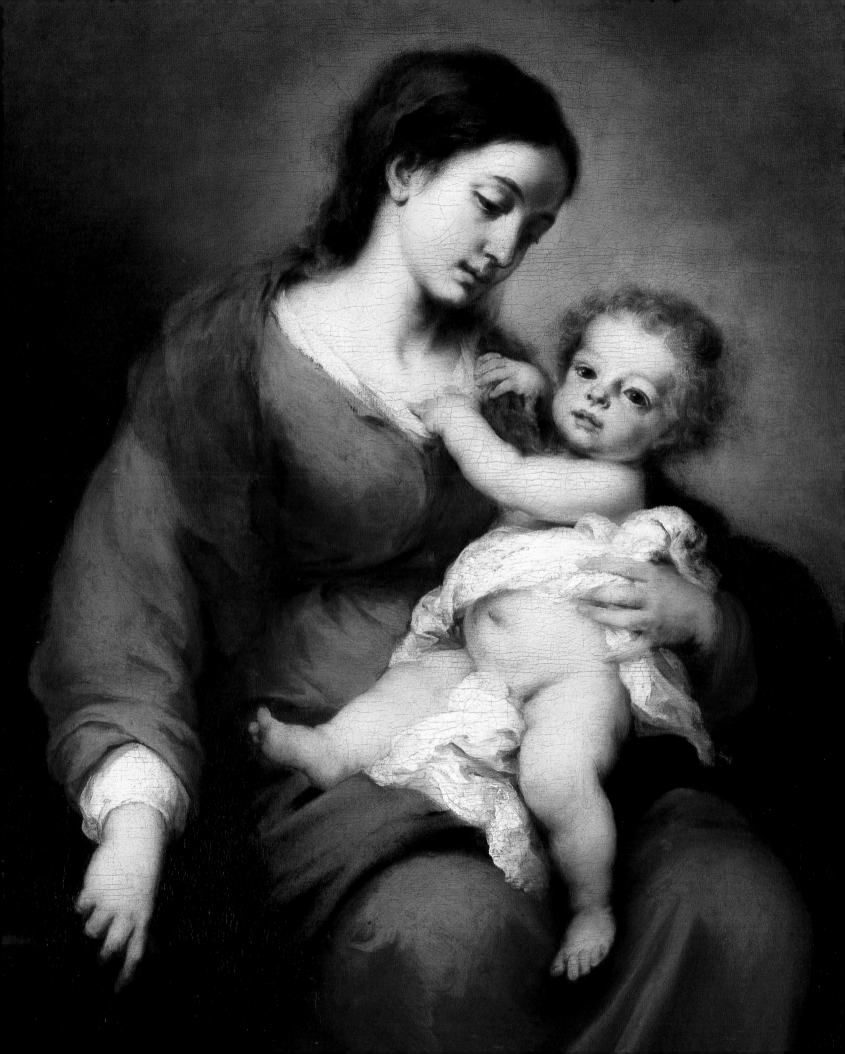

THE DEVOTIONAL PAINTINGS OF MURILLO

Jonathan Brown

Devotional paintings are a casualty of the secularization of Western civilization. Placed within the sanitized precinct of the art museum, they are admired for their artistry and not for their function in assisting prayer and promoting spiritual development. Indeed, it could be argued that the best devotional paintings provoke rejection by audiences of today, who feel uneasy in the presence of their power. The devotional paintings of Murillo exemplify this phenomenon. It is the purpose of this essay to explain these works, which comprise a substantial part of his production, as vehicles to assist the faithful in realizing their spiritual aspirations. By inscribing Murillo within the centuries-long history of Christian worship and imagery and analyzing his pictorial strategies, it will show that he was one of the most effective devotional painters of the postmedieval epoch.

Devotional painting is underpinned by a theoretical foundation established in early Christianity, which accorded a privileged place for the use of images in the exercise of the faith. As has long been recognized, an important early spokesman for the efficacy of images was Pope Gregory the Great (c. 540–604), who justified their use as textbooks for the

Detail of Catalogue No. 23. VIRGIN AND CHILD ("SANTIAGO MADONNA"). *c. 1670. Oil on canvas. 65¼ x 43 in. (165.7 x 109.2 cm.). Lent by The Metropolitan Museum of Art, New York, Rogers Fund, 1943*

illiterate. As he wrote: "for what the Scripture teaches those who read, the image shows to those who cannot read but see." [1]

The didactic function of holy images was complemented by a second, which has been called "empathic meditation,"[2] or the use of images for personal prayer. The definition of the function and validity of images in the rituals of prayer is found in an apocryphal letter of Pope Gregory, written to the hermit Secundinus, which tersely spells out the basic and immutable rationale for devotional painting. Secundinus had requested an image of "Our Savior," which occasioned a gift from his correspondent consisting of two small panels, one depicting Christ and his mother, the other Saints Peter and Paul. These images were accompanied by a letter, which explained how they were to be used.

> Your request (for images) pleases us greatly, since you seek with all your heart and all intentness Him, whose picture you wish to have before your eyes, so that, being accustomed to the daily corporeal sight, when you see an image of Him you are inflamed in your soul with love for Him whose picture you wish to see. We do no harm in wishing to show the invisible by means of the visible.[3]

This definition of images as a ladder to an ineffable God was derived from Neoplatonic thought and remained at the core of Christian devotional practice. However, none of the early writers were specific about the structure of these images. They speak of how they might be used but not what they might look like.

In truth, the definition of devotional imagery is complicated and does not admit of an unambiguous answer. Devotional images are sometimes characterized as being non-narrative, that is, as not illustrating a text, be it the Gospels or the lives of saints. However, common sense provides an immediate qualification of this definition; any holy image, even the largest, most elaborate altarpiece, can serve as the focus and stimulus of private meditation. Nevertheless, over the centuries, certain classes of imagery were developed to inspire private prayer in a nonliturgical context. As will be seen, devotional images tended to be small or of modest size, in keeping with their private function, and to employ pictorial strategies that might exercise the spirit as it sought to unite in compassionate love with the object of worship.[4]

The rise of devotional painting is usually dated to the thirteenth century and associated with the great mendicant orders, the Dominicans and the Franciscans. As the two conventual orders most in contact with the laity, they were well positioned to spread the practice across a wide segment of the population. The exercise of an individual expression of faith through the use of devotional imagery was not to be left to chance or choice. Ordinary people had to be taught to pray, a goal that was accomplished in several ways.

One was through the establishment of what are known as tertiaries and confraternities. The tertiaries were organized by the Franciscans and Dominicans to spread their ideals throughout the lay world and were governed by the rule of the order, whereas the confraternities were self-governing although ultimately responsible to the authority of the church, usually through bishops and archbishops. Another distinction is that confraternities were specialized organizations, created for the veneration of a particular cult of Christ and the Virgin or a saint.

Once organized into groups for spiritual development, the members had to learn to pray. One writer has concisely described the lengthy process involved in this experience. "In a learning process that lasted for centuries, ordinary believers were trained in spiritual

values that had evolved in the claustral world of the monasteries."[5] To further this process, guides for meditational practices began to be written, of which the most famous is the manual entitled *Meditations on the Life of Christ*. (The original text was in Latin although translations into vernacular languages quickly appeared.) The author of this treatise, which was written in Italy in the last quarter of the thirteenth century, is unknown, although he or she was a Franciscan who has long been known as Pseudo-Bonaventure.[6] The popularity of this text in the later Middle Ages (over two hundred manuscripts are still in existence) can be attributed to narrative strategies that heighten the emotions of the reader through enrichments of the Gospel narrative, all of which serve to humanize it and bring it down to earth by incorporating the details of everyday life. By partaking of the experiential world of the devout, the way was opened to begin the ascent of the spirit toward Christ. Only a quotation can do justice to the powerful effect of the lilting, urgent rhythm of the text, its accumulation of detail, and its unfailing efficacy in harnessing the emotions to serve pious purposes. Here is a brief passage that describes the maternal care lavished by the Virgin Mary on her infant son:

> Solicitously and intently she watched over the care of her beloved Son. O Lord, with how much concern and diligence she nursed Him, that He might not have the least trouble! And with how much reverence, caution, and saintly fear did he who knew it was his God and Lord (Saint Joseph) treat the Child, kneeling to take Him and put Him back in the manger. With how much happiness, confidence, and motherly authority did she embrace, kiss, gently hug, and delight in Him whom she saw as her son! Oh, how often and how gently she looks at His face and all parts of His most holy body! How regularly and skillfully she placed the tender limbs while swathing them! As she was most humble, so she was most prudent.[7]

The *Meditations on the Life of Christ* are in the vanguard of a great surge of mystical piety which spread through Europe in the fourteenth and fifteenth century and which culminated in a movement of Netherlandish origins known as the *Devotio Moderna*. Taking a more ascetic turn than the mystics and directing its energies mainly toward ordinary believers, the Modern Devotion promoted private prayer and meditation as one of the principal means to promote the soul's ascent to God. A book of Latin prayers, known as the "Hours" and originally intended for the daily use of priests and monastics, was translated into the vernacular. In addition, followers were urged to model their lives on Christ and trained to use their imagination in conjunction with the prayers, summoning up images, often gruesome images, of the suffering of the Passion.

The fifteenth century also witnessed an upsurge in illustrated Books of Hours, which offer a lucid example of the use of images in conjunction with private devotion.[8] These books, mostly intended for a wealthy clientele, contained a series of prayers, with the Little Office of the Blessed Virgin Mary at its core, which were meant to be recited at eight times throughout the day. The example reproduced here is chosen simply because it illustrates a theme that would be taken up by Murillo some two hundred years later. It comes from the Hours of Catherine of Cleves (figs. 22 and 23), created around 1440 in the northern Netherlands, a manuscript characterized by its quality and homey realism.[9] In keeping with the later medieval trend toward humanizing the life of Christ, the miniature shows the Holy Family in a domestic setting, with the Virgin Mary and Saint Joseph, busily at work, keeping an eye on the Christ child, who toddles about the room in a walker.

Above: *Fig. 22. Master of Catherine of Cleves.* HOLY FAMILY AT WORK, FROM THE HOURS OF CATHERINE OF CLEVES. *c. 1440. M. 917, p. 149. 7½ x 5″ (19.2 x 13 cm). The Pierpont Morgan Library, New York*

Right: *Fig 23. Bartolomé Esteban Murillo.* HOLY FAMILY IN THE CARPENTER'S SHOP. *c. 1670—75. Oil on canvas, 37 x 28″ (94 x 71 cm). Chatsworth, Devonshire Collection. Reproduced by permission of the Duke of Devonshire and the Chatsworth Settlement Trustees*

The juxtaposition of image and text on this leaf of the manuscript (the prayer belongs to the Saturday Hours of the Virgin and is read at Sext, or noon) demonstrates what might be called the operational use of pictures in private devotion.

Devotional images also were created in the larger format of easel paintings, which were much cheaper to produce and more versatile with respect to the places where they might be installed. The number of such images is beyond reckoning; they were to be found in almost every home, if not in painted form, then in the engravings and woodcuts which, after about 1500, made them affordable even to the poorest families.

The formats that were employed in fifteenth-century paintings proved to be decisive for their later history. One of the most popular is concisely described by Sixten Ringbom (following Erwin Panofsky's fundamental work on German devotional sculpture): "it

consists of isolating the main figure or the most important protagonists from a history. This brings the action to a standstill and gives the emotional experience connected with the action a duration suitable for contemplative absorption. . . ."[10] This formula was not the creation of the fifteenth century; its origins have been traced to the fourteenth. However, during the 1400s, in both Italy and the Netherlands, painters imbued devotional images with a new sense of realism that seems to have increased their efficacy as accessories to prayer and meditation (fig. 24). In this example, the figure of Christ carrying the cross has been extracted from the Passion and "brought to a standstill" to heighten the emotional experience of the viewer. In placing Christ against a dark background and casting a strong light over his form, Bellini (or a follower) deploys one of the enduring strategies of the devotional painter's art.

During the sixteenth century, image-assisted prayer essentially followed the patterns established in the later Middle Ages. However, an infusion of new energy was provided by the spiritual reform of the Catholic Church, which is epitomized, although it was not initiated, by the Council of Trent. In its decree on images promulgated on December 3–4, 1563, the Council was relatively brief, although it left no doubt of their efficacy.[11] Yet even before that date, various reform currents within the church were setting the stage for the renewed use of imagery in private prayer.

The most influential text was Saint Ignatius Loyola's *Spiritual Exercises*, which was approved by Pope Paul III in 1548. Although designed originally for Jesuit novitiates, this powerful tract would have a major impact on Catholic spirituality. The *Spiritual Exercises* were not illustrated; however, they explicitly relied on a visual mode of prayer through a device that Loyola called "composition, seeing the place." As he explained, "In contemplation or meditation on visible things, as in contemplating Christ the Lord, who is visible, composition will be to see by the eye of the imagination a physical place where that thing is found which I wish to contemplate."[12]

If Loyola relied on what might be called a pictorial imagination to assist prayer, there was a continued, steady stream of devotional manuals that combined illustrations and text in a traditional way. One example that might be cited is a publication by an Augustinian friar, Baltasar de Salas. His book, entitled *Devocionario y contemplaciones sobre los Quinze Misterios del Rosario de Nuestra Señora*, appeared first in Madrid in 1588 and then in Seville one year later. It is a book of rosary prayers designed to be held in the hand (the measurements are five inches high by three and a half inches wide), and is illustrated by simple woodcuts (fig. 25), which "see the place." Its prayers, as is customary, infuse the episodes from the Gospels with realistic, emotionally authentic details calculated to inspire empathic love for the Holy Family, and especially the Virgin Mary.

The spirit of this text is conveyed in the works of the two leading creators of devotional painting in sixteenth-century Spain, Luis de Morales (c. 1519–1585), and El Greco (1541–1614). Morales, who worked in Badajoz, on the Portuguese border, from about 1540 to his death, was principally a devotional painter.[13] His works are heavily influenced by Flemish art, which he might have seen in Seville and central Portugal, where he executed several commissions. (The Portuguese, through trade contacts with the Netherlands, were avid consumers of Flemish painting, especially from Antwerp.) Indeed, Morales's devotional paintings of scenes from the Passion of Christ partake of the spirit of the *Devotio Moderna*, with its pronounced emphasis on the pain and suffering endured by Christ during his martyrdom (fig. 26). The Madonna and child, the other great theme of devotional painting, was much cultivated by Morales (fig. 27). In both works, Morales

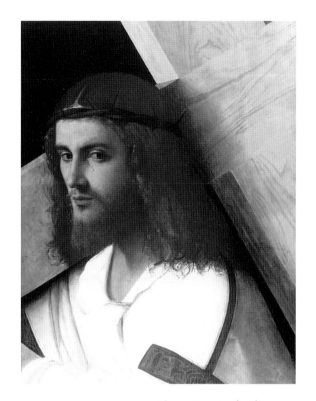

Above: *Fig 24. Attributed to Giovanni Bellini.* CHRIST CARRYING THE CROSS. *c. 1500–1505. Oil on panel, 23½ x 16⅝" (59.2 x 42.3 cm). Isabella Stewart Gardner Museum, Boston*

Below: *Fig 25. Page from Baltasar de Salas.* DEVOCIONARIO Y CONTEMPLACIONES SOBRE LOS QUINZE MISTERIOS DEL ROSARIO DE NUESTRA SEÑORA. *Madrid, 1588. Department of Rare Books and Special Collections, Princeton University Library*

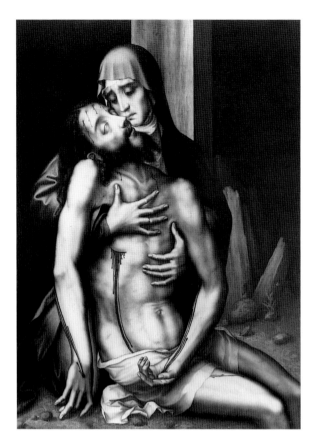

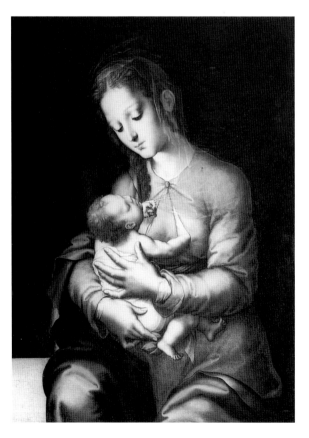

employs a dramatic composition featuring strongly lit figures posed against a dark background. Small in scale and executed on panel to permit a high degree of finish, Morales's works are perfectly suited for use in private devotion.

Although El Greco is best known for his multifigure, large-scale altarpieces, he was a prolific maker of devotional images, the success of which is attested to by the numerous repetitions, both autograph and apocryphal, which are still in existence.[14] El Greco's range is wider than that of Morales, in part because he incorporates some of the major ideas of the post-Tridentine period. For example, paintings of the Penitence of Saint Peter (fig. 28) are abundant and reflect the defense of the sacrament of penitence, which assumed great importance in the later sixteenth century.[15] The female counterpart of Saint Peter, Saint Mary Magdalene, also figures in numerous paintings by El Greco and his followers (fig. 29). Unlike Morales, who looked to the north for inspiration, El Greco's devotional paintings are Italianate. Yet his underlying pictorial strategies have much in common with those of Morales—half-length figures are presented in close range to the viewer and express their emotions in an unbridled way.

As a matter of fact, the traditions and functions of devotional painting proved to be durable, as was only to be expected. These images were embedded in the practice of private prayer and, like the prayers themselves, were considered to be powerful and efficacious; they had become, as it were, canonical. Therefore, Murillo's devotional paintings conform to the patterns described above. However, a closer study of the audience, function, and morphology of these paintings, which has never before been undertaken, reveals that they have distinctive qualities.

The first point to be stressed is their sheer quantity. Without having taken an exact census, it can be estimated that they comprise at least half of Murillo's production. This in itself is a noteworthy phenomenon in the history of seventeenth-century Sevillian painting. Obviously all of Murillo's important predecessors had executed works for private devotion, but none on the scale achieved by him.

Concerning the market for these paintings, a recent investigation of the trends of picture collecting in Seville helps to identify the clientele for Murillo's devotional art. In 1986, the historian Francisco M. Martín Morales published an illuminating study of the paintings listed in 224 postmortem inventories compiled in Seville between the years 1600 and 1670.[16] These inventories record 5,180 paintings, a sizable quantity in and of itself, and their significance is magnified because the author investigated just a third of the notarial offices in Seville, transcribing only inventories from the beginning years of each decade. While it is impossible to extrapolate, or even approximate, from this sample the total number of paintings in Sevillian collections, it was obviously very considerable.

As the next step, Martín divided the collectors into eight social groups, four of which provided most of the demand. About half of all the pictures were owned by nobility and merchants. In third place were *funcionarios*, or employees and officials of the local and royal administrations, and in fourth was the clergy. The author's analysis of the distribution of the subject matter of the paintings is the most relevant for this study of Murillo's art. Among all eight social groups, paintings of devotional subjects took first place, accounting for twenty-five percent of pictures with specified subjects (a total of 705). However, the ownership of devotional paintings was concentrated in two groups, merchants and *funcionarios*.[17] (It is interesting, if puzzling, that the nobility owned relatively few paintings of religious subjects.) This conclusion not only testifies to the widespread practice of private devotion among the laity but also may identify the principal consumers of

Murillo's devotional paintings. They were what would now be called the upper-middle and professional classes.

Unfortunately, data on specific individuals who owned Murillo's devotional works are very limited, although what is known supports the conclusions advanced in Martín's statistical study. In general, Murillo seems to have attracted a considerable clientele among the merchants of Seville. The best-known of these merchant-collectors is Nicolás Omazur (c. 1629–1698), a Fleming from Antwerp who settled in Seville around 1669 to pursue the family business in the silk trade. Omazur is by no means a typical owner of paintings by Murillo. He can only be described as a Murillo aficionado who assiduously and systematically formed a collection of the master's paintings and drawings. In other words, he collected works by Murillo for purely aesthetic reasons although otherworldly factors may be assumed to have been present, too.

The death inventory of Omazur's collection reveals that he owned thirty-one paintings by Murillo, of which fifteen seem to have been devotional works.[18] Although only a portion has been identified, the group as a whole provides an excellent introduction to the themes and formats of Murillo's devotional imagery. It goes almost without saying that Omazur owned a Virgin of the Immaculate Conception, the most popular of all Murillo's devotional subjects. In keeping with the Counter-Reformation defense of the sacrament of penitence, there were two representations of the penitent Magdalene and two of the penitent Saint Peter. Images of individual saints, another traditional subject, were also present, including the local saints, Saint Ferdinand and Saint Hermengild, and Saint Francis. Omazur also owned a pair of pictures representing the Ecce Homo (Man of Sorrows) and the Mater Dolorosa (the weeping Virgin), two of the most venerable subjects in the history of devotional painting. And, finally, there were paintings of the Good Shepherd and Saint John, perhaps related to the pictures in the Museo del Prado that represent these subjects as young boys.

The format of these paintings is far from uniform. The Virgin of the Immaculate Conception, which is identified with the so-called *Inmaculada Esquilache* (State Hermitage Museum, Saint Petersburg) is a large easel painting, measuring 92½ by 77⅛ inches (235 by 196 centimeters) and perhaps was created for a domestic chapel.[19] The *Penitent Saint Mary Magdalene* (National Gallery of Ireland, Dublin) measures 59½ by 41½ inches (151 by 105 centimeters), a more convenient size for use in the home.[20] The Omazur inventory also lists several paintings of reduced dimensions, some of which were executed on the durable supports of metal (probably copper) and stone. For example, the *Agony in the Garden* and the *Penitent Saint Peter Kneeling before Christ at the Column* have been identified with two small paintings in the Louvre, painted on obsidian and measuring 14 by 10⅜ inches (35.7 by 26.3 centimeters) and 13¼ by 12 inches (33.7 by 30.7 centimeters) respectively.[21] (figs. 30 and 31). Another entry lists a *Descent from the Cross*, which is described as a *lámina ochavada*, or a work on an octagonal metal support. Four more paintings are described as "*láminitas redondas*," small metal roundels.

These items from the inventory provide evidence that Murillo executed portable small-scale devotional paintings that could easily be incorporated into the decoration of any room or taken on journeys. In fact, they conform in size to the most common medium of devotional images, namely woodcuts and engravings. While most of the small works owned by Omazur have not been traced, there are about twenty still extant that illustrate how they might have looked. One is a *Virgin of the Immaculate Conception* (fig. 32), painted on canvas, which measures 14½ by 10¼ inches (37 by 26 centimeters) and is executed in a warm, sketchy manner.[22] Another would be the *Holy Family* (State Hermitage Museum,

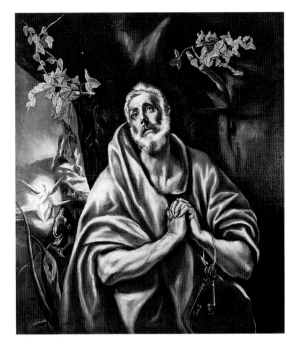

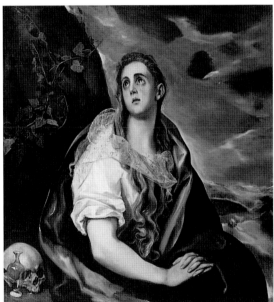

Opposite, top: *Fig 26. Luis de Morales.* PIETÀ. *c. 1560–70. Oil on panel, 49⅝ x 38½″ (126 x 98 cm). Real Academia de Bellas Artes de San Fernando, Madrid*

Opposite, bottom: *Fig 27. Luis de Morales.* VIRGIN AND CHILD. *c. 1560–70. Oil on panel, 33 x 25¼″ (84 x 64 cm). Museo Nacional del Prado, Madrid*

Top: *Fig 28. El Greco.* PENITENT SAINT PETER. *1590–94. Oil on canvas, 47⅜ x 42⅜″ (122.3 x 107.6 cm). San Diego Museum of Art, Gift of Anne R. and Amy Putnam*

Above: *Fig 29. El Greco.* PENITENT SAINT MARY MAGDALENE. *c. 1577–80. Oil on canvas, 42½ x 39⅞″ (108 x 101.3 cm). Worcester Art Museum, Worcester, Mass.*

Top: *Fig 30. Bartolomé Esteban Murillo.* AGONY IN THE GARDEN. *c. 1670. Oil on obsidian, 14 x 10⅜" (35.7 x 26.3 cm). Musée du Louvre, Paris*

Above: *Fig 31. Bartolomé Esteban Murillo.* PENITENT SAINT PETER KNEELING BEFORE CHRIST AT THE COLUMN. *1665–70. Oil on obsidian, 13¼ x 12" (33.7 x 30.7 cm). Musée du Louvre, Paris*

Saint Petersburg) (fig. 67), on panel; its dimensions are 9¼ by 7 inches (23.8 by 18 centimeters).[23] As these examples demonstrate, Murillo was quite prepared to produce devotional images on the most modest of scales.

Given Omazur's voracious appetite for paintings by Murillo, he was always acquiring new works, which makes his collection a springboard for identifying another important owner of Murillo's devotional works. This is Justino de Neve (fig. 17), a canon of the Seville Cathedral and one of the artist's most important patrons.[24] As the patron of the church of Santa María la Blanca, Neve commissioned four major works for the refurbishment, which was completed in 1665, as well as paintings for the chapter room of the cathedral and the Hospital de los Venerables Sacerdotes. At the sale of his estate in 1685, Omazur purchased several devotional works by Murillo, including many of those in the small format mentioned above.

As a priest, Neve's ownership of devotional works by Murillo comes as no surprise. Another, loftier example of an ecclesiastical patron is Ambrosio Ignacio Spínola, archbishop of Seville from 1670 to 1684. In 1673, he commissioned Murillo to paint the *Virgin and Child in Glory* as the central work of the altarpiece in his private oratory (Walker Art Gallery, Liverpool).[25] According to his biographer, the archbishop prayed twice a day before this image.

As Francisco Martín's study suggests, the majority of the owners of Murillo's devotional works may have been, like Nicolás Omazur, merchants and functionaries. Although much work remains to be done in the study of their collections and household goods, a few documents have come to light that begin to provide a picture of this group of owners. In the dowry of Ana Jacoba Sanvitores de la Portilla, who married Nicolás de Tamariz on April 10, 1664, there was included a painting measuring three *varas* high (approximately two and a half meters) of the "Conception of Our Lady," presumably a Virgin of the Immaculate Conception. Ana Jacoba was the daughter of an important official of the Casa de Contratación, which governed trade with the American colonies; he, the scion of an important noble family.[26]

A Genoese merchant who lived in Cádiz, named Giovanni Bielato, presents a profile comparable to that of Nicolás Omazur in that he was an avid collector of Murillo's paintings. At his death in 1674, which occurred in Genoa, a total of seven paintings were registered as in his possession.[27] Not all are obviously devotional works, and the fact that the entire group was displayed in one room suggests that they were regarded as much as works of art as inspiration for prayer. However, Bielato owned an *Immaculate Conception* (Nelson Atkins Museum of Art, Kansas City), a *Penitent Magdalene* (Wallraf-Richartz Museum, Cologne), and an *Infant Saint John* (private collection, Rochester, Michigan), all of which unequivocally belong to the genre.

Another foreign merchant who possessed a devotional painting by Murillo was Pedro Colarte, a Fleming from Dunquerque, who settled in Cádiz and prospered in the Indies trade.[28] He died on February 3, 1701, by which time he had been granted the noble title of marqués del Pedroso. Among his possessions was a large painting (measuring more than nine and a half by six and a half feet) of the *Trinities of Heaven and Earth* (fig. 33).

This list of owners, if falling short of being complete, bolsters the hypothesis that Murillo's devotional paintings were executed primarily for personal rather than institutional use. The next step is to consider how individuals utilized these beautiful pictures.

One of the most frequent subjects in Murillo's devotional repertory is the Virgin and child, a subject so common in Catholic art as to hardly require comment. However, among

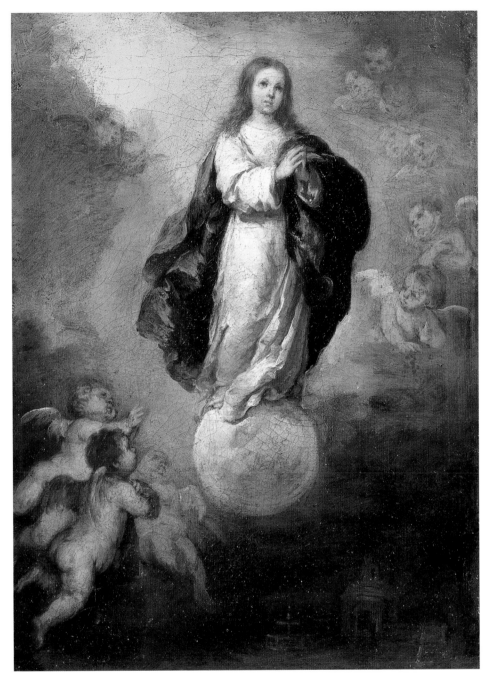

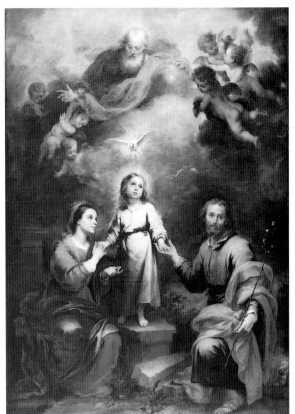

the approximately twenty-five examples is a subset depicting the Virgin of the Rosary. The execution of these paintings is probably to be attributed to Murillo's membership in the Confraternity of the Rosary, which had a chapel in the Dominican church of San Pablo (now La Magdalena).[29] Murillo was admitted to the brotherhood on February 7, 1644, and remained an active member until his death thirty-eight years later. The association of the artist with the confraternity suggests that the paintings of the Virgin of the Rosary may have been made for other members of the *cofradía*. More important, they provide a point of entry into understanding how Murillo's devotional paintings might have been incorporated into the ritual of prayer.

Confraternities of the Rosary were primarily devotional in purpose as opposed to the better-known penitential and lesser-known sacrament brotherhoods.[30] Under the aegis

Right: *Fig 34. Bartolomé Esteban Murillo.* VIRGIN OF THE ROSARY. *c. 1650—55. Oil on canvas, 64½ x 43¼″ (164 x 110 cm). Museo Nacional del Prado, Madrid*

Opposite, top: *Fig 35. Bartolomé Esteban Murillo.* ADORATION OF THE SHEPHERDS. *c. 1650. Oil on canvas, 6′1⅝″ x 7′5¾″ (187 x 228 cm). Museo Nacional del Prado, Madrid*

Opposite, bottom: *Fig 36. Bartolomé Esteban Murillo.* CHRIST ON THE CROSS. *c. 1660. Oil on canvas, 6′10½″ x 44½″ (208.9 x 113 cm). The Putnam Foundation Collection, Timken Museum of Art, San Diego*

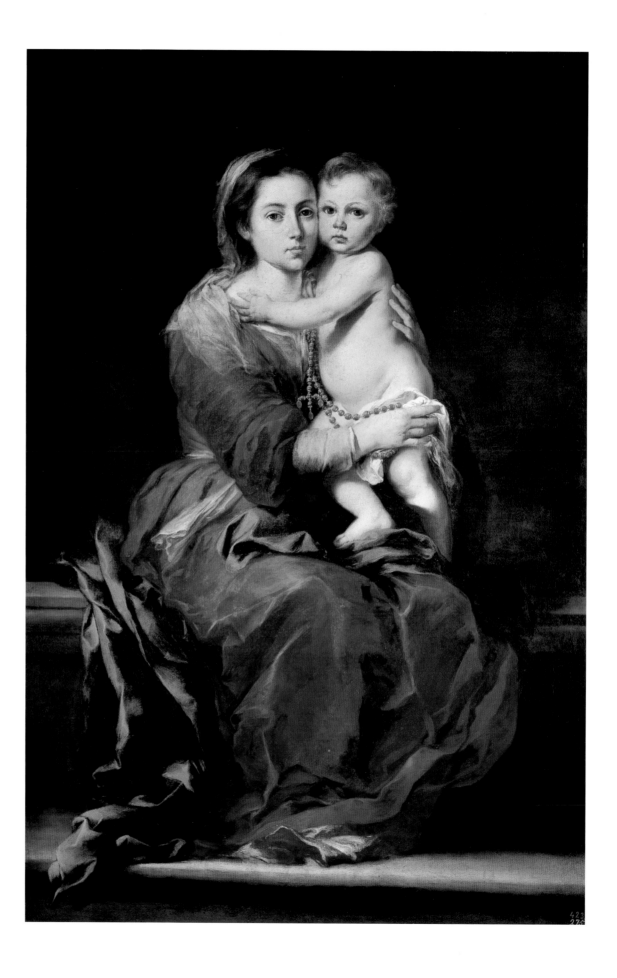

of the Dominicans, who claimed to be the inventors of the famous ritual of prayer, Rosary confraternities were centered on devotion to the Virgin Mary, and they proliferated during the sixteenth and seventeenth century. Murillo's representations of the Madonna of the Rosary are interesting in and of themselves (fig. 34); they depict, as it were, the "Hail Marys" around which Rosary prayer is organized. All follow the traditional format for devotional images and show the Virgin and child under strong illumination and placed against a dark background.

Rosary worship involves a second component, the so-called fifteen mysteries upon which the devout meditate as they repeat the incantation of Hail Marys, Our Fathers, and Glory Be to the Father. (The rosary beads, of course, are used to keep count of the numerical progression of the Hail Marys.) The mysteries are divided into three sections—the Joyful Mysteries, the Sorrowful Mysteries, and the Glorious Mysteries—each of which is based on events in the lives of Mary and Christ. As an aid to the devotions, books of Rosary meditations were continually being published, one of which has been mentioned above.[31] This is Baltasar de Salas's *Devocionario y contemplaciones*, which is a typical devotional text in its elaboration of the Gospel narrative and its appeal to the emotions through the accumulation of realistic detail.[32] By reading the text while contemplating a painting by Murillo, the dynamic interaction between word and image experienced by the worshipper comes alive. The painting chosen for this example is the *Adoration of the Shepherds* (fig. 35), of uncertain provenance, alongside of which is placed the relevant passage from Salas's *Devocionario*.

Contemplate, my soul, the crying of the newborn, which was like that of other creatures. Contemplate how that inexperienced maiden wraps him in the poor and meager clothing that was found there, without any preparation. Contemplate now the cradle made of that hard manger and the company of those rustic animals. Contemplate the lack of preparation the delicate infant had for such a cruel winter. Contemplate the knowledge of the animals which, at first sight, kneel down on the earth to adore him (an action so alien to their nature). Contemplate the summons of the angel to the shepherds, and what the angel told them, as Saint Luke affirms.[33]

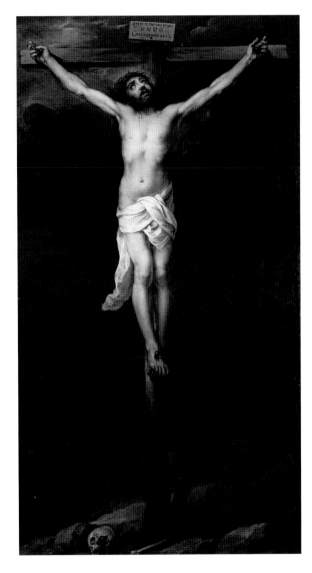

Another example may be drawn from one of the five "misterios dolorosos" found in Salas's text. This is the Crucifixion, which is accompanied here by the non-narrative composition by Murillo (fig. 36 and cat. no. 9).

Contemplate, oh my soul, the meekness and patience with which the good Jesus places his body and head on the cross, his eyes in ecstasy, raised toward heaven. He opens his arms in mercy and offers himself to his eternal Father in sacrifice for the rescue of humankind. And then they take a nail to fasten his left hand. Consider, then, that this left hand is closer to the heart, which feels greater pain when they wound it. And you should consider how, in driving in the nail, they pierce the nerves and tendons with its thickness.

Contemplate how, after placing the titulus, they cut the cords with the intention that the body would hang only from the nails, understanding that this would cause Him more pain, and finally you cannot imagine a torture they did not apply.[34]

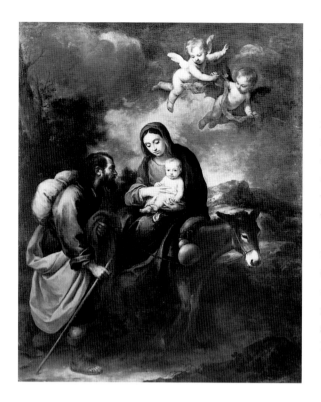

Fig 37. Bartolomé Esteban Murillo.
The Flight into Egypt.
c. 1660. Oil on canvas, 61¼ x 49¼"
(155.5 x 125 cm). Szépmüvészeti
Múzeum, Budapest

The pious response to devotional imagery was absorbed by the painters who were schooled in prayer, as Murillo certainly was. As painters created devotional works, they automatically remembered their prayers. This is demonstrated in the most important artistic treatise of seventeenth-century Seville, written by the painter Francisco Pacheco (1564–1644). It is entitled *Arte de la pintura* and was published in 1649.[35] Part of the book is dedicated to iconographical prescriptions, or advice to painters about how to represent holy subjects. In many respects, Pacheco's book is typical of the post-Tridentine preoccupation with doctrinal accuracy; however, as a practicing painter, if one of considerable erudition, he opens a window into the mental processes involved in creating devotional works. As will be seen, his procedures are thoroughly imbued with the practices of private prayer.

Before arriving at his prescription for the iconography, Pacheco in effect makes a mental picture, using Loyola's technique of "seeing the place." It is instructive to read his text on the Flight into Egypt and to place it beside one of Murillo's renditions of the theme (fig. 37). It is evident at once that both painters, however different their styles, have in mind the same goal, which is to arouse the empathy of the viewer. The story begins with an angel appearing to Joseph and advising him to flee Bethlehem for Egypt. He awakens Mary, and the story begins.

> The most holy lady rose from bed and aroused her small son who, not without tears, having been awakened so much before time, caused his mother to spill them, too. Like oriental pearls, they would fall over the Child's face. . . . For his part, Joseph, solicitous and fearful, saddled up the small donkey because it was necessary to keep his beloved jewels in a safe place.[36]

At this point, Pacheco cites a learned authority to justify the inclusion of a donkey; otherwise the Virgin and child would have had to travel on foot. Then he continues: "In effect, leaving their poor house, without saying farewell to anyone nor arranging for money, clothing, or food, they set out to travel such a hard and dangerous road."[37]

Pacheco now adopts the plaintive, emotional tone of the devotional prayer as he says the following: "What hardship would those pious travelers suffer and what tears of compassion the Virgin would shed over the long road, which for good travelers would take twelve or fifteen days but which for those who traveled so uncomfortably would take fifty days, or two months, especially because they were so poorly supplied and had so hastily departed."[38]

At length, Pacheco prescribes how the picture should be painted, but only after he ensures that the correct emotional charge has been planted. In Murillo's painting, that charge is detonated. Knowing of the difficult road and the perilous circumstances faced by the Holy Family, the viewer immediately is moved by the imperturbable calm and serene beauty with which the Holy Family endures the difficult journey.

The understanding of Murillo's approach to devotional painting can be extended by looking at the following episode of the Holy Family in Egypt as described by Pacheco. Murillo's assimilation of the strategies of devotional literature, which are also embedded in Pacheco's text, is seen in the *Holy Family with the Infant Saint John in the Carpenter's Shop* (fig. 38), the very subject of which is characteristic of the down-to-earth technique of these prayers.

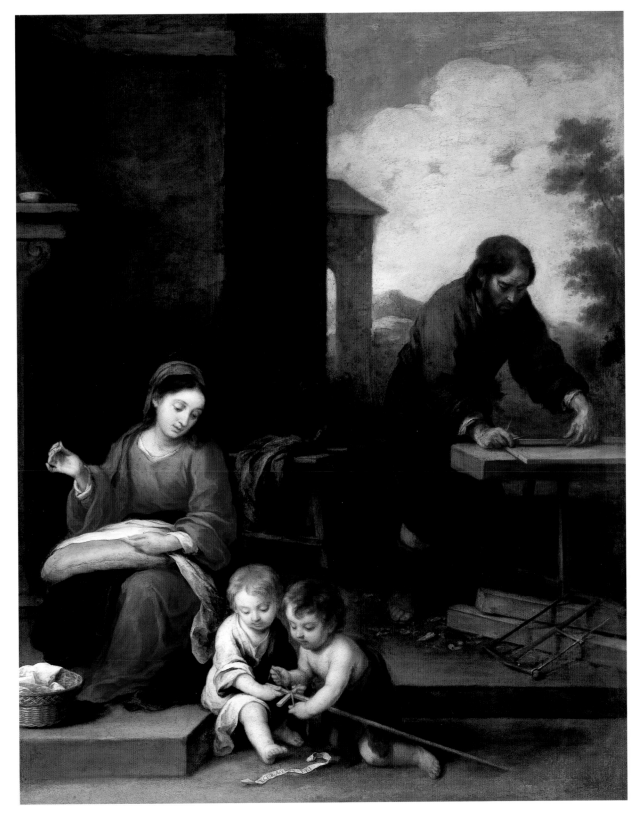

Fig 38. Bartolomé Esteban Murillo. HOLY FAMILY WITH THE INFANT SAINT JOHN IN THE CARPENTER'S SHOP. c. 1660–70. Oil on canvas, 61½ x 49⅝″ (156 x 126 cm). Szépmüvészeti Múzeum, Budapest

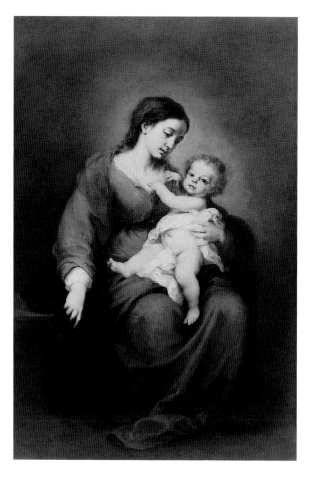

Above: *Fig 39. Bartolomé Esteban Murillo.* VIRGIN AND CHILD, CALLED THE SANTIAGO MADONNA. *c. 1670—80. Oil on canvas, 65¼ x 43″ (165.7 x 109.2 cm). The Metropolitan Museum of Art, New York, Rogers Fund, 1943*

Opposite, top: *Fig 40. Guido Reni.* CHRIST CHILD AND YOUNG SAINT JOHN. *c. 1610. Etching, 6 x 5″ (15.5 x 13 cm). Graphische Sammlung Albertina, Vienna*

Opposite, middle: *Fig 41. Bartolomé Esteban Murillo.* INFANT CHRIST OFFERING A DRINK OF WATER TO THE INFANT SAINT JOHN THE BAPTIST, CALLED NIÑOS DE LA CONCHA. *c. 1675—80. Oil on canvas, 41 x 48⅞″ (104 x 124 cm). Museo Nacional del Prado, Madrid*

Opposite, bottom: *Fig 42. Bartolomé Esteban Murillo.* CHRIST CHILD ASLEEP ON THE CROSS. *c. 1670—80. Oil on canvas, 55½ x 42½″ (141 x 108 cm). Sheffield Galleries and Museums Trust*

For seven years the Virgin and her son and husband remained in Egypt ... in a village now called Maturea, where can be seen the well in which the Virgin washed her sweet son. Far from their country, missing the Temple and its solemnities and sacrifices, they saw many abominations of idolatry and vices that profaned the majesty of God.

This place in Egypt where they lived for those seven years can be painted as each one wishes, with certain pious considerations. I have done it this way since I was a young man. In a poor house, through the door of which you can see the street, Saint Joseph is planing a piece of wood on a carpenter's bench, his hat hung on the wall, saw and compass hanging from a cord. On the floor, among woodchips and shavings, [there are] other tools, an adze and a hammer. The Christ child, one or two years old, wearing a tunic, is seated on the ground near his mother, looking at a cross made of two sticks tied with a string. The most holy Virgin, seated and dressed in her tunic and mantle, sews on a cushion, and [there is] a small basket with a white cloth, scissors, and thread. And so it is known that it is Egypt, a few houses and gypsies appear in the street.[39]

Pacheco's seamless fusion of devotional text and iconographical prescription shows how deeply ingrained the techniques of prayer could become in the minds of pious painters. In Murillo's case, his membership in the Confraternity of the Rosary ensures that he was thoroughly versed in the practices of empathic meditation and compassionate love. His success as a devotional artist is ultimately based on his ability to find convincing visual equivalents for the pious emotions generated by the practices of private prayer.

Murillo's fundamental strategy is to engage the emotions of the devout by employing a small, effective repertory of formal tactics. One of the most frequent is to direct the gaze of the holy figures toward the viewer. This is undoubtedly a commonplace of devotional painting; however, in Murillo's hands, this gaze is suffused by a quiet, tender expression of compassionate love that awakens the spirit of the faithful. His careful calibration of emotional expression is lucidly demonstrated in the genesis of one of his late renditions of the Virgin and child, the so-called *Santiago Madonna*, painted in the 1670s (fig. 39 and cat. no. 23).[40]

As he often did, Murillo made a preparatory drawing (cat. no. 23, fig. 2) to gauge the various solutions of the formal and emotional problems he was encountering.[41] In the drawing, the Christ child looks up at his mother with an adoring expression, evoking the powerful experience of maternal love. Although the composition is effective, it excludes the viewer from the scene, and this led the artist to change the position of the Christ child's head. However, he leaves the position of the arms and hands in place and thus continues to reinforce the bonds of dependence which link the child to his mother.

Another tactic used in this painting, and in many others, involves the illumination. In the drawing, complex light effects are achieved by the application of transparent washes of brown ink, whereas in the painting Murillo reverts to the traditional dark background used by devotional painters to create an indeterminate space. In addition, the painter softens the light around the head and shoulders, making a persuasive visual equivalent of the tender love evoked by the subject.

Murillo's distinctive approach to devotional imagery is perhaps most clearly seen in compositions based on prints by or after other artists. Like almost every seventeenth-century painter of Seville, he was an avid consumer of prints, which he often used for inspiration, sometimes borrowing individual motifs, sometimes entire compositions.[42] A favorite source is Guido Reni, one of the most influential religious painters of the age. Reni made an etching of the Christ child and the young Saint John the Baptist in a landscape (fig. 40), and it appears to have provided the starting point for one of Murillo's most famous devotional images, known as the "Niños de la Concha" (fig. 41), after the conch shell with water offered by the Christ child to his companion.[43] In effect, Murillo intensifies what might be called the infantile solemnity of the scene, eliciting that automatic response experienced when observing pretty children at play. This is done through the use of loose brushwork that seems almost to caress the figures as it brings them to life. Above the boys are three putti, who almost dissolve into the ambient clouds and assume the attitude of prayerful devotion, providing an inspiration to those who look upon the small painting. The incorporation of putti as intermediaries between the worshipper and the holy figures is one of the most frequent devices used by Murillo in his devotional works, especially during his later years. They are meant to inspire emulation through their pious example.

These pictorial devices come together very effectively in one of Murillo's most moving and characteristic images, the *Christ Child Asleep on the Cross* (fig. 42), also a work of the 1670s.[44] The cult of the Christ child appears to have originated in the Franciscan Order during the Middle Ages and later assumed many forms and guises.[45] The image of the Christ child sleeping on the cross emerged in Italy toward the end of the sixteenth century and its popularity was promoted, once again, by Guido Reni and his followers, who produced several variations on the theme.[46] Murillo's version is designed to evoke the maximum emotional response, although the underlying elegance of the design cannot be denied. The Christ child is depicted as if in a profound, deep sleep, the perfect image of innocence despite the menacing presence of the cross and the skull and, at his feet, the thorns that will one day be woven into a crown of martyrdom. In the sky, two putti, painted so loosely as to be near the point of dissolving, direct the viewer toward the object of veneration below.

Having been cut loose from the moorings of prayer, Murillo's devotional paintings now float free in the realm of pure aesthetics. As art objects, they hold their own although the perception of their quality in the minds of many viewers may be overwhelmed by the residue of Catholic devotional spirit that still clings to them. The divorce between form and function, however unfortunate, is not likely to be healed. Murillo invented convincing correspondences to the experience of empathic love for the Holy Family and the saints, who serve as models of conduct and as intermediaries in the spiritual negotiations between the mundane and the divine. Inserted within a regimen of prayer, the paintings brim with spiritual energy and help to prepare the soul for life after death. However, when exhibited in the secular environment of the art museum, their deeper meanings evanesce, and they become illustrations instead of inspirations of faith.

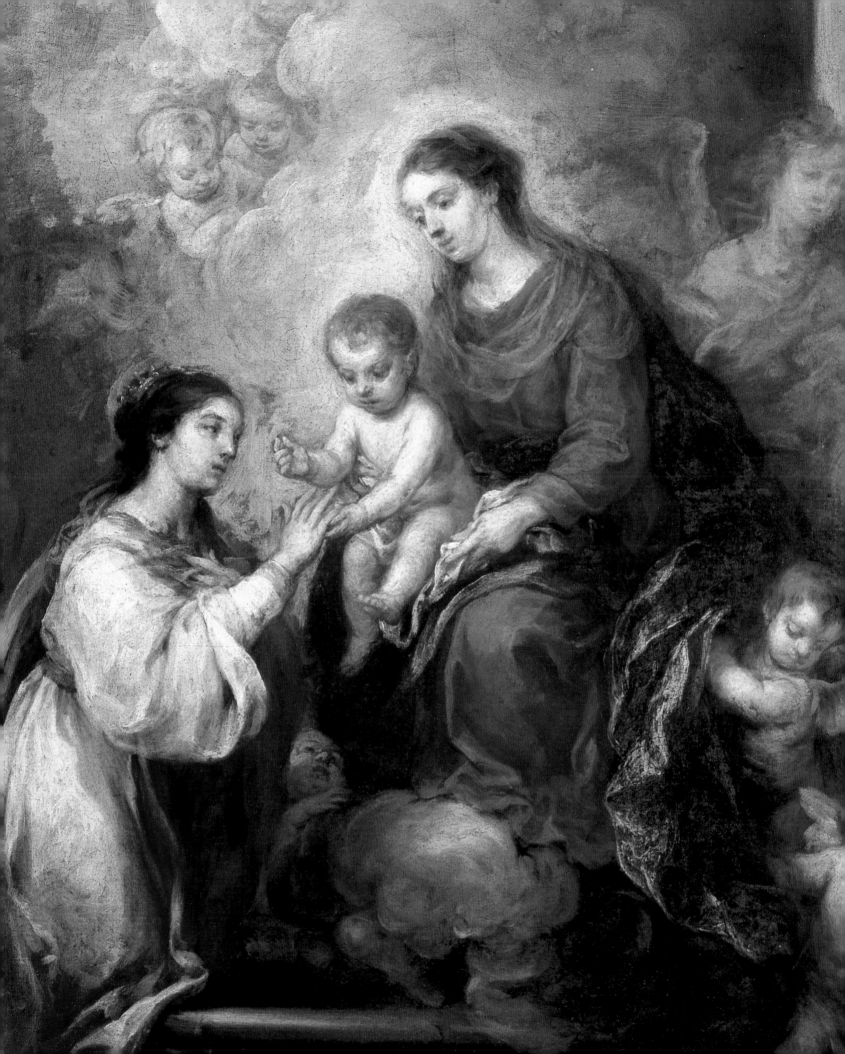

MURILLO'S DRAWING ACADEMY

Peter Cherry

I. THE SEVILLE ACADEMY AND THE STATUS OF PAINTING

In January 1660, the leading painters of Seville elected Bartolomé Murillo and Francisco de Herrera the Younger as presidents of the city's first art academy.[1] Dedicated to drawing from the male nude model, the academy was an institutional embodiment of the nobility of the visual arts and therefore represented an important moment in the long campaign of Spanish painters for a more elevated social and professional status.[2]

It is likely that the academy was the initiative of its joint first presidents; Murillo, who drew throughout his career, probably frequented private drawing academies on his visit to Madrid in 1658 and Herrera had been in Italy until 1654, where such academies were long established.[3] The Seville academy was self-financing and its success depended upon the commitment and subscriptions of its artist members.[4] However, Herrera's involvement with the academy was short-lived and his name is last registered in April 1660. This may have been due to conflicts of personality or policy resulting from Herrera's arrogant nature and he soon left Seville to take up residence at the court.[5] Murillo remained as president and is mentioned in the academy's accounts up to 1663, but after this date does

Detail of Catalogue No. 30. THE MYSTIC MARRIAGE OF SAINT CATHERINE. *1680–82. Oil on canvas. 28 x 20½ in. (71.1 x 52.1 cm). Los Angeles County Museum of Art, Gift of The Ahmanson Foundation, M.83.168*

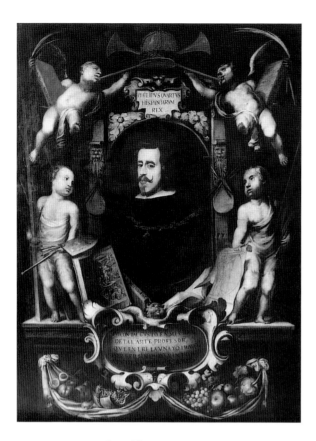

not appear in the membership until the term of 1671–72. This in turn may be attributable to differences of opinion with Juan de Valdés Leal, another notoriously proud artist, who gave up the post of *mayordomo* of the painters' confraternity of Saint Luke in 1663 to become president of the academy for a four-year term.[6] Valdés Leal served only three years as president and he did not feature among the list of academicians who approved the definitive statutes of the academy in 1673. However, Palomino, who met him in his youth in Córdoba in the early 1670s, claims that after returning to Seville he presided over the academy for many years, which forced Murillo to hold an alternative life academy in his own house.[7]

The academy placed itself under the protection of a noble patron, firstly Don Juan Fernández de Hinestrosa, conde de Arenales (d. 1670), who was succeeded by Don Manuel Luis de Guzmán Manrique de Zúñiga, marqués de Villamanrique. Although this was an honorary role, these noblemen were undoubtedly sympathetic to the painters' cause and Villamanrique was an important patron of Murillo. The integrity of the Seville academy was maintained by statutory conditions concerning the racial purity, religious orthodoxy, and social status of its members.[8] This was a markedly secular institution, whose meetings were held in a room in the Seville trade exchange, the Lonja, without involvement of members of the clergy. However, every time members crossed the threshold of the academy they were obliged to say a prayer to the Holy Sacrament and the Virgin of the Immaculate Conception for assistance in their studies, and a prominently displayed painting ensured the inspiring, protective presence of the *Purísima* at all times.[9] This ritual act of religious devotion and the silence that was imposed on the room during drawing sessions—in which all conversation that did not pertain to drawing was banned—gave meetings a suitably grave atmosphere, which was in sharp contrast with the bustle of the workshop floor.

In 1666, the academy's *mayordomo*, Juan Martínez de Gradilla, donated in perpetuity to the academy a portrait of Philip IV as protector of painting (fig. 43).[10] Although the Seville academy was not under royal patronage, the portrait was a memorial to the king, who had died the year before and who was well-known for his interest in painting. The swags of fruit at the base of the image symbolize the artistic fruits of the king's enlightened protection and he appears in the picture flanked by putti bearing the attributes of drawing (on his left) and painting (on his right), and a number of artistic treatises. A hyperbolic verse inscription in the first person, as if they were words uttered by Philip himself, declares the king a "profesor" or practitioner of the liberal art of painting who would consider giving up the throne in order to dedicate himself to this art.[11] This image expressed one of the most compelling proofs of the noble status of the art of painting for contemporaries; since the king, the highest individual in the land, not only esteemed painting but also practiced it himself, it was self-evident that the art was noble.

At the Seville academy, artists gathered in the room in the trade exchange to draw from the model "for the study and benefit" of their art.[12] This was regarded as pure study, rather than practical preparatory work for particular paintings; utilitarian studies of the posed model for specific works in hand were normally undertaken in the artists' own workshops. The fact that the statutes prohibited any member from using the facilities of the academy to paint the floats of Corpus Christi processions or any other decorative work in this vein that was beneath the dignity of the institution is a clear indication of the separation of study and production in the academy.[13] Thus "study" and the "grandeur of art" are linked in the phrasing of the statutes of the academy, since the figure drawing practiced here symbolized the higher vocation of the artist, as distinct from the normal, everyday labor of the artists' workshop.[14]

The drawing academy was not a teaching institution and did not aim to replace the traditional apprenticeship and guild system; painters in Seville continued to learn to paint in the workshops of masters, to be examined in the statutory guild exam, and eventually to practice as members of the long-established painters' guild of Saint Luke. The trade guilds were traditionally companies of craftsmen, who regulated and endorsed the manual skills necessary for an artisan to ply his trade.[15] Founding members of the academy, however, were undoubtedly united in the belief in the elevated, intellectual nature of art, which distinguished painting from the crafts. As Michelangelo had said, the artist paints with the mind, not the hand.[16] For Renaissance theorists of art, the creative imagination of the painter placed him on a par with the poet and both were practitioners of a liberal art, in contrast with the manual dexterity of, say, a cobbler, who merely practiced a mechanical craft, the work of the hand alone. From its inception, therefore, the Seville academy was an elite body of artists, which defined itself as a separate body to the painters' guild. Its twenty-four founding members included the leading painters of the city, but represented only a number of practicing artists who would have been registered with the Seville guild. Moreover, painters who had successfully completed the guild examination were not automatically guaranteed membership of the academy. This august body reserved the right to grant its own separate academic degrees, and documents refer to its members by the elevated titles of academician ("académico") and professor ("profesor"), meaning a practitioner of a liberal profession, rather than an artisan who practiced a trade.[17] While the academicians shared the worthy aspiration to raise the standing of their profession in the eyes of their contemporaries and to be treated as artists, rather than mere artisans, it is unlikely that the relatively short-lived Seville drawing academy changed the local art economy in any significant way or led to material advancement for artists, such as more advantageous relations with patrons, greater freedoms in the exercise of their art, or higher prices.

2. ACADEMIC IDEALS

The academy was an appropriate expression of artists' ambitions for social distinction and recognition as practitioners of a liberal art since this was, by definition, the home of intellectual pursuits and debate. Ancient academies were schools of philosophy and in their modern incarnation took the form of literary gatherings and meetings of humanist scholars.[18] The most famous Sevillian academy was one held in the early years of the century in the residence of the duque de Alcalá, the Casa de Pilatos, which was attended by some of the city's leading intellectuals and included the painter Francisco Pacheco.[19] Murillo and Herrera the Younger would probably have been more conscious of the precedents of Italian art academies, the most important of which were Giorgio Vasari's Accademia del Disegno in Florence (1563) and the Roman Accademia di San Luca (1593). The Florentine academy of drawing embodied the social and professional aspirations of its founders, since it conferred nobility on its members and their children.[20] Its pedagogic aims, however, were limited; although artistic instruction was offered to selected students in the art of drawing (disegno), the academy did not aim to replace workshop training. Federico Zuccaro's projected reform of the Florentine academy in about 1578 aimed to unite both the theory and practice of drawing, with instruction in a number of theoretical subjects and the establishment of life drawing.[21] This program was later instituted by Zuccaro in the Rome academy, which became the first modern teaching academy and an important center for life study.[22]

In Spain, these precedents had inspired attempts to found an art academy in Madrid early in the century, a move by which Spanish artists could place themselves on a par with their admired Italian counterparts.[23] The draft petition for the establishment of a royal

academy in Madrid in 1624 envisioned the value of this "pious and Christian Academy" primarily in maintaining the caliber of religious painting by "teaching scientifically the theory and practice of this art, with its concepts and rules and the necessary exercises" and invoked the example of the academies of classical antiquity and of contemporary Italy.[24] A centerpiece of academic instruction in this academy was to be the life class.[25] The Florentine royal painter Vicente Carducho, himself a member of the Accademia del Disegno of Florence, was probably the author of this document and was certainly a prime mover in the project.[26] His *Diálogos de la pintura* (1633) is itself an academic text which is heavily indebted to Federico Zuccaro's aesthetic ideas and also overtly served his campaign to raise the status of the profession of painting.[27]

Drawing became the fundamental academic principle and activity. One of the reasons for this was that drawing was a teachable discipline and skill. It was also regarded as the activity common to all of the visual arts and for this reason the Seville academy, as in the Italian academies and the projected academy of Madrid, included painters, sculptors, and architects.[28] Of greater relevance in the academic context, however, was the belief in drawing as the founding principle of painting and an expression of the artist's intellectual faculties, which was, therefore, proof of his elevated intellectual status. This is what Pacheco referred to, for instance, when he asserted that drawing was the single faculty which distinguished artists from artisans.[29] The belief derived from Italian art theory, which defined *disegno* as the fundamental artistic value, encompassing both "design" and the practice of drawing, and the medium by which concepts born in the artistic imagination were translated into pictures. The prevalent Neoplatonic view of artistic creativity, moreover, taught that speculative drawing from the mind enabled the artist to access a higher realm of beautiful concepts and forms that could be distilled onto paper. These ideas associated with drawing were common currency by the seventeenth century and inform the treatises of Vicente Carducho and Francisco Pacheco.[30] One of Carducho's most memorable precepts was that the artist should "draw, speculate and draw some more."[31]

In their writings, both Carducho and Pacheco emphasized the necessity for learned painting and knowledge of the scientific precepts of art. In response to this, the art academy was the appropriate place for the formal study of painting as a liberal science, with its own principles and rules. Theory set painting on an equal intellectual footing with other humanist disciplines and in the academy of Madrid, for instance, over the full three-year course it was intended to impart the theory and practice of perspective, anatomy, symmetry, and physiognomy, with lectures on mathematics and astrology, as well as composition, propriety, and decorum in the representation of narrative images.[32] Although images of artists' academies represent their members engaged in speculative scientific inquiry, often shown, for instance, attending anatomy lessons, this image is more likely to represent an ideal of academic study, rather than a reality.[33]

Gradilla's portrait of Philip IV (fig. 43) has been interpreted as an academic "text," reflecting the intellectual aspirations of the Seville academy and a coherent ideology concerning the nobility of art and its scientific study.[34] One of the putti holds drawing and measuring instruments, and a loose print of the proportions of the male figure from Albrecht Dürer's *Four Books of Human Proportion* (1528). A number of books on art are also shown: Francisco Pacheco's *Arte de la pintura* (Seville, 1649), Vicente Carducho's *Diálogos de la pintura* (Madrid, 1633), and the works of Giorgio Vasari, the biographer of the artists of the Italian Renaissance and founder of the Florentine drawing academy. Also present is Juan Valverde's *Historia de la composición del cuerpo humano* (Rome, 1556), an anatomical treatise with illustrations believed to be by the Spanish artist Gaspar Becerra.[35] These texts and images

are emblematic proofs of the intellectual pretensions of academies, the scientific, learned dimension of art that was embodied in academic institutions and that is here tailored to a particular Spanish context. It is likely too that this image—in common with other representations of artists' academies of the period—represents an ideal, rather than reflects the reality of artistic activity in the Seville academy.

The Seville academy does not appear to have been a teaching institution along the lines of the Rome academy or the projected painting academy in Madrid.[36] Its first members were all established masters who had passed the guild exam, not students. The studies ("estudios") of the members mentioned in the documentation are not specified and would appear to refer only to drawing from the nude model in the life class. Although the original statutes gave the president of the academy the authority to grant the title of academician to those who studied there and "were found capable," there is no mention of a curriculum, nor any formal means for the assessment of progress in drawing. The later statutes of the academy refer to students ("discípulos"), as well as the "studies" ("estudios") of its members. By this time, a course of study and academic titles were envisioned; it was recommended that members study over four consecutive years, after which time those who were found competent were to be given a certificate signed by the academy's patron and president, which also entitled them to exercise offices in the academy.[37] However, there is no evidence that this recommendation was ever instituted.

Earlier commentators imagined Murillo himself explaining proportion and anatomy to other members of the Seville academy, in the manner of an eighteenth-century art academy.[38] However, there is no evidence of any formal instruction in scientific anatomy in the Seville academy. This would not have prevented the more serious members from consulting anatomical manuals in order to clarify the location and function of bones and muscles. Indeed, some knowledge of this kind would have been useful to enable them to address the live model in an informed way. Significantly, no mention is made in the documentation concerning the academy of any equipment relevant to speculative intellectual activities, which would also appear to confirm the absence of a teaching program.[39] This is in contrast with the variety of artistic aids that would have been stocked in the workshops of individual members of the academy, such as casts of sculptures and body parts, skeletons, mannikins, drawings, prints, and books.[40] Such studio equipment was not only for the use of the master, but a teaching resource.[41]

It appears that the pedagogic aims of the Seville drawing academy, if any, appear to have been extremely vague and never to have constituted a formal program of instruction. The evidence suggests that this was exclusively a communal life class, a convenient place where artists could regularly gather to draw from the live nude model, unburdened by any theoretical concerns.[42] In this respect, the academy appears closer to the private studio-academies that flourished in Italy and Spain at this time.[43] These generally were informal gatherings of artists in the house of a nobleman or the studio of a painter to draw from the male nude model, an activity that did not include a theoretical dimension. By the second half of the century, it appears to have been a common practice in Madrid for artists to draw from the live model in such private academies (fig. 44).[44] Murillo may have drawn the nude in one of these on his visit to Madrid in 1658 and, after withdrawing from the official Seville academy, is said to have organized private life-drawing sessions in his own house in the 1670s. Murillo's contemporary, Valdés Leal, is reported to have frequented life academies in Madrid in 1664, where he drew two or three figures an evening in order to show off his facility and virtuosity. The anecdote also indirectly sug-

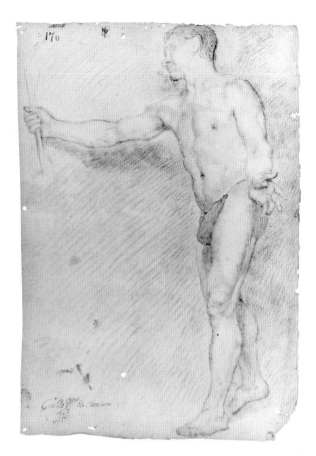

Fig. 44. Claudio Coello. MALE NUDE. *c. 1680. Red and black chalk, 11¾ x 8″ (29.6 x 20.3 cm). Museo de la Casa de la Moneda, Madrid*

Opposite, top: *Fig. 45.*
Anonymous. SEATED MALE
NUDE. *c. 1660–65. Red and black
chalk, 15½ x 10½″ (39.6 x 26.4 cm).
Museo de la Casa de la Moneda,
Madrid*

Opposite, bottom: *Fig. 46.*
Anonymous. MALE NUDE WITH
A POLE. *c. 1660–65. Red and black
chalk, with white heightening, 19½ x
13″ (49.8 x 33 cm). Museo de la Casa
de la Moneda, Madrid*

gests that in such gatherings artists were free to draw how they pleased, in the absence of any formal instruction. For Palomino, however, who recounted this story, the approach was at odds with the considered, methodical study usually associated with the academy.[45]

3. DRAWING FROM THE MODEL

The Seville drawing academy was a life class, an *academia del desnudo* for the benefit of practicing artists of different levels of artistic maturity and expertise. Drawing from the nude male model became the fundamental activity of artists' academies; later, such a drawing itself came to be known as an "academy." This was due to a belief in the human figure as both the most noble and most challenging artistic subject, and the basic component of the narrative painting, regarded as the most elevated of all types of painting. Regular drawing from the live nude model was considered beneficial artistic training in itself, primarily because this allowed the figure painter to acquire a familiarity with and an understanding of the human body, while exercising and developing his graphic skills. The artist's study of the large anatomical forms seen by the eye, as well as their realistic expression in different poses and movements of the model, resulted in a more natural-looking articulation of the surface anatomy and the avoidance of anatomical mannerisms and mistakes. Study of the live model was also useful in familiarizing the artist with the sensual realities of the human body, such as lightfall on the surface of translucent skin, an experience that prints or sculptures would not allow.[46]

The premium set upon the study of the human figure in the academic context elevated figurative narrative painting illustrating religious, historical, and mythological subjects, over more lowly types of painting, such as landscape and still life. It seems surprising, then, that landscape and still-life painters were members of the Seville academy.[47] However, these artists would have shared the same professional and social aspirations as their colleagues. Moreover, in the local context of Seville it was common for painters to produce figurative religious paintings, whatever the specialist branch of painting with which they were identified. The single core activity of life drawing also bridged the different artistic professions. Although painters were in the majority and occupied all of the high offices of the academy, the founding members included the gilder Pedro Onorio de Palencia and the architect Bernardo Simón de Pineda, and the sculptors Pedro Roldán (from 1664), Gabriel de la Mata (from 1664), and Juan Ruiz Gijón (from 1668), among others. Sculptors came to the academy to model in three dimensions from the life; this is clear from notice of a violent argument in 1666 between the sculptor Andrés Cansino and one of his assistants called Marcos who had come to the academy to "modelar."[48] This inclusion of the different professions also respected the strong local tradition of *retablo* construction and decoration in Seville, a collaborative endeavor that united the skills of architect, sculptor, painter, and gilder, who often knew one another well.

The documentation shows that artists regularly met to draw from the live model in two-hour evening sessions in a room rented in the Lonja, the Seville trade exchange.[49] Swords carried by members of the academy as a sign of nobility were to be removed during academic elections and not to be worn while seated drawing, thus ensuring a certain fraternal equality before the model. Of the corps of twenty-four "profesores" that made up the academy, twelve were to attend the drawing sessions and took turns to set the model ("poner la actitud") and ensure that the pose was held. Sessions took place at night by artificial light; this allowed control of the lighting of the model, especially for poses lasting for more than one session, and created emphatic contrasts of light and shade which aided artists' management of *claroscuro* in modeling the figure. This would account for the force-

ful modeling of the figure in some life studies (fig. 45) and it is clear from the shadows cast by the figure in Claudio Coello's life study (fig. 44) that this was drawn in directed light from above. The academy's account book lists expenses for lighting and heating, and the costs of a hanging oil lamp to light the model, an hourglass to time poses and sessions, cords to suspend the limbs of the model in open, expansive attitudes, as well as a dais on which he posed. One model, called Pedro, was paid for four poses ("actitudes") over eight nights; one of these poses was carried over two nights, and another over three nights.[50] No evidence exists for the identity of the models in Seville, apart from their names and, occasionally, their nationality, although models were normally men around thirty to thirty-five years old, who were chosen for their fine physiques. They were probably lower-class individuals, since they were responsible for cleaning and heating the academy, something that was clearly beneath the dignity of the members. Prevailing values of decorum and modesty in the depiction of the male nude—even in the life class—means that the genitals are disregarded in seventeenth-century Spanish life studies of the male nude, concealed by the pose or omitted altogether, perhaps due to the model's wearing a pouch (fig. 44).

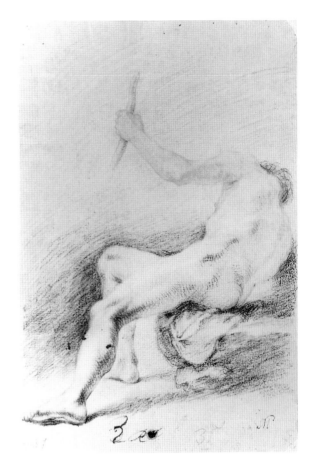

Although the Seville academy functioned for over a decade, the drawings produced by its members have not been securely identified.[51] It is possible that the normative style usually employed in life drawings has prevented recognition of these today. However, such drawings may also have suffered a high loss rate. Drawings in charcoal would have been particularly fragile. While life studies were not normally the type of drawings sought after by private collectors, they were desirable reference material for artists and were particularly useful in nonverbal workshop teaching and as models to be copied by pupils, and thus migrated between different artists' studios.[52] The noticeable wear and tear on surviving chalk drawings would appear to testify to such a use.

A group of six drawings worth considering in the context of the Seville academy is today in the collection of the Casa de la Moneda in Madrid.[53] These represent studies of single male models in different poses and are on a similar type of rather coarsely textured buff and buff-gray paper.[54] The drawings are evidently the work of mature artists, rather than beginners, and show that even in the ostensibly normative discipline of life drawing the distinctive individual style of an artist could surface. Two of these drawings are inscribed with the name of Francisco de Herrera the Younger (figs. 47, 48) in what appears to be a seventeenth-century hand, and this attribution is consistent with their style.[55] The other four drawings are by different contemporary hands and the style and spirit of one of these (fig. 49) is reminiscent of the drawings of Murillo (fig. 50).[56] While it is likely that the group of drawings represents studies from the live model drawn by artists at an academy, there is no real evidence that they come from the Seville drawing academy.[57] The drawings by Herrera may well have been made during his career in Madrid, where private academies flourished. What is clear, however, is that they represent the type of drawings that were made at the Seville academy.

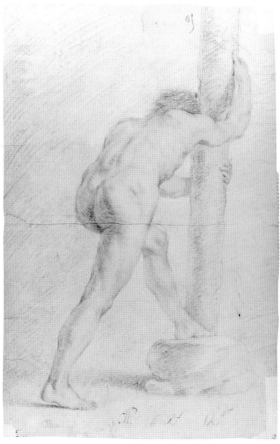

The figures are drawn in red chalk, with black chalk used to define contours and strengthen shadows and, in some of the drawings (figs. 46, 47, 48), white highlights are used in modeling the figure. In this choice of medium, the drawings are consistent with established contemporary practice.[58] Murillo's *Self-Portrait* (cat. 33, fig. 2) displays one of his own studies of a male nude drawn in red chalk. The tonal medium of chalk was preferred for drawing from the nude, since it conveyed the natural softness of skin and, in the case of red chalk, the metaphorical warmth of living flesh. Chalk facilitated the handling of light and shade (*claroscuro*), with which the artist created the illusion of the three-dimensionality of figures, as well as representing the play of light on luminous skin surfaces. As was the norm

with academic life drawings, the complete figure is represented, in which the artist's attention has been evenly applied to the whole. The handling of the medium in these drawings is methodical and uniform throughout the whole figure, and reflects the disciplined approach to the study of the nude model that is in contrast to the spirited touch of studies from the artist's imagination. In terms of technique, the drawings exhibit a combination of tonal and linear marks to model the figures. The blunted end of the red chalk has been rubbed onto the coarse paper to create varying depths of tone—in the case of some drawings (figs. 47, 48, 49) the bite of the paper giving it a painterly texture—and this is combined with hatched lines made with a sharpened end of the chalk that follow the form of the figure. Herrera's figures are mostly modeled in tonal patches, with some hatching marks in the torso of one of them (fig. 47). One of the other drawings (fig. 45), in contrast, makes bold use of black chalk hatching over a more finely handled red chalk drawing.

In these sheets considerable attention has been paid to the contour of the figure, which was regarded as the primary controlling element of drawings according to prevailing theory and practice of draughtsmanship.[59] A number of corrections and adjustments to the contour can be seen; in the left side and left leg of the nude with the cross (fig. 49), for instance, and the left leg of the nude with a pole and his left shoulder, which has been partly effaced with white heightening (fig. 46). The subtlety and assurance of Herrera's handling of contour (fig. 48), which is defined by lines and marks of different densities, contrast with the heavier insistence on this feature of other hands (figs. 46, 49). In a number of drawings, the shading of the background is also used to define further the contour and enhance the relief of the figures.

Herrera's two drawings (figs. 47, 48) represent a seated figure, which is possibly the same model, viewed from two different angles. They are remarkably realistic. Herrera has not disguised the fact of this individual's rather scrawny physique, which can be clearly seen in the folds of flesh in the sunken stomach area of one of the drawings (fig. 47), and which is unlike the more muscular build of men usually chosen as models.[60] The anatomical features of the figures are treated broadly in Herrera's drawings, with relatively little descriptive detail contained within their contours, while the musculature of some of the others in the group of drawings is defined with greater emphasis (figs. 45, 46, 49). All of the drawings, however, betray the artists' close attention to the live model in their representation of large anatomical forms in a factual way. Musculature is accurately modulated by the draughtsmen and the muscles flex correctly in the drawing of the model raising a pole (fig. 46). The author of the figure with a cross (fig. 49), like the others of this group, has treated the anatomy as surface as well as structure; the complex bone and muscle structures of ribcage and knees, for instance, are drawn taking account of their covering of flesh and skin.

While the science of anatomy was a key area of academic interest in the sixteenth century, it was clear to artists of Murillo's generation that its excessive study was at odds with aesthetic values.[61] Indeed, to them some of Pacheco's works epitomized this problem, particularly his paintings for the ceiling of the Casa de Pilatos, in which the nudes are anatomically pedantic and highly artificial looking, with overly prominent musculature deriving from his earnest study of the works of Michelangelo in print form.[62] The broad, sensuous treatment of the large anatomical forms that characterizes the group of drawings in the Casa de la Moneda, on the other hand, has resulted in figures that were considered more naturalistic and aesthetically pleasing than works in earlier drawing styles. Moreover, a preference for comparatively generalized, understated anatomical features demonstrates that the artist's direct experience of the nude model was an approximation to reality and that a subtle process of selection took place even in forms observed from

the life.[63] This is perhaps not surprising since the concept of idealization was so closely identified with the processes and practice of drawing itself.

Although the drawings represent the figure alone, there is a certain degree of contextualization. The wooden box on which the model probably sat has been converted into a rocky outcrop (figs. 47, 48), as has the platform on which the model's foot rested in two drawings. Herrera reworked one of his life studies to expand this landscape theme (fig. 47), by adding rocks and foliage, and a fruit garland around a classical herm, in this way playfully embellishing the drawing perhaps for a collector.[64] Ironically, however, this all too natural nude figure sits, Narcissus-like, in an idealized world of nature symbolized through classical motifs. The academic study of the nude model was conventionally devoid of narrative content. The props that accompany the figure in such studies, such as the wooden stick—barely indicated in two drawings (figs. 45, 51)—used to support the model's arms in expansive positions, were normally used only to articulate poses and actions. The figure raising a pole (fig. 46), for instance, is not intended to illustrate any particular lit-

Above: *Fig. 51. Anonymous.*
WALKING MALE NUDE.
c. 1660–65. Red and black chalk,
21¼ x 16⅛" (54 x 40.9 cm). Museo de
la Casa de la Moneda, Madrid

Opposite, top: *Fig. 52. Bartolomé*
Esteban Murillo. BROTHER
JUNIPER AND THE BEGGAR.
1645–46. Oil on canvas, 69¼" x 7¾"
(176 x 221.5 cm). Musée du Louvre,
Paris

Opposite, middle: *Fig. 53.*
Bartolomé Esteban Murillo.
BROTHER JUNIPER AND
THE BEGGAR *(recto). 1645–46.*
Pen and ink, 8⅜ x 9" (21.3 x 22.8 cm).
Ecole Supérieure des Beaux-Arts
(no. 1679), Paris

Opposite, bottom: *Fig. 54.*
Bartolomé Esteban Murillo. SAINT
FRANCIS SOLANO TAMING A
WILD BULL *(recto). 1645–46.*
Pen and brown ink with brown wash
over black chalk, 8¾ x 13¼" (22.2 x
33.5 cm). Museum of Fine Arts,
Boston, Frances Draper Colburn
Fund, 1920

erary subject, but is a dynamic physical action studied for its own sake. This is not to say, however, that the study may not have later served the artist in conceiving figures for subjects such as the Raising of the Cross or the Labors of Hercules.

The most interesting drawing in this respect is that of a figure tied to a cross (fig. 49). This is the most carefully drawn and finely modeled figure of the group of drawings and betrays an accomplished hand. The figure is subtly foreshortened and its perspective shows that the model was posed on a dais above the eye level of the draughtsman. The model is posed leaning against a crossbeam, holding onto the horizontal bar with one hand and with his other arm resting upon it. The raised left arm allowed for a view of the complex anatomy of the shoulder area and an uninterrupted view of the rib cage. The change in the position of the model's left hand established the correct relation between this and the forearm behind the beam, although differences in the depiction of the rope that binds only this hand to the cross suggest that this particular detail was invented, rather than observed. It reveals that the artist was thinking of the figure in the context of religious iconography, as a figure of Christ or a martyr saint with a cross.[65] The soulful heavenward gaze of the model is also part of the expressive convention of such subjects. This figure is therefore not merely an objective study of the nude model, but is already an embodiment of religious emotion. In keeping with this role, the draughtsman has subtly idealized the figure; harmonious contours, smoothed-out anatomical details, and elegant *contrapposto* combine to create a figure of muscular power and beauty. Whoever drew this figure may well have been familiar with the animating principles of Carducho's academy in Madrid earlier in the century, in which the study of the nude model was conceived as a means of improving the caliber of religious painting in Spain.

4. MURILLO'S DRAWING IN PRACTICE

Murillo and other artists of his generation, such as Herrera the Younger, Valdés Leal, and Cornelius Schut—all founding members of the academy—established drawing as central to their artistic practice. Murillo's surviving drawings suggest that he followed logical graphic procedures for the preparation of his paintings and, in accordance with prevailing academic thinking of the time, practiced drawing in its two traditional forms: as a creative resource and a means of attaining representational virtuosity. Drawing for Murillo, therefore, was a means of inventing and varying figural compositions, such as the Virgin of the Immaculate Conception, whose image was at the core of Sevillian practice, and of representing these skillfully.[66]

Indeed, drawing is a key activity that separated Murillo's art from that of Francisco de Zurbarán, who was the preeminent Sevillian painter in Murillo's youth, and who based his works on print sources and live models. Murillo's sheer graphic ability and Zurbarán's artistic limitations show clearly in their respective depictions of flying angels and cherubs. Zurbarán copied these figures from prints and imaginatively recombined them in his paintings, in accordance with conventional practice among Andalusian painters. Murillo also worked this way in a number of early pictures, but only on rare occasions later in his career.[67] Whereas Zurbarán was evidently incapable of visualizing and executing the complex aerial movements and foreshortenings of groups of flying figures, Murillo excelled in these. These figures are his own inventions, which he did not repeat in any formulaic way in his paintings, and which are the very embodiments of his graphic virtuosity. Murillo's imagination was crucial here, since even the limited repertoire of the posed live model was not useful for their depiction. However, he had probably learned and refined this skill in the traditional manner, initially by copying figures from prints

and progressing to drawing from sculptures of cherubs suspended on cords, in order to practice foreshortening.[68] A number of drawings by Murillo for angels and cherubs have survived and, given their importance in religious painting, it is not surprising that these are the subject of a considerable number of seventeenth-century Spanish drawings.[69]

Murillo's surviving drawings for his cycle of paintings for the small cloister of the Sevillian monastic church of San Francisco (1645–46) already show him making practical use of different graphic procedures, since the size and importance of this early commission would have necessitated rigorous preparation. From this point in his career, Murillo had evidently developed the technique of expressing first ideas for subjects in sketches.[70] A sketch in chalk exists for the main figures in Murillo's painting for *Saint Salvador of Horta and the Inquisitor of Aragón* and a more elaborate pen and ink sketch of *Brother Juniper and the Beggar* (fig. 53).[71] Murillo's later sketch (fig. 55) for his painting of *Saint Francis Embracing Christ* for the Sevillian church of the Capuchinos (1668–69) represents his continued use of the chalk medium to rough out ideas in this way.[72] Although this drawing probably records Murillo's inspired first idea for the figural composition, the artist was faithful to his original conception in the resulting painting (fig. 56), although any intermediate stages in revising the image are unknown. Only a number of iconographic adjustments separate sketch and painting; in the final work, Murillo substituted the exchange of gazes between the protagonists for the greater emotional intensity of Saint Francis's love of Christ, represented in the sketch by his reaching forward to kiss Christ's wound.[73] Later in his career, Murillo favored sketching in pen and ink alone, when his drawing style itself developed toward greater spontaneity, freedom, and energy.[74]

A subsequent stage in Murillo's preparatory graphic process is represented by more highly resolved compositional and figure studies. The difference between Murillo's sketch for *Brother Juniper and the Beggar* (fig. 53) and his study for *Saint Francis Solano Taming a Wild Bull* (fig. 54) for San Francisco el Grande (1645–46) depends upon a higher degree of completeness of details such as the hands and feet of the saint in the latter drawing, greater control and economy of line, with a consequently more considered relationship between line and tonal washes, and a more even attention to the composition as a whole. This latter drawing shows that Murillo drew in ink over a rough chalk underdrawing or sketch. Murillo's later frequent employment of this technique in his drawings suggests that this was the main way in which he resolved a loose sketch into a more focused study.[75] By this means, he clarified his ideas on the same sheet, rather than in a number of separate drawings.

In accordance with analytical drawing practices established since the Renaissance, Murillo sometimes went on to study in further detail the important component parts of compositions in separate drawings. A number of drapery studies survive for figures in Murillo's early paintings for San Francisco el Grande.[76] A chalk study exists for a particularly prominent angel in his painting of the *Vision of Saint Anthony of Padua* (fig. 11) and another chalk drawing from around the same date (cat. no. 4, fig. 1) is a study of the facial expression of the repentant Magdalene for a painting now in Richmond, Virginia (cat. no. 4).[77] Murillo's magnificent chalk drawing of *Christ on the Cross* (fig. 50) may be considered a drawing of this type, in which the artist has rendered in detail the main figure of the composition of the *Christ on the Cross* in the Meadows Museum (cat. no. 21). However, the drawing remains unusual in Murillo's corpus for its high degree of technical refinement and finish.

The Italian model of *disegno* as a rigorous intellectual process of logical distillation was advocated by the theorist and painter Vicente Carducho, who recommended drawing "with much work, study and science" as the means by which the image could be brought to a near-perfect conclusion.[78] Murillo undoubtedly knew Francisco Pacheco's meticu-

Fig. 55. Bartolomé Esteban Murillo.
Saint Francis Embracing
Christ. *1668. Black chalk, 13¼ x*
8⅞" (33.9 x 22.6 cm). Courtauld
Gallery, Courtauld Institute, London

lous model drawings in pen and ink, which he sometimes signed and dated to signify their definitive status of finish in the graphic process.[79] However, Murillo does not appear to have conceived of drawings in this way, as semi-autonomous, finished works that could be directly transferred to the canvas. While some of his preparatory drawings are at times relatively more highly resolved than others, only one can be regarded as a finished model drawing in the traditional sense; the pen, ink, and wash drawing of *Christ in the Garden of Gethsemane* (Biblioteca Nacional, Madrid).[80] The circumstances of Murillo's creation of this drawing are unknown, but, like equivalent works by Sevillian artists such as Pacheco or Alonso Cano, it may have been made for the approval of a client. In this very carefully executed drawing, complete with an illusionistic drawn frame around it, the contours of forms are clearly articulated and the lighting is subtly modulated, while the pupils of the eyes have been drawn in order to give the expressions of the figures maximum definition. The light black chalk squaring suggests that it was prepared for transfer.[81]

In the case of the compositional study of *Saint Francis of Solano Taming a Wild Bull* (fig. 54), it would have been perfectly possible for Murillo to have painted from the information contained in this drawing and from auxiliary studies for the figures, while improvising changes on the actual canvas.[82] This study could, in practice, have acted as a model drawing.[83] This is likely to have been the case with a number of other complete compositonal drawings by Murillo that are known today. One of these, representing the *Adoration of the Kings* (private collection), is drawn in ink over a chalk underdrawing and shows great tonal range through an extensive use of washes.[84] Another work of this type is a well-known ink drawing of the *Infant Christ Child Asleep on the Cross* (Musée du Louvre, Paris), drawn in pen and wash over a chalk sketch.[85] This evidently served as the model for a painting of this subject, allowing for some adjustments that were made while painting, such as the angle of Christ's head and incidental details of the landscape.

Murillo may also have painted from the ideas contained in even less finished studies than these examples. Murillo's chalk study of the *Holy Family with Angels* (British Museum, London), for instance, could have provided the artist with enough visual information to allow him to improvise this image on a larger canvas.[86] This may indeed have been the case with a painting of the *Vision of Saint Anthony of Padua* (formerly Kaiser Friedrich Museum, Berlin), which could have been painted from a study now in Paris.[87] Murillo may have used his drawn studies as prompts to his powers of improvisation in an *alla prima* painting technique.[88] This would have been particularly easy when the imagery was a familiar part of the artist's repertoire. Murillo probably even preferred to paint from such drawings, since these allowed for a degree of creative improvisation during the act of painting, rather than from highly finished model drawings that would have inhibited him too much. In this way and in common with his contemporaries, Herrera the Younger and Valdés Leal, Murillo, too, may have wished to capture in his expressive and direct painterly handling something of the inspired spontaneity, energy, and vividness of his sketches and studies.[89]

These aesthetic values are relevant to Murillo's occasional use of preparatory oil studies on canvas.[90] Murillo sometimes made a single small-scale oil study of a composition before painting, as was also the practice of Valdés Leal in Seville.[91] Both artists may have known such works by Rubens, who normally made them on wooden supports, as well as those of Vicente Carducho. Some of Murillo's oil studies may have been made in order to preview compositions for patrons. Their value for the artist was as studies of a whole composition in terms of color; in these trial pieces Murillo could essay decisions concerning color harmonies, illumination, and atmosphere.

In a number of cases drawings can be shown to have preceded studies in oil. A prepara-

tory study in pen and ink with wash and a small oil study are known for Murillo's painting of *Saints Justa and Rufina* (cat. nos. 15 and 16, fig. 1) painted in 1665–66 for the high altarpiece of the Capuchinos in Seville.[92] The small painting is essentially faithful to Murillo's conception in the drawn study, but develops the image with changes in the saints' attributes and the addition of color. It may be assumed that Murillo referred to the oil study when he came to paint the large altarpiece, while improvising further minor changes at the painting stage.

It is not clear, however, whether drawings always preceded these small-scale paintings. Some were probably sketches in the strict sense of the term, which were painted directly from Murillo's imagination. A case in point are two oil sketches representing the *Baptism of Christ* and *Christ Giving the Keys to Saint Peter*, which combine brush drawing and patches of color applied with particular spontaneity and freedom.[93] As with his studies on paper, Murillo may have availed himself of the animated freshness of touch in such paintings as a stimulus to his distinctive handling in full-scale paintings that flowed from these. While oil studies were used to try out overall pictorial effects and are therefore relatively lacking in detail, known examples by Murillo display varying degrees of finish. The figures in Murillo's oil study of the *Virgin and Child with Saints* (Wallace Collection, London) are quite clearly defined, particularly the angels, as are the central figures in his late oil study of the *Mystic Marriage of Saint Catherine* (cat. no. 30).[94] Murillo tried out his ideas for these complex multifigural works in drawn sketches and may have used the oil study in place of drawings on paper to further elaborate and refine the compositions.

The dearth of graphic evidence makes it difficult to ascertain the role of drawing in the study of the human figure in Seville before the establishment of the academy. Sevillian artists would occasionally have had recourse to the live model in order to study particular passages of anatomy for specific works, in accordance with Renaissance practice. In his treatise, Francisco Pacheco mentions drawing from models, although his own painting would suggest that he did not always make full use of this resource.[95] The correct, natural-looking anatomy of Pacheco's painting of the *Crucified Christ* (1614, Fundación Rodríguez Acosta, Granada), however, derives from an informed study of a live model. In this respect, Pacheco may have learned from the precedent of his contemporary, Juan de Roelas (c. 1560–1625), an educated artist who was said to have studied anatomy.[96] Roelas's figure of Saint Andrew in the *Crucifixion of Saint Andrew* (c. 1612, Museo de Bellas Artes, Seville) is a nude painted in a Venetian style, which endows the body with the appearance of living flesh. The extraordinary naturalism of the figure also increases its pathos and the facial expression is one of the most moving in the history of Sevillian painting. Zurbarán evidently painted from the live model for a number of his nude male figures in religious pictures of the 1620s and 1630s. In his series of paintings of the *Labors of Hercules* painted in Madrid in 1634 for the Hall of Realms of the Buen Retiro palace (Museo del Prado, Madrid), Zurbarán depicted the figure of Hercules from a posed model, apparently unmediated by drawings, and it is this naturalistic approach that endows the mythological subjects with an often-noted stilted, overly realistic air.[97] Alonso Cano also appears to have sometimes restudied his figures from live models, and in 1644 he is reported to have employed a poor man to model for him for paintings that required nude figures.[98] This may be the case with the nudes in his *Descent into Limbo* (Los Angeles County Museum of Art), in which the figures of Christ, Adam, Eve, and the child Seth are reminiscent of an exercise in comparative anatomy and are also somewhat idealized, most probably through a process of drawing.[99]

Murillo's early painting of *Brother Juniper and the Beggar* (fig. 52) follows Renaissance practice as advocated by Leonardo, in which the composition was drawn from the imagination and live models were then studied in their respective poses.[100] Murillo's pen study shows

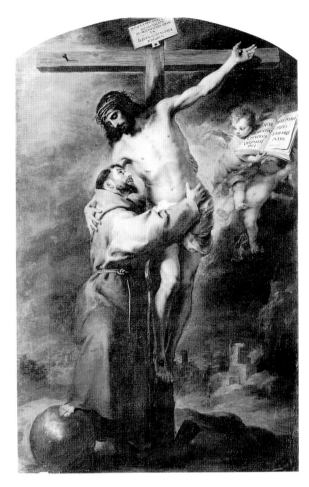

Fig. 56. *Bartolomé Esteban Murillo.* SAINT FRANCIS EMBRACING CHRIST. *1668. Oil on canvas, 9'3½" x 6' 2" (283 x 188 cm). Museo de Bellas Artes, Seville*

Brother Juniper standing and the kneeling beggar reverentially removing his tunic (fig. 53), and this composition remained essentially unaltered in the final painting. It is evident, however, that for his painting Murillo restudied the figures from the life and in this the precedent of earlier Sevillian artists, noted above, would have been influential.[101] In the drawing, Murillo paid more attention to the beggar, reworking the figure's contours to establish an expressive and graceful attitude, and depicting the anatomy only in a schematic way. In the painting, however, the same figure has been depicted from a live model, either mediated by a drawing, or painted directly from the model himself. This is a portrait of a specific individual, kneeling in a natural manner, whose particular and detailed anatomy has clearly been observed, rather than imagined.

This was probably not Murillo's practice later in his career, when he developed the full potential of drawing and no longer relied on the live model. Few artists of his generation would have wished to limit their art to a dependence upon posed models. Earlier in the century, Caravaggio had been notorious for this approach, dispensing with drawings and, according to Carducho, painting "without precepts, doctrine or study, but only with the power of his spirit and with nature before him."[102] Murillo and his colleagues prized the creative imagination of the artist, which allowed him to invent and to idealize figures.[103] A case in point is Murillo's painting of *Saint Francis Embracing Christ* (fig. 56), a major work from the decade of the foundation of the drawing academy. Murillo's original idea for the composition was expressed in a chalk sketch (fig. 55) and any intermediate drawings that led Murillo to his end result are unknown.[104] He may have used a live model to check the anatomy of the figure in this position, although this was not really necessary by this point in his career, since practice and experience would probably have allowed him to improvise it from his imagination. It is also possible that the figure was studied in drawings that are now unknown. Murillo's drawing of a *Christ on the Cross* (fig. 50) is of relevance here. This figure was probably drawn directly from Murillo's imagination and it abides by the convention of weightless elegance for this subject, without the stresses of a realistic depiction of the action. Once again, the anatomical information necessary for such a familiar image as this would have been so well known to Murillo that he could recall it at will.

The figure of Christ in this drawing possesses great corporeal beauty, in response to prevailing conventions of decorum, which meant that an appropriate degree of idealization was necessary in the depiction of exemplary sacred figures.[105] The idealization of Murillo's nude figures of Christ, however, is not at the expense of verisimilitude. Indeed, the discipline of descriptive life drawing could have been vital in maintaining their natural appearance.[106] Murillo's experience and knowledge of the human body, fueled by his study of the nude male in academic sessions and assimilated into his visual memory, could be drawn on in the creation of new, imaginary figures. The observation of real anatomical relations in a drawing such as the figure with a cross (fig. 49) would have been remembered when Murillo came to draw similar figures from his imagination (fig. 50), albeit selectively. The rubbed condition of the drawing of the *Christ on the Cross* is responsible for a certain loss of definition in the handling of the surface musculature of the figure, which is so clearly modeled in the related painting (cat. no. 21).[107] However, it was probably also the case that the anatomical information registered in a life study would have been further suppressed and edited in such ideal figures as this for the sake of greater beauty, while remaining essentially correct and convincing to the lay viewer.

Two drawings by Juan Carreño (figs. 57, 58) suggest that this practice was a widely extended one among Murillo's contemporaries at court. Here, Carreño has imaginatively

drawn on a life study (fig. 57) as a source for his improved figure of Christ (fig. 58); in the latter figure, he attenuated the proportions and anatomical structures, thickened the arms and reduced the masses of legs and stomach, and sacrificed the descriptive accuracy of the contour of the life study for more abstract, flowing outlines.

Murillo's drawing of the *Christ on the Cross* (fig. 50) shows that, like other artists of his time, he followed the idealizing principle of smoothing out the irregularities and surprises of the live model in favor of an understated and improved surface musculature made up of regular and harmoniously interrelated planes.[108] Smoothly flowing contours contain the figure as a unified, harmonious whole and its marked planarity contrasts with the more assertive volumes of the life study.[109] The studied play of light suggested by the chalk medium conveys qualities of soft, living flesh, of an immaculacy unlikely to have been witnessed before the living model. In Murillo's paintings, color was the most important additional key to the quality of verisimilitude, a vital factor in creating the sensation of believable figures of flesh and blood, albeit more beautiful and admirable than those normally seen in everyday experience.

The generalized, smoothed-out forms of Murillo's figures approximated to an ideal of beauty stored in his creative imagination. Murillo undoubtedly was well versed in Neoplatonic theories of ideal beauty, but he appears to have been driven less by abstract theoretical convictions than a practical commitment to drawing as a means of creating beautiful and expressive figures parallel to nature. In this process, Murillo's vision of corporeal beauty was also formed and guided by images from the world of art. Although there is no surviving evidence of his study of ancient sculpture, a collection of which existed in Seville in the Casa de Pilatos, this was a traditional source for the idealization of nude figures. Apart from paintings and prints, works from the local school of sculptors, such as Juan Martínez Montañés's *Christ of Clemency* (cat. no. 9, fig. 1), would also have been referents in Murillo's well-stocked visual memory. Murillo's figures are the result of an interplay between imagination, memory, and observation. Rather than being a self-conscious synthetic process, however, Murillo's drawings suggest that his selective idealization of figures was more intuitive, inherent in the very act of drawing, and something he refined through practice and experience.

In Murillo's *Self-Portrait* (cat. 33, fig. 2), painted around 1668, the artist chose to show himself flanked by the tools of his profession: on the right, there are brushes and a palette laid out with colors; on the other side is a sheet of paper with a red chalk study of a nude male figure drawn with the chalk holder that lies over it, while the scientific dimension of drawing is symbolized by a pair of dividers and a ruler. Murillo drew throughout his life, but it is not surprising that he should wish to underline the importance of drawing for his art in a self-image painted in the same decade as the establishment of the Seville drawing academy. The traditional twin foundations of painting—drawing and color— are here given equal status and Murillo's preparatory works—consisting of drawings on paper and oil sketches in color—show that his paintings are the result of the harmony of these two values. The forehead of the artist, the source of his artistic intelligence, is highlighted by strong light; he engages the viewer directly with his gaze; and his painting hand illusionistically projects beyond the fictional cartouche that frames his image. Murillo's own "living" likeness, therefore, testifies to the creative means of mind, eye, and hand which guaranteed his lasting fame.

Fig. 58. Juan Carreño de Miranda. NUDE CHRIST. *c. 1680. Black and red chalk, 16½ x 9″ (42 x 23 cm). Museo Nacional del Prado, Madrid*

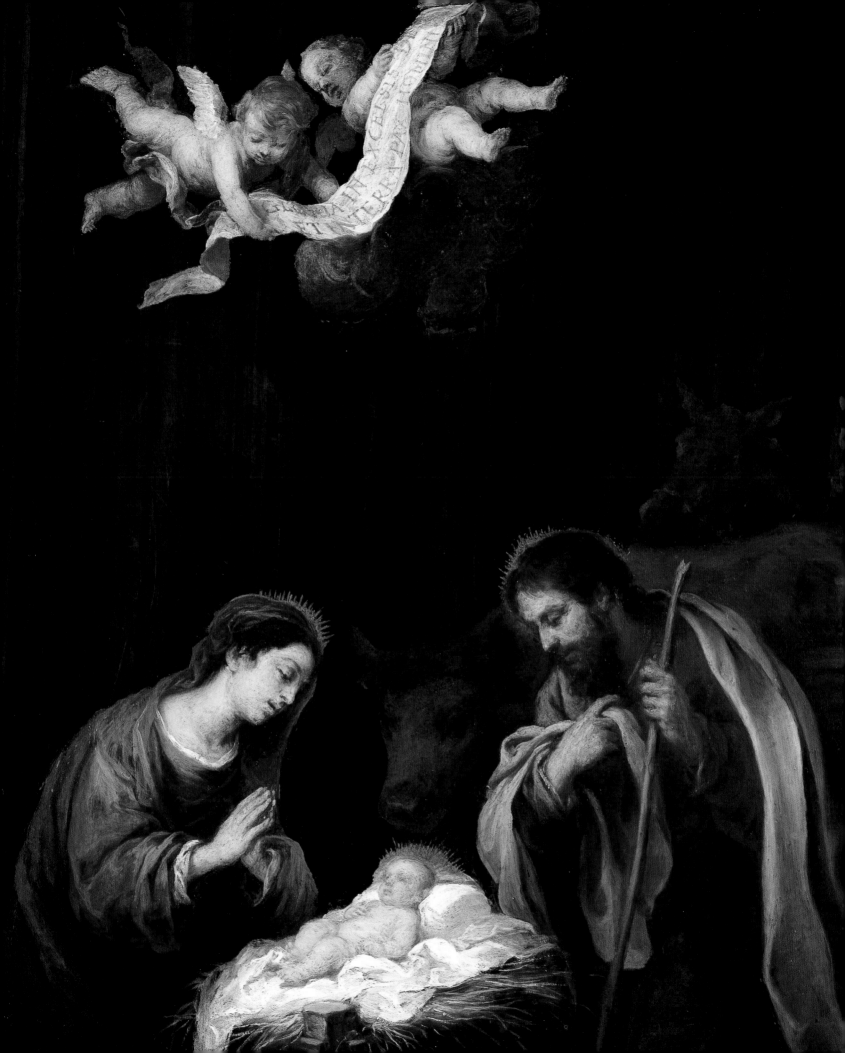

A Forgotten Legacy:
Murillo's Cabinet Pictures on Stone, Metal, and Wood

William B. Jordan

When Murillo's devoted patron Don Justino de Neve (fig. 17) lay on his deathbed in May 1685, he wanted to make a special gift to the Carthusian monastery at Seville, "in memory of the great affection and goodwill that I have for the said monastery."[1] What he chose was a small *Nativity* by Murillo that was described as painted on stone and set in a giltwood frame on which were carved three small angels. What is quite possibly that painting now belongs to the Museum of Fine Arts, Houston (cat. no. 20). It relates to others in the Neve collection itself and to a growing number of paintings that can be identified today, and from documents, that reflect an aspect of the artist's activity unsuspected only two decades ago: the painting of small cabinet pictures prized in their time, and for nearly two centuries afterward, by the most discriminating of collectors. We mean here to call attention to this facet, albeit a small one, of Murillo's *oeuvre* and to lay the groundwork for the almost certain discovery in the future of similar works, whose trail was only lost in the not-too-distant past.[2]

Detail of Catalogue No. 20. THE NATIVITY. *c. 1665—70. Oil on obsidian. 15 1/16 x 13 7/16 in. (38.3 x 34.2 cm)*
Museum of Fine Arts, Houston, The Rienzi Collection, Gift of Mr. and Mrs. Harris Masterson III

Ever since the sixteenth century, certain painters in Italy and northern Europe culti-
vated, alongside regular ecclesiastical commissions, the practice of making cabinet pic-
tures for the private devotion of well-to-do clients (fig. 59).[3] These differed from the
usual devotional paintings in that they were often quite small and, occasionally, not in a
rectangular format, thus calling attention to themselves as objects by their diminutive-
ness, their very shape, or both. Moreover, almost by definition, they were conceived as
little jewels that showcased the artist's technical skills as well as the precious materials of
which they were often made—the finest pigments applied to supports of pure copper,
tin or silver, various kinds of exotic stones, fine wood panels, or even glass—and whose
intrinsic value was often reflected in the luxury of their finely wrought frames. Such small
objects were valued highly—often the same as, or more than, vastly larger canvases by the
same painters. The general impression today is that Spanish painters did not widely par-
ticipate in this trend, yet Spanish inventories of the seventeenth century abound in ref-
erences to small, anonymous devotional images, usually on copper. No doubt, many of
these were imported from abroad, yet cabinet pictures on copper and other hard sup-
ports can now be identified by a surprising number of Spanish masters, including El
Greco, Sánchez Cotán, Maino, Caxés, Van der Hamen, Pereda, Ribera, Juan de Zurbarán,
Alonso Cano, Valdés Leal, Carreño de Miranda, Mateo Cerezo, Claudio Coello, and oth-
ers. But no painter of the Spanish golden age, it seems, was more given to this practice
than Murillo.[4]

Francisco Pacheco painted *The Baptism of Christ* and *Christ Fed by the Angels* on two slabs
of jasper in 1620 for Father Juan de Pineda, of the Colegio de San Hermenigildo, and
described later on how, in the manner of the Italians he was emulating, he adapted the
figures to the beautiful chance markings of the stone to suggest the landscapes and clouds.[5]
Proclaiming these, the first stones he painted, to be among the best things he had made
in his life, he went on to describe in detail just how to paint on jasper. Murillo and all the
painters of Seville knew Pacheco's published work, and probably these very jaspers, since
they were on public view, but they surely also knew in the collections of Seville other
examples of this kind of work, pictures like Jacopo Bassano's exquisite small *Adoration of
the Magi*, on jasper, in the collection of the Kimbell Art Museum, Fort Worth (fig. 60).[6]

In his monumental monograph and catalogue raisonné of Murillo's work, published
in 1981, Diego Angulo Iñiguez acknowledged the documentary evidence that Murillo
had painted on stone. Nevertheless, he failed to recognize that the *Nativity* mentioned
above (which he knew only from a photograph) was painted on stone and, thus, to con-
nect it to the pertinent documents.[7] He also, inexplicably, questioned the authenticity of
Murillo's two most beautiful works of this type, which had also belonged to Justino de
Neve. Angulo faithfully recorded all the inventory references known to him from Murillo's
time and shortly thereafter to works painted on what were described as *láminas*. In the
seventeenth century, as well as now, the word *lámina* was most commonly understood to
refer to paintings on metal plate, usually copper.[8] It was also occasionally used, with qual-
ification, to refer to paintings on other hard surfaces, such as when, in the Neve inven-
tory of 1685, six works on stone were called "*láminas de piedra*." It is not unthinkable that a
painting on wood panel could be called a *lámina*, but that was not the norm, and usually
such works were described as *tablas*. Nevertheless, Angulo's reluctance to believe that
Murillo painted on copper led him to assume that these references were to paintings on
wood, despite the weight of common usage to the contrary.[9] All eighteenth- and nine-
teenth-century literary and trade references to paintings on copper, as well as most of
those on marble, were relegated to the section of his catalogue reserved for disputable

works. Since these works were not known to him, of course, such caution was part of a commendable, and largely successful, effort to "purify" the artist's *oeuvre* of two centuries of uncritical inflation. This accomplished, however, the time has come to take a second look at some of these references. We are aided in doing this by the publication after Angulo's monograph of documents not known to him.

THE COLLECTIONS OF JUSTINO DE NEVE AND NICOLÁS OMAZUR: DOCUMENTED CABINET PICTURES ON VARIOUS HARD SUPPORTS

Justino de Neve and Nicolás Omazur stand out among all of Murillo's patrons—the first as the Maecenas of the decoration of the church of Santa María la Blanca (in 1665) and among the artist's lifelong best friends, and the second as the great friend and collector who assembled the largest private collection of the artist's paintings in the seventeenth century. Neve, who became a canon of the cathedral in 1658 and founded the Hospital de los Venerables Sacerdotes in 1671, was from a family of rich Flemish merchants who had made their fortune in trade with the Indies. When the artist died in 1682, Neve was named an executor of his estate. At the time of Neve's own death, three years later, he possessed a collection numbering some 160 paintings, among which twenty-four were described as *láminas* painted on stone or metal.[10] Omazur was a wealthy silk merchant born in Antwerp. By the time of his death in Seville in 1698, he owned 228 paintings, among them many Dutch and Flemish works he had brought with him to Spain. Included in the collection were thirty-one originals by Murillo (and an additional seven that were described as copies after him), a number surpassed today only by the Museo del Prado. He also had formed the first known collection of the artist's drawings. Among Murillo's paintings owned by Omazur were several purchased from the estate of Justino de Neve in 1685, and no fewer than seven of these were small cabinet pictures on stone and metal, some of which can be identified today.[11]

The first two are a pair of paintings described in Omazur's inventory as being painted on black jasper—*Agony in the Garden* (fig. 62) and *The Penitent Saint Peter Kneeling before Christ at the Column* (fig. 63), both in "wide, swooping, carved giltwood frames."[12] In the Neve inventory, these had been described simply as being "láminas de piedra" and were valued at 400 *reales* each.[13] As Murillo's fame was already spreading to the north of Europe by the time of Omazur's death, it did not take long for these extraordinary paintings to be taken abroad. They were acquired by the conde de Fraula (1646–1738), director of the domains and finances of the Spanish Netherlands. Upon his death, they were bought by Clement Augustus of Bavaria, Elector of Cologne, at whose sale in Bonn in 1764 they were attributed to Abraham Jansz. Van Diepenbeeck.[14] There they were bought by the Paris dealer Neveu, who knew what they really were, and auctioned them again in Paris seven months later, as Murillos.[15] They were purchased by the comte de Vaudreuil, one of the great French collectors of his time, and at his estate sale in 1784 they were acquired by Lebrun for King Louis XVI. The following year they were placed on view in the Pavillon Neuf of the Louvre, where they have remained ever since.[16]

It is difficult to fathom today why scholars such as Curtis[17] and Mayer[18] failed to recognize the hand of Murillo in these works, seeing instead that of the artist's disciple Francisco Meneses Osorio, an imitator of his style and sometime copyist of his work.[19] Stranger still is the failure of Angulo, who discovered the inventory of Justino de Neve, in which Meneses Osorio himself was the appraiser, helped by two other artists. This team unequivocally appraised the paintings as originals by Murillo and valued them more highly than some of his canvases. Such myopia has not gone unchallenged, however. Jonathan Brown

Fig. 60. Jacopo Bassano. THE ADORATION OF THE MAGI. *After 1555. Oil on jasper, 7¼ x 5½″ (18.4 x 14 cm). Kimbell Art Museum, Fort Worth. Bequest of Hedy María Allen, New York*

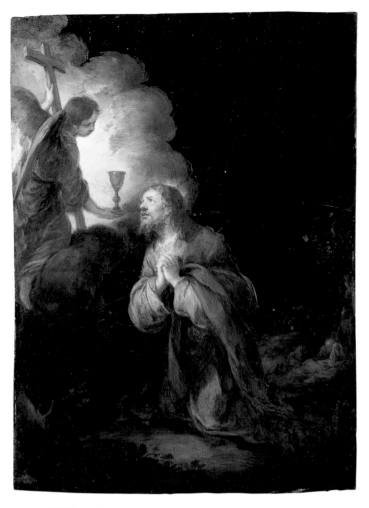

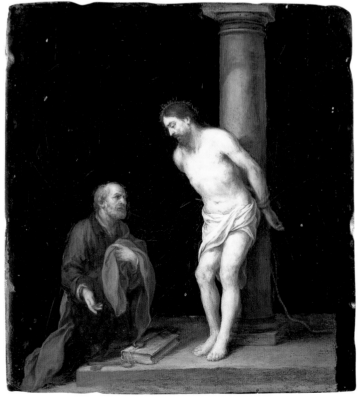

Above: *Fig. 61. Unpolished back side of the block of obsidian used for* AGONY IN THE GARDEN (*fig. 62*), *with chips, in places, showing what the polished side looked like before the artist painted on it*

Right, top: *Fig. 62. Bartolomé Esteban Murillo.* AGONY IN THE GARDEN. *c. 1665—70. Oil on obsidian, 14 x 10¼″ (35.7 x 26.3 cm). Musée du Louvre, Paris*

Right: *Fig. 63. Bartolomé Esteban Murillo.* PENITENT SAINT PETER KNEELING BEFORE CHRIST AT THE COLUMN. *c. 1665—70. Oil on obsidian, 13¼ x 12⅛″ (33.7 x 30.7 cm). Musée du Louvre, Paris*

was the first modern scholar to defend the attribution;[20] Claudie Ressort and Olivier Meslay of the Louvre,[21] and Duncan Kinkead,[22] have also done so in vigorous terms. Perhaps the reason for the failure to appreciate these paintings lies in the failure, first, to understand the extent to which the greatest Spanish painters were eager to embrace trends common elsewhere in Europe and to make them their own, as well as the great sophistication of many Spanish collectors, who knew far more about other schools of painting and patterns of collecting than most foreign *cognoscenti* knew about the Spanish.

The recent cleaning and analysis of these paintings by the Louvre has been revelatory.[23] First, and most important, they are not painted on black jasper, as Nicolás Omazur's inventory had maintained, nor on black marble, as most later writers had said. They are painted on the rarest of supports—obsidian (fig. 61). Although this black volcanic glass can be found in scattered Mediterranean locations, the most abundant and likely source for a painter in Seville was Central America, where Murillo's son Gabriel had gone to live and where Justino de Neve's family had made their fortune in trade. There, for centuries, the Aztecs had cut and polished it into mirrors and precious cult objects. Indeed, Olivier Meslay has proposed that the obsidian slabs used by Murillo were in fact objects of pre-Columbian origin known as "smoking mirrors," several examples of which are preserved in the Musée de l'Homme, Paris.[24] Quite possibly, as in the case of Pacheco's paintings on jasper, the stones for which had been found by Father Pineda and given to him to paint on, Neve himself gave these stones to Murillo to be made into devotional images. It is a pity that the frames, which seem to have been especially opulent and baroque in their form, did not survive French Neoclassical taste.

In both of these paintings, Murillo used the gleaming black surface of the polished obsidian, which has been left in reserve around the figures and the suggestions of architecture and landscape, to give a sense of depth to the surrounding space. Yet the light reflecting off this shiny, vitreous surface simultaneously underscores its flatness. Murillo has not tried to rein in the breadth of his brush strokes, as though he were, contrary to his nature, a miniaturist. Instead, while definitely more controlling of his brush than in his very spontaneous oil sketches, he has modeled the forms with the same vigorous and energetic brushwork that we can see in his large-scale finished compositions of the mid- to late 1660s.[25] It is perhaps the sensuousness of his open brushwork in contrast to the polished smoothness of the backgrounds, lending a certain artificial quality to both these works, that may have confounded the perception of early scholars seeking to relate them to any others they knew by the artist.

While Angulo knew and published a photograph of a small *Nativity* once belonging to the Sabin Galleries in London, he did not know that this painting, too, was executed on a stone support.[26] Recently bequeathed to the Museum of Fine Arts, Houston, by a local collector who had purchased it in London in the 1950s, this painting (fig. 64; see also cat. no. 20), it turns out, is executed on a similar, though slightly larger, slab of obsidian, whose back side closely resembles the pair in Paris (see cat. no. 20, fig. 1).[27] As in the Louvre's paintings, Murillo left a large portion of the polished obsidian surface in reserve around the figures and landscape, but at an undetermined date—probably at the turn of the twentieth century, when the work was sold in Paris—the bare stone was overpainted in Murillo's manner to suggest a more conventional sky. Thus Angulo, who knew only a photograph of the picture in this repainted state, had no reason to suspect that it was not a small work on canvas and, notwithstanding the caveat that he had not actually seen the picture, he was inclined to accept it as autograph. In the light of what we now know, it seems more than likely that this is the painting that Justino de Neve bequeathed to the Carthusian

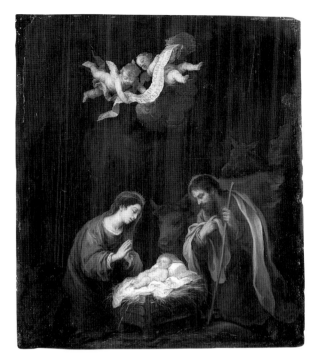

Fig. 64. Bartolomé Esteban Murillo. THE NATIVITY *(cat. no. 20). c. 1665–70. Oil on obsidian, 15⅛ x 13½″ (38.3 x 34.2 cm). Museum of Fine Arts, Houston, The Rienzi Collection, gift of Mr. and Mrs. Harris Masterson III*

Monastery of Seville in 1685—minus, alas, what must have been a spectacular giltwood frame, in which the two putti in the painting's sky were complemented by three others that were carved around the top and sides of the frame.[28]

In addition to the three works on obsidian, Justino de Neve apparently also owned several other Murillo cabinet pictures on copper. Although they were not attributed in his inventory, they were valued highly. Some of them were bought by Omazur after Neve's death, and in both of his inventories they are described as originals by Murillo. Two of them were a pair of octagonal pictures, said to measure approximately ½ *vara* [42 centimeters, which may have included the frames], described as a *Pietà* [or *Descent from the Cross*] and a *Virgin and Child with Saint John*, each in a silvergilt frame with corner pieces of gilt bronze [or brass] cherubs' heads.[29] Both of these paintings may have reached England during or following the upheavals of the Peninsular War.[30] A picture that could have been Omazur's *Pietà*, a copper octagon, 13 by 13 inches, was auctioned in London on April 15, 1813, as part of a group of fifty cabinet pictures said to come from the collection of Queen María Luisa in the Palace of the Buen Retiro in Madrid, captured in the vicinity of Vitoria from fleeing French forces who were taking them to the Louvre, and sent to auction by the captain of the guerilla forces of Navarra.[31] The painting fetched £63, one of the higher prices in the sale.[32] Acquired by H. A. J. Munro, son of a former British consul in Madrid, it was last recorded when bought, for £110 5s., in his sale at Christie's in 1878 by a bidder identified only as Fraser. The painting may still exist in a British collection today.[33]

The small, octagonal *Virgin and Child with Saint John* on copper that was paired with the *Pietà* in the Neve collection is very likely the picture of that size and description in the Lansdowne collection, at Bowood (fig. 65). The painting is really a *Holy Family with the Infant Saint John*. In light of this, it is noteworthy that Kinkead, who did not connect the inventory entry to the Bowood picture, mistranscribed the reference to it as a "Virgin and Child and Saint Joseph," whereas the original document clearly reads "Virgin and Child and Saint John" ("nuestra señora el niño y san Joan").[34] The fact that the Neve inventory lists only three of the four is typical of its sketchy treatment of such details (especially compared to Omazur's).[35] Angulo, who had not actually seen the painting and did not note that it was painted on copper, published a badly cropped photograph of it and was inclined to accept it as autograph.[36] Having recently examined the painting at firsthand, there is absolutely no doubt in my mind that it is a fully autograph work by Murillo painted around 1670, although it is badly in need of restoration, having suffered some abrasion in the figures and flake-loss in the darker areas.

The Lansdowne *Holy Family with the Infant Saint John* arrived in England in the summer of 1809 with the return of Lord and Lady Holland from their second sojourn in Spain.[37] Inscribed on the back of the copper is: "Painted by Murillo and given to me by Sr. G. M. Jovellanos at Cadiz. 1809. H. Holland."[38] This provenance is confirmed by a touching series of letters from the great Spanish statesman and collector, now sidelined by the intrusive French régime, to his friend Henry Holland: "the original little picture by Murillo [elsewhere: '*Virgencita de Murillo*'] that I sent for from Gijón for you is the only true original that I have by that artist. I wish I were the owner of the *Death of Saint Clare* or some of the other famous works by the author, but I offer what I have and [what I] can, so that you do not lack a legitimate piece by his gracious hand."[39] In another letter, he apologizes: "I should wish that the picture were of another subject for the finicky [collectors] of London, but I didn't have another."[40] Ten years later, in the first published monograph on Murillo, Captain Edward Davies, who had made a study of the painter's works while in Spain, praises Jovellanos's connoisseurship by referring to the picture at Holland House:

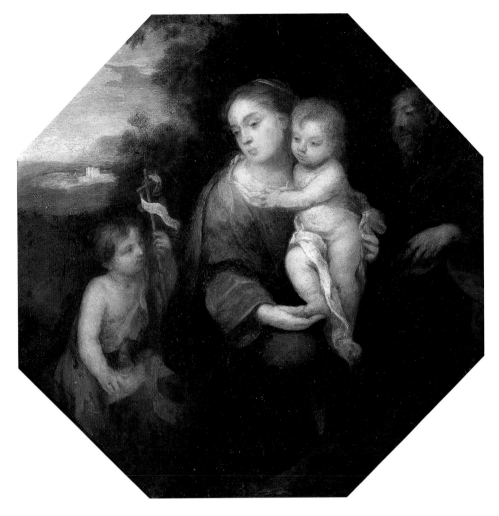

Fig. 65. Bartolomé Esteban Murillo. HOLY FAMILY WITH THE INFANT SAINT JOHN. *c. 1670. Oil on copper, 13 ½ x 13 ½" (34.3 x 34.3 cm). Lansdowne collection, Bowood, Wiltshire*

"An exquisite monument of his taste is in the possession of my Lord Holland, a small Virgin and Child by Murillo."[41]

A third octagonal copper attributed to Murillo, also measuring 13 ½ by 13 ½ inches (34.3 by 34.3 cm), was an *Assumption of the Virgin* once in the collection of the earl of Northbrook.[42] Curtis described it as representing the Virgin upborne on clouds, with the twelve apostles and two Marys surrounding the open tomb.[43] Also described by Stirling[44] and Waagen,[45] it was lent to the British Institution in 1840 by the previous owner, Sir Thomas Baring.[46]

In addition to the octagonal coppers by Murillo in the Neve and Omazur collections, there were four other small pictures described as *laminitas redondas*, or small roundels, that were probably also on copper.[47] Two of them, circular in format, formed a pair representing the Sainted King Ferdinand and Saint Hermengild.[48] The other two formed a slightly larger pair, apparently oval in shape, representing Saint Joseph and Saint Anne.[49] No further trace of these is known.

Other cabinet pictures on copper or on panel are documented as belonging to close relatives of Murillo's in the years following his death. Few, if any, of these can be associated with pictures known today, but there are tantalizing convergences between these descriptions and works known later to have existed. Especially important are the nine *láminas*, described as originals by Murillo, that were recorded in the possession of the artist's son Gaspar at his death in 1709.[50] We may never be able to know such pictures as the two *láminas* of Jacob's Dream and the Dream of Joseph, which were among those that

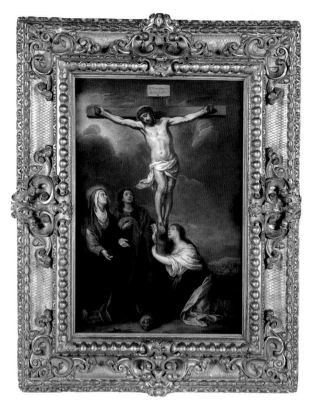

Gaspar owned,[51] but the few cabinet pictures on copper and panel that do exist should make us wish that one day we might.

OTHER EXTANT CABINET PICTURES

Probably one of the first Murillos to leave Spain is the *Christ on the Cross with the Virgin, Saint John, and Mary Magdalene*, in the Meadows Museum, Dallas (cat. no. 21), which is said to have been taken to Flanders in the seventeenth century by the marqués de Rodríguez d'Evora y Vega, who married into the family of the counts of Steenhuyse, in whose possession it remained until being auctioned in Paris in 1860.[52] Partially compensating for the relatively poor condition of this work is the fact that it is the only one of Murillo's cabinet pictures that retains its original frame, one of the most beautiful and finely wrought frames of the Spanish Baroque (fig. 66). A giltwood, reverse-profile molding with complex volutes accentuating the centers and corners, it recalls the opulent decorative vocabulary of the parish church of Santa María la Blanca, for which Murillo had completed a series of important canvases for Justino de Neve by 1665. The painting's style, too, seems to conform to this date, although it has been dated as late as the 1670s.[53] Despite its small size and somewhat abraded condition, the figures still project great emotional force.

An exquisite and highly developed drawing for the figure of Christ belonged to the late Sir Brinsley Ford (see fig. 50), demonstrating that as much thought and preparation might go into a cabinet picture as into the largest altarpiece. The expressive face and eloquent gesture of the Virgin, as well as those of Saint John and the Magdalene, contribute to a heightened emotional impact. The figure of Christ, and the definition of his loincloth, present obvious parallels to the figure of Christ in Justino de Neve's *Penitent Saint Peter Kneeling before Christ at the Column* (fig. 63), which must have been painted around the same time. The golden drapery around the Magdalene's legs in the Meadows painting, one of the better-preserved parts of the picture, is also especially close in its handling to the mantle of Saint Peter in the Louvre painting, further suggesting the proximity in date of the two works. The way in which Saint John, in the Meadows painting, holds his red drapery to his breast and gestures with the other hand is similar to the way in which Saint Peter, in the Louvre painting, does the same thing. And Saint Peter's blue robe is rendered in a notably similar way to the blue mantle of the Virgin in the Meadows work, now that that part of the painting can be seen after the removal of the overpainting that had previously obscured it.

Angulo, who attributed the Meadows picture to a disciple of Murillo, knew the painting before its recent cleaning, when thick and extensive—though extraordinarily skillful—repainting completely obscured all signs of damage but covered up large areas of original paint in the process. This may not entirely explain his reluctance to accept a work on copper as an original by the artist, but it establishes that he was not looking at what we are seeing today.

In addition to being painted on copper or stone, extremely small devotional images were also painted on wood panel. In 1660 Juan de Valdés Leal signed a pair of such tiny works—*The Marriage at Cana* and *Christ in the House of Simon* (Musée du Louvre, Paris)—which, despite his very free and broad manner of painting, valiantly depict a multitude of small figures in expansive architectural settings.[54] Murillo's loveliest work of this type, the tiny *Holy Family in the Carpenter's Shop*, in the Hermitage (fig. 67), has been wrongly called a sketch by Angulo, who followed in this the view of earlier writers. But as Ludmila Kagané has cogently argued, despite its small size it is a completely finished work of around

1660–65 that postdates by many years the two large-scale versions of the subject, in Dublin and The Hague, whose compositions differ in many details.[55] Arriving in France in the eighteenth century, this little jewel belonged to the duc de Tallard, at Besançon, who also owned a pair of coppers attributed to Murillo, an *Ecce Homo* and a *Mater Dolorosa*.[56] At the auction of Tallard's collection following his death in 1756, where the painting was bought by L. A. Crozat, the baron de Thiers, for the huge sum of 802 *livres*, it was described in these terms: "Ce morceau est d'un grand fini. Il est peint sur bois. . . ." A handwritten note in the margin states: "C'est le plus joli morceau du monde. Il est vigoureux de couleur et tout esprit. . . . Quand il sera remis en état, ce que ne sera pas difficile, on m'en dira des nouvelles."[57] It is obvious from this that the panel had deteriorated and the painting was in need of restoration in 1756. No doubt at that point, the paint layer, with the priming intact, was transferred from the original panel to a new oak panel, a technique pioneered by the French. This sequence of events is confirmed by the presence of Crozat's wax seal on the back of the replacement panel today.[58] In 1771 Crozat's collection, including this work, was bought by Catherine the Great. It is, indeed, not hard to imagine how, in the time of Chardin and the young Jean-Baptiste Greuze, a work such as this by a seventeenth-century painter could have been so highly prized.

Small works by Murillo on panel are extremely rare; thus, a recently discovered *Christ at the Column* (fig. 68; see also cat. no. 11), of a scale and facture similar to those of the Hermitage *Holy Family*, is a welcome addition to his *oeuvre*. In this tiny composition bathed in a silvery light, the serene figure of Christ, his arms tied behind him, stands before a truncated column in passive meditation on his fate. The anatomy of his body is vividly modeled in light and shade, with the same sensuous impasto seen in the Russian panel. Especially striking is the way in which, in both of these works, the folds of the white drapery—the loincloth of Christ as well as the sewing in the Virgin's lap—have been modeled by the confident manipulation of a small stiff brush through the thick white paint. Having appeared not long ago on the London auction market, nothing for sure is known as yet of its provenance.[59] Nevertheless, it should be noted that a small *Christ at the Column*, ½ *vara* high and in a frame that had not yet been gilded, was recorded in Murillo's studio when he died in 1682. Although it was simply called *"un quadro de Xpto a la coluna,"* without specifying whether it was on panel or canvas, we cannot rule out that it might have been this picture.[60]

To judge from the number of eighteenth- and nineteenth-century literary and sale references to small coppers attributed to Murillo representing the Immaculate Conception of the Virgin, this subject must have been the most popular one among his cabinet pictures—hardly surprising, since this was his most popular subject in general.[61] Furthermore, there is evidence that Murillo may have executed at least one *Immaculate Conception* on obsidian, similar to the works that belonged to Justino de Neve.[62] Although, to be sure, not all the paintings recorded by these references were actually by Murillo, an extremely beautiful *Immaculate* on copper is known today that gives us a good idea of what those that were looked like.

The proliferation of images of the Immaculate Conception in Spain after 1661 corresponded with the issuance in that year by Pope Alexander VII of the papal bull *Sollicitudo omnium ecclesiarum*, which legitimized the cult, and his authorization in December 1664 of the celebration of the Office and Mass of the Immaculate Conception in Spain.[63] It is not surprising that many of these images were made for private devotion in a society whose zeal for the cult was the primary source of pressure on the Vatican to approve it.

Opposite, top: *Fig. 66. Bartolomé Esteban Murillo.* CHRIST ON THE CROSS WITH THE VIRGIN, SAINT JOHN, AND MARY MAGDALENE *(cat. no. 21), in its original frame. c. 1665–70. Oil on copper, 24 x 16½" (60.8 x 42.1 cm). Algur H. Meadows Collection, Meadows Museum, Southern Methodist University, Dallas*

Opposite, bottom: *Fig. 67. Bartolomé Esteban Murillo.* HOLY FAMILY IN THE CARPENTER'S SHOP. *c. 1660–65. Oil on panel, 9¼ x 7" (23.8 x 18 cm). The State Hermitage Museum, Saint Petersburg*

Above: *Fig. 68. Bartolomé Esteban Murillo.* CHRIST AT THE COLUMN *(cat. no. 11). c. 1660–65. Oil on panel, 12⅜ x 6" (31.5 x 15.2 cm). Private collection*

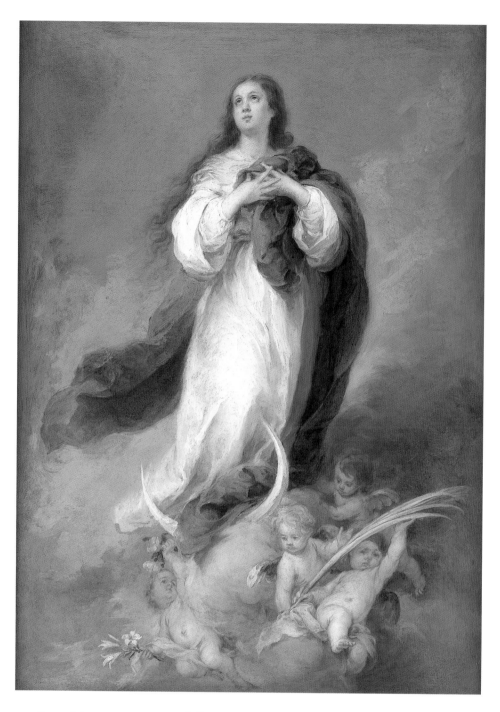

One of the most exquisite of all Murillo's *Immaculates* is a small, very late painting on copper, in the Arango collection, Madrid (fig. 69), which was only discovered in 1985.[64] In 1724 Antonio Palomino, meaning to single out the principal works by Murillo known to him, referred to a small *Immaculate Conception* on copper in the prior's cell of the Carthusian monastery at Granada, calling it "*cosa maravillosa.*"[65] Notice of this little picture was also published in Paris in 1745 and 1762 in d'Argenville's paraphrase of Palomino.[66] By 1788 a copper of identical size and subject had been acquired by the crown prince, the future Carlos IV, for his collection of cabinet pictures at the Casita del Príncipe at El Escorial.[67] Whether these two references to *Immaculate Conceptions* on copper by Murillo could have concerned the same work is impossible to know at present, but either could be the painting in the Arango collection.[68]

Because of its very spirited execution, Alfonso Pérez Sánchez has written that this picture might have been an oil sketch or *modello* by the master that served as a point of departure for studio replicas.[69] Although there is, indeed, a large-scale studio work that follows the composition almost exactly (fig. 70), and another that follows it in part, this was probably not an oil sketch.[70] The painting of oil sketches on canvas was a standard part of Murillo's preparation for major large-scale works; a tiny *Immaculate Conception* in the Louvre is one of these (see fig. 32). Its broad technique and summary modeling are characteristic of the sketches. In this copper *Immaculate*, on the contrary, the fluidity of touch is a factor of Murillo's late style. Its nervous brush strokes are aptly related by Pérez Sánchez to the vibrant drawings of the artist's last years. But in its exquisite balance of spontaneity and finish it differs from the sketches.

While this little picture no doubt inspired large-scale versions by followers of Murillo, internal evidence suggests that it was not itself derived from any known large version. Quite visible *pentimenti* in the blue drapery, on both the left and the right sides, confirm that the artist decided to lengthen the fluttering mantle on the left and to widen the figure's profile on the right after he had nearly finished the painting. These changes were incorporated from the outset in both paintings that derive from it. Therefore it is clear that, despite its small size, this copper is a prime version and should be ranked among the best of Murillo's *Immaculates*, a finished work in itself meant to highlight, as only a work on copper can do, the deftness of the master's touch.

The ravenous appetite of foreign collectors for works by Murillo led the conde de Floridablanca to decree on October 5, 1779, on orders from King Carlos III, an absolute embargo on the exportation of his works from Spain.[71] But, as with modern-day laws of this type, the one-way flow did not stop. By 1806 Ceán Bermúdez would write:

> Very few works by Murillo remain in private hands, at the present day, in this city; while, at the beginning of the last century, there was scarcely a reputable house in Seville in which some picture by his hand was not to be found. When the Court of Philip the Fifth was here, they began to disappear; some were made presents of to the Grandees (Magnates), and others sold to Ambassadors and other Noblemen; which at this time are the ornament of the collections at Madrid and other Courts of Europe.[72]

By the end of the war with the French, the situation described by Ceán had worsened considerably, for even the masterpieces that were in private hands in Madrid ten years earlier had mostly gone abroad. Works by Murillo began leaving Spain not long after the artist's death—first to Flanders and Germany, and not long afterward to France and then to England. After the French Revolution, London clearly became the principal market for his paintings. And all this happened at a time when the vogue for cabinet pictures among collectors was at its peak. No wonder that there were hardly any left in Spain. And no wonder that many of those offered on the foreign market at the time were probably imitations painted to address this market.

We have only begun in recent decades to retrieve an understanding of the patterns of collecting in seventeenth-century Spain, and the ways they affected what artists painted. As the effort continues, it will be well to remember these small works by Murillo, four of which are now located in American collections.

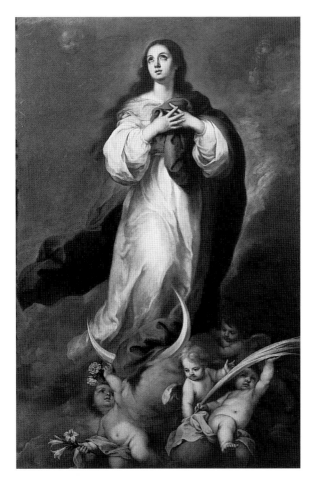

Fig. 70. Follower of Bartolomé Esteban Murillo. Virgin of the Immaculate Conception. *Oil on canvas, 65 x 43¾″ (165 x 111 cm). Formerly the Oscar Cintas Foundation*

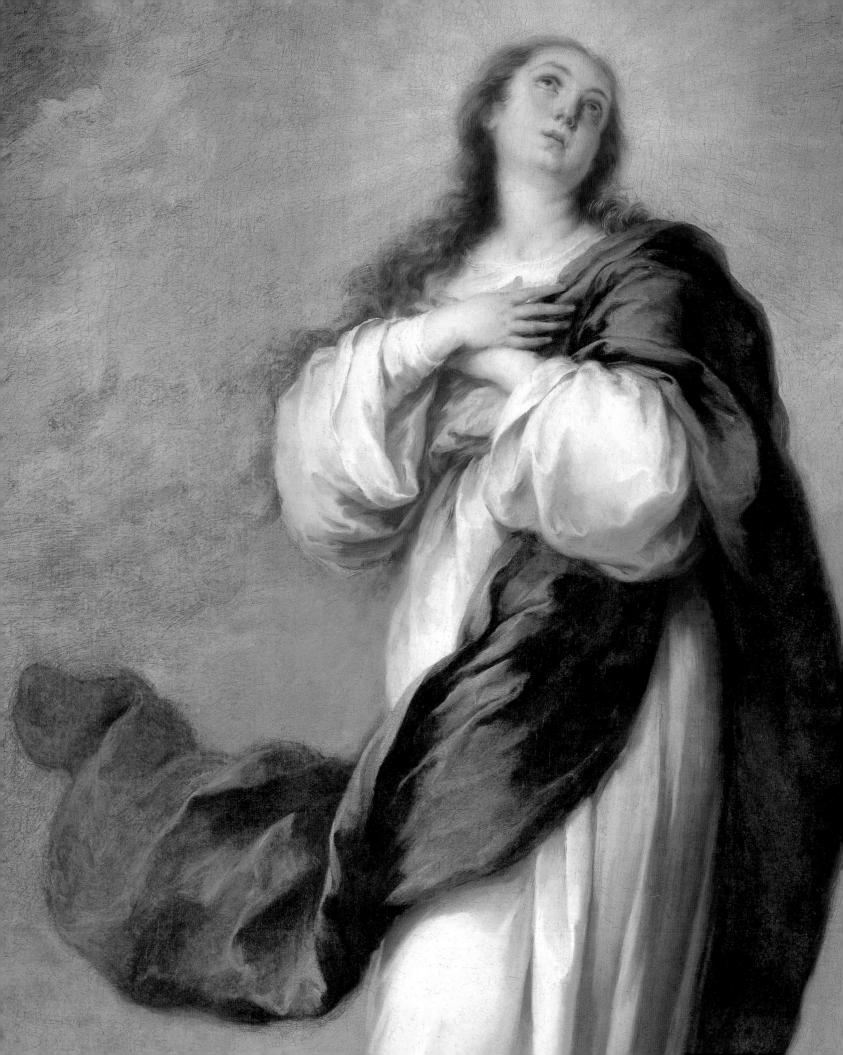

LOOKING AT MURILLO'S TECHNIQUE

Claire Barry

Murillo's achievements were once thought to rival those of Titian and Van Dyck, yet until recently his painting technique has been overlooked.[1] The declining enthusiasm for Murillo's religious paintings in the twentieth century corresponds to the relatively few articles devoted to his working methods, while Velázquez's technique, along with the greater acceptance of his work, has inspired greater interest in the same period.[2] Examination of Murillo's painting practices is complicated by the fact that few of his works are signed or dated, and some details of his early life and travels remain a matter of conjecture.

The publication of art treatises in Spain during the seventeenth and early eighteenth centuries attests to the serious interest in the study of painting practices in Murillo's time. Spanish treatises echoed many of the ideals of the Italian academic tradition, and offered practical information on the art of painting.

The Italian-born Spanish painter Vicencio Carducho published *Diálogos de la pintura* in Madrid in 1633. This largely theoretical treatise is based on a series of "dialogues" between a hypothetical master and pupil that argue for granting professional status to

Detail of Catalogue No. 28. VIRGIN OF THE IMMACULATE CONCEPTION. *c. 1680. Oil on canvas. 86¾ x 50¼ in. (220.5 x 127.5 cm). The Cleveland Museum of Art, Leonard C. Hanna, Jr. Fund 59.189*

the artist. Carducho also attempted to establish a painting academy in Madrid modeled after Italian prototypes.[3] Pacheco, a painter who taught Velázquez and Alonso Cano, wrote the most important art treatise of the seventeenth century in Seville, *Arte de la pintura*, published in 1649. The anonymous *Tractado del arte de la pintura*, published around 1656, discusses the practice of oil painting, including the organization of the studio and a list of technical terms. Palomino's *El museo pictórico y Escala óptica*, which appeared in Madrid in 1715, was intended as a practical guide to painting. In spite of its late date, Palomino's treatise has a retrospective tendency and perhaps provides a more accurate account of seventeenth-century painting practices than does Pacheco's treatise.

While Pacheco's *El Arte de la Pintura* provides a nearly contemporary reference for understanding some of the methods and materials available to Murillo, and the theories of artistic practice current in his lifetime, it is not completely reliable. By the time it was published in the 1640s, many of Pacheco's ideas were probably out of date. Moreover, he inflated his account of Spanish painting practice by adding to the pigments discussed colors mentioned by Pliny and Vitruvius,[4] and he placed a misleading emphasis on Italian, rather than northern, materials and techniques.[5] As Véliz has observed, "Pacheco's treatise was a kind of propaganda piece for his ideal of the erudite painter, and this humanistic bent may have influenced him to emphasize the use of those techniques or materials that agreed with his ideal, while omitting others because of their less noble nature."[6]

The present study hopes to shed light on Murillo's working methods by examining evidence presented in the paintings themselves, relating that evidence to techniques described in contemporary treatises where applicable. The cleaning of six paintings by Murillo at the Kimbell Art Museum, including: *The Virgin of the Immaculate Conception*, c. 1655–60 (cat. no. 8), *Saint Justa* and *Saint Rufina*, c. 1665 (cat. nos. 15 and 16), the *Nativity*, c. 1665–70 (cat. no. 20), *Christ on the Cross with the Virgin, Saint John, and Mary Magdalene*, c. 1665–70 (cat. no. 21), and *Four Figures on a Step*, c. 1655–60 (cat. no. 31), provided for the first time an opportunity for an in-depth examination of several of the artist's important works executed on a variety of supports. The planning of *Bartolomé Esteban Murillo (1617–1682): Paintings from American Collections* allowed for the expansion of the study to include technical examination of additional examples of the artist's work. These paintings include: *Saint John the Baptist Pointing to Christ*, c. 1655 (cat. no. 6), *The Adoration of the Magi*, c. 1655–60 (cat. no. 7), *Jacob Laying the Peeled Rods before the Flocks of Laban*, c. 1665 (cat. no. 13), *The Return of the Prodigal Son*, 1667–70 (cat. no. 18), *Ecce Homo*, c. 1675 (cat. no. 27), *The Virgin of the Immaculate Conception*, c. 1680 (cat. no. 28), *The Mystic Marriage of Saint Catherine*, 1680–82 (cat. no. 30), *Two Women at a Window*, c. 1655–60 (cat. no. 32); and *Self-Portrait*, c. 1655–60 (cat. no. 33).

Sixteen paintings from American collections were studied in all, including devotional as well as genre paintings and a variety of supports and sizes. Whenever possible, the paintings were examined with the aid of the stereomicroscope and X-radiography. Cross sections from six paintings were also analyzed.[7] The present study is indebted to the recent scholarship into seventeenth-century Spanish painting techniques by Jonathan Brown, Carmen Garrido, Gridley McKim-Smith, Zahira Véliz, and others. It also hopes to expand upon Hubert von Sonnenburg's 1982 technical study of the five genre paintings in Munich, Ana Sánchez-Lassa de los Santos's recent examination of *Saint Peter* in Bilbao, and unpublished manuscripts by Victoria Leanse and Gwendolyn Fife. While it is beyond the scope of this examination to provide a comprehensive analysis of Murillo's technique, it is our hope to contribute to a topic deserving further attention as the artist's paintings are reassessed through exhibitions such as this.[8]

THE MATERIALS OF PAINTING
SUPPORTS

Murillo realized the greatest number of his paintings on canvas, although he also worked on panels of copper, wood, and stone. Canvas was the support of choice for seventeenth-century Sevillian painters. The ease of stretching, enlarging, and transporting the fabric made it especially practical for large commissions. In contrast to what is found in Velázquez's work, the texture of the canvas support played a minimal role in Murillo's paintings.[9] Murillo's choices of support seem to be based on practical considerations related to the size and type of painting rather than on purely aesthetic ones.

For large, horizontal compositions, including those from the Jacob series (*Jacob Laying the Peeled Rods before the Flocks of Laban* and *Laban Searching for His Household Gods in Rachel's Tent*, cat. nos. 13 and 14), as well as for *The Return of the Prodigal Son* (cat. no. 18), Murillo joined separate widths of fabric with horizontal seams using a moderately coarse *taffeta* weft, a simple plain-weave canvas.[10] The artist arranged his compositions according to the size of the canvas panels, placing the major figures below and background areas above the lowest horizontal seam. In one instance, Murillo appears to have pieced a canvas together for reasons of economy. This is in a small painting apparently for personal use, the modest *Self-Portrait* (cat. no. 33), in which a horizontal seam appears beneath the edge of the painted oval frame.[11]

The standard widths of the *taffeta* canvas that Murillo used in oversized compositions suggest that the size of the loom measured a little over one meter (approximately 44–45 inches).[12] This dimension corresponds to the canvas width von Sonnenburg found in *Three Boys Playing Dice* (fig. 21), where the original selvedges were preserved.[13] This loom size must have been widely used throughout Italy and Spain, because similar widths appear in works by Tintoretto and Velázquez, among others.[14]

Although all of the canvases examined for this exhibition had been relined, several of the weaves could be identified with the help of X-radiography or raking light. There appears to be a direct correspondence between the type of canvas used and the scale of the painting. Not surprisingly, the smallest canvas, the late oil study *The Mystic Marriage of Saint Catherine* (fig. 71), had the finest weave. Murillo used a plain weave *taffeta* canvas, somewhat coarse and unevenly spun, in a single width on four modest-sized paintings: two genre paintings, *Two Women at a Window* (cat. no. 32) and *Four Figures on a Step* (cat. no. 31), both dated 1655–60; and a pair of devotional works, *Saint Justa* and *Saint Rufina*, c. 1665 (cat. nos. 15 and 16).[15] The *taffeta* weave was probably the most commonly used in Seville and throughout Europe in the seventeenth century; Velázquez employed it prior to 1623, when he left for Madrid.[16]

For three large devotional paintings, Murillo used more expensive and refined twill weave canvases, suggesting that he adopted a higher quality support for important commissions, particularly those that depicted the Virgin or Christ.[17] The large loom size of the twill weave must also have suited the oversized vertical formats of these works. *Saint John the Baptist Pointing to Christ*, c. 1655 (cat. no. 6), *Virgin of the Immaculate Conception*, c. 1655–60 (figs. 91 and 92), and *Virgin of the Immaculate Conception*, c. 1680 (cat. no. 28) are all painted on twill canvases. Like Velázquez, who used patterned canvas supports in his early Seville period for paintings of iconographical importance, Murillo seems to have used precious patterned canvases for his Immaculate Conceptions and other images of Mary.[18] The *Immaculate Conception* paintings in both Saint Petersburg (State Hermitage Museum) and in Melbourne (National Gallery of Victoria) exhibit patterned damask weaves.[19]

Fig. 71. Detail of X-radiograph of MYSTIC MARRIAGE OF SAINT CATHERINE *(cat. no. 30), showing the fine canvas weave used for the oil study.*

Murillo experimented with a variety of unusual and precious materials for portable small-scale devotional panels. The different aesthetic qualities offered by wood, copper, and stone supports seem to have directly influenced Murillo's choices. Unlike his work on canvas, the physical properties of these panels played a direct role in the surfaces of these paintings. The artist's use of a wood panel in the *Ecce Homo* (cat. no. 27) seems somewhat unusual in this work, since wood was more frequently used in sixteenth-century Spanish painting.[20] Its use recalls that of Luis de Morales, a sixteenth-century Spanish artist who painted moving depictions on panel of Christ's suffering in a style inspired by Michelangelo and Leonardo da Vinci. He painted numerous images of Christ wearing a crown of thorns, generally on wood or copper.

Murillo's use of copper reflects an earlier artistic practice that would be largely discontinued by the end of the seventeenth century. Copper was widely employed as a support for oil paintings in the north from the mid-sixteenth through the mid-seventeenth centuries, as well as by artists working in Rome.[21] Murillo would have seen several examples of Flemish and Roman paintings on copper in private collections in Seville.[22] Pacheco discussed the preparation of metal plates for painting, and Murillo was only one of many Spanish painters who executed small paintings on copper.[23] The copper support offered Murillo a smooth and rigid painting surface that imparted a jewel-like quality to his small devotional works such as *Christ on the Cross with the Virgin, Saint John, and Mary Magdalene* (cat. no. 21). Copper also offered greater portability and durability than wooden panels.

The Houston *Nativity* (cat. no. 20) provides an exceptional example of Murillo's appropriation of a pre-made obsidian block, a black volcanic glass with a lustrous sheen, as a painting support. This intimate nocturnal scene of Christ's birth is particularly suited to the obsidian support, with its dark, reflective, even mysterious, qualities. Murillo's intriguing use of this stone, explored by Jordan in his essay in this catalogue, and by Meslay,[24] is known through only three examples. In addition to the Houston work, there are two other known paintings on obsidian: *Agony in the Garden* (fig. 62) and *Penitent Saint Peter Kneeling before Christ at the Column* (fig. 63), both dated c. 1665–70. Examination at the Louvre under the binocular microscope confirmed the transparency of the support and the presence of white inclusions that are typical of obsidian. Although the stone on which the *Nativity* is painted was not analyzed, it shares several characteristics with the Louvre panels, and is assumed to be obsidian.

As Meslay observed, America was the probable source for the obsidian. The volcanic glass was commonly found in both Central and South America, where it was shaped by pre-Columbian artisans into utilitarian objects.[25] The rectangular panels that Murillo used exhibit a smoothly polished surface, while their reverses share a rough surface with the glassy character of the obsidian revealed in only a few scattered conchoidal fractures (see fig. 61 and cat. no. 20, fig. 1). Meslay linked the appearance of these two panels with a rectangular Aztec "smoking mirror," an instrument of divination to communicate with the spiritual world in the Musée de l'Homme, Paris.[26] The fact that the Aztecs cut, shaped, and polished the stones completely by hand adds to the special allure of these panels. Measuring 15 1/16 by 13 1/2 inches, the Houston support is slightly larger than the Louvre examples, but all three panels are about one inch thick (figs. 72 and 73).[27] Since Seville was the principal European port for the Americas, the Aztec mirrors could have been transported by ship back to Spain, where Murillo utilized them as supports for small devotional paintings.[28]

GROUNDS

Murillo's grounds were related to the type of support used; fittingly, the paintings on copper, wood, and obsidian show a greater divergence than his works on canvas. Although Pacheco recommended an oil priming for stone,[29] Murillo most likely applied ox gall or eggwhite over the areas he intended to paint on obsidian.[30] This thin, transparent layer would have allowed the artist to paint on the smooth glass surface without the use of a traditional ground. In the finished image, the artist exploited the tonality of the stone by leaving large areas of it exposed to suggest a dramatic night sky. Murillo applied a thin layer of white lead and umber in oil over the copper support for *Christ on the Cross with the Virgin, Saint John, and Mary Magdalene*, c. 1655–60 (cat. no. 21), while he prepared the wood support for *Ecce Homo*, c. 1675 (cat. no. 27) in the traditional manner, that is, with a light gesso ground.

In the canvas paintings examined, Murillo employed a range of tinted and moderately colored earth grounds.[31] These grounds share many qualities with those used by other seventeenth-century painters working in Seville, including Zurbarán, Velázquez, and Herrera the Elder.[32] Velázquez employed earth grounds in a variety of tones, including grays and light browns, although he frequently added lead white to achieve greater luminosity, and in some cases he used almost pure white grounds.[33] The use of colored grounds reflects a major trend throughout Europe in the seventeenth century that had started in the sixteenth century in Italy when northern Italian artists such as Correggio, Dosso, and Parmigianino first adopted colored surfaces for painting. Venetian artists such as Titian continued to use white grounds until late in the century, when eventually the workshops of Bassano and Tintoretto also began to use colored primings.[34]

The ground layers in all the paintings sampled for this exhibition shared similar characteristics.[35] They contained siliceous earth, consisting largely of calcium carbonate, or calcite, with inclusions of earth or black pigments, and were applied in a single layer. Colors fell within a middle range, from buff to light brown and gray, corresponding to the tone of the local "earth of Seville," although additional pigments may have been added. Some of the variations in Murillo's grounds may have resulted from differences in materials available or the work of different apprentices in his workshop, although it is also possible canvases were purchased already prepared.[36]

Both Pacheco and Palomino refer to "earth of Seville," used as a priming almost exclusively in oil. Palomino suggests the addition of pigments that were left over from the artist's palette or brushes to enhance drying.[37] Pacheco praises the clay for its qualities: "the best and smoothest priming is this clay that they use in Seville, ground to a powder and tempered on the slab with linseed oil," and credits the ground with the sound condition of his paintings.[38] Murillo's use of this preparation may have contributed to the longevity of many of his canvases. The artist generally applied his grounds thinly. The arc-shaped incisions observed in the ground layer of *Saint John the Baptist Pointing to Christ*, c. 1655 (cat. no. 6), the earliest of the paintings examined, as well as in *Jacob Laying the Peeled Rods before the Flocks of Laban*, c. 1665 (cat. no. 13), probably resulted from his use of a wooden or metal spatula or *imprimadera*.[39]

The exact color of Murillo's grounds is often difficult to pin down. Because the cross sections often appear misleadingly dark, the color of grounds viewed in a cross section under high magnification must be correlated with their appearance in the paintings. Areas of exposed ground on the painting surfaces—found in occasional gaps along contours, along the edges, or in areas of loss—were compared with the layers in the cross sections

Opposite, top: *Fig. 72. Side view of* AGONY IN THE GARDEN *(fig. 61). The Aztecs cut, shaped, and polished the obsidian block by hand.*

Opposite, bottom: *Fig. 73. Side view of* NATIVITY *(cat. no. 20)*

to characterize the priming layers. Originally, the preparations probably appeared lighter, but they have apparently darkened over time as a result of oxidation, the yellowing of the oil binder, and the absorption of wax-resin adhesives used in some linings.

Murillo's canvas paintings give the impression of an artist experimenting with a variety of grounds, aware of the effect of the color on the appearance of the final image. Murillo sometimes applied a second layer to the priming, or *imprimatura,* to affect the tonality of the upper paint layers, a practice Zurbarán also followed.[40] In *Two Women at a Window,* c. 1655–60 (cat. no. 32), he added a local dark gray *imprimatura* beneath the shutter, the white scarf of the older woman, and the arms of the young woman.

Curiously, the pair of related devotional images, *Saint Justa* and *Saint Rufina,* c. 1665 (cat. nos. 15 and 16), exhibit different colored grounds, medium brown and ocher respectively. It is possible that the artist's choice was based on the individual requirements of the paintings. The light-colored ground was better suited to the cool palette of red and green used for the draperies in *Saint Rufina,* while the brown ground was a more appropriate choice for the warm palette of the pendant, dominated by the yellow drapery of *Saint Justa.* Other paintings exhibiting a similar palette of gold and blue, including *Virgin of the Immaculate Conception,* c. 1655–60 (cat. no. 8), and *Virgin of the Immaculate Conception,* c. 1680 (cat. no. 28), also have medium brown grounds.

Murillo's genre paintings also exhibit a variety of toned grounds. Examination revealed that *Two Women at a Window,* c. 1655–60 (cat. no. 32), was executed on an overall light gray ground, while *Four Figures on a Step* (cat. no. 31) is on a warm brown ground that is reflected in the flesh tones of the old woman, as well as through the thinly painted background. Sonnenburg also uncovered a range of tones in Murillo's genre paintings in Munich, where the early *Two Boys Eating Melon and Grapes* (Alte Pinakothek) had a two-layered red-brown ground, while the other examples exhibit yellow-brown grounds.[41]

In *Jacob Laying the Peeled Rods before Laban,* c. 1665 (cat. no. 13), the yellow-brown ground can be seen in the thinly painted shadow of Jacob's drapery, while *Laban Searching for His Household Gods in Rachel's Tent,* c. 1660 (cat. no. 14) has a grayish brown ground. The tonality of the ground is reflected throughout the foreground and in shadow areas such as at the feet of Laban. In *Self-Portrait,* c. 1655–60 (cat. no. 33), a warm red-brown ground shows through thin areas of the jacket and is also exposed in small losses in the oval frame. *The Mystic Marriage of Saint Catherine,* 1680–82 (cat. no. 30), exhibits a pale brown ground.

Murillo's use of midtone grounds had a direct impact on the artist's painting method, and allowed him to execute his canvases with greater efficiency and economy. While white grounds required the use of thick layers of full-bodied paint, mid-toned grounds could be more thinly covered. Murillo sometimes incorporated the exposed ground in the modeling of forms, utilizing the light ocher priming as the half tones in the young boy's flesh in *Return of the Prodigal Son,* 1667–70 (cat. no. 18). The optical effect of a colored ground allowed Murillo to obtain the various shadows and dark tones in a painting with the application of a simple glaze. Murillo frequently left areas of the priming in reserve (i.e., unpainted) in the course of painting, then covered them thinly. This practice would have provided the artist with a "short cut" to facilitate the painting of large commissions or multifigure compositions. A striking example can be seen in the X-radiograph of *Four Figures on a Step,* c. 1655–60 (figs. 80 and 81), which reveals that Murillo reserved space for the old woman's eyeglasses, then laid in her flesh tones economically around them.[42]

The paintings examined provided numerous examples of this technique. In *Saint John the Baptist Pointing to Christ* (cat. no. 6), Murillo thinly glazed the ground to create the shadows in the drapery and flesh tones. Thinly glazed areas of reserved ground also helped

shape Christ's eyebrows and beard. In the multifigure composition *The Adoration of the Magi*, c. 1655–60 (cat. no. 7), Murillo left numerous details in the figures unpainted, then added thin glazes over the brown ground to create their features. Evidence presented in these paintings, where the ground was often exposed in gaps along the edges of figures with little overlap of paint at the borders of compositional elements, and selective details were left unpainted until a late stage, reflected the fact that Murillo based his compositions on preparatory designs.[43]

PREPARATORY STUDIES

Murillo started his pictures with a clear vision of the final composition. This is reflected in the fact that there are so few *pentimenti* in his paintings.[44] Murillo based his works on preparatory drawings (see the essay by Cherry in this catalogue) and he also created colored oil sketches, such as *The Mystic Marriage of Saint Catherine* (cat. no. 30) to develop his concept prior to painting. While Pacheco found small monochrome oil sketches on canvas in red or black-and-white to be a useful means of working out compositions, Carducho advocated the use of colored oil sketches.[45] At least thirty-six oil sketches by Murillo are known today, a number that suggests their importance in his working process. Probably many more are lost. He used the expensive pigment ultramarine for Saint Catherine's blue drapery in the Los Angeles study, a costly pigment that he also employed in his finished paintings.

Although infrared examinations of Murillo's paintings did not reveal any underdrawing, the artist may have transferred his designs to canvas with pale chalks, a practice mentioned by both Pacheco and Palomino.[46] Palomino also described outlining the chalk drawing with the *tinta de perfilar*, a transparent mixture containing red lake (a natural organic dye precipitated on a base or substrate) in oil that could also serve as the underpainting in shadows.[47] This "tinta" would have been clearly visible on Murillo's light or midtoned grounds. Preliminary outlines in red lake were glimpsed in a number of the paintings examined, where they were sometimes visible along the edges of forms. Murillo used red lake to sketch contours for the kneeling child and the Magi in the foreground of *The Adoration of the Magi* (cat. no. 7), while he applied similar preliminary outlines for the old woman's white sleeve in *Four Figures on a Step* (cat. no. 31) and the green dress of *Saint Rufina*. The artist also indicated minor details such as the green and red neck bows in *Saint Justa* and *Saint Rufina* with red lake.[48]

The practice of sketching in red lake was commonly employed by artists working both in Italy and the north.[49] As early as the sixteenth century in Venice, Tintoretto applied thin streaked underlayers in red lake to indicate preliminary outlines.[50] During Murillo's time, the French seventeenth-century painter Georges de La Tour also made use of this technique, a fact that suggests that this sketching practice may have been widely adopted throughout Europe.[51] Murillo may have occasionally used incisions to lay out his designs, because the obsidian support of *Nativity* (cat. no. 20) is scored with numerous faint marks, including a diagonal line that seems to indicate the placement of Joseph's staff. In some cases Murillo may have transferred his compositions to canvas with the help of cartoons, which would have helped him to meet the demands of executing large commissions, such as his cycle for the refectory of the convent of San Leandro. In one of these works, *Saint John the Baptist Pointing to Christ* (cat. no. 6), it appears that Murillo reused the same cartoon for the heads of both Saint John the Baptist and Christ, flipping the orientation of the drawing for each figure. When X-radiographs of the two heads were overlapped, the outlines and features could be superimposed (figs. 74, 75, 76, and 77). Palomino described several methods of

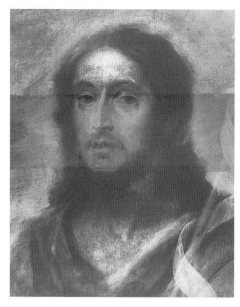
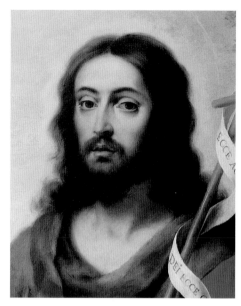
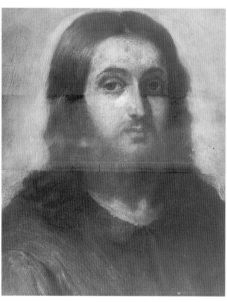

transferring outlines. In one, the outlines of the original would be painted in red lake; then an impression would be taken on paper and transferred to a new support while the pigment was still wet. Another technique involved stretching gauze over the original and copying the design in chalk.[52] The chalk outlines could then be transferred to a new support by mechanically rubbing through the gauze.

Murillo's recycling of a cartoon in *Saint John the Baptist Pointing to Christ* is perhaps not surprising. The artist's well-known habit of borrowing both individual elements as well as whole compositions from artists such as Rubens, Van Dyck, or Reni for his own paintings is discussed in this catalogue by Stratton-Pruitt and Cherry. Pacheco classified three grades of painters: the *principantes*, who copy entire compositions from other works; the *aprovechados*, who can put together a composition from motifs taken from many different works; and the *perfectos*, who have reached the final stage of total invention. Murillo exemplified all three grades in his practices.[53]

The underlying importance of drawings in Murillo's paintings can be seen not only

in the planning but also in the artist's handling of paint. His characteristic hurried and abstract zigzag and loopy brushwork seen in the painted draperies of *Saint John the Baptist Pointing to Christ* (cat. no. 6), *The Return of the Prodigal Son* (cat. no. 18), and *Virgin and Child* (cat. no. 23), and in the flesh tones of *The Mystic Marriage of Saint Catherine* (fig. 88) and the *Nativity*, recall the rapid shading with similar strokes in Murillo's drawings.

THE PAINT LAYERS
THE PIGMENTS

Murillo's palette contained pigments that were widely used throughout Europe in the seventeenth century, and consisted of lead white, ultramarine, azurite, indigo and smalt, vermilion and red lake, lead tin yellow, red and yellow ocher, copper resinate green, carbon, and bone black. The blue pigments ultramarine, azurite—which are mineral pigments—and smalt, a powdered glass pigment, held special significance for Murillo's palette, and the ways in which the artist employed these colors shed light on the importance he gave to individual paintings, and to elements in a single composition, as well. To fully appreciate Murillo's intentions as a colorist, it is also essential to understand how smalt, like other pigments, has changed with time. For certain of Murillo's paintings, changes due to smalt discoloration are more visually and aesthetically significant than has been previously acknowledged.

Since there was a considerable difference in cost among these blues, both the scale and importance of the work determined Murillo's choice of pigments. Ultramarine was the most expensive, while smalt, with weak tinting strength and a high transparency in oil, was comparatively cheap. The artist used ultramarine exclusively for the Virgin's drapery in his Immaculate Conceptions. In large-scale works meant to be viewed from a distance, such as *Saint John the Baptist Pointing to Christ* (cat. no. 6), or in minor commissions, such as *Saint Justa* (cat. no. 15), Murillo used smalt for blue drapery. Throughout the paintings examined, smalt was often identified in less important areas such as backgrounds or skies.[54] When first applied, smalt would have approximated the color of ultramarine. When used in oil, unless lead white was added, however, it eventually discolored to a dull grayish brown, as in the drapery of *Saint Justa* (cat. no. 15). Venus's drapery in Velázquez's *The Toilet of Venus* represents one of the few well-preserved examples of Spanish seventeenth-century paintings where smalt is used in the oil medium.[55] An early copy of *Saint Justa* (fig. 78) records the original smalt blue color. In *Saint John the Baptist Pointing to Christ* (cat. no. 6), the tonality of the smalt was preserved in the highlights of Christ's drapery where it was mixed with white lead, but it discolored in the thinly painted shadows. Although cost must have played a significant role in Murillo's choice of smalt, he may have adopted this pigment for its specific color as well. It provided the artist with a third blue pigment whose cool tonality, distinct from either ultramarine or azurite, he may have consciously admired.

In *The Virgin of the Immaculate Conception* (cat. no. 8), Murillo combined the use of ultramarine, azurite, and smalt. In the Virgin's mantle, he followed the practice described by Pacheco and Palomino of underpainting ultramarine with another blue to compensate for its translucency in oil, applying azurite (now turned gray) as the underlayer (fig. 79).[56] This technique allowed Murillo to apply the precious ultramarine thinly without sacrificing its intensity. Although it might be thought that Murillo intentionally excluded blue from the golden sky in *The Virgin of the Immaculate Conception* (cat. no. 8), in fact, the gray clouds among which *putti* appear beneath the Virgin (cat. no. 8), were originally

Above: *Fig. 78. Copy of* SAINT JUSTA *(Formerly Thyssen-Bornemisza Collection). The copy records the original color of Saint Justa's smalt blue drapery.*

Below: *Fig. 79. Photomicrograph (9x) of blue drapery in* VIRGIN OF THE IMMACULATE CONCEPTION *(cat. no. 8), showing Murillo's use of an azurite underlayer beneath the ultramarine pigment.*

Opposite, top: *Fig. 80. Detail of X-radiograph,* FOUR FIGURES ON A STEP *(cat. no. 31), showing plain weave* taffeta *canvas. Murillo reserved space for the old woman's eyeglasses, then painted her flesh tones around them.*

Opposite, bottom: *Fig. 81. Detail of old woman,* FOUR FIGURES ON A STEP. *Murillo used heavy impasto to create the appearance of wrinkled skin.*

smalt blue. This same change also occurred in the *Virgin of the Immaculate Conception* (cat. no. 28). For these important devotional paintings, the smalt discoloration strikes a somber, ominous tone in the skies of otherwise spiritually uplifting images. In a small work on copper, the *Virgin of the Immaculate Conception* (fig. 69), however, the soft blues Murillo used in the lower clouds are better preserved, providing a touchstone for understanding the original color harmonies of the artist's large representations on canvas.

The treatise-writers of Murillo's time understood the problems associated with blue pigments. Palomino frequently referred to smalt, noting its use as a pigment as well as a drying agent in linseed oil, but he observed that "it should be used in moderation, because if much is used it kills the color."[57] Pacheco noted azurite's tendency to blacken, especially when applied without the admixture of white lead.[58] This darkening occurred in the Virgin's mantle in Murillo's *Adoration of the Magi* (cat. no. 7), and the appearance of other costumes in the painting were altered due to the artist's use of copper resinate glazes. In *Jacob Laying the Peeled Rods before the Flocks of Laban* (cat. no. 13), the discoloration of this green has resulted in a jarring contrast between the pastel hues of the distant landscape and the brownish trees in the foreground. In the foliage at the far left, the copper resinate greens have discolored more than those at right and center. These pigment changes were among the factors that have altered Murillo's paintings with time; others include the darkening of certain works through the yellowing of the oil binding medium and the increasing transparency of the paint layers.[59]

THE LAYER STRUCTURE

Most of the cross sections taken as samples from the paintings examined show a simple paint layer structure, with only one or two layers on top of the ground, which suggests that Murillo had an efficient painting technique. In some works, the artist prepared details with a local gray underlayer, as he did for the red bow in *Saint Rufina* (cat. no. 16) or the shutter, the white scarf worn by the old woman, and the young woman's arms in *Two Women at a Window* (cat. no. 32).[60] Murillo appears to have added calcite to his pigments to increase the fluidity of the paint without altering its color.[61] Numerous calcite particles were observed in the paint layer in *Saint Justa* and *Saint Rufina* (cat. nos. 15 and 16), as well as in other examples. Murillo also used relatively simple pigment mixtures. Reflecting a Sevillian love of color, the artist frequently juxtaposed pigments of complementary colors to maximize their intensity. In the *Virgin of the Immaculate Conception* (cat. no. 8), for example, Murillo contrasted the ultramarine drapery with a golden sky, while he portrayed the draperies in the devotional pair *Saint Justa* and *Saint Rufina* (cat. nos. 15 and 16) in complementary hues.

THE HANDLING OF PAINT

Perhaps the most inimitable aspect of Murillo's technique, his brushwork, reflects the artist's extraordinary talent as a draftsman; and a transformation can be seen from the intense naturalism and sculptural quality of his early paintings to the lighter, energetic facture of his late, "vaporous" works. Murillo's skill at distinguishing flesh tones, a hallmark of his technique, was evident in the earliest works examined. The palpable reality of the nearly life-sized figures in *Saint John the Baptist Pointing to Christ* (cat. no. 6) is intensified by their direct confrontation of the viewer and the immediacy of Saint John's muscular arm, silhouetted against the sky. Although the figures at first appear strikingly similar, Murillo

portrayed Saint John with ruddy skin tones, while those of Christ are more luminous, with a greater admixture of white lead, softly modulated with pink glazes (figs. 74, 75, 76, and 77). Murillo treated different elements in the composition with a variety of brushwork, another characteristic of his technique; but the brushwork is suppressed in favor of the overall effect. Although Murillo filled in broad areas of drapery with speed, using bold brushwork, at a normal viewing distance the bristle impressions disappear and the drapery appears smooth. The artist blocked out the sky with energetic brushwork, then applied the clouds with soft, diffuse edges. The foliage was rendered in three schematic stages. Murillo first laid in a pale celadon green with assured staccato strokes, which he followed with a dark green, and finished with gold highlights applied with low impasto.

The wrinkled skin of the old woman in *Four Figures on a Step* (figs. 80 and 81), perhaps one of Murillo's most unforgettable figures, represents his brushwork in its most vigorous and descriptive form. Applied with heavy impasto, the brushstrokes create the impression of aged skin, almost appearing as sculpture in low relief. The intense realism of the woman recalls Ribera; but Murillo stopped short of painting individual strands of hair as the earlier master had. Similar to her flesh tones, the woman's white sleeves are painted with bravura brushwork and impasto, the gray shadows quickly blended by painting wet-in-wet. The brushwork brings the figure into sharp focus in the foreground, while the flesh tones of the young man and woman in the background are thinly applied with no visible brushwork and appear softly out of focus.

When the surface of *Four Figures on a Step* (cat. no. 31) was viewed under magnification, numerous wood splinters were found stuck to the paint; wood particles were also identified on the surfaces of *Saint Justa* and *Saint Rufina,* dating from the same period. Fine grains of wood as well as flecks of gold leaf were found on the surface of *Nativity* (cat. no. 20). Perhaps Murillo painted in a busy studio where other activities related to painting, such as woodworking in the preparation of stretchers or frames, were carried out. Although Seville was an active center for polychrome sculpture, the carving was most likely completed in a location separate from the painting.[62]

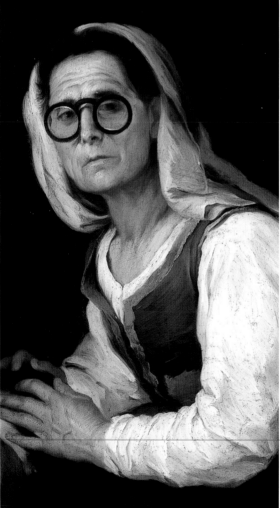

Murillo's obvious delight in the individual treatment of his figures in his genre paintings is evident in *Two Women at a Window* (cat. no. 32). The artist characterized their ages through their different skin tones. As we have noted, he used loose, textured brushwork to describe the wrinkles of the older woman; he achieved the young woman's luminous complexion by applying local glazes over a smooth, opaque paint layer. The X-radiograph reveals a rare example of a *pentimento*, and this change is also visible upon close examination of the paint surface. Murillo slipped the young woman's chemise off her shoulders, giving her presence a greater feeling of immediacy than it would have had if he had left the composition as he originally conceived it.

The images of *Saint Justa* and *Saint Rufina* (cat. nos. 15 and 16) embody a beauty and piety usually associated with Murillo's images of the Virgin. Although conceived as a pair, the paintings display differences in handling. The bold and rapid brushwork in Saint Justa's gold drapery as well as throughout the sky, executed with a stiff paint characteristic of the artist's use of this color, contrasts with Murillo's more refined treatment of these elements in *Saint Rufina*. Saint Justa's flesh tones are illuminated with a soft, diffuse light, while those of Saint Rufina appear more luminous with individual highlights defined. X-radiographs reveal that Murillo modified both images, possibly reworking the paintings in response to one another (figs. 82 and 83). These changes, as well as the differences in

Top: *Fig. 82. X-radiograph of* SAINT JUSTA *(cat. no. 15).
Murillo reworked the flesh tones and the background surrounding
the sitter's head.*

Above: *Fig. 83. X-radiograph of* SAINT RUFINA *(cat. no. 16).
Murillo began by sketching* Saint Rufina *holding a large oval plat-
ter, then converted it to two white earthenware jugs.*

handling seen in the two paintings, suggest that the artist may have abandoned the paint-
ings, then returned to them at a later date.

Murillo began by sketching Rufina holding a large oval platter, which he then con-
verted to two white jugs. Murillo's rendering of *Saint Justa* was more labored. He reworked
the flesh tones and the surrounding background before the paint layers had dried, refin-
ing her profile with the sky color. The top layer of flesh tone, which contained more white
lead, pulled apart upon drying, revealing a warmer underlayer. Murillo also changed the
color of Saint Justa's drapery; a red lake layer underlies much of the yellow sleeve and
(now discolored) blue smalt drapery. However, it is also possible that Murillo used the
red lake to modify the tonality of Justa's drapery, since the artist used this pigment for
the shadows in Rufina's green dress. The bows were the final details added to the cos-
tumes, and these were modeled wet-in-wet.

Murillo's *Crucifixion* (cat. no. 26) is remarkably luminous, a characteristic of works
on copper; but in discussing the artist's brushwork in this jewel-like painting, allowances
must be made for its condition. Similar to some other works on this support, *Crucifixion*
(cat. no. 26) has suffered due to adhesion problems between the oil paint film and the
copper sheet, which resulted in numerous tiny flake losses in the red draperies of the
Virgin and Saint John, as well as pinpoint losses throughout the sky. The well-preserved
passages, such as the crumpled drapery of Mary Magdalene, reveal the crispness in han-
dling that is typical of Murillo's work on this smooth and non-absorbent support. The
copper support facilitated Murillo's precise handling of Christ's anatomy and the ener-
getic treatment of his white loincloth. The rich saturation of color, particularly in the
draperies of the foreground figures, was another advantage offered by the copper panel.
Its lack of absorbency allowed for a technique utilizing very thin paint layers, which
Murillo exploited throughout the landscape and sky. He covered the surface with deli-
cate scumbles—light opaque layers of color applied over a darker underpaint—to sug-
gest the soft clouds in the moonlit sky, where the pink and ocher tints framing the figure
of Christ create a spiritual light. The absence of texture in the panel allowed the artist
to create an illusion of space in the atmospheric, silvery landscape that is surprising in a
painting so small.

By contrast, Murillo's *Nativity* on obsidian is a tour de force of tenebrism (cat. no. 20).
Of all his supports, Murillo's use of obsidian had the most immediate impact on the
appearance of the painted image, because he employed it without the benefit of an inter-
vening ground layer. Murillo responded to the challenge of painting light on dark, a
method that was developed by sixteenth-century Italian artists such as Sebastiano del
Piombo and Bassano, who exploited the color of unprimed slate supports.[63] One of the
advantages of painting light on dark is that it aids the speed of execution, and the use of
polished obsidian provides the benefit of exceptional durability. But in the *Nativity* (cat.
no. 20) Murillo was clearly responding to the aesthetic possibilities offered by the mir-
rorlike quality of the support.

In the Louvre paintings on obsidian, *The Agony in the Garden* and *The Penitent Saint Peter
Kneeling before Christ at the Column* (figs. 62 and 63), Murillo utilized the tonality of the black
support to evoke a dark and brooding atmosphere befitting scenes from Christ's Passion.
In the *Nativity*, Murillo left the obsidian exposed in the background to create a luminous
night sky. He allowed the streaky, vertical white inclusions in the glass to become an inte-
gral part of the image, where they seem to represent rays of heavenly light: a broad shaft
descending from the clouds focuses light on the Christ child. Prior to its recent cleaning,
most of the background in the *Nativity* had been overpainted with soft golden clouds that

lacked the crisp brushwork evident in original passages (fig. 84). This repaint, which was most likely added in the twentieth century, was extremely soluble. It may have been applied to conceal a repair to the obsidian support in the upper left; however, it also covered original passages, such as vestiges of the wispy clouds Murillo applied to offset the *putti* at upper right. The natural color of the obsidian heightens the drama of the scene, intensifying the luminosity of the flesh tones and imbuing the intimate portrayal of Christ's birth with a spiritual resonance. The open and free brushwork of the figures marks the height of Murillo's art, where the flawlessly smooth, polished surface of the support allows for a particularly crisp and detailed handling. The deftness of Murillo's touch recalls his treatment of the *Crucifixion* (cat. no. 26) and other works on copper, while lacking none of the bravura of his brushwork in monumental paintings.

Murillo created astonishing landscapes on a small scale by exploiting the characteristics of copper and obsidian supports. In especially large commissions such as *Jacob Laying the Peeled Rods before the Flocks of Laban* (cat. no. 13), however, it has been recognized that someone other than Murillo painted the background scenery.[64] Close examination of the paint surface has revealed that the sheep and the figures at the far right were painted on top of the completed landscape, providing evidence to support the presence of another hand (fig. 85). This does not conform to Murillo's usual practice of filling in the background around the figures in the final stages of painting. By contrast, in Cleveland's *Laban Searching for His Household Gods in Rachel's Tent* (cat. no. 14), Murillo painted the draperies of the foreground figures directly over the ground and he utilized the preparation layer to create the shadows at the feet of Laban. The schematic treatment of the background foliage in *Laban Searching*, painted with economy using different shades of green and spongy, impastoed highlights, recalls the foliage in *Saint John the Baptist Pointing to Christ* (cat. no. 6). A *pentimento* appears in the two figures above Laban's proper left shoulder. Two shepherds facing forward, one holding a staff, were later covered with landscape and replaced with the figure of a pointing shepherd, a revision that suggests Murillo's involvement in the Cleveland landscape.

In *The Adoration of the Magi* (cat. no 7), Murillo's versatile brushwork facilitated his creation of a complex, multifigure devotional subject. The composition focuses on the dense figural group in the foreground, while the landscape setting is restricted to minor background elements. Murillo describes the features of the background soldiers with a minimum of brushstrokes, and displays his usual skill in differentiating the figures through the quality of their flesh tones. The artist's deftness in modeling features using brushwork that follows form, recalls his treatment of the old women in *Four Figures on a Step* and *Two Women at a Window* (cat. nos. 31 and 32). Murillo painted some elements, such as the fur of the kneeling Magi, wet-in-wet; while he applied other details, for example, the unusually elaborate embroidery on the draperies and the highlights on the gold objects, in a final stage when the underlying layers had dried.

As in his earlier portrayals of *Saint Justa* and *Saint Rufina* (cat. nos. 15 and 16), Murillo's flesh tones in the two paintings of the Immaculate Conception possess the soft contours and glowing quality characteristic of his celebrated "vaporous" style. Murillo achieved these effects through the use of delicately applied finishing glazes; but while the Cleveland *Virgin* reflects the light Venetian coloring characteristic of the artist's late style, the flesh tones of the Dallas *Virgin* display stronger contrasts of light and shadow. Murillo also painted the flesh tones of the Cleveland *Virgin* more thinly; the X-radiograph reflects his economical use of white lead; he also added luminosity by applying highlights to details such as the tip of the nose and chin (fig. 86 and cat. no. 28). Murillo

Top: *Fig. 84.* THE NATIVITY *(cat. no. 20) before cleaning, prior to removal of the later (twentieth-century) additions of landscape and sky, which obscured the polished obsidian surface originally left in reserve by Murillo.*

Above: *Fig. 85. Detail of shepherds,* JACOB LAYING THE PEELED RODS BEFORE THE SHEEP OF LABAN *(cat. no. 13). The sheep and figures were painted on top of the completed landscape.*

Fig. 86. Detail of X-radiograph, Virgin of the Immaculate Conception *(cat. no. 28), showing Murillo's use of a twill weave canvas for the devotional painting. The X-radiograph also reveals that Murillo painted the flesh tones thinly with an economical use of white lead paint.*

blocked in the sky around the figure with the freedom associated with his late style, using looping brushwork to describe the clouds, sometimes moving his brush in a diagonal, criss-cross fashion. He used contrasts of light and shadow to activate the surface patterns on the Virgin's blue drapery, which appears to move with a burst of energy. Unfortunately the shadow areas in the blue swag have suffered, due to blanching and abrasion.

The painterliness of Murillo's late style can be observed in both the monumental *Return of the Prodigal Son* (cat. no. 18), and in the small late oil study, *The Mystic Marriage of Saint Catherine* (cat. no. 30). In the *Prodigal Son*, the consistency of Murillo's paint becomes more fluid and the artist has executed the flesh tones in a soft manner, where the edges of faces seem to dissolve. The painting reflects the spirited handling typical of his late work. Murillo's treatment of the tattered silk of the prodigal son is a tour de force. With virtuoso brushwork, he describes the drapery with great economy, mixing the vivid pink lining with coral and red lake shadows wet-in-wet. With a similarly fluid technique, Murillo has applied the green embroidered pattern, and embellished the design with pink highlights using seemingly haphazard, zigzag brush strokes. Displaying his usual broad range of handling, Murillo uses impasto to simulate the texture of the cow's fur, and a stiff paint for the gold robe of the figure on the right, while the father's crimson robe is painted more thinly. He treats background figures in a sketchy manner, while focusing light and color on the central foreground characters. His use of glazes to describe the dirty feet of the prodigal son heightens the narrative. The greater number of paint layers and use of glazes as well as the soft color harmonies reflect a Venetian influence. Set against a silvery landscape, the *Prodigal Son* is unified with an ethereal atmosphere and luminosity not achieved in the artist's earlier works.

Murillo executed the late oil study *The Mystic Marriage of Saint Catherine* (cat. no. 30) in preparation for his final altarpiece in Cádiz. This colored oil sketch, the only one represented in the exhibition, stands as a work of art in its own right, despite its preparatory nature, and provides insights into an essential facet of Murillo's working method. In spite of its diminutive scale and sketchy brushwork, the *Mystic Marriage* possesses a spacious atmospheric quality with which Murillo achieved his final conception of the composition. The loose and sketchy brushwork displays a freedom and speed reflecting the artist's exceptional skills as a draftsman (fig. 87). Rather than sketching the outlines of forms, Murillo modeled the light passages, allowing areas of exposed ground to represent details, such as facial features, that complete the image. Yet the variety and differentiation of brushwork within the oil study reflect Murillo's technique in his finished paintings. He treats draperies, flesh tones, and foreground and background figures in *The Mystic Marriage* in an individual manner, establishing how the composition would read from a distance. His concern with establishing the color of the final image is reflected in his treatment of the blue draperies of Saint Catherine (fig. 88)—where he applies lapis lazuli—and Mary, where he uses smalt, unfortunately now discolored.

Examination of these paintings, albeit only a fraction of Murillo's oeuvre, reveal that the artist generally employed materials and techniques that were commonly used in seventeenth-century Seville, with some similarities to, but many differences from those employed by Velázquez. Considering that, unlike Velázquez, Murillo rarely worked outside his native city, his technique displays an exceptional knowledge of both northern and Italian art. Murillo's experimentation with a variety of toned grounds and supports, the aesthetic implications of his use of copper and obsidian, as well as the color changes that

have altered some works, emphasize the importance of taking into account the physical properties of his paintings. Murillo spawned many imitators and copyists who mimicked superficial aspects of his style, although they often failed to capture the essential under-lying character of his work. The careful process of preparatory drawing imbues Murillo's paintings with a clarity and directness of handling that is evident both in his earthy genre subjects and in his devotional paintings. The originality of his idiosyncratic brushwork has perhaps not been fully appreciated. The spontaneity of his handling, as his paintings evolved toward an increasingly individual style, is inimitable.

Note to the reader: X-radiographs were computer enhanced; stretcher bars were dig-itally suppressed.

Above: *Fig. 87. Detail of angel,* Mystic Marriage of Saint Catherine *(cat. no. 30), showing Murillo's use of zigzag brushwork in the shading of the arm.*

Left: *Fig. 88. Detail of Saint Catherine,* Mystic Marriage of Saint Catherine. *Murillo applied the precious pigment ultramarine for Saint Catherine's blue drapery, underscoring the impor-tance he placed on the small oil study.*

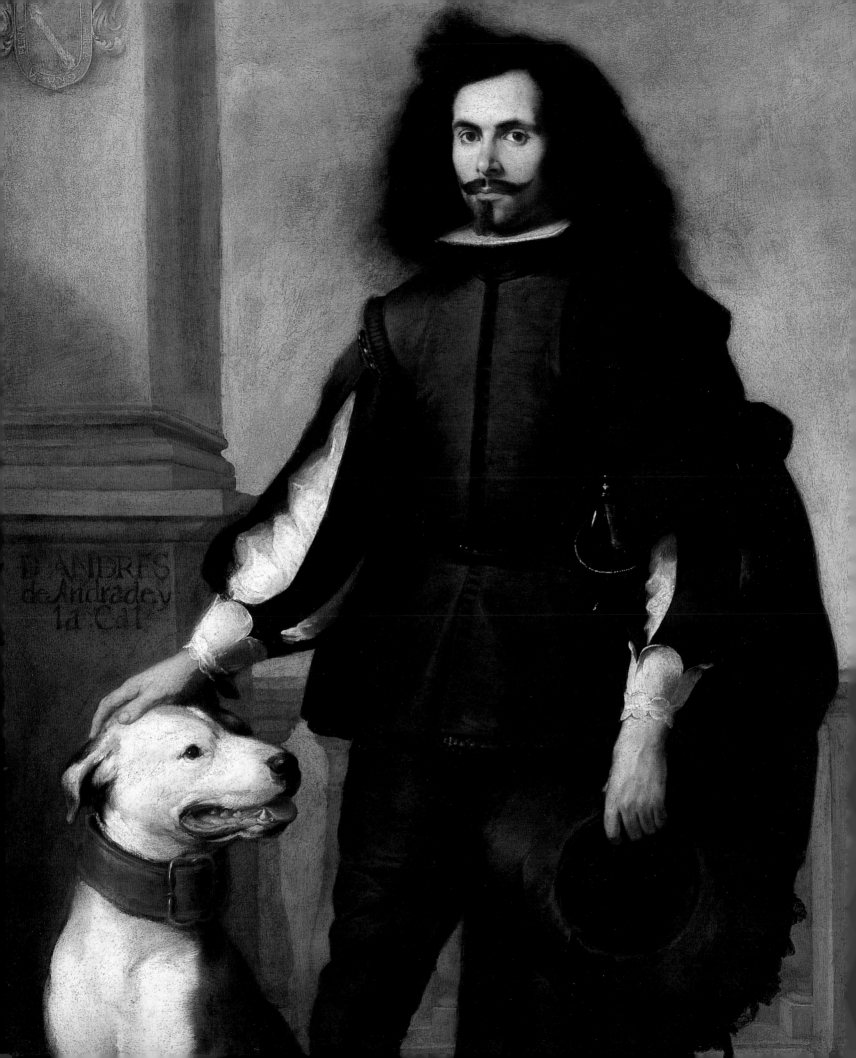

D ANDRES
de Andrade y
la Cal

MURILLO IN AMERICA

Suzanne L. Stratton-Pruitt

MURILLO IN FRANCE AND ENGLAND

In the late seventeenth century, Murillo was the best-known Spanish painter outside of Spain, excepting perhaps Jusepe de Ribera, whose career had taken place almost entirely in Italy. In fact, Murillo's paintings were so popular abroad that in 1779 the minister of Carlos III, the conde de Floridablanca, prohibited the export of his works. The artist's paintings could be found in Antwerp, Rotterdam, and, especially, in England, brought there by merchants and diplomats who had returned from posts in Spain with paintings in their luggage.[1] It is this European trade that forms the background to the collecting of Murillo's work in America.

As an example of how the paintings traveled: Richard Cumberland was sent to Madrid in 1780 to negotiate with Spain on Gibraltar. He stayed a year, during which time his interest in painting and his position gave him access to Spanish collections. Cumberland brought Murillo's *Saint John the Baptist in the Desert* (National Gallery, London) to England; Gainsborough purchased it after Cumberland's death in 1786, and he copied it in 1787.[2]

Detail of Catalogue No. 34. PORTRAIT OF DON ANDRÉS DE ANDRADE Y LA CAL. c. 1665–72. Oil on canvas. 79 x 47 in. (200.7 x 119.4 cm). Lent by The Metropolitan Museum of Art, Bequest of Collis P. Huntington, by exchange, 1927

In the Discourse pronounced by Reynolds on the death of Gainsborough in 1788, he mentioned Murillo as a source for Gainsborough's "fancy pictures."[3] Thus, by the end of the century, though only a few paintings by Murillo had reached England, they were well known, highly regarded, and influential.

In the early nineteenth century, as a result of the Peninsular War, great numbers of paintings left Spain, many of them for England. The duke of Wellington received 165 Spanish paintings at Apsley House, his home, including Velázquez's *Waterseller of Seville* and twelve works attributed to Murillo, all of which had slipped through the hands of Joseph Bonaparte, "the usurper king." Following the war, the duke offered to return the works to Ferdinand VI, the new king of Spain, but the conde de Fernán Núñez, then Spanish ambassador to London, insisted that Wellington had acquired the works through "just and honorable means" and even pressed Velázquez's *La Tela Real* on Wellington's brother, Lord Wellesley.[4]

The painters John Frederick Lewis, David Wilkie, and George Augustus Wallis all traveled to Spain, the latter sent there by the Scottish merchant William Buchanan. Wallis was in Spain from 1808 to 1813; taking advantage of the wartime situation, he acquired Velázquez's *Venus with a Mirror* (National Gallery, London), the Jacob series by Murillo that had belonged to the marquesses of Santiago (see cat. nos. 13 and 14), as well as their *Virgin and Child* (see cat. no. 23). It was a buyer's market. Buchanan bought Murillo's *Saint Thomas of Villanueva* and *Sleeping Christ Child,* which had belonged to the minister Manuel de Godoy; Sir John Brackenbury, English consul in Cádiz, assembled a collection including Murillo's *Don Andrés de Andrade* (see cat. no. 34); and Julian Williams, English consul in Seville, became both collector and dealer. In 1832, his collection was said to have included as many as thirty-seven paintings by Murillo, as well as drawings. Frank Hall Standish, who spent his last years in Spain, acquired fifteen paintings and twenty-two drawings attributed to Murillo. Standish offered his collection to the English government in the hope of obtaining a title of nobility. Rebuffed, he left the works instead to King Louis-Philippe, who had assembled a Galerie Espagnole in Paris.

In fact, many of the paintings by Murillo acquired by English collectors during the nineteenth century (a number of which, as we will see, made their way later into American collections) had journeyed to England from Spain via France.[5] In the eighteenth century, the French were hardly aware of Spanish painting, though in 1782 Louis XVI had purchased two paintings by Murillo, *Urchin Hunting Fleas* (fig. 20) and the *Holy Family,* called *The Virgin of Seville,* both now in the Louvre. Interest in Spanish art (earlier listed in French publications under "Italian school") intensified with the publication of Alexandre Louis Joseph de Laborde's *Voyage pittoresque et historique de l'Espagne* (Paris, 1806–20) and J. B. P. Lebrun's *Recueil des gravures . . . d'après un choix de tableaux . . . recueillis dans un voyage fait en Espagne . . .* in two volumes (Paris, 1809). The fifteen paintings illustrated therein all belonged to Lebrun, who exhibited them in his home in Paris; seven were attributed to Murillo.[6] However, Spanish paintings in French collections were rarities until the Peninsular War, when French troops removed hundreds of works from the churches and monasteries of Spain to France. The French Republic legitimized the artistic plunder of its generals, even lending it an altruistic gloss: "The French Republic, on account of its strength, the superiority of its intellectuals and its artists, is the only country in the world that can provide a secure exile for these masterpieces."[7] Marshal-General Soult (fig. 89), commander of the French troops in Andalusia, was only the most extreme example of the enlightened greed that so lightened the load of Spanish altars. Soult and his cohorts were, ironically, aided in their search for the best paintings by Antonio Ponz's *Viage de*

España, published in the closing years of the eighteenth century, and by Ceán Bermúdez's biographical dictionary of Spanish artists, published in 1800.[8] These volumes documented the artistic patrimony of Spain city by city, site by site. Soult efficiently amassed 180 Spanish paintings, including twenty of Murillo's finest works,[9] and the baron Charles Nicolás Mathieu de Faviers returned to France with three works by Murillo, the *Saint Giles before Pope Gregory XI* (cat. no. 1) and the *Saint Diego in Ecstasy before the Cross* (cat. no. 1, fig. 1), from the monastery of San Francisco, as well as a *Virgin of the Immaculate Conception* painted on copper, which was attributed to Murillo.

In 1835, King Louis-Philippe sent Baron Taylor to Spain to purchase Spanish paintings. Many, in an age unconcerned with the moral implications of despoiling a country of its artistic heritage, thought this a fine idea at a ripe moment. An Englishman writing in *The Spectator* lauded the project:

> With a munificence truly regal, and that cannot fail of gratifying such a nation as the French, the King appropriated a million and a half of francs (about 60,000 pounds sterling) out of his own private purse to the purpose of forming a gallery of Spanish pictures. Baron Taylor . . . traversed the Peninsula in every direction, exposed not only to many inconveniences but even dangers, from the state of warfare—for his ardour in the pursuit of his object would not allow him to avoid any place where fine works of art were to be found; and he ultimately succeeded in transporting to France four hundred and fifty choice specimens of Spanish painting. . . . When will our Government take such a step to enrich the arts of this country? Why might not England have made this collection?[10]

Louis-Philippe's Galerie Espagnole opened to the public on January 7, 1838. The five rooms of the Louvre thus allocated to Spanish painting contained over five hundred works of art, including more than forty attributed to Murillo (twenty-two can be identified today); nineteen paintings attributed to Velázquez; twenty-five to Ribera; and, eighty-two (!) to Zurbarán. The Galerie Espagnole was on public view for eleven years, stimulating an interest in Spanish painting and, equally, feeding the Romantic imagination about Spain.[11]

At midcentury, the major French collections of Spanish painting were dispersed. Soult's holdings went on the block in Paris in 1852.[12] When Louis-Philippe left the throne of France, his Spanish paintings went with him, and the Galerie Espagnole was auctioned at Christie & Manson, London, in May 1853.[13] The works left to the king by Standish were auctioned as a separate lot a week later.[14] Other French and some Spanish collections were sold as the century wore on. So, the English had an opportunity, after all, to acquire paintings by Murillo and other Spanish artists.

Until these sales, when the market for Spanish paintings boomed, English enthusiasm for Spanish art had been tempered by its primarily Catholic subject matter. Murillo was initially much favored on account of his genre pictures, but his fame then generated a demand for other subjects by his hand. William Buchanan wrote in 1803 to his agent in Italy: "Of those pictures for which you require to draw immediately, I should prefer either two or four of the Murillos. He is a master not to be had in England, and if the subjects are good, and finely painted, will sell very high, and what is of as much consequence very readily. Several have asked after Murillos."[15] Two years later Buchanan returned to the matter: "In a letter of about a year back you mention the subjects of 4 of the Murillos [from the Capuchin Convent, Genoa], but not of the other two. He is a master in

Fig. 89. Jean-Baptiste Isabey. Marshal-General Soult, Duke of Dalmatia, *detail from the Austerlitz Table. 1808–10. Porcelain. Musée national du château de Malmaison et Bois-Préau*

great repute in this Country and therefore I think the whole six might be sent home, unless any of them are Crucifixions or Martyrdom subjects, or the like. . . ."[16] Two months later he elaborated, "people don't like to see *Death* in their Drawing Rooms or Dining Rooms. . . . the people of England don't give their money to be made melancholy."[17]

Four decades later, Richard Ford, in his widely read "Handbook for Spain," continued Buchanan's reservations about the acceptance of Spanish painting in England. Ford pointed to the practical inconvenience of transporting paintings intended for immense altarpieces to the "confined rooms of private English houses." As well, there was the problem of the "all too frequent repulsiveness of the subjects" painted by:

> artists, who were employed by priest and monk, necessarily become tinctured with *their* all-pervading, all-dominant sentiment. The subjects of cowled inquisidores, the Maecenates of Spain, look dark, gloomy, and repulsive, when transported, like hooded owls, into the daylight and judgment of sensual Paris, or coupled with the voluptuous groupings of siren Italy. But Spanish art, like her literature, is with few exceptions the expression of a people long subject to a bigoted ascetic despot, and fettered down to conventional rules and formulae, diametrically opposed to beauty and grace, and with which genius had to struggle.[18]

(All this from a great *admirer* of Spanish painting.) Accordingly, English collectors would likely prefer the gentle Catholic imagery of Murillo to Zurbarán's ascetic saints proffering skulls or Juan de Valdés Leal's tortured martyrs. Until his fame was eclipsed by the rising star of Velázquez, Murillo was the preferred Spanish painter in England because his religious narratives had an immediacy, a genrelike quality, a feeling of everyday reality. Murillo was a painter of Catholic subjects of course . . . but not *too* Catholic.

MURILLO'S REPUTATION IN AMERICA

In April 1826 the painter Thomas Sully visited the collection of European paintings brought by Joseph Bonaparte to his home in exile in Bordentown, New Jersey. Sully pronounced that "Murillo looks dirty and cloudy in the tone and in the flesh; except in small pictures of a portrait size, *there* the flesh was rich and natural."[19] We cannot know, however, whether what Sully saw was actually by Murillo's hand.[20]

The first painting surely by Murillo to reach America was his *Roman Charity*, sent to Philadelphia by Richard Worsham Meade, the United States envoy in Cádiz. It was exhibited at the Pennsylvania Academy of Fine Arts from 1816 to 1845, when it was destroyed in a fire.[21] In the catalogue of the 1818 exhibition of old master paintings at the Pennsylvania Academy of Fine Arts, "The Roman Daughter" is listed without further comment, but the author expanded upon another Murillo painting in the exhibition, an *Agony in the Garden*:

> In this specimen of the artist he has proved what is chronologized of him: that there is but little of the academy in his design or composition. It is a chaste and faithful representation of what he saw or conceived. Truth and simplicity are never lost sight of. The colouring is clear, tender, and harmonious. To say too much of this picture, would be to diminish its excellence, and leave little to the eye of good taste.[22]

One of the paintings in the present exhibition, *Four Figures on a Step* (see cat. no. 31), was shown in New York at the American Academy of Fine Arts in March 1830. Richard Abraham of London had amassed a collection of old master paintings that he evidently

hoped to sell in the United States. Murillo's painting, then called "A Spanish Peasant Family," was described as magnificent: "The colouring is equal to any master that ever painted, and the whole possesses a force and excellence which only requires to be seen to be appreciated. . . ."[23]

What we can be reasonably sure of, however, is that the *Agony in the Garden* so warmly received by the author of the 1818 Philadelphia exhibition catalogue was not, in fact, by Murillo. It had been recognized over a century earlier that Murillo's fame had spawned imitators:

> his favourite subjects were beggar-boys, as large as life, in different actions, and amusements; which he usually designed after nature, and gave them a strong and good expression. His original paintings of those subjects, have true merit, and are much esteemed, many of them being admitted into the most capital collections of the English nobility; but of those, there are abundance of copies, which, to the dishonour of the artist, are sold as originals to injudicious purchasers.[24]

The first book about Murillo published in America was written by Charles B. Curtis, who was born in Philadelphia, served as a captain with the New York volunteers in the American Civil War, and came to the practice of law in New York. His avocation of collecting prints after paintings by the Spanish masters led to a serious art historical enterprise. In 1883, Curtis published his very scholarly catalogue raisonné of the paintings by Velázquez and Murillo. His observations about the difficulty of distinguishing between works by Murillo and the merely "Murillesque" hold true today:

> His paintings were mostly religious, for which class of works the demand was constant and unlimited. . . . As Murillo was constantly occupied, it is probable that, to meet the popular want, he often entrusted the copying of his works to such of his pupils as he considered competent.
>
> He founded a school, and left followers whose power was deeply felt during the succeeding ages. His imitators might be numbered almost by hundreds, and they were to be found in Seville even during the present century.[25]

Thus, part of the reason for the the waxing and waning of Murillo's critical fortunes may be because a "Murillo" was not always a Murillo. Catalogues of old master exhibitions in nineteenth-century America often include Murillo's name. There were over one hundred listings for works attributed to him in exhibitions before 1876.[26] Generous attributions to Murillo were, unsurprisingly, particularly numerous in sales catalogues. For example, the Spanish paintings sold in 1851 in London from the collection of John Meade, who had represented England in Spain, included twenty-nine paintings "by Murillo."[27]

To be sure, there was no embarassment in the nineteenth century about having good copies of paintings by the old masters. Copying was both a traditional aspect of artistic training and the only way to create colored replicas of famous works of art. Copies had great educational value, especially for the vast number of Americans who would never travel abroad. Samuel F. B. Morse intended that his 1833 *Exhibition Gallery of the Louvre* (fig. 90) tour the United States. This would have shown the public, in one large-scale picture, thirty-seven old master paintings. These faithful representations include Murillo's *Holy Family* and *Urchin Hunting Fleas* (fig. 20), which, in this imaginary assemblage of the Louvre paintings, Morse placed importantly to either side of the portal. The catalogue of the

sale of the collection of Richard W. Meade held in Philadelphia in 1853 forthrightly described a *Saint Thomas of Villa Nueva* [sic], *distributing alms to the poor* as a "Copy from Murillo by one of his pupils, and said to be equal to the original."[28] Authentic paintings by Murillo in America were very few until after the turn of the century. In 1886 Murillo's biographer, Luis Alfonso, was able to attribute only eight paintings in United States collections to Murillo.[29] One of those, a *Holy Family* in the Metropolitan Museum of Art, was sold at auction in 1929, the museum's curators presumably no longer considering it authentic.[30]

When the permanent collection of the Albright Art Gallery was published in Buffalo in 1907, Murillo was specifically represented on the list of "painters represented in copies," including one (of many, many versions) after the *Virgin and Child* in the Pitti Palace, Florence (fig. 10) and another after the *Virgin and Child* then in the Corsini Gallery, Rome.[31] American acquisitions of copies, however, had begun at least a century earlier. John R. Murray, a New York businessman, returned from his European tour in 1800 with copies of favorite paintings he had commissioned. Some of these might have been of the paintings by Murillo in the Hermitage, where Murray developed a "partiality" to Murillo, who, he wrote, "had taken Nature for his guide & he painted her with her pencil, dipped in her own colors, and . . . directed by her genius."[32] Education was the main impetus for the establishment of public collections in America, and good copies were considered adequate to the task. In 1853, Shearjashub Spooner's three-volume compendium on the fine arts was published in New York. In his preface the author noted: "With the progressive increase of wealth, leisure, and refinement in a country, the Fine Arts gradually and silently, but surely, assert their importance and take leading rank among the pursuits that diffuse a grace on worldly prosperity, and tend by their successful prosecution to heighten the measure of a country's glory."[33] A year later, as though in response to Spooner, the women of Cincinnati organized a gallery to exhibit 199 commissioned copies of masterpieces such as Raphael's *School of Athens,* Van Dyck's *Charles I*, and Murillo's *Virgin of Seville* "for the improvement of public taste and the encouragement of art."[34]

Even when given an opportunity to see authentic works, however, the American public was not quick to appreciate all early European painting. In 1860, James Jackson Jarves

brought from Europe a collection of early Italian pictures, which he exhibited in New York.[35] Henry James, for one, was unimpressed by those "queer quaint pictures . . . with patches of gold and cataracts of purple, with stiff saints and angular angels, with ugly Madonnas and uglier babies, strange prayers and prostrations."[36]

Another collection of old master paintings on public view in New York was Thomas Jefferson Bryan's "Gallery of Christian Art." For twenty-five cents, a visitor could see French, Dutch, Italian, and Flemish paintings through the eighteenth century, including, in 1852, three works by Murillo.[37] However, most of the paintings in Bryan's Gallery were so alien to American taste that the collection could not find a home in an art museum.[38] The collections of Jarves and Bryan were perhaps instructive as to the formal achievements of European painters, but they did not suit the American partiality for morally uplifting art. On the rare occasions, however, when Americans were presented with an opportunity to see a really fine selection of old master paintings, their response was appreciative. The duque de Montpensier loaned thirty of his paintings, mostly Spanish, to the Boston Atheneum in 1874. Henry James, who described Murillo's *Virgin of the Swaddling Clothes* (fig. 91) as the "gem of the collection," was amused by the "almost reverential demeanor of the spectators . . . we were reminded once more that we are a singularly good-natured people. We take what is given us, and we submit, with inexhaustible docility, to being treated as children and simple persons. We are vast, rich, and mighty, but where certain ideas are concerned we sit as helpless in the presence of Old-World tradition, dim and ghostly though it may be, as Hercules at the feet of Omphale."[39]

The Napoleonic wars were profitable for American businessmen and farmers. Increasing fortunes brought about an increasing interest in art. It has been observed that "The process was hastened, however, by the intense nationalism that pervaded American thought and life during the first half of the nineteenth century and by the fact that the philosophical traditions of the British eighteenth-century Enlightenment endowed the fine arts with a social and national value that helped to justify the national cause."[40]

Ralph Waldo Emerson championed the fine arts. The writings of the English art critic John Ruskin, widely known and read in America, spoke eloquently for the relationship between art and morality. Later in the century, Charles Eliot Norton, the first American professor of the history of art (at Harvard University), reiterated the connection between artistic expressions of beauty and morality:

> The concern for beauty, as the highest end of work, and as the noblest expression of life, hardly exists among us, and forms no part of our character as a nation. The fact is lamentable, for it is in the expression of its ideals by means of the arts which render those ideals in the forms of beauty, that the position of a people in the advance of civilization is ultimately determined. The absence of the love of beauty is an indication of a lack of the highest intellectual quality, but it is also no less an indication of the lack of the highest moral dispositions.[41]

Norton's comments, published in 1895, suggest that the good work of the ladies of Cincinnati and elsewhere had as yet exerted an insufficient impact on American sensibilities.

Norton may have been discouraged about the prospects for the fine arts in America, but his countrymen had been commissioning art at home and purchasing it abroad.[42] They also, however, heeded John Ruskin's insistence on the superiority of modern artists,[43] and were perhaps simply more confident about purchasing modern paintings: narrative works with moralizing and cautionary tales were the most popular acquisitions.[44] The

Fig. 91. Bartolomé Esteban Murillo. VIRGIN OF THE SWADDLING CLOTHES. *c. 1655–60. Oil on canvas, 54 x 44⅛" (137 x 112 cm). Private collection*

author of *A Plea for Art in the House*, published in Philadelphia in 1876, made the acquisition of old master paintings seem a perilous undertaking:

> The commercial axiom that supply always equals demand is as true in the old picture market as in any other. If a master comes to the front, is written up by Mr. Ruskin, or is brought into fashion for any other reason, his works suddenly find their way into the market. . . . But old pictures are dangerous for another reason. . . . They are not only liable to forgery and imitation, but they are very liable to fluctuations of taste. Some of us remember well when Mr. Ruskin began to write up Turner and write down Claude. . . . Another master who has fluctuated very much is Murillo. Good Murillos have been sold very cheap of late years. No doubt they may recover, but it would be hazardous to buy them on speculation.[45]

Spooner, writing only twenty years earlier, had noted that Murillo's paintings "command enormous prices," also warning that "The works of Murillo have been largely copied and imitated, and so successfully as to deceive even connoisseurs."[46]

A Plea for Art in the House also favors clear evidence of good craftsmanship in paintings: "there is one thing which will always command a price, namely honest hard work. The highly finished pictures of the great Dutch school are liable to less fluctuation than any other works of art. . . . They contain good, downright, hard work; they are not scamped; there is no "execution" for execution's sake in them, as there is in Murillo. . . ."[47]

Fledgling American collectors had no Bernard Berensons, no learned guides through the thickets of the art market. European dealers were quick to find the new market for art in the new nation. In 1820 a Boston autioneer offered a: "Gallery of . . . original cabinet paintings, being a truly splendid and valuable collection, selected with great care and expense from the various cabinets of [Europe] . . . the whole in elegant frames."[48] And, some years later, "the greatest and best collection of genuine paintings by the Old Masters ever offered by us or seen in the United States" was offered for sale in New York."[49] Caveat emptor.

However, Americans who could afford the European tour were quickly learning. Certainly, they could and did study paintings through books, if they could not see much of the real thing at home. And, they did keep up with events in the art world of Europe. The auctions of Spanish painting held in Paris and London at midcentury were covered in American newspapers and magazines. The frenzied bidding for Murillo's "Soult" *Immaculate Conception* (fig. 19) and the unprecedented high price paid for it by the Louvre was reported by an American journalist with considerable sensitivity to the real value of the painting:

> It is not the historic fact which the picture commemorates that excites this marvelous interest—most of the competitors reject that, probably, as a fable; it is not the religious sentiment with which the canvas glows, that attracts so potently—that is quite generally scorned as fanaticism nowadays; but the power of the human mind—the magical and mysterious capacity of genius to endue a few handfuls of pulverized earths, spread over a piece of cloth, with beautiful and sublime thoughts, like the breath of God inspiring the clay of the first man into life and dignity,—that it is that, in spite of rationalistic scepticism or infidel scorn, commands around this old Catholic painting the homage of the times. . . . Gold, rank, sceptres—what are these compared to the pencil of Murillo?[50]

In 1853, Richard Ford berated his fellow Englishmen for their reluctance to travel to Spain: "Influenced more by the asceticals than by the aestheticals of Spain—the dread of bandits, oil and garlic has been stronger with picture fanciers than the love for Zurbaran, Murillo and Velasquez."[51] Ford's cranky admonishment might have been heard by Americans, who increasingly traveled to Spain and, in a nineteenth-century tradition, wrote about its art and architecture.

Nathanial Hawthorne did not go to Spain, though he was in England, excepting a visit to Italy, from the spring of 1853 to June 1860. In his diaries, Hawthorne repeatedly insisted (perhaps playing a bit the rough-hewn "Yankee abroad") on his unfamiliarity with the fine arts. On March 26, 1856, he made his first visit to the National Gallery, London: "It is of no use for me to criticize pictures, or to try to describe them, but I have an idea that I might acquire a taste, with a little attention to the subject, for I find I already begin to prefer some pictures to others. This is encouraging. Of those that I saw yesterday, I think I liked several by Murillo best."[52] In July 1857, Hawthorne visited the huge exhibition "Art Treasures of the United Kingdom," held in Manchester. He was understandably daunted by the hundreds of works of art gathered under one roof, "like having innumerable books open before you at once, and being able to read only a sentence or two in each."[53] With Yankee fortitude, Hawthorne forged on: "I mean to go again and again, many times more, and will take each day some one department, and so endeavor to get some real use and improvement out of what I see. . . . Doubtless, I shall be able to pass for a man of taste by the time I return to America."[54] By mid-August, Hawthorne was a confident amateur of art:

> I do begin to have a liking for good things, and to be sure that they are good. Murillo seems to me about the noblest and purest painter that ever lived, and his Good Shepherd the loveliest picture I have seen. . . . I find myself recognizing more and more the merit of the acknowledged masters of the art; but, possibly, it is only because I adopt the wrong principles which may have been laid down by the connoisseurs. But there can be no mistake about Murillo,—not that I am worthy to admire him yet, however. . . . In all these old masters, Murillo only excepted, it is very rare, I must say, to find any trace of natural feeling and passion; and I am weary of naked goddesses who never had any real life and warmth in the painter's imagination. . . .[55]

At Manchester, Hawthorne would have seen two of the paintings in the present exhibition: *Blessed Giles before Pope Gregory IX* (then belonging to Philip W. S. Miles, Esq.) (cat. no. 1) and the Metropolitan Museum's *Virgin and Child* (then in the collection of Lord Overstone) (cat. no. 22).[56]

Other Americans saw paintings by Murillo in Seville and Madrid, their experience primed by a study of Spain and its culture. By midcentury, several very knowledgeable guides to Spanish art had been added to the publications available earlier. Besides Richard Ford's 1845 *Handbook,* there was William Stirling-Maxwell's *Annals of the Artists of Spain* and Sir Edmund Head's *A Handbook of the History of the Spanish and French Schools of Painting*, both published in London in 1848.[57] Thus, armed with guidebooks to both sites and the appreciation thereof, American tourists traveled to Spain.

A Year in Spain by a Young American, published in Boston in 1829, reveals, as is often the case, the close relationship between the "notes" of a tourist and his studied preparation for the trip. He mentions that Murillo studied with Velázquez (as asserted in the early

biographies, but now considered untrue), that he never left Spain, that Murillo added a "warmth and brilliancy of coloring" to Velázquez's "truth to nature," and so on:

> Nothing indeed can be so true and palpable as Murillo's scenes of familiar life, nothing so sweet and heavenly as the features and expression of his Virgins. Murillo brought the school of Seville, or more properly of Spain, to the height of its glory. He seems to have combined the excellences of Vandyke and Titian, and truth of the one and the warm carnation of the other. . . . [58]

It is also clear, however, that the young American really looked at the paintings to which the guidebooks drew him. His response to the *Saint Elizabeth of Hungary* (fig. 92) then in the Academy in Madrid seems spontaneous:

> She is represented washing the sore of a beggar. At one side is an old man, one might almost fancy a living one, binding his leg. On the other, a ragged lad, afflicted with some loathsome disease, and who, unable to endure the pain and irritation, is scratching his head in agony. The subject of this painting is disgusting enough, and the reality of its execution renders it still more so. It will, however, offend less, if it be remembered that Murillo painted it in Seville, to hang in the Hospital of Charity. It is, perhaps the most perfect imitation of life which exists on canvas.[59]

In 1832, Mrs. Caroline Cushing published her memoirs of a trip to France and Spain. She found the collection of the Museo del Prado much superior to that of the Louvre and noted that: "The eye of a novice, even, may instantly detect the vast difference between the two styles of painting, and the great superiority of the Spanish over the French. The number of Murillo's paintings . . . is very great; and I can scarcely imagine any thing more perfectly beautiful than the best efforts of this inimitable master."[60]

Another American visitor, Severn Teackle Wallis, had evidently taken the more conventional European tour before his visit to Spain:

> The traveler who has seen Murillo, only in England, Italy, or France, has but a poor idea of the master's skill . . . and he may rest assured, were he to pack off for Seville to see the pictures only, that no man who had visited them before him would call it a fool's errand. . . . Among those who are not critically read, in things of art, the general notion of Murillo is, that his chief excellence consisted, in painting, to a miracle of truth, the boys and beggars and the common out-door life of Spain. . . . In Seville, the mistake is very soon corrected. The traveler finds himself surrounded by triumphs of Murillo's, in the very loftiest walks of art.[61]

William Cullen Bryant declared that the "full merit" of the Spanish painters "cannot be known to those who have never visited Spain." He wrote of the Museo del Prado that "the place is made glorious with the works of the gentle and genial Murillo."[62] Indeed, American travelers abroad could see paintings by Murillo in many of the galleries and palaces in England and the continent, but they would also heed the injuction that "Until you have seen his works in Spain, you will not know what a Murillo is."[63]

Excepting the years around and during the Civil War, Americans continued to visit Spain and to record their impressions. In 1872, John Hay, who would become a great

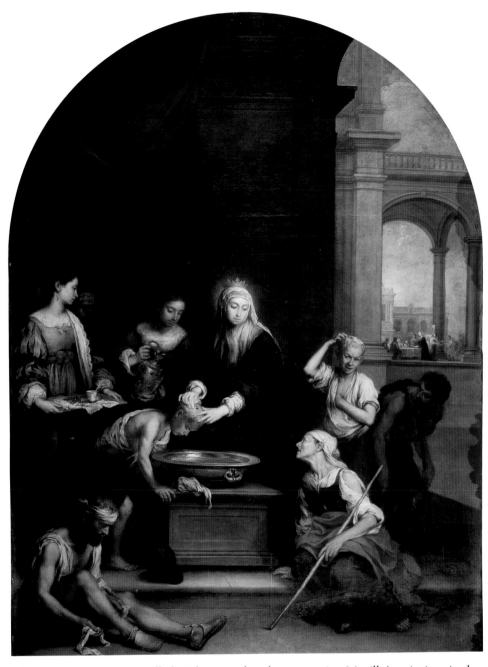

Fig. 92. Bartolomé Esteban Murillo. SAINT ELIZABETH OF HUNGARY ATTENDING THE SICK. *1667–70. Oil on canvas, 10′8″ x 8′ ½″ (325 x 245 cm). Church of the Hospital de la Caridad, Seville*

American statesman, recalled with particular pleasure seeing Murillo's paintings in the Academy in Madrid: "I think in these pictures of Murillo the last word of Spanish art was reached. There was no further progress possible in life, even for him. 'Other heights in other lives, God willing.'"[64] In 1873 the travel writer Augustus J. C. Hare, who recommended Ford's *Handbook* and, especially, the very popular guidebook by Henry O'Shea,[65] recalled his impressions of favorite paintings, including Murillo's *La Virgen de la Servilleta* (Museo de Bellas Artes, Seville): "When Murillo was working at the convent, the cook entreated to have something as a memorial, and presented a napkin as the canvas, on which this brilliant, glowing Madonna was painted, with a Child which seems quite to bound forward out of the picture."[66]

Willis Baxley's reminiscences of the three years he spent in Spain were published in 1875. Declaring that "the pall fell on the tomb of art" when Murillo died, Baxley waxed eloquent about the sublime paintings in the Prado:

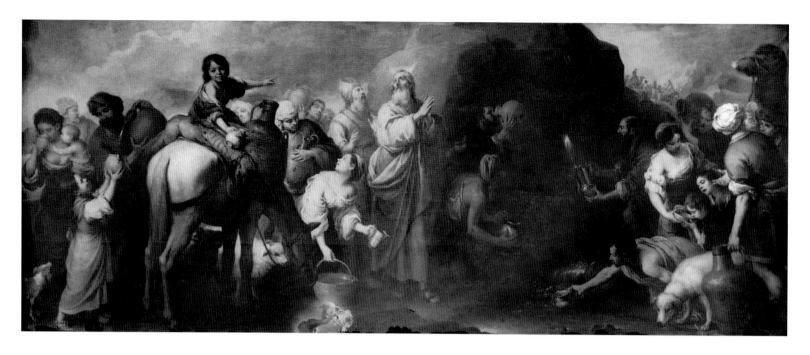

Fig. 93. Bartolomé Esteban Murillo.
MOSES STRIKING THE
ROCK. *1667–70. Oil on canvas,*
11′6″ x 18′ (350.5 x 548.5 cm). Church
of the Hospital de la Caridad, Seville

Among Spanish painters of religious subjects and ecclesiastical personages, Murillo holds the same pre-eminence that Velazquez does in the line of Court portraiture. His masterpieces have given him abroad the highest place in public estimation. Drapery, distant views, diaphanous nature, transparent colouring, and rich, harmonious tone, are in fullest perfection in his works. His ideal grace placed him beyond reach of rivals in his day or since; and gave him a power of awaking at will, deepest sympathies and tenderest emotions.[67]

Not all Americans were quite so smitten. George Parsons Lathrop admired Murillo's talent, but his appreciation was tempered by a palpable anti-Spanish bias. In his *Spanish Vistas* (1883), Lathrop described the *Saint Thomas of Villanueva Distributing Alms* (fig. 18) as "a grand study of beggary—vagabondism as you may see it today throughout Spain."[68] Of the *Moses Striking the Rock* (fig. 93) in the Hospital de la Caridad, Lathrop took nasty pleasure in detailing the "naturalistic genius" of the artist: "The representation is terribly true; and the range of observation culminates in the figure of the mother drinking first, though her babe begs for water; for this is exactly what one would expect in Spanish mothers of her class, whose faces are lined with a sombre harshness, a want of human kindness singularly repellant."[69] However, Lathrop's opinion of Spanish painting as "on the whole depressing" was at radical odds with most Americans, who were more often deeply moved by *Moses Striking the Rock*:

> . . .a great crowd of thirsty ones made glad and exultant by the miraculous bringing forth of the refreshing stream. The faces are so famished and eager, so exultant and grateful! At one side upon a white horse is a child . . . laughing for joy. . . . To the other side a dog is seen lapping, lapping, with as much evident delight and joy as any human being, while a child close by drinks eagerly from a dish. . . .[70]

Americans of the Romantic century, seeing his paintings for the first time in Spain, loved the Murillo who "with no inspiration but his own genius and the Andalusian sunshine pouring in at his window . . . dreaming as only poets dream; and then seeking to give

expression to his dreams, till he almost took the sunlight out of heaven to suffuse the glowing canvases with which he illumined the city of his birth."[71]

MURILLO AND THE CRITICS

Nineteenth-century art critics were less enthralled by Murillo's work than was the general public. John Ruskin, whose writings were widely read in America and perhaps held in even higher regard than in England,[72] was among the first to condemn Murillo's art. Initially Ruskin had defended Murillo, of whom he wrote in 1836: "It is true that his Virgins are never such goddess-mothers as those of Correggio or Raphael, but they are never vulgar: they are mortal, but into their mortal features is cast such a light of holy loveliness, such a beauty of sweet soul, such an unfathomable love, as renders them occasionally no unworthy rivals of the imagination of the higher masters."[73] However, by 1844, Ruskin had undergone a radical turnabout. He now found Murillo a particularly pernicious example of mediocrity on account of exercising "a most fatal influence on the English school":

> His drawing is free but not ungraceful, but most imperfect, and slurred to gain a melting quality of colour. That colour is agreeable because it has no force or severity; but it is morbid, sunless, and untrue. His expression is sweet, but shallow; his models amiable, but vulgar and mindless; his chiaroscuro commonplace, opaque, and conventional: and yet all this so agreeably combined, and animated by a species of waxwork life, that it is sure to catch everybody who has not either very high feeling or strong love of truth, and to keep them from obtaining either.[74]

Ruskin especially loathed Murillo's genre paintings, which he knew well in the Dulwich Art Gallery, describing the beggar boys as "repulsive and wicked children."[75] (Murillo was not the only artist to be placed in Ruskin's "School of Errors and Vices."[76] There, too, were late Raphael, the Carracci, Guido Reni, Correggio, and Caravaggio!)

Ruskin's harsh criticism of the Spanish master undoubtedly influenced Charles L. Eastlake—keeper of the National Gallery in London, champion of the Gothic Revival style, and influential arbiter of taste. Eastlake was repelled by Murillo's genre paintings in Munich, describing the *Two Boys Eating a Tart* (fig. 94) as "an instance of the unclean and morbid pleasure which Murillo felt in depicting squalor and poverty. . . . a needless display of rags and dirty feet."[77] Of the *Old Woman Delousing a Boy* (fig. 95): "That any painter of refinement could bring himself to depict such a group as this is truly marvellous but that an artist whose name is associated with the lofty aims of religious art should so frequently have drawn his inspiration from the gutter, presents a problem respecting pictorial taste which must puzzle the optimist."[78] However, Eastlake was equally scathing about Murillo's religious paintings. In the Louvre, he dismissed Murillo's *Immaculate Conception* as "utterly devoid of religious feeling, objectionable in colour, and deficient in the higher qualities of pictorial skill." He considered *The Angels' Kitchen* "a pretentious, but exceedingly foolish picture," and, regarding the *Holy Family*, he wrote:

> The treatment of this picture is eminently common-place, and therefore unpleasant. . . . The animal in the centre of the foreground is not the Agnus Dei of sacred allegory, but a lamb, and nothing more; while the introduction of the heavenly group, though excusable in early and unsophisticated forms of religious art, becomes offensive in a composition of so confessedly terrestrial a character.[79]

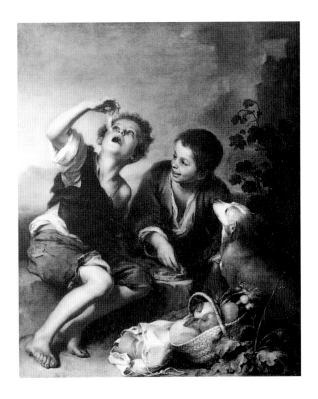

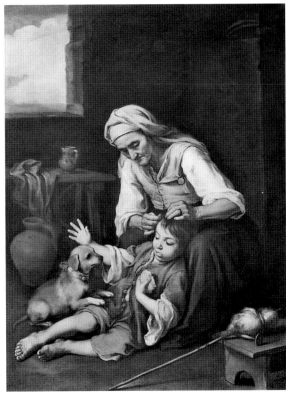

Top: *Fig. 94.* Bartolomé Esteban Murillo. TWO BOYS EATING A TART. *c. 1675–80. Oil on canvas, 48⅝ x 40″ (123.6 x 102 cm). Bayerische Staatsgemäldesammlungen, Alte Pinakothek, Munich*

Above: *Fig. 95.* Bartolomé Esteban Murillo. OLD WOMAN DELOUSING A BOY. *c. 1655–60. Oil on canvas, 58 x 44½″ (147.4 x 113 cm). Bayerische Staatsgemäldesammlungen, Alte Pinakothek, Munich*

Ruskin and Eastlake were probably responding, in part, to the hyperbole (which Ruskin permitted only himself) surrounding Murillo's art. The great enthusiasm for golden age Spanish painting throughout the nineteenth century in England was criticized more mildly by Lord Frederic Leighton in a lecture on Spanish art given at the Royal Academy on December 10, 1889. He blamed the "strangely exaggerated" estimation of Spanish painting on two books available to English readers: "one a book of unsurpassed charm and brilliancy, which has long passed from the hands of the tourist to the shelves of the lover of literature—I speak, of course, of Richard Ford's "Handbook"; the other, a work of great elegance and much research, but, in its indiscriminate enthusiasm a very unsafe guide—Stirling's "Annals of the Artists of Spain."[80] Leighton recommended instead "a valuable corrective to the teaching of these two works"—Carl Justi's *Velázquez und sein Jahrhundert*.[81]

Murillo's lessened reputation at the end of the nineteenth century was due not only to critical displeasure or a simply more dispassionate assessment of his talent, but to the rising star of Velázquez. The greatest painters of seventeenth-century Spain had been spoken of in nearly one breath since Velázquez's works first became known outside of Spain. Velázquez was considered the consummate court painter, Murillo as the master of religious subjects. As early as 1827, David Wilkie had compared the two: "These two great painters are remarkable for having lived in the same time, in the same school, painted from the same people, and of the same age, and yet to have formed two styles so different and opposite, that the most unlearned can scarcely mistake them; Murillo being all softness, while Velasquez is all sparkle and vivacity."[82] When attention was turned by contemporary artists to Velázquez's dazzling technique rather than his subject matter, his fame soared, but did not eclipse that of Murillo. The American Charles B. Curtis, among others, defended Murillo: "It is much the fashion nowadays with a certain class, to exalt Velázquez and decry Murillo. With such critics I have little sympathy. Each has merits; perhaps I ought to be frank enough to admit that each has his defects."[83] However, Curtis's analysis of the differences between the artists and their appreciative audiences is a wholly Romantic construct:

> The difference between them is largely due to their temperaments and surroundings. Velázquez was worldly; Murillo, religious. Velázquez labored for artists and critics; Murillo worked for mankind. Velázquez painted kings, and knights, and dwarfs, things of earth; Murillo painted virgins, and saints, and angels, things of heaven. The one consorted with courtiers; the other with monks. . . .
>
> Not only was there a contrast between the artists themselves, but there is a difference in those who observe and judge their works. Velázquez appeals to the critical and intellectual; Murillo to the sympathetic and spiritual. One fires the brain, the other touches the heart.[84]

Many American artists visited Spain from about 1860 through the early years of the twentieth century, drawn there primarily to study and copy Velázquez's paintings and to soak up the colorful atmosphere of still-exotic Spain. Like other American tourists, though, the painters themselves admired Murillo. Mary Cassatt, for example, pronounced an *Immaculate Conception* in the Prado "lovely most lovely."[85]

Even art amateurs outside the studios and critical circles at the turn of the century appreciated Velázquez's dazzling technique, then often interpreted as a harbinger of Impressionism. Havelock Ellis, better known as a "sexologist" than travel writer, knew Europe well but liked Spain best. In his *The Soul of Spain* (first published in 1908 and

reprinted twelve times), Ellis wrote perceptively that when "new technical methods of painting appeared with Manet . . . these new ways of approaching the problems of light and colour led to the triumph of Velazquez, who was found to have been the leader, three centuries ago, in the most modern movement of the conquest of painting over Nature."[86] Ellis also recognized that the decline of Murillo's critical fortunes was without merit: "Murillo, once counted as more than the peer of Velázquez, has fallen from his high estate in critical estimation, though his popularity among the masses, in and out of Spain, remains unaffected by the discussions of critics. . . . He has suffered from his popularity and from the critical reaction aroused by that popularity."[87] Increasingly, art lovers in England and America were finding Murillo's gentle interpretations of religious subjects (i.e., most of his paintings) difficult to appreciate. The more insightful, Arthur Symonds among them, were attuned to the periodicity of taste and the importance of considering the context in which a work of art was created:

> All these painters of Martyrdoms, and Assumptions, and Biblical legends, painted with a vivid sense of the reality of these things: their pictures tell stories, a quality which it is in the present unwise, limited fashion to deprecate. . . . In Murillo the Spanish extravagance turns to sweetness, a sweetness not always to our taste, but genuine, national, and perfectly embodied in those pictures in which he has painted ecstasy as no one else has ever painted it. . . . It is precisely because these saints of Murillo abandon themselves so unthinkingly, with so Spanish an abandonment, to their mystical contemplation, that they may seem to us, with our northern sentiments of restraint, to pose a little. In desert places, among dimly lighted clouds, that rise about them in waves of visible darkness, they are dreamers who have actualised their dreams, mystics who, by force of passionate contemplation, have attained the reality of their vision; and the very real forms at which they gaze are but evocations which have arisen out of those mists and taken shape before their closed or open eyes.[88]

James M. Hoppin, professor of art history at Yale University, writing in 1892, tried to lead the Anglo-American viewer to a more willing acceptance of the premises of Spanish Catholic painting:

> The religion of this passionate and imaginative Spanish people expressed itself in art, or art formed a vehicle of worship and a symbol of infinite things, which calmer blooded Protestant races can no more understand than they can, without bigotry, deny; if not the highest and most spiritual, it is nevertheless a ladder of the soul; as in Ribera's picture of "Jacob's Dream" the coarse, dark-browed Spaniard who lies asleep on the earth under a tree, sees the sky open and angels ascending and descending.[89]

More often, both art critics and the authors of popular books about art were content with a superficial and reductive assessment of Murillo's art, one that facilitated clever verbiage over serious criticism. One such writer redefines the three phases (*estilo frío, estilo cálido, estilo vaporoso*) with which Murillo's stylistic development was traditionally described, as a development from "natural work tinged with the unreal" to "the natural . . . mingled with the unreal" to "the natural . . . lost in the unreal," resulting in "an injudicious blend of the real with the impossible."[90]

Opposite, top: *Fig. 96. Edward*
Poynter. THE RETURN OF THE
PRODIGAL SON. *1869. Oil on*
canvas, 47½ x 36" (120.7 x 91.4 cm).
The Forbes Magazine Collection,
New York

Opposite, bottom: *Fig. 97.*
Arthur Hacker. CHRIST AND
THE MAGDALENE. *1890. Oil on*
canvas, 6'7¾" x 45½" (202.5 x 115.5
cm). Walker Art Gallery, Liverpool

For Roman Catholics, however, Murillo's images, so familiar through prints and copies, remained the embodiment of articles of faith: "It is impossible to meditate on any of these mysteries in our Blessed Lord's life without one of these pictures rising up instantly in one's mind, as the purest embodiment of the love, or the adoration, or the compunction, which such meditations are meant to call forth: they are in themselves a prayer."[91] Ripley Hitchcock, examining the dearth of religious painting in modern times, considered Murillo "the last of the great religious painters." Hitchcock observed that despite the "decorative works of Messrs. Lafarge and Lathrop . . . no one can claim much vitality for religious art in America," adding: "No one can justly blame artists alone for the non-existence of great art in our day. Pictorial like literary art must reflect more or less clearly the tendencies of its age. The critical and even sceptical spirit of the time is fatal to the simple and devout faith upon which truly religious art must rest."[92]

Popular books about Spanish artists were published in profusion around the turn of the century.[93] Alas, many of the authors relied little on the good scholarly work of Curtis or Justi, instead quoting *ad nauseam* the saccharine descriptions of Edmondo de Amicis ("In art Velasquez is an eagle; Murillo an angel."), whose *Spagna* was published in English in 1880 and then appeared in a number of editions.[94] De Amicis and his fans undoubtedly did more to spread the notion of Murillo as a sweet and sentimental painter than did the paintings themselves. Gazing at the *Virgin of the Immaculate Conception with the Half-Moon* in the Prado, De Amicis was overcome, not for the first or last time, with emotion:

> I was seized with inexplicable passion for that face. More than once in looking at it, I felt the tears coursing down my cheeks. Standing before that picture my heart softened, and my mind rose to a height which it had never attained before. It was not the enthusiasm of faith; it was a desire, a limitless aspiration toward faith, a hope which gave me glimpses of a nobler, richer, more beautiful life than I had hitherto led; it was a new feeling of prayerfulness, a desire to love, to do good, to suffer for others, to expiate, and ennoble my mind and heart. . . . I fancy that my soul never shone more clearly in my face than then.[95]

This sort of overwrought reaction to Murillo's art of course invited contempt: " 'How perfectly sweet Murillo always is,' I heard an American lady say before one of his pictures in the Prado. Even an American could not say that before Titian, or Rembrandt, or Rubens, or Velasquez. But it is quite true. Murillo is always sweet, at all times, in every picture. And sometimes he is so moved by his own sweetness that he seems about to burst into tears."[96] Murillo's reputation suffered the additional indignity of his being a favorite among the ladies, his:

> Catholicism tempered, become amiable . . . agreeable, operatic, and trivial, on a level with the artistic taste of the greater number at the time *when women begin to share in culture and to influence politics* [emphasis added]. Enter a church in Italy marvellous with some masterpieces of the Renaissance; note the paper flowers; note the large wax doll dressed in satins, decked with sham jewels and pathetic ex-votos, the center to which is directed the worship of the poor, of women and children. An analagous position in the history of painting is occupied by the art of Murillo.[97]

Surely, too, the critical reaction to Murillo's religious works must have been grounded in

consideration of nineteenth-century religious paintings, which, even when at their most successful, were rarely comparable to the production of the old masters. Consider Edward Poynter's *Return of the Prodigal Son* (fig. 96) as compared with Murillo's version of the subject in the present exhibition (cat. no. 18). In Poynter's interpretation, the father receives the son in an emotional embrace that seems choreographed rather than spontaneous. Murillo interprets the same moment with restraint, eschewing drama for a focus on the facial expressions of the father and son, which are fully expressive of penitence/forgiveness without drama, without sweetness or sentimentality. The more astute among nineteenth-century art critics certainly recognized the distance between the Baroque grandeur of a religious painting by Murillo and the infelicitous efforts of their contemporaries. When Arthur Hacker's *Christ and the Magdalene* (fig. 97) was shown at the Royal Academy, London, in 1891, Claude Phillips described the expression of the Magdalene as "rather one of ardent love than of devout adoration." He went on to say: "The painter has . . . made a capital mistake . . . that of showing Christ himself as a mortal among mortals, mean in physique, weak and suffering in body, and himself pitiable as he is pitying. The true ring of sincerity does not, indeed, make its presence felt in this clever piece, which remains therefore without sufficient excuse, if we adopt the highest standpoint in estimating its worth."[98] And there was the persistent problem of what constituted a "Murillo":

> Murillo has been cheapened by forgers and copyists who have succeeded in placing many of his shortcomings and very little of his quality on their hurried canvases. Every picture dealer in a Spanish city of any pretensions has a Murillo or two that he is prepared to vouch for even though the canvas gives the lie to his pretension. The artist's work has been used shamelessly for purposes of advertisement, it has paid the fullest penalties of popularity, and yet, a real Murillo in the best manner is a picture to which we can turn again and again . . . [99]

MURILLO AND AMERICAN COLLECTORS

Despite the apparent downswing in Murillo's "critical fortunes," the market for his works at the end of the nineteenth century remained strong:

> Our critics and painters have of late years enthroned Velasquez. We hear very little from them about Murillo, though in the sale-room, till within the last twelve years, he has always been the greater favourite. Mr. Curtis, in his work on these two artists, points out that Murillo has always, up to 1883, been on the whole more highly valued. He shows that twenty-one pictures by Velasquez only averaged about 38,000 francs, as compared with a 62,000 francs average for fifty-three works by Murillo. Yet this is quite intelligible. Velasquez . . . has been hampered in the sale-rooms by the stolidity of the features of his princes and the acidulated expressions of his little princesses.[100]

Curtis was confident of Murillo's continuing popularity:

> Admitting that the public is not always wise, I may nevertheless say, that the many are right as often as the few, and, as the result of my observation and experience, I am prepared to maintain that, in the long run, a man passes for what he is worth, that there is no test of merit so safe and decisive as success, none from which it is

Top: *Fig. 98. Advertisement in "The Shopping Guide,"* The House Beautiful (*October 1917*)

Above: *Fig. 99. Bartolomé Esteban Murillo,* VIRGIN OF THE IMMACULATE CONCEPTION. *c. 1670. Oil on canvas, 6′6″ x 53″ (198.1 x 134.6 cm). Detroit Institute of Arts, Gift of James E. Scripps*

so hopeless to appeal. We may be certain that in the time of those now living, the verdict of the world, as to Murillo, will not be set aside. . . .

Murillo always has possessed, as without doubt he always will possess, the public esteem.[101]

In the end, however, an appreciation of Murillo lay not solely in popular appeal, but in the judgment of distinguished art historians. Americans traveling to Spain around 1900 read in their trusted Baedekers an essay on Spanish art by Carl Justi, in which he assured them that:

It has lately become fashionable to depreciate Murillo in contrast with Velazquez, partly in reaction against his popularity with the layman and partly on technical and artistic grounds. It appears to us that neither reason is justified. The two masters should not be compared—the one holds the mirror to nature and his period, the other shows us what lies behind the brow. . . . the depreciation of Murillo . . . has its real ground in the modern materialist's dislike of the mystical subjects of the painter. He has represented things which the power of Velázquez refused to grapple with; but to give reality to the never-seen is also legitimate art.[102]

Justi gave the American traveler leave to ignore the anti-Murillo fulminations of Ruskin and Eastlake. In fact, Eastlake himself might have rued the contempt with which his earlier (younger) self had decried Murillo. In 1902 Eastlake wrote:

We read Vasari, Lomazzo, Lanzi; Kügler, Schlegel, Passavant; Walpole, Reynolds, and Ruskin; but we find most of them differing in their verdicts, and sometimes as to the very principles on which they have based their award. It is the fate of criticism to attain no finality of influence. . . . The best that one can say of such opinions is that for the most part they reflect rather than guide a popular taste.

To the earnest student who by his researches clears up disputed points of fact, who ransacks ancient archives to correct a date or disestablish a fiction, we owe a permanent debt of gratitude.

To the critic who favors us with views derived from personal prejudice or fleeting fashion, and which as time goes on will probably fade with his own identity, we have only incurred a slight and somewhat transient obligation.[103]

By the turn of the century, great fortunes had been made and Europe watched with some anxiety as wealthy Americans began to collect works by the old masters.[104] After World War I, Americans were in a particularly good position to acquire European paintings: "The recent decline of European civilization and the economic breakdown of the Old World have made it possible for us to acquire works of art which, previous to the war, were not obtainable at any price. . . . The changes in the fortunes of the European aristrocracy will, undoubtedly, make available a great many masterpieces for the American collector."[105] As early as 1900, the Wilstach collection in Philadelphia included Murillo's *Christ Carrying the Cross* (see cat. no. 10) and, by 1914, it could be said that, "There is scarce a gallery of any note without its Murillo, even New York of the New World."[106] For the new American collector, Murillo was both a popular and a sentimental favorite: "Murillo was the favourite painter of our fathers and grandfathers, before realism and Velasquez and Sargent and Zuloaga had

come to his undoing."[107] There were few middle-class Americans who had grown up without prints of Raphael's charming putti from the "Sistine Madonna" in Dresden or one or another of Murillo's depictions of Christ or Saint John the Baptist as children (fig. 98).

At the auction houses, Murillo's paintings held their own despite critical grumblings and continued to command respectable prices in a climate of taste when "Murillo is esteemed less highly and Rembrandt has been restored to his place among the giants."[108] When the collection of the duke of Sutherland was auctioned in 1913, the pendant paintings of *Saint Justa* and *Saint Rufina* (see cat. nos. 15 and 16) got the highest price of the day.[109]

American Art News reported that the London art sales of 1916 were "perhaps chiefly remarkable for the growth of a new type of buyer, largely recruited from the ranks of those suddenly become rich with various industries pertaining to the War. . . . The most sensational sale of the season was that of the Murillo Holy Family for 6,200 gns."[110] When a collection in Berlin was sold in 1918, a *Virgin of the Immaculate Conception* by Murillo brought the highest price, by far.[111] In fact, the most coveted of Murillo paintings were his versions of the *Immaculate Conception*, without which, evidently, no collection of European painting would be complete.

A headline in the *New York Herald Tribune* of May 28, 1927, trumpeted: "21,000 is Paid by American for Murillo Painting. Canvas Said To Be Original of Artist's 'Immaculate Conception.' "[112] In 1931, the *New York Times* announced a papal gift to the Catholic University of America—a mosaic replica of Murillo's *Immaculate Conception* in the Louvre. When the *Saint Thomas of Villanueva Giving Alms to the Poor* (see cat. no. 19, fig. 2) appeared on the New York art market, it was noted that: "In America, as elsewhere, Murillo's inspired portrayals of religious themes have been favorites with collectors and public alike for many years. Scarcely an important collection exists without one of his classic Madonnas, paintings rich in spiritual feeling and refined sentiment."[113]

In 1908 James E. Scripps purchased in London a *Virgin of the Immaculate Conception* for the Detroit Institute of Arts (fig. 99) and an early photograph (fig. 100) of the Baltimore collection of Henry Walters shows Murillo's *Inmaculada* in pride of place, centered on the rear wall of the gallery.[114] In 1922, DeWitt V. Hutchins of Riverside, California, purchased Murillo's *Immaculate Conception with the Mirror* (fig. 101) in Paris, with the expressed intention of installing it in the new chapel built at his Mission Inn. When it arrived in New York, the painting was installed for a while in the Hispanic Society of America, then at the Metropolitan Museum of Art. In 1924, while on view in Los Angeles, the painting served as the frontispiece for the December issue of *Arts and Decoration* and was discussed in the editorial column.[115] A year later the painting was on view at the Chicago Art Institute[116] and in 1928 it was at the Smithsonian Institution.[117]

Throughout the twentieth century, American collectors and museums continued to acquire works by Murillo and to occasionally deaccession paintings no longer attributed to his hand. In the 1997 edition of H. W. Janson's *History of Art*, Murillo's accomplishment is properly recognized: "The work of Bartolomé Esteban Murillo . . . is the most cosmopolitan, as well as the most accessible, of any Spanish artist. For that reason, he exerted a vast influence on innumerable followers, whose pale imitations have obscured his considerable achievement."[118] With the present exhibition, the first dedicated to Murillo in America, his considerable achievement is no longer obscured.

Top: *Fig. 100.* THE WEST GALLERY, HENRY WALTERS GALLERY, BALTIMORE, *1909. The Walters Art Museum, Baltimore*

Above: *Fig. 101. Bartolomé Esteban Murillo.* IMMACULATE CONCEPTION WITH THE MIRROR. *1670–80. Oil on canvas, 6'3¾" x 57" (192.5 x 145 cm). Museo de Arte de Ponce, Luis A. Ferré Foundation, Inc., Ponce, Puerto Rico*

CATALOGUE

Suzanne L. Stratton-Pruitt

with additional entries by William B. Jordan

I. The Blessed Giles before Pope Gregory IX

1645–46. Oil on canvas. 65½ x 73¼ in. (166.3 x 186 cm)
North Carolina Museum of Art, Raleigh. Purchased with funds from the State of North
Carolina, 52.9.178

PROVENANCE: *Claustro Chico*, monastery of San Francisco, Seville; Baron Mathieu de Faviers, Paris; M. Aguado, marqués de las Marismas, Paris; M. Llubois, Paris; John Miles, Kingsweston, Gloucestershire, by descent to Philip W. S. Miles, and to Napier Miles

EXHIBITIONS: Manchester 1857, no. 620; Bristol 1906, no. 187; London 1913–14, no. 156; London 1938, no. 17, ill. 51; New York 1939, no. 260, pl. 87; Columbus 1941, 2, 10, no. 4, pl. 11; Toledo 1941, no. 73; Winter Park 1946, no. 12, ill. cover; Colorado Springs 1947, 21, ill.

SELECTED REFERENCES: Stirling-Maxwell 1848, vol. 2, 836; vol. 3, 1434; Tubino 1864, 188–89; Blanc 1869, 16; Curtis 1883, 242, no. 309; Lefort 1892, 88, no. 305; Montoto 1932, 52; Raleigh 1956, 84–85, no. 211, ill.; Gaya Nuño 1958, 240, no. 1847; Braham 1965, 449; Pérez Delgado 1972, 50; Gaya Nuño 1978, 87, no. 16, ill.; Angulo 1981, vol. 1, 257–58; vol. 2, 6–7, no. 3; vol. 3, pl. 9; Paris 1983, 11 and 61, fig. 8; Sullivan 1986, 60–66, fig. 19

INSCRIPTION: *Florece en Santidad Gil, Y el noveno / Gregorio por hablarle va a perosa, / Visítale fray Gil el pecho lleno / De fervor Y obediençia Afectuosa / Teme entrar Y al fin entra al claustro pleno, / Siendo su amor Y fe tan milagrosa, / Q[ue] admirando Al Pontífice aquedado, / En extasis Divino arrebatado.*

Like *Fray Julián of Alcalá's Vision of the Ascension of the Soul of King Philip II of Spain* (cat. no. 2), this painting is one of the eleven scenes from the history of the Franciscan order painted by Murillo for the *claustro chico* (the small cloister) of the monastery of San Francisco in Seville. Also like the painting in Williamstown, its subject matter is rather arcane, though the much more legible inscription has rendered it accessible. The Blessed Giles was a devout follower of Saint Francis of Assisi who, after entering the order in 1209, focused his efforts on spreading Christianity in the north of

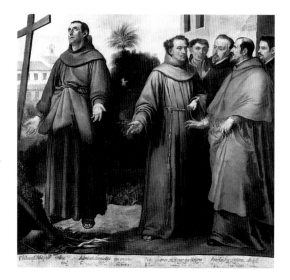

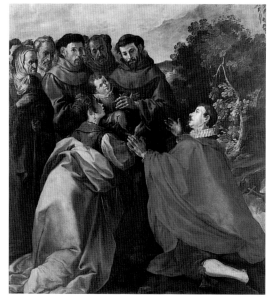

Africa. When he returned to Italy from Tunis, Giles retired to a contemplative life and died at Perugia in 1262.

Giles's prayer was so intense that at times he levitated, a pious feat that came to the attention of Pope Gregory IX. A seventeenth-century chronicle of the Franciscan order records the precise subject of Murillo's painting: "The Pope called him to Viterbo so that he could behold what made him famous. He graciously received him and spoke to him a few words about the Kingdom of God at which time he entered the rapture of profound ecstasy for the space of four hours. The next day, in the company of some cardinals, the Pope conversed with Blessed Giles again, and at once the same thing happened again. . . ."[1]

A similar miraculous levitation is pictured in another painting created for the *claustro chico, Saint Diego in Ecstasy before the Cross* (fig. 1). In both works, the main event is witnessed by solemn figures who respond thoughtfully, quietly, and with restrained gestures to the demonstration of the power of prayer. Their response is perfectly appropriate to the dignified suspension of gravity through which Murillo expresses the intense faith of Giles and Diego, whose feet barely leave the ground, just inches enough to suggest how very far from earth their thoughts are. When the *Blessed Giles* was auctioned from the collection of Baron Mathieu de Faviers in 1837, the subject was described in the sales catalogue in the most general terms: "Pope Benedict [*sic*], dressed in the pontifical robes, attended by a cardinal and another distinguished member of the clergy, receives two monks who are presented to him and appear to be ready to defend the privileges of the Franciscan Order."[2] So subtle is Murillo's depiction of the miraculous levitation that the author of the catalogue did not recognize it. (Nor did he make much of an effort to do so, directing the viewer instead to figure out

Top: *1. Bartolomé Esteban Murillo.* SAINT DIEGO IN ECSTASY BEFORE THE CROSS. *1645–46. Oil on canvas, 67¼" x 6'¾" (171 x 185 cm). Musée des Augustins, Toulouse*

Left: *2. Francisco de Herrera the Elder.* THE INFANT SAINT BONAVENTURE CURED BY SAINT FRANCIS. *1627. Oil on canvas, 7'8⅛" x 7'1¾" (234 x 218 cm). Musée du Louvre, Paris*

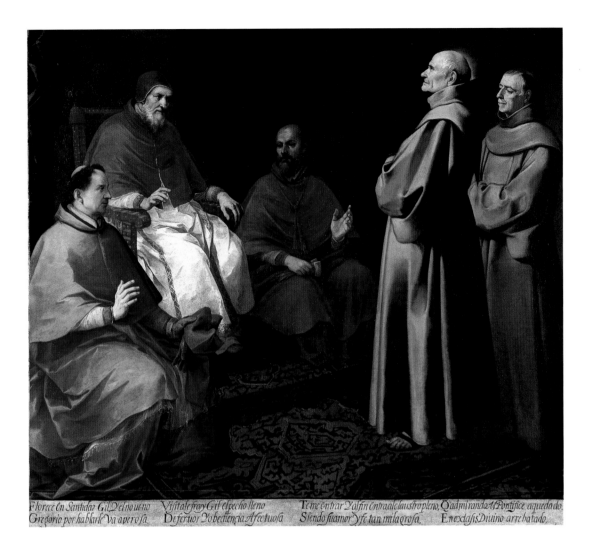

Florece en Santidad Gil, De I no ueno | Visitale fray Gil el pecho lleno | Teme entrar, y al fin entra al claustro pleno, | Q[ue] admirando el Pontifice, a quedado,
Gregorio por hablarle, Va apero sa. | De feruor, Y obediencia Afec tuo sa. | Siendo su amor, Y se tan mila gro sa. | En extasis Diuino arrebatado.

the inscription himself: "The inscription placed at the bottom of the picture explains the subject and the place for which it was painted."[3])

The narrative paintings created by Murillo for the Franciscans, his first large commission, actually represent the end of an era of a particular kind of religious painting in Seville. Murillo's work at the Franciscan monastery reflects a tradition of series of inspirational paintings about the most exemplary members of the orders. The young artist would have been familiar with the work of Francisco de Zurbarán and Francisco de Herrera the Elder, who both contributed paintings about the life of Saint Bonaventure to the church of the college of San Bonaventura in Seville about fifteen years before Murillo got his commission from the Franciscans. Similar series of narrative paintings were those created by Zurbarán for the Dominican monastery of San Pablo el Real (for which he contracted to paint twenty-one pictures, including fourteen on the life of Saint Dominic),

and his scenes from the life of Saint Peter Nolasco for the monastery of the Merced Calzada. In the paintings for the *claustro chico* of the Franciscan monastery, Murillo followed the examples of Zurbarán and Herrera in the quiet simplicity of their compositions, in their carefully wrought chiaroscuro, and in the choice of unidealized figure types. An instructive comparison may be made between the Saint Giles and, for example, Herrera the Elder's *Infant Saint Bonaventure Cured by Saint Francis* (fig. 2) painted for the college in Seville. In his paintings for the *claustro chico,* Murillo proved that he could compete with the masters of an older generation, and from here on he moved away from reliance on their example to create a personal style.

Notes:
1. Sullivan 1986, 65.
2. Translated from the *Catalogue des tableaux capitaux et de premier ordre . . . Mathieu de Faviers* (Paris, 1837), 9, no. 8.
3. Ibid.

2. FRAY JULIÁN OF ALCALÁ'S VISION OF THE ASCENSION OF THE SOUL OF KING PHILIP II OF SPAIN

1645–46. Oil on canvas. 66⅞ x 73⅝ in. (170 x 187 cm)
Sterling and Francine Clark Art Institute, Williamstown, Mass.

PROVENANCE: *Claustro Chico*, monastery of San Francisco, Seville; Marshal-General Nicolas Soult, duke of Dalmatia, Paris; M. G. de Guitaut, Paris; baron de Cabrol, Paris

EXHIBITIONS: London 1966, no. 14; Durham 1967, no. 69, ill.; Williamstown, Mass., 1978, 1983, 1988 [no catalogues]; Hanover, N.H., 1991, 453, no. 220, color pl. 16

SELECTED REFERENCES: Palomino 1724, 420; Ponz 1772–94, vol. 9, 97; Ceán Bermúdez 1806, 46–57; Réveil 1818–34, vol. 3, pl. 146; Thoré 1835, vol. 22, 47–48; Stirling-Maxwell 1848, vol. 2, 835; Tubino 1864, 273; Jameson 1867, 273; Blanc 1869, 16; Curtis 1883, 223–25, no. 268; 265, no. 383; Stirling-Maxwell 1891, vol. 4, 1631; Mayer 1913, xi; Angulo 1961, 2, pl. 2, fig. 2; Baticle 1964, 93–96; Braham 1965, 451; Mullaly 1966, 166–67, ill. 166; Kubler 1970, 11–31, pls. I and II; Butler 1970, 50, fig. 3; Angulo 1972, 55–57; Gaya Nuño 1978, 86, no. 11; Angulo 1981, vol. 2, 11–12, no. 8; vol. 3, pl. 15; Lehmann 1986, 39, fig. 6; Held 1997, 507–8, ill. 509

INSCRIPTION: *Precursor de sus gracias este /Santo Philipe sus mejor[es] /Dios ...aron /efimero ...ala /Notarlas des... lo que /Cico contestes sombras s... /En usa y otra repetida nube / Del segundo Philipo el Alma s[ube].*

The inscription along the bottom of the painting is barely legible. Today, when the climate and lighting controls in museums are rigorously monitored to assure the safety of works of art, it is amazing to think that the eleven narrative paintings created by Murillo for the monastery of San Francisco in Seville were actually intended to be installed out of doors. They were commissioned for the walls of the *claustro chico,* the "small cloister" of the huge monastery, to serve as continuous reminders of exemplary Franciscan lives, and there they hung for more than one hundred and fifty years. When Ponz saw them there in the late eighteenth century, he noted that some of the paintings were already in a poor state of conservation, though, he said, the damage had been done earlier. By Ponz's time, the Franciscans had installed curtains over the paintings, which were opened for art-loving visitors and on feast days.[1] Murillo's paintings remained in the *claustro chico* until the Napoleonic Wars; in 1810 they were removed to the Alcázar (the royal palace) in Seville for "safekeeping," destined for the museum of Spanish painting then planned by Joseph Bonaparte, the "intruder king" placed on the Spanish throne by his brother Napoleon. Four of the eleven works went to Paris with Marshal-General Soult, this painting among them.

Because the inscription was weather-damaged even before the beginning of the nineteenth century, after one hundred and fifty years of exposure, the subject of the Clark Art Institute painting has been disputed over the years. Ponz wrote that he was informed [*según me dixeron*] that the painting represented the soul of Philip II ascending to heaven, and Ceán Bermúdez, in 1806, concurred. However, by the time it was auctioned from the collection of Marshal-General Soult, the subject was described in the sales catalogue as representing the heaven-bound soul of Philip of Heraclea, who was martyred by fire in A.D. 304.[2] Stirling-Maxwell, in 1873, thought it represented Saint Philip Benizzi, a deacon of the church, to whom the Virgin appeared on a cloud

of fire. Mrs. Anna Jameson, in her *Legends of the Monastic Orders*, identified the gesturing figure as Saint Francis himself. In 1883 Curtis wrote: "Among so many tales the reader is sure to find one to suit him."[3] The matter is now put to rest. Ponz and Ceán Bermúdez, who had, after all, actually spoken with members of the Franciscan order living in the monastery, were correct. Diego Angulo Iñiguez found the story of the prophecy of Friar Julián of Alcalá, also known as Julián de San Agustín, told in the chronicles of the order written by Antonio de Daza only a few years after Julián's death and published in Madrid in 1682.[4] Although the subject of this work is obscure to viewers today, it would have been familiar to seventeenth-century Franciscans, and the inhabitants of the monastery of San Francisco might have identified with the young man in the dark habit of the order who gestures toward the brilliant apparition on the left of the painting as he reveals its meaning to the gentlemen on the right. So naturalistically are these figures depicted, that they might be an audience gathered from Murillo's Seville just outside the portals of the monastery. It is not impossible that the head of the young man at the upper right corner is a self-portrait of the young painter himself.

When this painting was on view in London in 1966,[5] it surprised an audience accustomed to quite a different Murillo: "This is not the Murillo that our grandparents idolised. The sombre colouring, the intense naturalism of the heads upon which a clear light falls, and the sharp outline of the drapery are in keeping with the taste of the moment. Indeed, the picture is reminiscent of Zurbarán, one of the spoilt darlings of our generation."[6] It had become a tradition to characterize Murillo's work as falling into three general styles: *frío* (cold), *cálido* (warm), and *vaporoso* (vaporous). The "Murillo that our grandparents idolised" was the master of color and gauzy effect of his mature, "vaporous," manner, so the painter's early work, with its firm contours and sombre colors—Murillo's "cold" style—was less

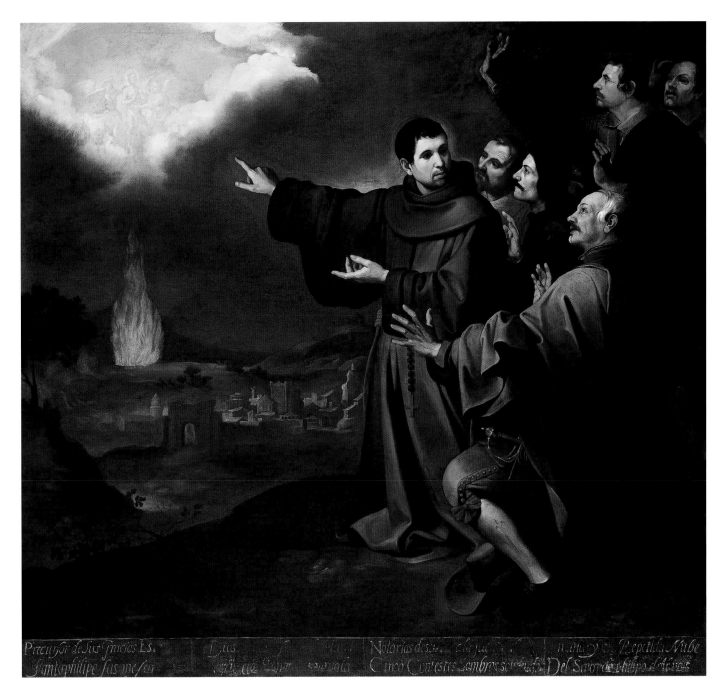

Precutsor de Jus Gracios Es. Dios Notarias desu... el qual n... y en Reperticia Nube
Santophilipe fus me/eu ...ge ... Cinco Contestes Lombres se... Del Senor de philipo de...

familiar to the public. However, it was, by the mid-twentieth century, a style more easily appreciated by eyes accustomed to abstract painting. The clearly defined forms, the unambiguous gesture of the young Franciscan and the rhetorical response of his audience, the brilliant light breaking through a steely sky to reveal the naked soul carried heavenward by angels—these elements speak to a modern viewer equally moved by the simple but powerful compositions of Francisco de Zurbarán.

NOTES:

1. Ponz 1772—94, vol. 9, 97: "uno, ú otro de estos quadros está ya muy maltratado, cuyo mal vendrá del tiempo pasado; pues al presente están muy bien guardados con sus cortinas, manifestándolos á los curiosos, é inteligentes, y descubriéndolos en dias festivas."

2. This interpretation was later taken up and defended by Kubler 1970, but his arguments are no longer accepted.

3. Curtis 1883, 265.

4. Angulo 1981, vol. 1, 252.

5. *Forty Paintings and Sculptures*. Exh. cat. Heim Gallery, London, November 1966.

6. Mullaly 1966, 166.

3. THE FLIGHT INTO EGYPT

c. 1647–50. Oil on canvas. 82½ x 65½ in. (209.6 x 166.4 cm)
The Detroit Institute of Arts, Gift of Mr. and Mrs. K. T. Keller,
Mr. and Mrs. Leslie H. Green, and Mr. and Mrs. Robert N. Green

PROVENANCE: Sir William Chapman (d. 1748); James Mendez; Micham sale, February 1756; Sampson Gideon, to his son Sir Sampson Gideon (later Lord Eardley), Belvedere, Erith, Kent; Lord Saye and Sele, London; Sir Culling Eardley; Mrs. Culling Hanbury, Bedwell Park, Hertfordshire; Sir Francis Fremantle; Maurice Harris

EXHIBITIONS: London 1822, no. 125; London 1845, no. 50; Manchester 1857, no. 643; London 1862, no. 16; London 1902, 93; London 1938A, no. 229; Madrid and London 1982–83, no. 7; Princeton 1982, no. 25

SELECTED REFERENCES: Martyn 1766, vol. 1, 14; Waagen 1854, vol. 2, 341; Bürger 1865, 129; Curtis 1883, 168, no. 127; Richardson 1948A, 78–80, ill. cover; Richardson 1948B, 362–67, ill.; Soria 1959, 275; Angulo 1961, 14; Braham 1965, fig. 6; Gaya Nuño 1978, no. 23; Angulo 1981, vol. l, 246; vol. 2, 208, no. 230; vol. 3, pls. 46 and 47

The painting entered British collections quite early, by the mid-1700s. It has been suggested that it was brought from Spain rolled, for it is framed in a magnificent Chippendale frame that must have been especially made for it in London in the mid-eighteenth century.[1] It is also possible that an impressive new frame was demanded by the grand space in which the painting was installed when it was in the collection of Sir Sampson Gideon at Belvedere, his country home in Kent. According to an early catalogue of his pictures, the *Flight into Egypt* and a Virgin of the Immaculate Conception by Murillo shared the drawing room ["which is 35 feet long, 30 wide, and 21 high"] with outstanding paintings by Veronese, Rubens, Quentin Metsys, Luca Giordano, and Tintoretto.[2]

When the work was exhibited in the Murillo exhibition seen in Madrid and London in 1982–83, the catalogue, noting that this painting was slightly preceded in date by the *Flight into Egypt* from about 1645 in the Palazzo Bianco in Genoa (fig. 1), added: "The two are very similar; the only slight difference is in the figure of St. Joseph." In fact, although the compositions are very alike, and are both undoubtedly based on a print of this very

popular subject, the subtle changes that Murillo did make are actually important ones. Examining them enables us to better understand the minute attention to details, particularly those of human interaction, that lent Murillo such power as a painter of devotional images.

Murillo made no obvious adjustments to his second painting, the one in Detroit; thus, the donkey is the same, the bundle of belongings carried on his haunches the same. However the physical relationship between Mary, Saint Joseph, and the child has been significantly altered. Mary holds the Christ child closer to her breast and leans her head closer to him. Saint Joseph stands nearer to her, and his gaze, rather than wandering heavenward as it does in the Genoa painting, is focused on his small family. He is altogether a more forceful figure, striding forward purposefully, and leading the donkey with a tauter rein. Murillo has closed the family circle and emphasized the role each plays. Although the compositions of the two paintings are clearly based on a single prototype, their impact on the viewer is markedly different.

NOTES:
1. Richardson 1948B, 367.
2. *A Catalogue, of Pictures; belonging to Sir Sampson Gideon, Bart. at Belvedere, in the County of Kent* (Anon., n.d.), 6.

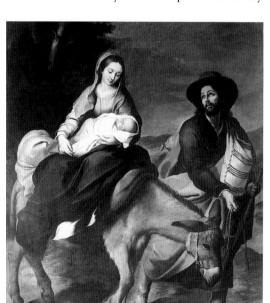

Fig. 1. Bartolomé Esteban Murillo. THE FLIGHT INTO EGYPT. c. 1645. Oil on canvas, 6'10¾" x 64¼" (210 x 163 cm). Palazzo Bianco, Genoa

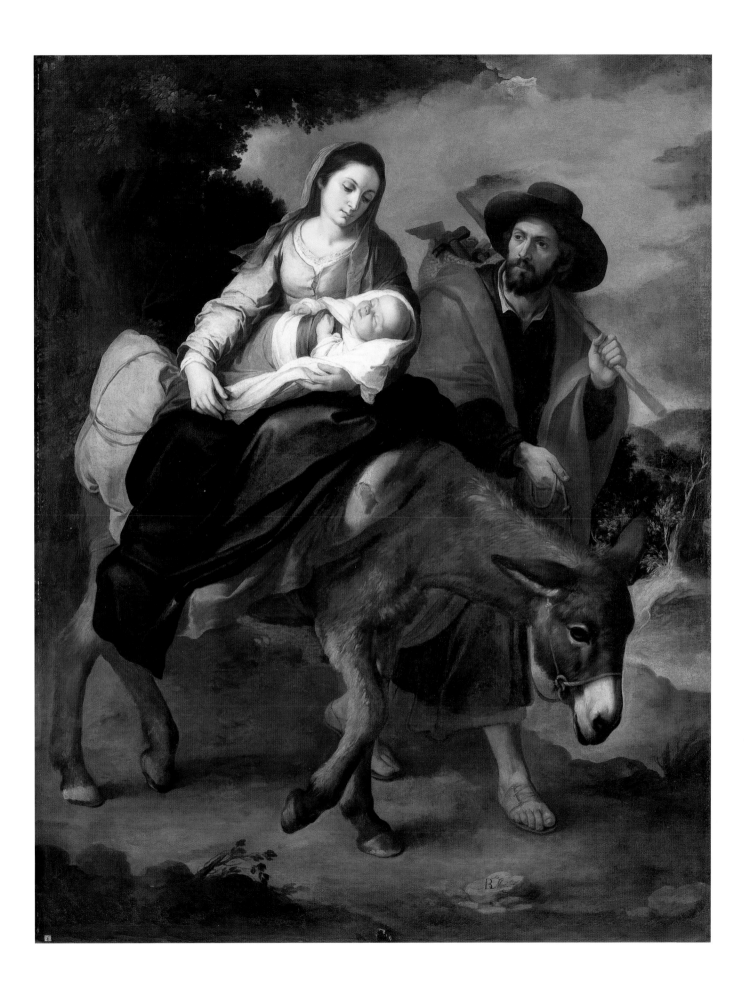

4. Saint Mary Magdalene Renouncing the Worldly Life

Early 1650s. 65¼ x 42¾ in. (165.7 x 108.6 cm)

Virginia Museum of Fine Arts, Richmond, The Adolph D. and Wilkins C. Williams Fund

PROVENANCE: John Elwick sale, Oxenham; Sir Francis Cook, Doughty House, London; Richmond, England; Sir Frederick Cook, Bart.; Sir Herbert Cook; A. and W. C. Williams gave it to the Virginia Museum of Fine Arts

EXHIBITIONS: None prior

SELECTED REFERENCES: Davies 1819, 100; Brockwell 1915, 160, no. 522; Anon. 1953, 253, 255, fig. 6; Virginia 1966, 75, ill.; Angulo 1981, vol. 2, 284, no. 361; vol. 3, pl. 93; Brown 1976, 87, 88, fig. 51; Young 1977, 448

This painting was in England by 1816, when it was sold by the picture dealer John Elwick. A few years later, in his book about Murillo published in 1819, Edward Davies suggested that the model for the Magdalene was Murillo's daughter Francisca, who had entered the convent of Madre de Dios in Seville: "She is tearing off her variegated dress previous to taking the veil. Being neither handsome, nor her dress otherways than gaudy, it is the least captivating of all his pictures."[1] (It is very unlikely, of course, that Murillo would paint his pious daughter in the act of tearing off her clothes.) A century later, when the painting was in the collection of Sir Frederick Cook in England, Maurice W. Brockwell wrote with more understanding that the Magdalene's "gaudy" dress (a yellow low-cut robe and white undergarment) and the jewels on the cushion on the ground represented "the vanities of the world that she has renounced."[2]

During the twentieth century, the authenticity of the painting in the Virginia Museum of Fine Arts has been questioned by a few scholars; however, the discovery of an early drawing that is clearly a study by Murillo for this painting (fig. 1) supports the attribution of the picture to the artist.[3]

This work is unusual among Murillo's depic-

tions of the Magdalene, for the artist has chosen an iconographic type different from others he painted, such as the example from San Diego in this exhibition (cat. no. 5) or the painting in the Academia de Bellas Artes de San Fernando, Madrid (cat. no. 5, fig. 1) or that in the National Gallery of Ireland, Dublin. This is not the Magdalene in her desert grotto, shedding tears of repentance. Indeed, since the Renaissance, it had been the custom to portray Mary Magdalene as a beautiful young woman, with the most sensuous examples, and the most artistically influential ones, emanating from the brush of Titian. When the young Florentine nobleman Baccio Valori visited Venice, he wrote: "There I met Titian, almost immobilised by age who . . . showed me a very attractive Magdalene in the desert. . . . I told him she was too attractive, so fresh and dewy, for such penitence. Having understood that I meant that she should be gaunt through fasting, he answered laughing that he had painted her on the first day she had entered [her repentant state], before she began fasting, in order to be able to paint her as a penitent indeed, but also as lovely as he could, and that she certainly was."[4]

Mary Magdalene was a favorite saint of the Counter-Reformation, for her story of sin and repentance illustrated for the faithful the efficacy of the sacrament of penance upon which the Catholic Church insisted and the Protestants denied. Saint Francis de Sales, in his *Introduction to the Devout Life*, stressed the Magdalene's role as a model of conversion and love, and he wrote about both the Prodigal Son and Mary Magdalene as repentant sinners whose example should inspire the devout to beg God's pardon for their own sins.[5]

Murillo's depiction of the Magdalene in the Virginia painting expresses her yearning for forgiveness and mystical union with God at the very moment she renounces worldly things and turns instead to an austere life dedicated to prayer.

Fig. 1. Bartolomé Esteban Murillo. STUDY FOR SAINT MARY MAGDALENE RENOUNCING THE WORLDLY LIFE. *Early 1650s. Red chalk, dimensions unknown. Collection unknown. Provenance: J. C. Robinson (Lugt no. 1433)*

NOTES:
1. Davies 1819, 100.
2. Brockwell 1915, 160.
3. Brown 1976, 87. See also Young 1977, 448.
4. Quoted from Haskins 1993, 245.
5. Ibid., 254.

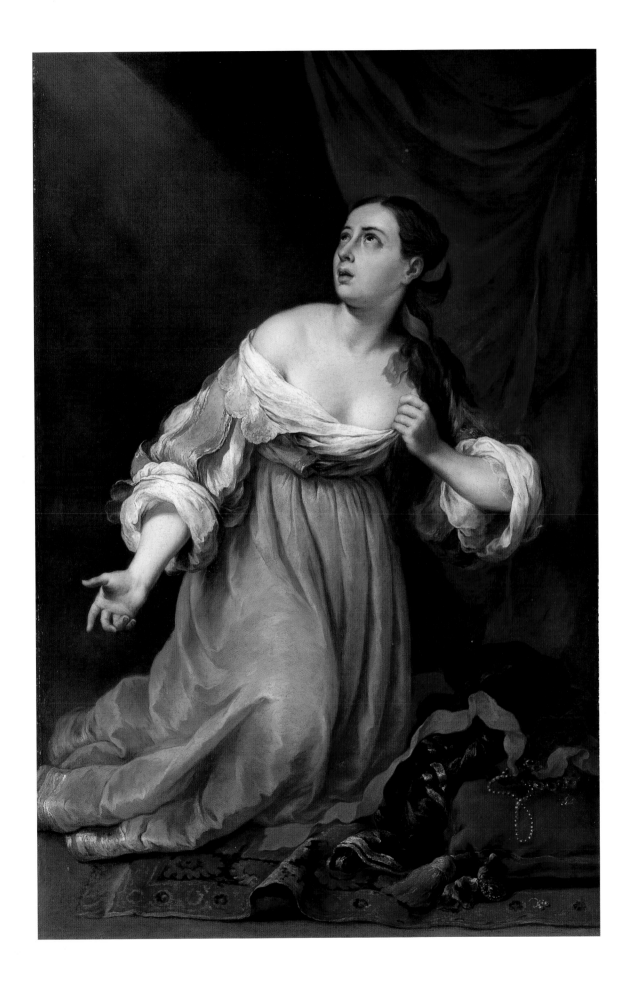

5. The Penitent Magdalene

c. 1650–55[1]. Oil on canvas. 63¼ x 41½ in. (160.7 x 105.4 cm)
San Diego Museum of Art, Gift of Mr. and Mrs. Henry H. Timken

PROVENANCE: King
Louis Philippe, Paris; Mr.
Wells, London; marqués
de Llano, Paris and
Madrid

EXHIBITIONS: Paris
1838–48, no. 159; San
Diego 1931, ill.; San Diego
1935, 30, no. 585; San
Diego 1936, 31, no. 360;
Los Angeles 1960, no. 17

SELECTED REFERENCES:
Ford 1853B, 1334; Poland
1931, 2–3; Siple 1932, 115;
Trivas 1941, 137; Andrews
1947, 92–93, illus.; Gaya
Nuño 1958, no. 1896;
Morse 1955, 116; San
Diego 1960, 93, ill. 94;
Petersen 1968, ill.; Morse
1979, 201; Gaya Nuño
1978, 117, no. 369; Angulo
1981, vol. 2, no. 362; vol. 3,
pl. 70; Wilson 1984, 259,
no. 212, ill. 260

In the New Testament, Mary Magdalene was a disciple of Christ, and a friend who was present at his Crucifixion. She witnessed his death and burial, and, in a significant role given to a woman, was the main witness to his resurrection. Seeing the stone removed from the opening to the sepulchre, she runs to find Christ's disciples, who find the tomb empty, and, not knowing that he is destined to rise again from the dead, they return to their homes: "But Mary stood without at the sepulchre weeping: and as she wept she stooped down, and looked into the sepulchre, and seeth two angels in white sitting, the one at the head, and the other at the feet, where the body of Jesus had lain." (John 20:11–12). Outside, she sees a man she assumes to be a gardener, and asks where they have taken Christ's body: "Jesus saith unto her, Touch me not; for I am not yet ascended to my Father: but go to my brethren, and say unto them, I ascend unto my Father, and your Father; and to my God, and your God. Mary Magdalene came and told the disciples that she had seen the Lord, and that he had spoken these things unto her." (John 20: 17–18)

The words of the resurrected Christ, "Touch me not," gives rise to the often painted subject called by its Latin name, *Nolo me tangere*, which shows the meeting of Jesus and the Magdalene in the garden. However, in the popular imagination, Mary Magdalene was always more closely associated with the story told in the *Golden Legend*, a woman who retired to a desert grotto to a life of penitential prayer, the weeping Magdalene whose image paralleled that of Saint Jerome, who also sought to earn eternal salvation through life as a penitential hermit. The San Diego painting of *The Penitent Magdalene* by Murillo includes an open book on the ground before the praying figure, a book that is a more obvious element in another version by the painter (fig. 1). The book, also frequently included in images of Saint Jerome, is symbolic of the contemplative life to which the Magdalene has retired.

Nakedness in religious paintings was frowned on by the promoters of orthodox Counter-Reformation iconography, but painters found ways in which to plausibly suggest the Magdalene's abstinence from jewels and rich garments while at the same time retaining her modesty. Murillo thus enveloped most of her body with a billowing drapery; her hands clasped in prayer cover her bosom, and her shoulders are covered by her long hair.

The Magdalene weeps for her sins, and so invites the pious viewer to weep in remorse for his own. She weeps over the dead body of Christ. Indeed, she is the mourner who has given the English language the word "maudlin," a seventeenth-century pronunciation of the French "Madeleine." Today the term connotes tearful sentimentality, but for seventeenth-century Catholics, the Magdalene's tears were an authentic and vivid sign of true repentance, and penance, the confession of sin followed by the forgiveness of sin, was, and is, a sacrament of the Catholic Church.

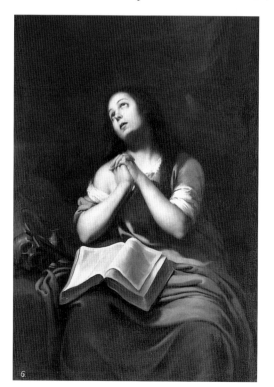

Fig. 1. Bartolomé Esteban Murillo. MARY MAGDALENE. *c. 1650. Oil on canvas, 63⅜ x 43″ (161 x 109 cm). Academia de Bellas Artes de San Fernando, Madrid*

NOTES:
1. Angulo, who knew this painting only from a photograph, thought that it probably dated from 1650–55, as do the versions in Dublin (Angulo 1981, vol. 2, no. 357) and the one formerly in Saint George's Church, New York (Angulo 1981, vol. 2, no. 360). It seems entirely possible, however, that it is a later reprise of the same popular subject.

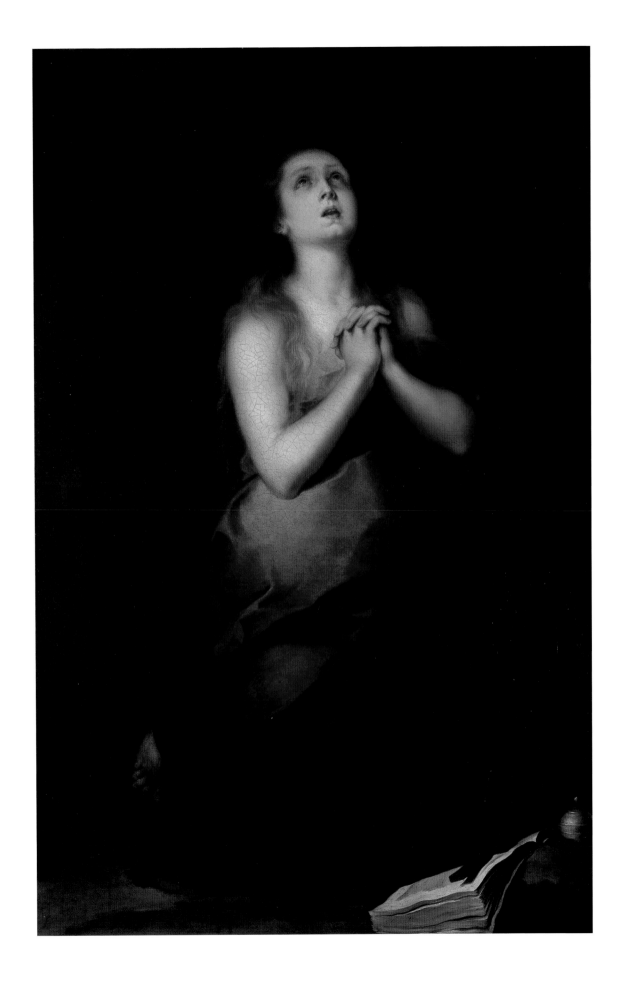

6. SAINT JOHN THE BAPTIST POINTING TO CHRIST

c. 1655. Oil on canvas. 106⅜ x 72⅝ in. (270.2 x 184.5 cm)
The Art Institute of Chicago, Louise B. and Frank H. Woods Purchase Fund

PROVENANCE: Refectory, monastery of San Leandro, Seville; Antonio Bravo, Seville; King Louis-Philippe, Paris; Antoine-Marie-Philippe-Louis d'Orléans; duque de Montpensier, Seville, Palacio de San Telmo, and Puy de Dôme, Château de Randon; Lt. Colonel Bullen, England

EXHIBITIONS: Paris 1838–48, no. 188; Madrid and London 1982–83, no. 22

SELECTED REFERENCES: Standish 1840, 183; Tubino 1864, 184; Minor 1882, 85; Curtis 1886, 190, no. 177; Alfonso 1883, 152; Stirling-Maxwell 1891, vol. 4, 1619; Calvert 1907, 13, 164; Carriazo 1929, 180; Soria 1960, 12–14, ill. 13; Gaya Nuño 1978, no. 41; Morse 1979, 201–2; Angulo 1981, vol. 2, 21–22; vol. 3, pls. 110–11; Baticle and Marinas 1981, 118; Paris 1983, 62 and fig. 121

INSCRIPTION: Upper left: *OMNES CREDERENT PER ILLUM* [John 1:7: That all men through him might believe]. Upper right: *HIC ERIT MAGNUS CORAM DOMINO* [Luke 1:15: He shall be great in the sight of the Lord]

This painting is one of four scenes from the life of Saint John the Baptist painted by Murillo for the Shod Nuns of Saint Augustine in the convent of San Leandro in Seville. The paintings are mentioned in a letter written by Francisco de Bruna y Ahumada to the conde del Aguila around 1781.[1] Three of the four paintings dedicated to the life of John the Baptist are known today: This one in the Art Institute of Chicago, the *Baptism of Christ* (fig. 1), and *Saint John the Baptist with the Scribes and Pharisees* (fig. 2). The fourth, which has disappeared, was described in the nineteenth century as "Saint John the Precursor," but its actual subject is unknown. Another painting by Murillo was also in the refectory; it represents *Christ Washing the Feet of Saint Augustine* (Museo de Bellas Artes, Valencia).

In 1812, as a result of the French occupation of Seville, the nuns sold the Chicago painting to Antonio Bravo, a wealthy cloth manufacturer who amassed a huge collection of paintings, more than eight hundred of them.[2] *Saint John the Baptist Pointing to Christ* was sold in 1837 by Bravo's brother Aniceto Bravo for the collection of Louis-Philippe in Paris. Bravo gave a receipt for the painting to one Luis Bouisson, on the account of the artist Adrien Dauzats, who accompanied Baron Isidore Taylor in Seville while the baron was acquiring Spanish paintings for the French king. When Louis-Philippe's collection was auctioned in London in 1853, this was one of the works purchased by the deposed king's son, the duque de Montpensier.

Like the slightly earlier series of paintings created by Murillo for the monastery of San Francisco (see cat. nos. 1 and 2), the works that decorated the refectory of San Leandro were probably installed at eye level. That is, they were not designed as part of an altarpiece, which would require great care as to the legibility of the compositions from a distance, a consideration that a

Top: *Fig. 1. Bartolomé Esteban Murillo.* BAPTISM OF CHRIST. *c. 1655. Oil on canvas, 7′7¾″ x 63″ (233.2 x 160.1 cm). Staatliche Museen zu Berlin, Gemäldegalerie*

Left: *Fig. 2. Bartolomé Esteban Murillo.* SAINT JOHN THE BAPTIST WITH THE SCRIBES AND PHARISEES. *c. 1655. Oil on canvas, 8′6¾″ x 70⅜″ (261.2 x 178.8 cm). Fitzwilliam Museum, University of Cambridge*

number of Murillo's later commissions would demand. Nevertheless, the style of the *Saint John the Baptist Pointing to Christ* is very different from the earlier paintings, and seems to respond to the need for clarity and readability in paintings for Spanish altarpieces. Strong chiaroscuro and a muted palette in the San Francisco pictures are replaced with clear, bright colors illuminated by the light of day. No composition could be simpler than these two figures of Saint John and Christ standing side by side, clearly defined against a verdant landscape with the Jordan River glistening in the distance. This economy of means is carried out as well in the companion pictures. In the *Baptism of Christ,* the large figures are shown close to the picture plane, their poses and gestures eloquent but restrained. *In Saint John the Baptist with the Scribes and Pharisees*, the anecdotal moment in the life of the saint is staged with only a few actors.

Murillo's talent for presenting an image with a minimum of fuss and a maximum of aesthetic appeal, perfectly exemplified by *Saint John the Baptist Pointing to Christ*, would serve him well in commissions for altarpieces to come, and in devotional paintings as well.

NOTES:
1. Carriazo 1929, 180. Bruna's description of the paintings in the refectory includes a *Last Supper* by Francisco Pacheco. The early descriptions of Sevillian religious houses by Ponz and Ceán Bermúdez do not mention these paintings because they were not aware of them. The nuns lived in seclusion—*in clausura*—and the refectory was thus not open to the public.
2. The other three paintings on the subject of Saint John were purchased by an English industrialist, Nathan Wetherell, who had a leatherworks factory in Seville. When he learned that Marshal-General Soult was coming for the pictures, Wetherell bought them from the nuns and hid them until the French left Seville. These were the paintings now in Berlin and Cambridge, as well as the missing picture.

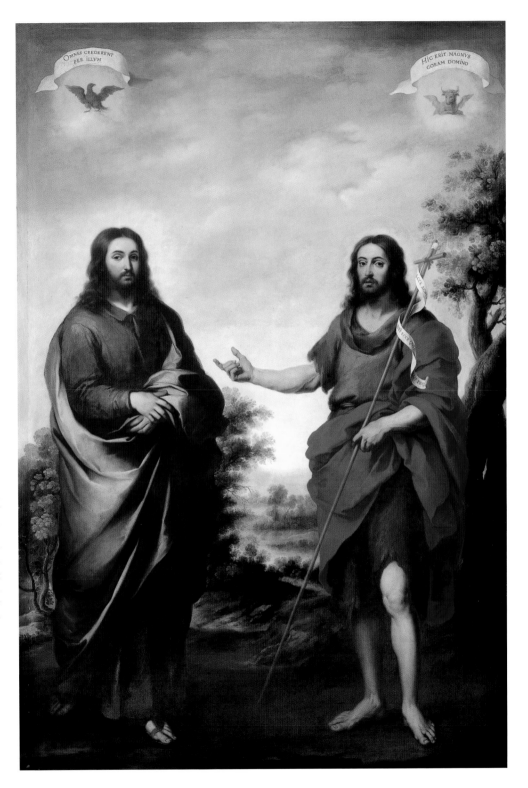

7. THE ADORATION OF THE MAGI

c. 1655–60. Oil on canvas. 75⅛ x 57½ in. (190.8 x 146 cm)
Lent by The Toledo Museum of Art, Purchased with funds from the Libbey Endowment, Gift of Edward Drummond Libbey

PROVENANCE: William Stanhope (later 1st earl of Harrington); 3rd duke of Rutland, Belvoir Castle, Leicestershire; by descent to the dukes of Rutland; Count Alessandro Contini-Bonacossi, Florence; anonymous owner

EXHIBITIONS: Rome 1930, no. 49; Madrid and London 1982–83, no. 28; Princeton 1982, no. 26

SELECTED REFERENCES: Eller 1841, 242–43; Waagen 1854, vol. 3, 398; Tubino 1864, 206; Curtis 1883, 167, no. 125; Stirling-Maxwell 1891, vol. 4, 1618; Manners 1903, 136, ill.; Suida 1930, 144; Mayer 1930, 308; Toledo 1976, 116, pl. 58; Brown 1976, 68, fig. 43; Gaya Nuño 1978, 90, no. 49; Angulo 1981, vol. 2, 206, no. 227; vol. 3, pls. 176 and 177; Mallory 1982–83, 95–99, fig. 6

The Adoration of the Magi was acquired by Colonel William Stanhope (later the 1st earl of Harrington) in 1729 when he was in Spain to conclude the Treaty of Seville; thus, this painting left Spain only forty-seven years after Murillo's death. Early collectors of paintings by Murillo were especially attracted to his genre paintings, but the religious works were clearly not disdained. Although the churches of Seville were most devastatingly sacked of their works of art at the time of the Napoleonic invasion, the clergy of poorer parishes had already begun this process before the war. Sometime during the eighteenth century, for example, the Seville church of Omnium Sanctorum (All Saints) had exchanged seven paintings by Murillo for what Ponz considered a really awful altarpiece.[1]

From around 1760 *The Adoration of the Magi* was in the collection of the dukes of Rutland, installed in the paintings gallery at Belvoir Castle, Leicestershire. In his *History of Belvoir Castle*, published in 1844, the Reverend Irvin Eller praised the painting "for its rich composition and brilliant colouring, which are perfect":

> The conception, colouring, and costume of this picture, are superb. The action takes place in a ruinous building, at the corner of which, above the heads of the figures, are seen some loose timbers, which in falling have arranged themselves in the shape of a cross. The Virgin, with an exquisitely simple expression of countenance, uncovers the Infant Christ, to whom the wise men (one of whom is kneeling) are making their respective offerings of myrrh, gold, and frankincense. Two children of surpassing beauty, especially the one looking out of the picture, stand behind as train-bearers. In the background are soldiers with spears.[2]

The painting remained the property of the dukes of Rutland until it was purchased by Count Alessandro Contini-Bonacossi in 1926. In 1930 it was shown in Rome in an "Exhibition of Old Spanish Paintings from the Collection of Count Contini Bonacossi In Aid of The Fascist Institute of Culture and National Institute C. Donati . . .

under the patronage of His Excellency Benito Mussolini,"[3] a curious, but interesting, venue.

A preparatory drawing for this painting is in a private collection in Paris.[4] It has been suggested that the composition of both the drawing and the painting is closely based on a 1620 engraving by Lucas Vosterman after Peter Paul Rubens's *Adoration of the Magi* (1615), now in the museum in Brussels.[5] It is indeed likely that Murillo was familiar with the print, from which he followed Rubens's composition in picturing the Virgin standing, holding the child over a rather long-legged manger. Otherwise, Murillo's painting is very dissimilar to Rubens's busy, highly animated rendering. It is much closer to the quiet verisimilitude of Velázquez's 1619 painting of the subject (Museo del Prado, Madrid) or Francisco de Zurbarán's version of about 1638–40 (now Musée de Peinture et de Sculpture, Grenoble). In fact, all three of these Sevillian painters use a perfectly conventional composition that required little in the way of outside influence.

Although in his early works, such as those painted for the monastery of San Francisco (see cat. nos. 1 and 2), and in the paintings of his maturity, Murillo's palette often tends toward sombre tonalities, the colors in *The Adoration of the Magi* are notably bright and clear, especially the golden tones of the robe of the kneeling king. Murillo has focused the viewer's attention on the Christ child by highlighting not only the babe and his swaddling clothes, but the ermine cape and white head and beard of the king who bends forward in recognition of the son of God.

The presence of the two young pages to the left of the composition reminds us of Murillo's frequent depictions of children, whether in genre paintings or in paintings of religious subjects such as this and the *Saint Thomas of Villanueva as a Child Dividing His Clothes among Beggar Boys* (cat. no. 19).

NOTES:
1. Ponz 1772–94, vol. 9, 79.
2. Eller 1841, 242–43.
3. Advertisement in *Art News Supplement* (April 26, 1930), which also noted that "Special reductions on the Italian Railways will be granted during the Exhibition."
4. Brown 1976, 68–69, no. 7.
5. Madrid and London 1982–83, 170, and Mallory 1982–83, 95–99.

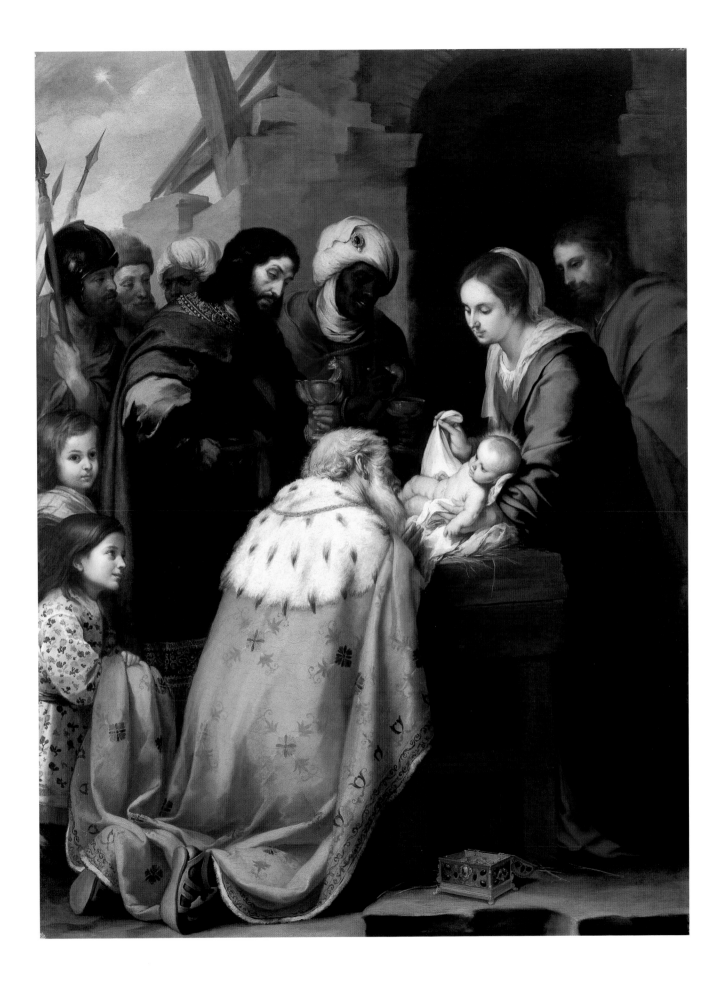

8. Virgin of the Immaculate Conception ("The Loja Conception")

c. 1655–60. Oil on canvas. 84 x 55⅜ in. (213.4 x 140.7 cm)
Algur H. Meadows Collection, Meadows Museum, Southern Methodist University, Dallas

PROVENANCE: Parish church, Loja, province of Granada; José Campos, Loja; Mr. R. Brooks, London; J. Osmaston, Esq., London; Sir W. Cuthbert Quilter, London; Hon. Fernando Berckemeyer, Lima, San Francisco, and Washington, D.C.

EXHIBITIONS: London, Palaeotechnic Gallery 1875, no. 106; London 1879, no. 132; London 1895, no. 122; London 1901, no. 84; London 1938B, no. 18; Indianapolis 1963, no. 53; The Spanish Pavilion, New York World's Fair, *Exhibition of Spanish Art* (April–October 1964); Corpus Christi 1979, no. 3; Madrid 2000, no. 13

SELECTED REFERENCES: Curtis 1883, 138, no. 50n; Tormo y Monzó 1915, 53, ill. opposite; Angulo 1961, 21–24, ill. pl. XXIII, fig. 39, and pl. XXIV, fig. 41; Muller 1963, 101; Wethey 1963, 207; Angulo 1974, 103–4, fig. 6; Brown 1976, 82–83; Gaya Nuño 1978, 94, no. 91; Angulo 1981, vol. 1, 314; vol. 2, 111–12, no. 104; vol. 3, pls. 99 and 100; López Rey 1987, 20, ill. 18.

Seville having taken the lead in the dispute, it is natural that some of the most perfect conceptions of Murillo and Alonzo [*sic*] Cano should have been devoted to the embodying of this incorporeal mystery; and never has dignified composure and innocence of mind, unruffled by human guilt or passion, pure unsexual unconsciousness of sin or shame, heavenly beatitude past utterance, or the unconquerable majesty and "hidden strength of chastity," been more exquisitely portrayed. The retiring virgin loveliness of the blessed Mary seems to have stolen so gently, so silently on her, that she is unaware of her own power and fascination.[1]

Richard Ford, Hispanophile and author of the *Handbook for Travellers in Spain* published in 1845, might well have been describing this very painting, an early version of a subject that Murillo turned to over twenty times. "The dispute" Ford mentioned was the theological argument about whether the

Fig. 1. Bartolomé Esteban Murillo. STUDIES OF PUTTI FOR THE VIRGIN OF THE IMMACULATE CONCEPTION AND OF THE HEAD OF THE VIRGIN MARY WEEPING. *c. 1655–60. Pen and brown ink (putti); black and red chalk (head of Virgin), 11⅛ x 7¾" (28.4 x 19.8 cm). The British Museum, London*

Virgin Mary had been sinlessly, "immaculately" conceived, untouched by Original Sin (there was no question about the sinless conception of her son Jesus Christ). Some churchmen, especially members of the Dominican order, rejected the idea; others, notably the Franciscans, fought hard to have the doctrine of the Immaculate Conception of the Virgin declared dogma. The struggle of the proponents of the doctrine required perseverance: it began in the Middle Ages and did not end until the Immaculate Conception was declared a dogma of the Roman Catholic church in the mid-nineteenth century.

Spanish theologians played a major role in the controversy through the centuries and the doctrine received support from the Spanish Habsburg rulers of Spain. Innumerable depictions of the subject were created by Spanish sculptors and painters, especially during the seventeenth century,[2] but no artist received more commissions to paint the Virgin of the Immaculate Conception than Murillo.

When a definitive iconography of the doctrine was evolving in the sixteenth century, the Virgin often appeared surrounded by symbols taken from the Marian litanies. These were eventually reduced to several: the rose of Sharon and the lily of the valleys (Song of Solomon 4:4), an olive branch, the spotless mirror (*speculum sine macula*, Wisdom 7:26) among the favorites. She is pictured "fair as the moon, clear as the sun" (Song of Solomon 6:10) and as the woman of the Apocalypse, described in Revelation 12:1: "And there appeared a great wonder in heaven: a woman clothed with the sun, and the moon under her feet, and upon her head a crown of twelve stars."

By the time Murillo painted the "Loja Conception" in the mid-seventeenth century, artists could dispense with a panoply of signs and symbols: everyone knew that this image represented the Virgin Immaculate. Although many of

Murillo's early works are marked by a rather dark palette, this subject, with its heavenly locale, demanded a brighter, lighter range of hues. Nonetheless, there are other characteristics of the style that enable us to place the "Loja Conception" early in the artist's career. If we compare this painting to a later version of the same subject, as we are able to do in this exhibition (see cat. no. 28), it is clear that Murillo is here still creating figures with clear contours and carefully defined volumes. The "Loja Conception" is also notable for the stillness of the figure of the Virgin Mary, suspended in the heavens upon the crescent moon, quite unlike the Cleveland figure, who seems to soar heavenward.

Although Murillo painted this subject many times, he was remarkably adept at individualizing images of an iconic type. A drawing in the British Museum (fig. 1) of the little angel pictured at the lower left shows how the artist attentively considered each detail of the composition so that the resulting painting would be unique.

NOTES:
1. Ford 1845, vol. 1, 401.
2. Stratton 1994, passim.

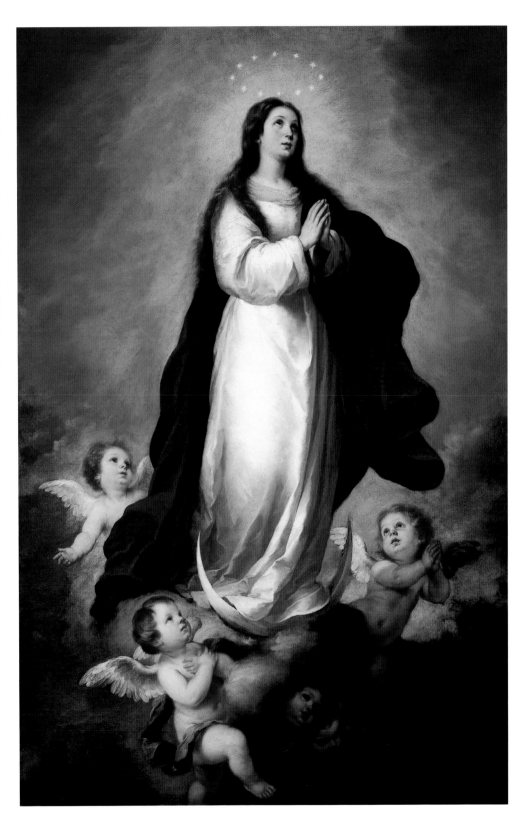

9. CHRIST ON THE CROSS

Early 1660s. Oil on canvas. 82¼ x 44½ in. (208.9 x 113 cm)
The Putnam Foundation Collection, Timken Museum of Art, San Diego

PROVENANCE: Kaunitz collection, Vienna; Count Jan Rudolf Czernin, Vienna; Putnam Foundation

EXHIBITIONS: Bern 1947, cat. no. 31; Sion 1951, cat. no. 27; National Gallery of Art, Washington, on loan 1957–65; Timken 1969, ill., n.p.

SELECTED REFERENCES: Viardot 1844, 273; Waagen 1866, 303; Curtis 1883, 203, no. 219d.; Alfonso 1886, 219, n. 1; Baedeker 1884, 323; Justi 1892, 70; Frimmel 1898–1901, vol. 1, pt. 3, 108; Justi 1904, 72; Calvert 1907, 123 and pl. 56; Mayer 1913A, ill. 95; Frimmel 1913–14, vol. 2, 344, no. 98; Wilczek 1936, 60, no. 48; Mongan 1969, 86–87, 128, no. 32, ill.; Gaya Nuño 1978, 101, no. 162; Angulo 1981, vol. 2, 226, no. 268; vol. 3, pl. 398; San Diego 1983, 66–67, 124, no. 24, ill.; San Diego 1996, 42–45, ill. 42 and 44

The history of this impressive painting can be traced back to the eighteenth or early nineteenth centuries in Vienna. Prince Wenzel Anton Kaunitz-Reitberg was an outstanding statesman, patron of the arts, and collector. The Akademie der Bildenden Künste in Vienna was under Kaunitz-Reitberg's protection and his palace in that city, the Kaunitz-Esterházy-Palais, housed his extensive art collection. By the time of his death in 1794, Kaunitz-Reitberg had acquired around two thousand pictures. Chancellor Kaunitz's son, Dominik Andreas, was an ambassador to Madrid from 1744 to 1779, and was followed in that post by his brother, Joseph Clemens, who died in 1785. The chancellor's grandson, Prince Alois Wenzel Kaunitz, held a diplomatic post in Madrid until 1806, but spent time there again during 1815 and 1816, when he acquired Francisco Goya's *Knife Grinder* and *Water Seller*, both now in the Budapest Museum of Fine Arts.[1] It is not known which member of the family purchased Murillo's *Christ on the Cross,* which was sold at auction in 1820 (the Kaunitz collection was dispersed between 1820 and 1830) to Count Jan Rudolf Czernin.

Czernin, who served as president of the Viennese academy between 1823 and 1827 and was responsible for the royal collection at the imperial court from 1824, was perhaps an even more discerning collector than Kaunitz-Reitberg. He acquired Jan Vermeer's *Artist in His Studio* (Kunsthistorisches Museum, Vienna), Titian's *Portrait of the Doge Gritti* (National Gallery of Art, Washington), as well as other major masterpieces, including Murillo's *Christ on the Cross.* For a century following Jan Rudolf's death,

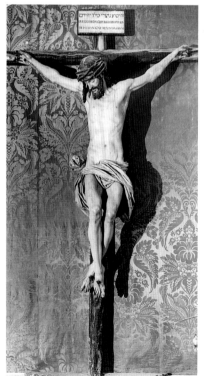

Fig. 1. *Juan Martínez Montañés.* CRISTO DE LA CLEMENCIA. *1603. Polychromed wood, height: 6′2¾″ (190 cm). Seville Cathedral, Sacristy of the Chalices*

his palace was open to the public during the winter months. In 1954, some of the Czernin collection was moved to the Residenzgalerie in Salzburg, and some was dispersed. The Putnam Foundation acquired this painting in 1955.

The great (and not so great) painters of Spain all created versions of the subject of Christ on the Cross, or the Crucifixion. From seventeenth-century Seville, Francisco de Zurbarán's painting of 1627, now in the Art Institute of Chicago, is impressive for its sober realism. A few years later, about 1631–32, Diego Velázquez, who had moved to Madrid from his native Seville about a decade earlier, painted a version that followed, as did Zurbarán's, the placement of the feet of Christ side by side, attached to the *supedaneum* with two nails. This followed the recommendation of Velázquez's teacher, Francisco Pacheco, who would later, in 1649, publish in his *Arte de la pintura* prescriptions for the most orthodox way in which to paint a variety of religious subjects.

Pacheco himself, however, had painted the polychromy of the sculptured Christ on the Cross, called the "Christ of Clemency," carved by Juan Martínez Montañéz in 1603 (fig. 1), in which the feet of Christ are crossed, as seen later in Murillo's painting presented here. This arrangement of the limbs of Christ creates a much more dramatic effect (the paintings by Zurbarán and Velázquez project a greater sense of stillness) and is followed by Murillo, who also intensifies the sense of drama by having Christ turn his face to heaven. In Murillo's painting, Christ is not dead, but rather shown at the moment he utters the painful words recorded in Matt. 27:16: "My God, my God, why hast thou forsaken me?" In Spain, this type of "Christ on the Cross" was understood to picture this particular moment, as in the sculptured *Cristo del Desamparo* (Christ Forsaken) by an unknown Spanish sculptor of the seventeenth century (Iglesia de Escurial, Cáceres). This culminating scene of the Passion of Christ was pictured in Spanish art at various moments and what we now tend to think of as simply a representation of "Christ on the Cross," or "the Crucifixion," had, for the pious patrons of the seventeenth century, a variety of invocations and cults. A sculpture or painting could represent *Cristo del Desamparo,* or *Cristo de la*

Agonía, or *Cristo de la Expiración*, or, as in the famous work by Martínez Montañés, *Cristo de la Clemencia*. In the case of the latter, we know from the contract for the commission that the patron, Mateo Vázquez de Leca, the archdeacon of Carmona, was very specific about how Christ should look. He was "to be alive, before he had died, with the head inclined towards the right side, looking to any person who might be praying; and therefore the eyes and the face must have a rather severe expression, and the eyes must be completely open."[2]

Although we do not have such specific information about the commissions for the three Murillo "Crucifixions" in the present exhibitions (see also cat. nos. 21 and 26), it is possible that they were all for private patrons (none of Murillo's large commissioned altarpieces seem to have included this subject), and that those patrons requested that Christ be shown at the moment he addresses his Father (Timken Museum of Art), at the moment of expiration (cat. no. 26), or as a narrative scene including mourning figures (cat. no. 21). Murillo responded with his customary facility for compositional variations of the same or similar subjects.

The Timken painting is a fine example of Murillo's mature style. The luminous figure of Christ is set against a dark background in which the shadowy outlines of the city of Jerusalem may be discerned. In the foreground, the skull of Adam signifies the hill of Golgotha upon which the cross stands. The colors are subdued, with Christ's pale flesh softly illuminated against the gray sky, and the technique is gentle, the forms created by soft strokes of the brush. Only enough touches of gore are used to underscore the reality of imminent death. A golden glow around the thorn-crowned head of Christ calls the viewer's attention to his emotional plea to his Father.

NOTES:
1. Takács 1975, 115–18.
2. Proske 1967, 40.

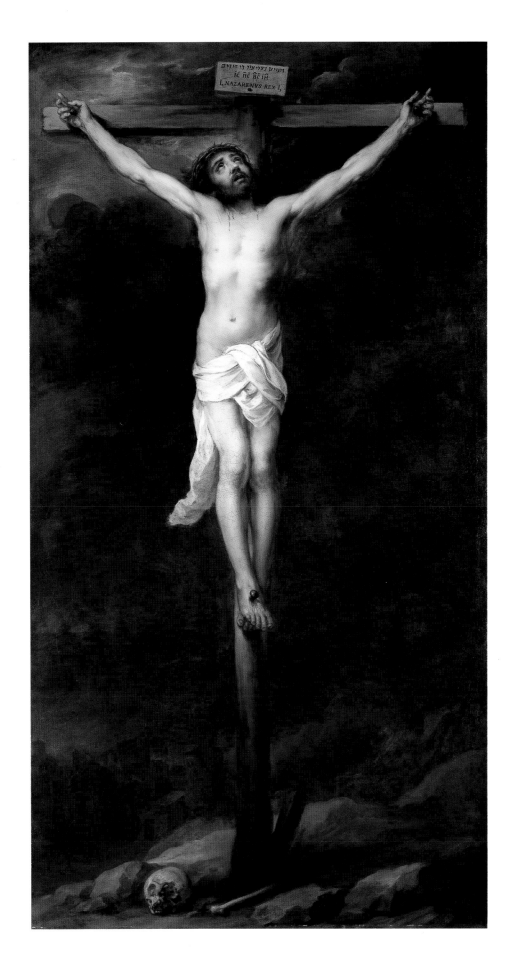

10. CHRIST CARRYING THE CROSS

c. 1660–65. Oil on canvas. 60 x 83 in. (152.4 x 210.8 cm)
Philadelphia Museum of Art, Wilstach Collection

PROVENANCE: Giuseppe Capecelatro, archbishop of Taranto, Naples; earl of Orford, Wolterton; J. E. Fordham; Gribble; Wilstach Collection, Philadelphia

EXHIBITIONS: None prior

SELECTED REFERENCES: Staël [1805], 525; Waagen 1854, vol. 3, 435; Jameson 1857, 284; Curtis 1883, 201, no. 213; Wilstach 1904, 63, no. 181, ill.; Paris 1963, 169; Angulo 1981, vol. 2, 223, no. 261; vol. 3, pl. 337; Paris 1983, 37

Titian painted the second picture; it is of Jesus Christ collapsing under the weight of the cross. His mother is coming to meet him. She kneels down when she sees him. How wonderful a mother's respect for her son's misfortunes and divine virtues! What a look in Christ's eyes! What divine resignation and yet what suffering, and through his suffering what sympathy with the human heart! This is undoubtedly the finest of my pictures. This is the one to which I continually return, without ever being able to exhaust the emotion it arouses.[1]

Madame de Staël visited the archbishop of Taranto, a very cultivated man with an impressive art collection, when she was in Italy in 1805. She recorded her impressions of this painting, which she erroneously attributed to Titian, in her travel journal. Several months later, when she began writing the novel *Corinne, or Italy*, she described the painting, as above quoted, as in the imagined art collection of the book's heroine.

Subsequent impressions of the painting echo Madame de Staël's sensitive reaction to this quietly moving subject. In 1854, when the picture was in the collection of the earl of Orford, Waagen wrote: "This picture proves that, in the sphere of feeling, art can attain even by means of realistic forms the highest excellence. In the head of the Virgin, namely, sorrow of the intensest and most noble and most resigned character is expressed; while the pale but delicate and transparent colouring is in the finest harmony with the subject."[2]

Only two paintings of this subject by Murillo are known today, this one and

Fig. 1. Bartolomé Esteban Murillo. CHRIST CARRYING THE CROSS. *Oil on canvas, 49¼ x 57½" (125 x 146 cm). Musée Thomas Henry, Ville de Cherbourg*

another in Cherbourg, France, given to the city by the art expert Thomas Henry in 1835 (fig. 1).[3] Only two paintings of this subject have been attributed to Murillo in early descriptions of the artistic treasures of Seville. In his travel book published in 1749, Udal ap Rhys mentions, in the cathedral of Seville, "The History of Christ bearing his Cross, in the Arch of the *Sagrario de la Torre*," a painting he claims to have been painted by Murillo, but is not mentioned by later writers.[4] Ponz noted only one version of the subject by Murillo, a *Jesús Nazareno* in the convent of the Merced Descalzada in Seville, then in the reliquary chapel opposite a sculptured *Jesús Nazareno con la Cruz a cuestas* by Juan Martínez Montañés.[5]

In Spain, this subject was closely associated with religious processions in which sculptures such as Martínez Montañés's *Jesús de la Pasión* (fig. 2), and similar images variously called *Jesús del Gran Poder*, *Jesús Nazareno*, or *Nazareno de la Divina*, were borne through the streets by the faithful during Holy Week.[6] Murillo's paintings obviously are intended for a more private devotional response than the public outpouring of piety inspired by processional images, and his *Christ Carrying the Cross* is a severely reduced composition as compared to paintings of the High Renaissance. The multifigured narrative scenes portrayed by Raphael, for example, in the so-called *Spasimo de Sicilia* (Museo

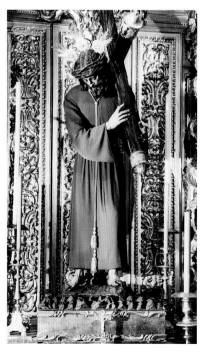

Fig. 2. Juan Martínez Montañés. JESÚS DE LA PASIÓN. *c. 1619. Polychromed wood. Church of El Salvador, Seville*

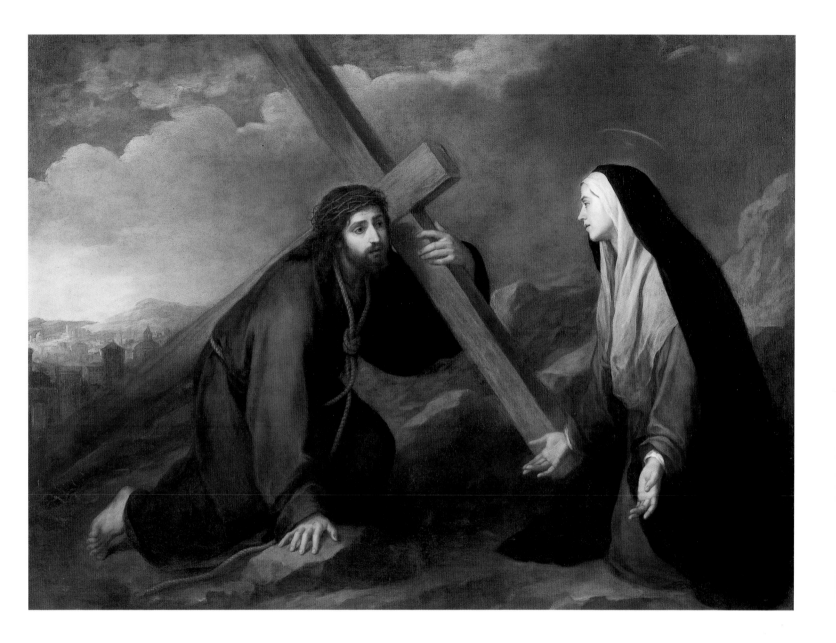

del Prado, Madrid), are reinvented by Murillo as a highly focused image of a mother's anguish. The subdued blue-gray tonalities and delicate sfumato effects perfectly express the quiet pain radiating from the constrained figures.

This painting is particularly appropriate to an exhibition dedicated to Murillo's work in American collections, for its presence today in the Philadelphia Museum of Art reflects the educational and philanthropic spirit in which North American museums were founded and filled with works of art. W. P. Wilstach and his wife formed a large collection of paintings that they bequeathed to a Philadelphia museum not yet built.

In her 1890 will, Mrs. Wilstach expressly stated: "I give and bequeath to the City of Philadelphia all my paintings, engravings, statuary . . . as the nucleus or Foundation of an Art Gallery for the use and enjoyment of the people."[7] Murillo's *Christ Carrying the Cross* was one of the Wilstachs' gifts to the public.

NOTES:
1. Staël 1998, 151–52.
2. Waagen 1848, vol. 3, 435.
3. Paris 1983, 60.
4. ap Rhys 1749, 111.
5. Ponz, vol. 9, 108.
6. See Webster 1998, passim.
7. Wilstach 1904, 6.

11. CHRIST AT THE COLUMN

c. 1660–65. Oil on panel. 12⅜ x 6 in. (31.5 x 15.2 cm)
Private collection
[Fort Worth venue only]

Although no large-scale work of this subject by Murillo is known, a very small painting described as *"un quadro de Xpto a la coluna"* was inventoried in the artist's studio when he died in 1682.[2] Without specifying whether the "picture" was a canvas or a panel, the inventory gave its approximate size as 1/2 *vara* (42 cm) and said that it was in a frame that had not yet been gilded (the measurements may have included the frame).

The iconographical type of Christ at the Column is closely related to other themes represented in this exhibition, such as the subject of Christ after the Flagellation, in the act of gathering his garments (see cat. nos. 12 and 22), or the Ecce Homo (see cat. no. 27)—both of them moments described in the Passion of Christ. Murillo's one

1. Alonso Cano. CHRIST AT THE COLUMN. 1631–32. Oil on panel, 15 x 7″ (38 x 18 cm). Tabernacle, Parish church, La Campana

other depiction of Christ at the Column was in another small painting, in the Louvre, which is executed on a slab of obsidian (see fig. 62 and discussion in the essay by Jordan in this catalogue). In that work, Christ is accompanied by the kneeling figure of the penitent Saint Peter, whose emotional reaction to the vision of Christ before him calls the viewer to prayer by example.

There was no shortage of examples upon which Murillo might have based this depiction of Christ at the Column. Perhaps the closest parallel to his image is an equally small panel, executed in 1631–32 by the Sevillian Alonso Cano and still in situ as the door to the tabernacle in the parish church of La Campana (fig. 1).[3] Murillo's composition is so close to Cano's that it is difficult to believe he did not know it. Nevertheless, the two artists' conceptions of the figure diverge significantly. In Cano's *Christ at the Column*, a relatively early work in his oeuvre, the figure is almost mannered in its slenderness; Murillo's is a robust figure, clearly informed by what the artist had learned from drawing from the life, which he advocated in the Academy. Its musculature is defined by a strong contrast of light and dark. Despite its tiny scale, the painting powerfully projects a moving duality between Christ's humiliation and his innate dignity.

In its execution, this picture is close to the even smaller panel, *The Holy Family in the Carpenter's Shop*, of 1660–65, in the Hermitage (see fig. 67 and discussion in the essay by Jordan in this catalogue). But perhaps what they have most in common is the idea that such a moving work can be small enough to hold with one hand. WBJ

NOTES:
1. An old handwritten label on the reverse of the panel indicates that the painting was part of the collection of "F. H. Standish," who, of course, bequeathed his Spanish paintings to King Louis-Philippe of France in 1841. The picture was not among these, however; nor was it in the sale of the Standish collection at Christie's, May 27–28, 1853, held after the death of Louis-Philippe. It is possible that the painting was not then attributed to a Spanish artist, in which case it would not have been among this group.
2. Angulo 1981, vol. 2, 445, no. 1523: "Un quadro de Xpto a la coluna con moldura por dorar, de media vara de largo."
3. Wethey 1955, 148, fig. 15 (showing the whole tabernacle); ed. 1983, 111, no. 3, fig. 43 (illustrating only the painting).

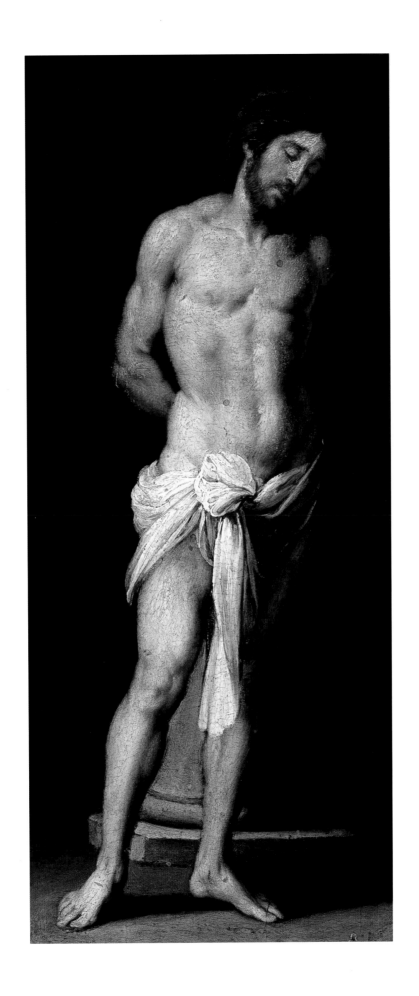

12. Christ after the Flagellation, Consoled by Angels

After 1665. Oil on canvas. 44½ x 58 in. (113 x 147.4 cm)
Museum of Fine Arts, Boston, Ernest Wadsworth Longfellow Fund, 53.1

PROVENANCE: Noel Desenfans, London; [Manuel Godoy, Príncipe de la Paz, Rome and Paris?]; marquis de Montcalm, Montpellier; S. M. Mawson, England; Sir Francis Cook, 1st Bart., Doughty House, Richmond, Surrey; Sir Frederick Lucas Cook, 2nd Bart., Doughty House, Richmond, Surrey; Sir Herbert Frederick Cook, 2nd Bart., Doughty House, Richmond, Surrey; Sir Francis Ferdinand Maurice Cook, 4th Bart.

EXHIBITIONS: London 1802, vol. 1, no. 47; London 1895, no. 148; London 1902, no. 80; London 1913–14, no. 188; Minneapolis Institute of Arts, *Venetian Tradition*, 1957; Dallas Museum of Fine Arts, *Religious Art of the Western World*, 1958

SELECTED REFERENCES: Robinson 1868, 48–51, no. 31; Curtis 1883, 201, no. 212; Mayer 1913A, 94; Mayer 1913B; Brockwell 1915, 159–60, no. 521, pl. 23; Anon. 1953, 253; Seligman 1961, pl. 98; Gaya Nuño 1978, 101, no. 161; Angulo 1981, vol. 2, 216–17, no. 245; vol. 3, pl. 327; González de Zárate 1994, 59, fig. 3 [as in Cambridge, Mass]; Seville 1996, 56–57, ill. 57; Navarrete Prieto 1998, 173, fig. 298

In his *Meditaciones* published in 1620 the Toledan mystic Alvarez de Paz wrote: "Untied from the column, great weakness caused you to fall upon the ground. You were so drained of lost blood that you could not stand up. Pious souls contemplate your dragging yourself along the ground, wiping up your blood with your body, searching for your garments to one side and another."[1] In Murillo's painting the two angels to the right of the composition, clad in white and mulberry-colored draperies, are the "pious souls" who witness Christ's suffering. He is pictured naked but for a cloth around his loins, kneeling on the ground in search of his garments, which lie in the foreground to the right. To the far left of the horizontal composition is the column with the rope and rods, the instruments of his torture.

It has recently been shown that Murillo based the poses of the angels and their garments on prints, borrowing a little from Jacob Matham's *Madonna and Child*, after Abraham Bloemaert (fig. 1), and a bit from Jan Muller's *Minerva and Mercury Arming Perseus for His Encounter with Medusa*, after

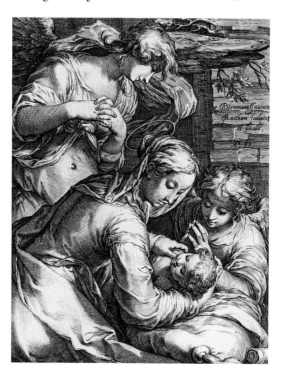

Fig. 1. *Jacob Matham (1571–1631).* MADONNA AND CHILD, AFTER ABRAHAM BLOEMAERT. *Print, 5¾ x 4½″ (14.6 x 11.2 cm).* © *The British Museum, London*

Bartholomeus Spranger (fig. 2).[2] Although Murillo would continue to use prints as compositional sources throughout his career, he usually introduced them into his compositions with a more subtle touch than in this midcareer work. Here, the unidealized, naturalistic figure of the suffering Christ seems to be from a world other than that of the highly mannered (though lovely) poses, delicately turned forms, and dramatic gestures and expressions of his witnesses.

This painting left Spain at a very early date, perhaps before 1779, when Carlos III issued an edict prohibiting the exportation of pictures from Spain, an edict especially aimed at the disappearing numbers of paintings by Murillo. It was acquired before the end of that century by Noel Desenfans, one of the most active importers of old master paintings into England:

> . . . in his double capacity of consul and picture-dealer, he was commissioned to form a collection of pictures for the King of Poland, Stanislaus Augustus Poniatowski, a well-known amateur and patron of art; but Stanislaus died before the pictures could be delivered, and the partition of Poland ensued, whereupon they were thrown on Desenfans' hands. Upon this, in 1802, he exhibited them in a great room in Berners Street, with a view of selling the collection in detail. . . .[3]

Desenfans was an early great admirer of Spanish painting. In his memoirs he wrote: "Spain has produced but three famed painters; Morales the Divine, the great Valesquez [*sic*], and Murillo, the favourite of all our collectors. Spain has thought it good policy to retain most of their works; so that few of them being dispersed they have brought that country less gold than the Peruvian mines, but have done her infinitely more honour."[4]

In his sale catalogue, Desenfans described the Boston painting in eloquent language:

> The painter offers us, in this truly moving performance, the Saviour of the world, reduced for our sins, to the abject condition of a vile culprit naked and trembling,

and in the most excruciating torments, yet that dignity and sweetness, that patience and resignation with which the Son of God went through the whole of his passion, are so well expressed in his countenance, that our feelings are the more worked upon at the sight of such humility and goodness. But the wise and religious artist, who was no doubt affected by his own work, has taken care to relieve us in some degree, for at the very moment that, fatigued and exhausted, the tyrants have left our Saviour in the utmost misery, he has, like another Parmegiano [*sic*], and with no less power, introduced two celestial beings, two fervent angels, who are comforting Christ, and sympathising with his pains. It was, as is well known, on subjects of devotion, that the devout Murillo excelled.[5]

Most of the paintings that Desenfans had acquired were left by him to Sir Francis Bourgeois [d. 1811], who in turn left them to Dulwich Col-

lege, where they formed the nucleus of the Dulwich Art Gallery. Other works were sold and dispersed, including this painting. By 1883 *Christ After the Flagellation, Consoled by Angels* was in the Cook collection at Doughty House, Richmond, Surrey, and there it remained until about 1953, when it was purchased by the Museum of Fine Arts, Boston. Its history between 1802 and 1883 is not entirely clear. It is possible that it was the painting sold by the marquis de Montcalm in Paris in 1850. It is probable that it was sold with the collection of S. M. Mawson in London in 1855. In that sales catalogue it was described as having belonged to "the Prince de la Paix." Isadora Rose de Viejo, whose work in progress, *The Second Painting Collection of Manuel Godoy, Prince of the Peace, in Rome and Paris*, she has kindly shared, thinks that Godoy might have acquired the painting in Rome by 1828, and shipped it to Paris in 1830 "where it would have been purchased by Mawson, perhaps at the 1834 rue de Gros-Chenet auction. . . . The possibility remains that Mawson's stated provenance for the painting was questionable."[6]

We do not, of course, need to be sure of every detail of a painting's history in order to take great pleasure in it. When the painting was exhibited in London in 1913, Sir Claude Philips aptly described it thus: "No doubt an early work is the 'Christ After Flagellation, Comforted by Angels' —a beautiful piece, undoubtedly Murillo's though of a truly tragic pathos, high above mere sentimental tenderness, such as we expect to find in Ribera and Zurbarán, rather than in the gentle painter of Madonnas."[7]

NOTES:
1. See Princeton 1982, 94.
2. Seville 1966, 56–57, and Navarrete Prieto 1998, 171–73.
3. Robinson 1868, 49–50.
4. *Memoirs of the late Noel Desenfans* (1810), quoted by Robinson 1868, 67–68.
5. Quoted from Robinson 1868, 49–50.
6. Correspondence, October 12, 2000.
7. *Daily Telegraph*, October 28, 1913, n.p.

Fig. 2. Jan Muller (1571–1628). MINERVA AND MERCURY ARMING PERSEUS FOR HIS ENCOUNTER WITH MEDUSA, AFTER BARTHOLOMEUS SPRANGER. *Print, 24 x 15½″ (60.7 x 39.6 cm).* © *The British Museum, London*

13. JACOB LAYING THE PEELED RODS BEFORE THE FLOCKS OF LABAN

c. 1665. Oil on canvas. 87¼ x 142 in. (221.6 x 361 cm)

Algur H. Meadows Collection, Meadows Museum, Southern Methodist University, Dallas

14. LABAN SEARCHING FOR HIS STOLEN HOUSEHOLD GODS IN RACHEL'S TENT

c. 1655. Oil on canvas. 95⅝ x 142½ inches (243 x 362 cm)

The Cleveland Museum of Art, Leonard C. Hanna, Jr. Fund 1965. 469

CATALOGUE NO. 13
PROVENANCE: Marqués de Villamanrique, Seville; marqués de Santiago, Madrid; earl of Northwick, Thirlestane House, Cheltenham; Sir John Hardy, Bart.; Dunstall House, Staffordshire; Sidney Sabin, London

EXHIBITIONS: Madrid and London 1982–83, no. 32; *Masterpieces from the Meadows Museum*, Wildenstein and Co., New York, September 29–October 30, 1987; Duke University Museum of Art, Durham, N. C., November 20, 1987–January 10, 1988; Lowe Art Museum, University of Miami, Coral Gables, Fla., January 26–April 24, 1988

SELECTED REFERENCES: Palomino 1724, 424; Cumberland 1787, vol. 2, 101–2, 123–25; Stirling-Maxwell 1848, vol. 2, 922; Waagen 1854, vol. 2, 204; Curtis 1883, 119–20, no. 9; Stirling-Maxwell 1891, vol. 3, 1093–94; vol. 4, 1604; Justi 1904, 14; Mayer 1927, 79, ill. 80; Stechow 1966, 367–77; Jordan 1968A, 288–96; Jordan 1968B; Jordan 1974, 44–46 and 100–102; Gaya Nuño 1978, 104, no. 207; Angulo 1981, vol. 1, 472–74; vol. 2, 29–34, no. 31; vol. 3, pls. 121–23; Burke 1986, 10–11, fig. 13; López Rey 1987, 4, 27, ill. 5, fig. 5; Brown 1991, 262, fig. 245; Mulcahy 1993, 73–80, figs. 9 and 12; Kagané 1995, 16–17, 34, ill. 17; Brown 1998, 124, fig. 275

We must not omit the well-known skill our Murillo had for the landscapes that came up in his history painting. And so it happened that the Marquis of Villamanrique decided to have a set of stories of the life of David by Murillo's hand, with the landscapes done by Ignacio Iriarte (who did them very well, as we have said). Murillo said that Iriarte should do the landscapes, and then he would place the figures in them; the other one said that Murillo should do the figures and he would fit the landscapes to them. Murillo, annoyed with this argument, told him that if he thought that he needed him for the landscapes, he was deluded; and so he did the said paintings, with the figures and landscapes, all by himself, and they are as marvelous as everything he did. These pictures were brought to Madrid by the said Marquis.[1]

It has long been recognized that Palomino's report erred in one regard, for the series is not based on the Life of David, but on the Life of Jacob. Richard Cumberland saw the set of paintings in the palace of the marqués de Santiago in Madrid in 1787 and described it correctly as "five grand compositions exhibiting the Life of Jacob in the different periods of his history."[2] Today the five paintings are widely dispersed. Two (cat. nos. 13 and 14) are in North American museums. *Isaac Blessing Jacob* (fig. 1) and *Jacob's Dream* (fig. 2) are both in the Hermitage, Saint Petersburg. *The Meeting of Jacob and Rachel* (fig. 3), which, it has been suggested, is largely by Murillo's workshop, has recently been identified as a painting now in Dublin, in the National Gallery of Ireland.[3] And,

there might even have been a sixth painting in the series, one representing *The Meeting of Jacob and Esau*, which was auctioned from the collection of "J. Taylor, Esq." in London in 1835, but has been lost sight of.[4] This speculation, however, must be weighed against Cumberland's assertion, after seeing the paintings in Madrid, that there were five paintings in all.

Murillo's paintings of the Life of Jacob are probably the ones described by a contemporary as installed on the façade of the palace of the marqués de Ayamonte y Villamanrique during the celebrations inaugurating the opening of the newly rebuilt and decorated church of Santa María la Blanca in Seville in 1665.[5] These works have long been among Murillo's best-known works. Cumberland thought them the finest paintings he had ever seen, with the exception of a *Venus* by Titian. When George Augustus Wallis, acting as agent for the dealer William Buchanan, obtained permission from the Santiago family to sell three of the paintings, they were sold at high prices: for the painting now in Cleveland, the earl of Grosvenor (later the duke of Westminster) paid the asking price of three thousand guineas by trading two paintings by Claude Lorrain, one

Top: *Fig. 1. Bartolomé Esteban Murillo.* ISAAC BLESSING JACOB. *c. 1660. Oil on canvas, 8′ ½″ x 11′8¾″ (245 x 357.5 cm). The State Hermitage Museum, Saint Petersburg*

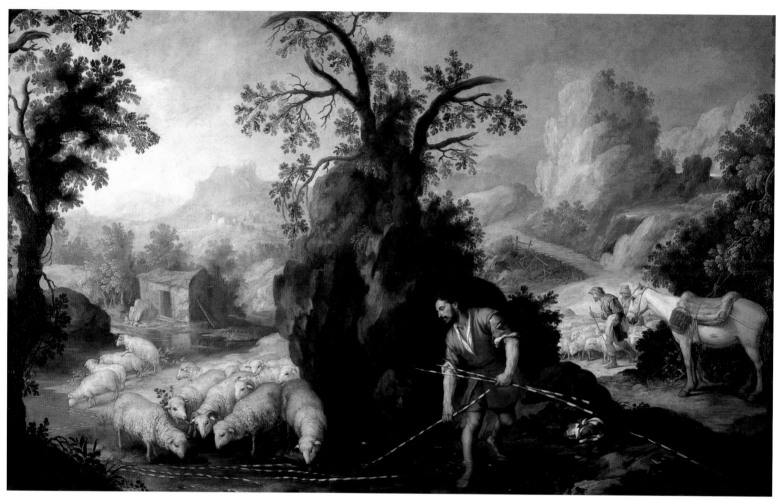

by Poussin, and giving twelve hundred sterling in cash. The two paintings now in the Hermitage were bought by Czar Alexander II of Russia.

The Life of Jacob was a well-known story in seventeenth-century Seville. Jacob, as the father of the twelve tribes of Israel, was interpreted by the Catholic Church as a prefiguration of Christ and Christianity.[6] In the scene of *Jacob Laying the Peeled Rods before the Flocks of Laban*, Murillo faithfully follows the complicated text of Genesis 30:25–43, in which Jacob tricks Laban out of some cattle through the remarkable feat of encouraging Laban's sheep and goats to conceive "ring-

streaked, speckled, and spotted" progeny on account of seeing the sticks of poplar, hazel, and chestnut that Jacob had peeled in stripes, revealing the white underneath. Nor is the story told in *Laban Searching for His Stolen Household Gods in Rachel's Tent* easy to follow. In Genesis 31:17–35, Jacob fled from the house of his father-in-law, Laban, who caught up with Jacob and his family on Mount Gilead, accusing Jacob of stealing the family idols. Jacob, who had not touched the idols, but did not know that Rachel had taken them, encouraged Laban to search: "Now Rachel had taken the images, and put them in the camel's furniture, and

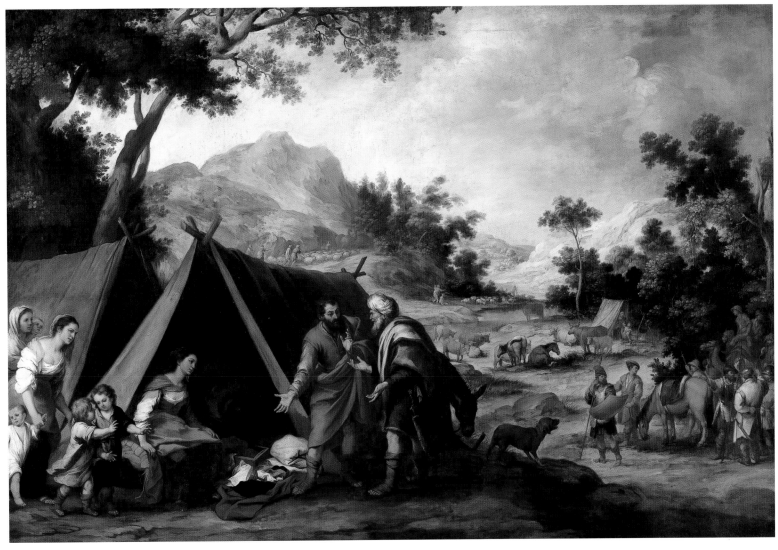

sat upon them. And Laban searched all the tent, but found them not. And she said to her father, Let it not displease my lord that I cannot rise up before thee; for the custom of women is upon me. And he searched, but found not the images." (Genesis 32:34–35).

Even more important to most viewers over the centuries than Murillo's powers as a storyteller was his ability to reconstruct an evocative setting for the narrative; Palomino was right in asserting that "they are as marvelous as everything he did." Nineteenth-century critics and amateurs were supremely uninterested in the complex biblical

stories the paintings represented. Waagen, for example, wrote tersely in 1838 of "the celebrated great Landscape by Murillo, formerly in the palace of St. Jago [sic] at Madrid, with Laban looking among Jacob's effects for his idols, but to no purpose, because Rebecca [sic] is sitting on them."[7] A more succinct version of the story could not be told. In 1869 Blanc described the painting at Grosvenor House as simply "a large landscape that ornamented the palace of 'Sant-Iago' at Madrid."[8]

Iriarte, with whom Murillo evidently had a disagreement over the execution of this commission, was a well-known landscape painter. As such,

CATALOGUE NO. 14
PROVENANCE: Marqués
de Villamanrique, Seville
[Madrid]; marqués de
Santiago, Madrid;
[William Buchanan];
duke of Westminster,
Grosvenor House,
London; Jacques Canson,
Paris; Carlos Guinle, Rio
de Janeiro

EXHIBITIONS: Cleveland
1966, no. 64, ill.; Madrid
and London 1982–83, no.
33

SELECTED REFERENCES:
Palomino 1724, 424;
Cumberland 1787, vol. 2,
101–2 and 123–25; Young
1820, 24, no. 69, ill.; Stir-
ling-Maxwell 1848, vol. 2,
922; Kugler 1854, 183;
Curtis 1883, 120–21, no.
10; Justi 1904, 14; Mayer
1927, passim; Mayer 1929,
79; Stechow 1966, 367;
Jordan 1974, 44; Angulo
1981, vol. 1 , 473–74; vol.
2, 29–34, no. 32; vol. 3, pls.
124–27; Cleveland 1982,
no. 220; López Rey 1987,
4–5, 27–28; Taggard
1992, 69–118; Mulcahy
1993, 73–80, figs. 10 and
11; Kagané 1995, 16–17, ill.
17 and 34

Fig. 2. Bartolomé Esteban Murillo. JACOB'S DREAM.
c. 1660. Oil on canvas, 8′ ¾″ x 11′9¾″ (246 x 360 cm). The State
Hermitage Museum, Saint Petersburg

he was something of an anomaly in Spanish sev-
enteenth-century painting. Although Velázquez,
Murillo, and other Spanish painters of the golden
age created some marvelous landscapes, those are
always just the backgrounds to the story—or the
portrait. And it was highly unusual for a Sevillian
painter to create what are basically large-format
landscapes populated with small figures.

The style of these landscapes, as has often
been noted, depends on northern landscape
paintings by Abraham Bloemaert or Joos de
Momper, which are in turn based on earlier prece-
dents by artists such as Joachim Patenir. Murillo
adapted to a much larger scale the system those
artists had developed of constructing and color-
ing a landscape, creating near, middle, and distant
spaces by manipulation of the composition, and
then emphasizing the distinctions among those
zones by using a darker palette in the foreground,

a lighter (greener) range of color in the middle
ground, and pastel blues to suggest a far distance.
Likewise, there is more detail in the foreground
and increasingly less as the viewer's eye moves into
the distance. Murillo creates a distinct foreground
in the Dallas painting with the framing device of
a tree to the far left and a craggy knoll in the cen-
ter against which the brightly lit figure of Jacob
stands out. The middle distance is indicated, in
part, by the size of the sheep, reduced in scale from
those in the foreground. In the Cleveland picture,
the tent of Rachel and the raised ground upon
which it stands creates a stage in the foreground
for the enactment of the scene in which Laban
accuses Jacob. In the middle ground a flat expanse
of land is enlivened by a number of small figures
and animals. In both paintings, the distance was
beautifully described by Cumberland as, "with
blurry mountainous outlines dissolved in the clear
brightness of the background . . ." Needless to say,
neither the geology nor the flora of these land-
scapes represents Murillo's Andalusia: they are
borrowed directly from the inventions of north-
ern landscape painters.

There can be no doubt that Murillo's workshop assisted him with many commissions, or he could not have accomplished all that he did. We know a great deal about the collaborative relationship between Peter Paul Rubens, for example, and the members of his workshop, and we can discern the difference between a painting by Diego de Velázquez alone and one that depended on the assistance of another painter or that is a copy by a member of the workshop after Velázquez. However, this aspect of Murillo's work has received relatively little attention (though we are increasingly able to tell a work by Murillo's hand from a painting by a follower). In the case of the Life of Jacob series, Rosemarie Mulcahy has noted stylistic quirks that suggest a significant participation of either the landscape painter Iriarte, as Palomino suggested, or a member or members of Murillo's own workshop. She has pointed to the similarity of composition and style between the *Jacob Laying the Peeled Rods* and the only known signed work by Iriarte, a *Landscape with Shepherds* (Museo del Prado, Madrid).[9] Angulo had earlier suggested that the break between the two painters might have taken place after work on the commission had begun, so that the Dallas and Dublin landscapes could be by another hand, with figures added by Murillo. It is hoped that one day the paintings in the Jacob series can be seen side by side so that these questions can be resolved. Certainly, it does not diminish the magnificence of the Dallas picture to admit it might not be entirely by Murillo. As Jordan wrote in the 1974 catalogue of the Meadows Museum collection:

> In the *Peeling of the Rods*, the eye is instantly seduced by the richness and harmony of color as the painter's brush lures it backward into a distant light. Celadon and aquamarine, palest pink and blue, ivory and rose are the colors. It is a dreamlike landscape in which the wages of time are told by the decaying shepherd's hut and dilapidated footbridge. But it is the brushwork itself that urges the beholder into an awareness of motion and time and strikes him with that immediacy of the moment of creation, which is at the very core of Baroque painting.[10]

NOTES:
1. Palomino 1987, 284–285.
2. Cumberland 1787, vol. 2, 124.
3. Mulcahy 1993, passim.
4. I am grateful to Rosemarie Mulcahy for sharing with me correspondence with Burton Frederickson, director of the Getty Art History Information Program. He found the sales catalogue with mention of this painting, described as "A renowned Work, from the Collection of the Marquis of Santiago, and one of a series, of which another is in the Gallery of the Marquis of Westminster." Thus far, the painting has not been identified.
5. Torre Farfán 1666, 284–85.
6. For a detailed explanation of the meaning of the Jacob series in the seventeenth century, see Taggard 1992, 69–118.
7. Waagen 1838, vol. 2, 315.
8. Blanc 1869, 16.
9. Mulcahy 1993, 78.
10. Jordan 1974, 46.

Fig. 3. Bartolomé Esteban Murillo. THE MEETING OF JACOB AND RACHEL. *c. 1660–65. Oil on canvas, 8′ ¾″ x 11′11″ (245.5 x 363.6 cm). The National Gallery of Ireland, Dublin*

15 AND 16. SAINT JUSTA AND SAINT RUFINA

c. 1665. Oil on canvas. 36¾ x 26⅛ in. (93.4 x 66.4 cm)
Algur H. Meadows Collection, Meadows Museum, Southern Methodist University, Dallas

PROVENANCE: Marqués de Villamanrique, Seville (?); conde de Altamira, Seville and London; marquis of Stafford, Stafford House, London; duke of Sutherland, Stafford House, London; Julius Böhler Gallery, Munich; Bernat Back, Szeged, Hungary (Rufina), resold to Böhler in 1929; private collection, France

EXHIBITIONS: London 1828, no. 35 (Justa); London 1858, nos. 71 and 78; London 1870, no. 131 (Justa); Szeged 1917, no. 13 (Rufina); Princeton 1982, nos. 27 and 28; Madrid and London, 1982–83, nos. 29 and 30; Dallas 1999, nos. 5.7 and 5.8; Madrid 2000, nos. 14 and 15

SELECTED REFERENCES: Tubino 1864, 200; Gower 1881–85, vol. I, nos. 23 and 24, ill. 1¹; Curtis 1883, 257 and 268, nos. 359 and 392; Alfonso 1886, 191–92; Stirling-Maxwell 1891, vol. 4, 1632; Justi 1892, 23; Lefort 1892, 91, no. 356 (Justa); Calvert 1907, 178; Jordan, 1974, 47–49 and 102; Gaya Nuño, 1978, 110–11, nos. 278 and 279; Angulo 1981, vol. 2, 276–77, nos. 346–47; vol. 3, pls. 143 and 144; Mallory 1983, 47–48, fig. 38 and pl. 6

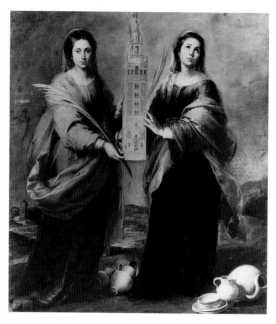

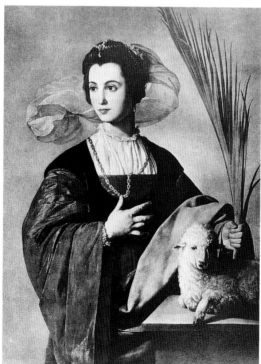

Top: *Fig. 1. Bartolomé Esteban Murillo.* SANTA JUSTA AND SANTA RUFINA. *c. 1665–66. Oil on canvas, 6'6¾" x 69¼" (200 x 176 cm). Museo de Bellas Artes, Seville*

Above: *Fig. 2. Alonso Cano.* SAINT AGNES. *c. 1635–37. Oil on canvas, 43¾ x 33⅞" (111 x 86 cm). Formerly Kaiser Friedrich Museum, Berlin, destroyed 1945*

The writer Hans Christian Andersen described his visit to the museum in Seville in his travel book *In Spain*, first published in 1863, including his specific response to the *Santa Justa and Santa Rufina* painted for the Capuchin church (fig. 1):

> There were two most beautiful figures of holy women; St. Justa and St. Rufina they were called, I believe: one could have fallen in love with them. Forgive, ye holy ones, forgive the Protestant who could dare to breathe such a thought; but these two are truly lovely! They are holding fast the Giralda tower of Sevilla, so that it should not fall during an earthquake—I wish they held me fast.[2]

He might have been equally taken by the beauty of *Saint Justa* and *Saint Rufina*, painted as pendants, now in the Meadows Museum, that represent the patron saints of Seville, daughters of a poor potter who were members of a clandestine group of Christians in Seville in the third century. The story of their martyrdom follows that of many of the saints who gave their lives for their faith during the early centuries of the Christian church. They refused to sell their ceramic wares for use in pagan ceremonies, were duly harassed by the idol worshippers, and finally destroyed an image of a false deity. They confessed their faith and were tortured and killed for refusing to sacrifice at a pagan altar. When Murillo painted Saints Justa and Rufina for the Capuchins, he showed them bearing a model of the Giralda, the tower of the cathedral of Seville that they were credited with saving during a terrible earthquake that afflicted the city.

There were earlier examples of paintings showing the two sisters together in one composition, bearing their attributes of the pottery and the palms of martyrdom, with the Giralda between them, either in the background (as in the 1555 painting by Hernando Sturmio, Seville Cathedral) or right between them (as in the painting of about 1615–20 by Miguel de Esquivel, Seville Cathedral), and this format was used again, much later, by Francisco de Goya (Seville Cathedral). Although Murillo's large-scale painting of the two virgin saints created for the church of the Capuchin

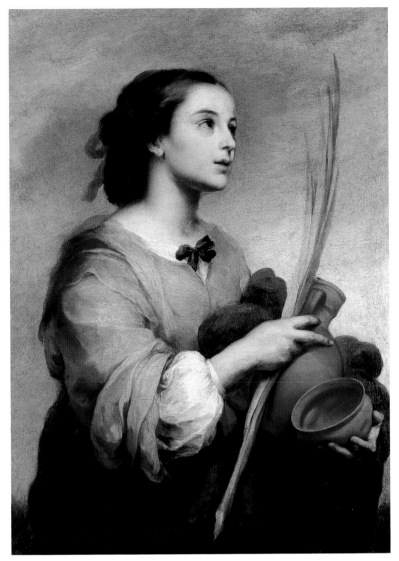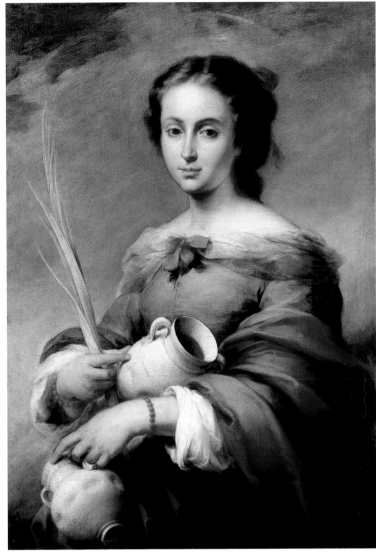

monastery in Seville follows this iconography, his pendant images of Justa and Rufina actually derive from a rather different pictorial tradition, the idealized "portraits" exemplifed by the beautiful *Saint Agnes* created by the Sevillian painter Alonso Cano around 1635–37 (fig. 2). Murillo carefully modeled the faces with delicate sfumato effects, but left the gesture of his brushwork more legible in his treatment of the draperies. Like Cano's painting, the Santa Justa and Santa Rufina by Murillo are both devotional paintings and objects of delectation. Their beauty is both a reflection of the purity of their faith and a pleasure to behold, both spiritually inspiring and sensuously appealing.

NOTES:

1. The illustrations of the paintings in Gower's book are tipped-in photographs that demonstrate without a doubt that these two paintings are the ones from Stafford House, despite the claims for other pairs of replicas to have belonged to the dukes of Sutherland. Murillo appears to have painted a small-scale version of this pair on copper plates, as such a pair, along with copies of them, are documented in the dowry contract of Gaspar Dionisio Vázquez in 1702 (Angulo 1981, vol. 2, nos. 344–45).

2. Andersen 1881, 162–63.

17. THE PRODIGAL SON AMONG THE SWINE
c. 1665. Oil on canvas. 63⅝ x 41⅛ (161.5 x 104.5 cm)
The Hispanic Society of America, New York

Several versions of the subject of the "prodigal son among the swine" were painted by Murillo. One of these is in the series of six paintings by Murillo illustrating the parable of the prodigal son, told in the gospel of Luke:

> A certain man had two sons. And the younger of them said to his father: Father, give me the portion of substance that falleth to me. And he divided unto them his substance.... And not many days after, the younger son, gathering all together, went abroad into a far country. And there wasted his substance, living riotously. And after he had spent all, there came a mighty famine in that country; and he began to be in want. And he went and cleaved to one of the citizens of that country. And he sent him into his farm to feed swine. (Luke 15:11–15)

In the end, of course, the prodigal son returns to his father, who forgives him the error of his ways. This series of paintings, touching on the themes of sin, repentance, and redemption/forgiveness were first documented in the early nineteenth century. In 1897 Sir Alfred Beit managed to acquire the five canvases in the series then owned by the earl of Dudley, as well as the sixth, repre-

senting *The Return of the Prodigal Son*, which had been given to Pope Pius IX by the Spanish queen Isabel II in 1856. They were given to the National Gallery of Ireland by the Alfred Beit Foundation in 1987.[1] The initial ideas for the compositions were generated by a series of ten etchings made by Jacques Callot (1592–1635).[2] The six scenes chosen by Murillo for his series of paintings represent *The Prodigal Son Receiving his Portion, The Departure of the Prodigal Son, The Prodigal Son Feasting* (fig. 1), *The Prodigal Son Driven Out, The Prodigal Son Feeding Swine* (fig. 2), and *The Return of the Prodigal Son*. Although all six paintings are masterly in composition and execution, not all are equally affecting. The scene representing the prodigal son feasting is blandly anecdotal, hardly convincing the viewer as to the riotous life and "wasted substance" of the biblical account. Murillo is at his best when focusing on the delivery of a particular emotion, a particular sentiment; thus, in the scene of the prodigal son reduced to feeding swine, which has also been called "The Repentance of the Prodigal Son," the viewer is moved by the lonely isolation of the figure in an inhospitable landscape setting, and by the pleading gestures of the penitent youth whose unguarded expression sends his prayers for redemption heavenward.

Four oil sketches related to this series of paintings by Murillo are in the Museo del Prado; one of them represents the prodigal son feeding swine. The painting now in the Hispanic Society offers, on a larger scale, yet another compositionally similar rendering of the same subject, and Murillo returned to Luke 15 when he painted *The Return of the Prodigal Son* for the Hospital de la Caridad for his friend and patron Miguel de Mañara (see cat. no. 18). The meaning of these two particular scenes is in itself instructive. The anecdotes of the prodigal son feasting or being driven out are just that—bits of the story line. However, the moments when the prodigal son expresses true repentance for his forays into sinfulness, and the moment his father receives him home with complete forgiveness, are

Fig. 1. Bartolomé Esteban Murillo. THE PRODIGAL SON FEASTING. *Before 1660. Oil on canvas, 41 x 53½" (104.5 x 135.5 cm). The National Gallery of Ireland, Dublin*

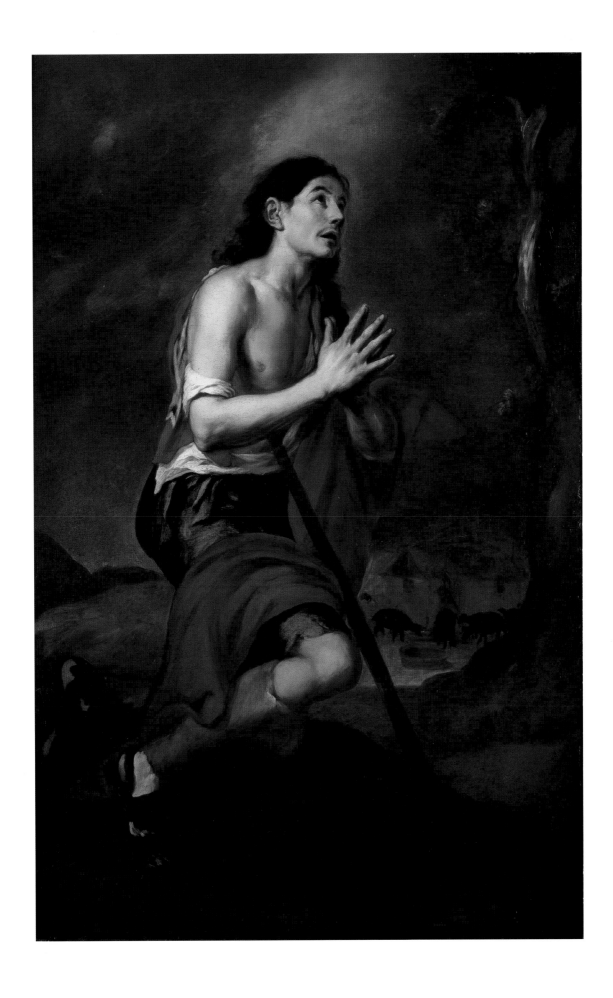

narrative expressions of basic tenets of the Catholic faith.[3] In his depiction of these, Murillo excels.

The painting in the Hispanic Society belonged to King Louis-Philippe, having been acquired for him from the duque de Hijar in Madrid by his agent Baron Isidore Taylor. It was exhibited in his Galerie Espagnole in Paris from 1838 until 1848. When Louis-Philippe's collection was auctioned in London, the painting was acquired for an English collection and remained in England until it was sold at auction in 1910, then attributed to Miguel Tovar, one of Murillo's followers. When Richard Ford wrote in *The Athenaeum* about the Louis Philippe auction in 1853, he described this painting:

> No. 110 represented "The Prodigal Son,"—in which the swine-feeding starveling kneels and prays, all rags and tatters. This picture—compared by a wag in the room, to Young Ireland praying to be spared the income-tax—is painted in the master's very earliest manner. It is full of force and truth,—in a style hovering between Ribera and Caravaggio. It is somewhat repainted,—but cannot be called dear at 110£.[4]

The fact that the work was already somewhat repainted by the mid-nineteenth century probably prompted the later attribution to a follower of Murillo. Now, however, that the painting has been skillfully restored, there is no question of its authenticity. Although some retouching has been necessary to mollify damage caused to the sky originally painted in smalt, the figure is as forcefully modeled as one can find in Murillo's work at this date: "It is full of force and truth,—in a style hovering between Ribera and Caravaggio."

The figure, clad in a white undergarment, green pantaloons, brown leggings, and leather sandals, kneels in three-quarters profile on a hummock of earth situated close to the picture plane. Behind him a mountainous landscape rises to the left. On the right the framing element of a tree rising along the right margin of the composition leads the eye to the black pigs in front of the distant farmhouse (the only elements that concretely tie the image to the story told in Luke 15). A glory of light breaking through the steel-gray sky illuminates the prodigal son's fervent expression.

NOTES:
1. See Mulcahy 1988, 45–53.
2. Dorival 1950.
3. For a full discussion of the interpretation of these themes by the church, see Taggard 1992, 1–66.
4. Ford 1953A, 594.

Fig. 2. Bartolomé Esteban Murillo. THE PRODIGAL SON FEEDING SWINE. *Before 1660. Oil on canvas, 41 x 53″ (104.5 x 134.5 cm). The National Gallery of Ireland, Dublin*

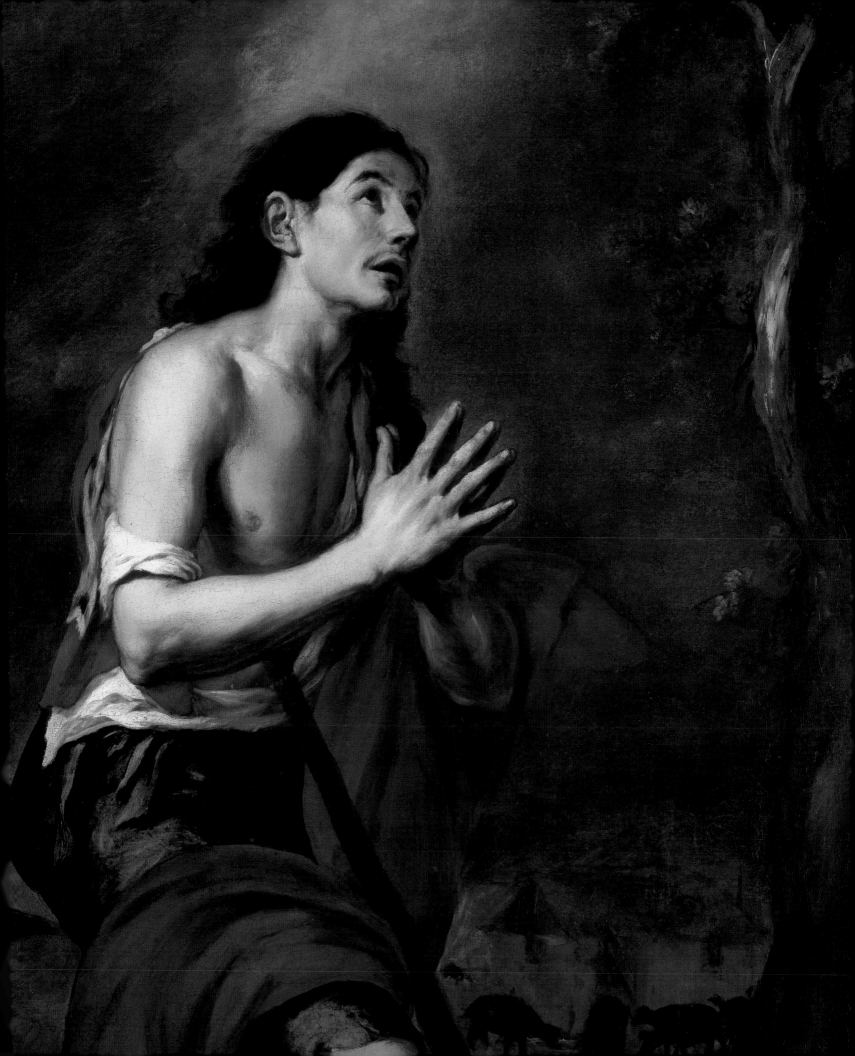

18. THE RETURN OF THE PRODIGAL SON

1667—70. Oil on canvas. 93 x 102¾ in. (236.3 x 261 cm)
National Gallery of Art, Washington, Gift of the Avalon Foundation

PROVENANCE: Church of the Hospital de la Caridad, Seville; Alcázar, Seville; Marshal-General Nicolas Soult, duke of Dalmatia, Paris; George Granville, 2nd duke of Sutherland, Stafford House, London; by descent to George Granville, 5th duke of Sutherland; Avalon Foundation, New York

EXHIBITIONS: London 1836, no. 22; London 1913—14, no. 83; London 1938A, no. 217; Madrid and London, 1982—83, no. 46

SELECTED REFERENCES: Ponz 1772—94, vol. 9, 148; Ceán Bermúdez 1800, vol. 2, 52; Buchanan 1824, vol. 1, 347; Jameson 1844, 191; Stirling-Maxwell 1848, vol. 2, 864; vol. 3, 1431; Waagen 1854, vol. 2, 67—68; Blanc 1869, 11—12; Curtis 1883, 116 and 195; Justi 1892, 64, fig. 20; Brown 1970, 265—77; Brown 1978, 128—46; Angulo 1981, vol. 1, 396—98; vol. 2, 86—87; vol. 3, pls. 274—77; Brown and Mann 1989, 109—10; Brown 1991, 265—66, fig. 247; Tomlinson 1997, 79, fig. 51; Brown 1998, 217, fig. 277

Murillo's paintings for the church of the Hospital de la Caridad in Seville, completed between 1667 and 1670, represent, as an ensemble, his acknowledged masterpiece (see pages 27—28 in this catalogue). The subjects of his paintings are the Acts of Mercy, based on Matthew 25: 35—36. *The Return of the Prodigal Son* represents, in this context, the act of "clothing the naked," here illustrated by the servants who bring forth fine clothing to replace the rags in which the penitent son returns to his father's home—and embrace.[1]

In July 1800 the governors of the Hospital de la Caridad received a letter informing them that the king of Spain, Carlos IV, would like to have the eleven paintings by Murillo in the church of the Hospital de la Caridad join the royal collections at the court. To this end, and so that the church would continue to have what it needed for the celebration of the mass, the king would send the artist Francisco Agustín to make exact copies of all the paintings to be installed in the church when the originals would be transported to the royal palace in Madrid.[2] The chairman of the board of governers wrote back, suggesting, as eloquently as he could, that the brotherhood would be delighted to have the copies made for the delectation of the court. The response was

that "the devout charity of the faithful would not be less fervid with the copies than with the originals," and so the matter went back and forth for some time, with a great deal of stalling on the part of the brotherhood. In the end, Carlos IV did not get his pictures, but few of them remain in the church today. In 1810 the "intruder king" Joseph Bonaparte ordered the pictures gathered for safekeeping in the old Alcázar of Seville, whence they were intended to be sent to the Louvre. Five of those paintings were "conveyed" to Paris by Marshal-General Soult in 1812, but they were installed in his house, not the Louvre. In 1835 Soult sold *Abraham and the Three Angels* (fig. 1) and *The Return of the Prodigal Son* to the duke of Sutherland and they were installed in Stafford House, London. These are the two paintings from the Hospital de la Caridad now in North American collections. In 1884, Mrs. Anna Jameson wrote: "The picture gallery in Stafford House. . . is excellently adapted to its purpose. . . . The length of the gallery is 126 feet, by 32 feet in width . . . illuminated by a vast lantern, 48 feet from the ground. . . . On one side of the central division are hung the two great pictures by Murillo. . . . each crowned by carved busts of the painter and life-size winged genii."[3] Despite the ups and downs of Murillo's critical fortunes through the decades, no critic since Mrs. Jameson has argued with the validity of her description of *The Return of the Prodigal Son*:

In every respect, this is one of his very finest pictures. The subject is treated in his usual familiar and domestic style, but nothing can exceed the expression of the son, as he looks up in the face of his father—eager, suppliant, deprecatory, intensely mournful; nor the dignified tenderness of the aged father, bending over him, and half embracing, half supporting the worn and almost sinking frame of his son. I know not any picture whatever which can go beyond this in heartfelt nature and dramatic power. The execu-

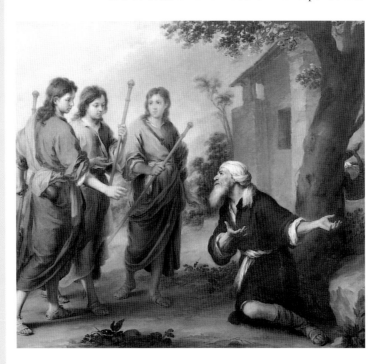

Fig. 1. Bartolomé Esteban Murillo. ABRAHAM AND THE THREE ANGELS. *1667—70. Oil on canvas, 7´9˝ x 8´7˝ (236.2 x 261.5 cm). National Gallery of Canada, Ottawa, Purchased 1948*

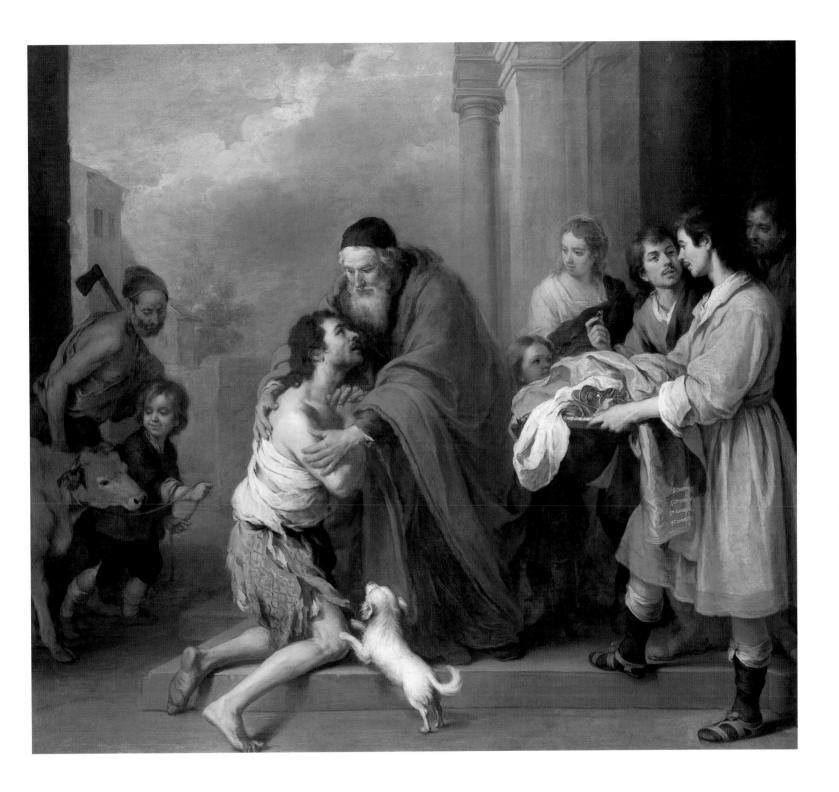

tion, too, is as fine as possible: the drawing so firm, the colours so tenderly fused into each other; the shadows so soft; the effect of the whole so in harmony with the sentiment and subject, that I consider it a rare example of absolute excellence in its class.[4]

NOTES:
1. For a full study of the Brotherhood of Charity and the commission for the eleven paintings by Murillo, see Brown 1970, reprinted in Brown 1978, passim.
2. See Gómez Imaz 1899, passim.
3. Jameson 1844, 167–68.
4. Ibid., 191.

19. SAINT THOMAS OF VILLANUEVA AS A CHILD DIVIDING HIS CLOTHES AMONG BEGGAR BOYS

1664—67. Oil on canvas. 86½ x 58¾ in. (219.7 x 149.2 cm)
Cincinnati Art Museum, Bequest of Mary M. Emery

PROVENANCE:
Monastery of San Agustín, Seville; Manuel Godoy; Horace François Bastien Sebastiani, Marshal of France; Alexander Baring, first Lord Ashburton; William Bingham Baring, 2nd Lord Ashburton, The Grange, Hampshire and London; by descent to Francis D. E. Baring, 5th Lord Ashburton; Mary M. Emery, Cincinnati

EXHIBITIONS: London 1819, no. 21; London 1853, no. 3; London 1871, no. 256; New York 1928, no. 48; Toledo 1941, no. 74; Pittsburgh 1954, no. 74; Madrid and London 1982–83, no. 64

SELECTED REFERENCES:
Ponz 1772–94, vol. 9, 136; Ceán Bermúdez 1800, vol. 2, 60; Ceán Bermúdez 1806, 95–96; Scott 1813, 101 and 105; Buchanan 1824, vol. 2, 264–65; Waagen 1838, vol. 2, 270–74; Jameson 1852, 202; Waagen 1854, vol. 2, 101; Curtis 1883, 269, no. 396; Stirling-Maxwell 1891, vol. 4, 1630; Justi, 1904, vi, 23, and 25; Calvert 1907, 73 and 176; Gaya Nuño 1958, 244, no. 1881; Angulo 1973, 71–75; Brown 1976, 153; Rogers 1978, 19–21; Gaya Nuño 1978, no. 131; Angulo 1981, vol. 2, 55–56, no. 55; vol. 3, pls. 221–23; Karge 1991, 178, ill.; Von Sonnenburg 1982, 15 and 18, fig. 3; Paris 1983, 59, fig. 110; López Rey 1987, 24–25, 28, and ill., 25, fig. 31; Moreno 1997, 134.

Thomas of Villanueva (c. 1488—1555), born to a prominent old Valencian family, joined the Order of Hermits of Saint Augustine at Villanueva in 1516. He was ordained a priest in 1520, served as prior in Salamanca, Burgos, and Valladolid, and became the *predicador* (court chaplain) to the emperor Charles V (Charles I of Spain). He was named archbishop of Valencia in 1544. Thomas of Villanueva was famous for his generosity to the poor and his concern for the orphans of his diocese. So expansive was his giving that it was thought that his own needs must have been provided by angels. The charity of Saint Thomas of Villanueva led to his canonization in 1658. Less than a decade later (on August 30, 1664), the monastery of San Agustín, located outside the

Carmona Gate in Seville, contracted with Murillo for the altarpiece of the Cavaleri chapel dedicated to its titular saint, Thomas of Villanueva.

The contract specified that the artist and the prior of the monastery would together to plan the altarpiece and that it would be completed in two and a half years. Four of Murillo's paintings for that project are known today: this one in the Cincinnati Art Museum; *Saint Thomas of Villanueva Healing a Lame Man* (fig. 1), and two smaller paintings—*Saint Thomas of Villanueva Giving Alms to the Poor* (fig. 2) and *Saint Thomas of Villanueva Receiving the Announcement of His Death* (Museo de Bellas Artes, Seville). However, although the Cincinnati and Munich pictures can be considered pendants (as they are nearly identical in size), and although the smaller paintings (of identical size) probably were intended for the *banco,* or predella, there is no written record of the altarpiece as a whole. When Ponz visited the monastery (by 1780) the Cincinnati and Munich paintings were in the chapel dedicated to Saint Thomas of Villanueva, but simply hanging on a wall. When Ceán Bermúdez published his *Diccionário* in 1800, he described seeing this painting in the quarters of the provincial of the order. However, by 1806 the Augustinians had sold the paintings. *Saint Thomas of Villanueva Dividing His Clothes among Beggar Boys* entered the collection of Manuel Godoy, the Spanish minister given the title "Prince of Peace" by his monarchs, and he (or the king) gave the painting to the French general Sebastiani. Godoy might not have been able to hold on to it anyway. A letter from G. Augustus Wallis to William Buchanan from Madrid in 1808 reported that the "existing government of Spain had given orders for the disposal of the pictures of the Prince of Peace, and of many others whom it considered as traitors to their country. . . ."[1] (This news no doubt fell on Buchanan's happy ears. Buchanan, an art dealer on an international scale, noted, "in troubled waters we catch the best fish."[2]) By 1814 the painting was in Buchanan's hands and he sold it to Alexander Baring, first Lord Ashburton. It remained in the hands of Baring's descendants until the fifth Lord Ashburton died in 1907. It was

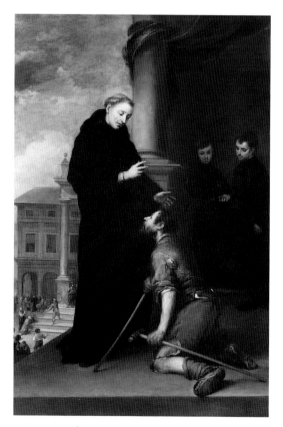

Fig. 1. Bartolomé Esteban Murillo. SAINT THOMAS OF VILLANUEVA HEALING A LAME MAN. *1664–67. Oil on canvas, 7'3" x 58¾" (221 x 149 cm). Bayerische Staatsgemälde-sammlungen, Alte Pinakothek, Munich*

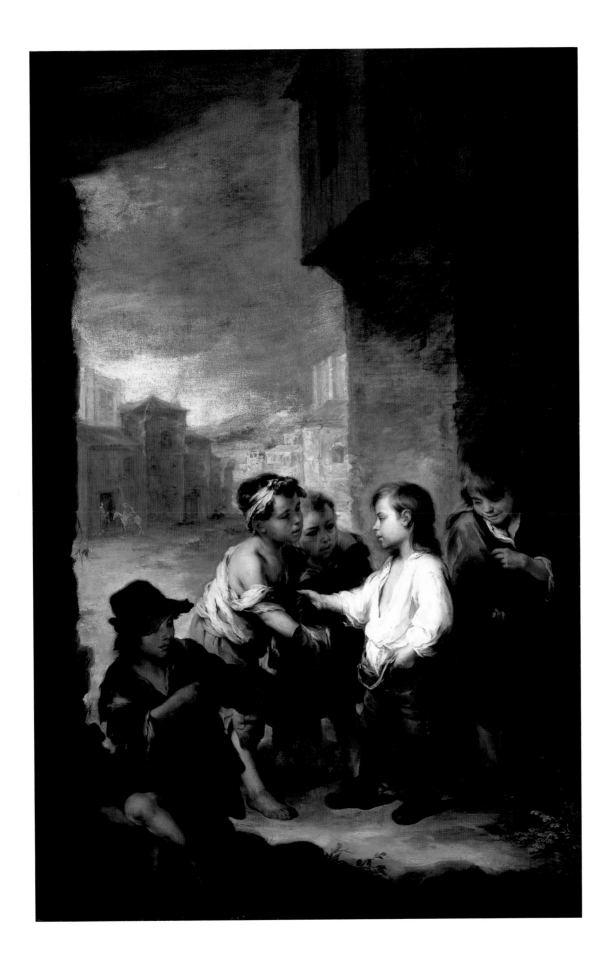

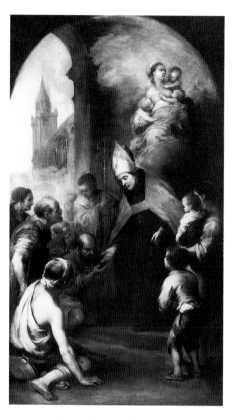

Fig. 2. Bartolomé Esteban Murillo. Saint Thomas of Villanueva Giving Alms to the Poor. *1664–67. Oil on canvas, 52½ x 30″ (133.4 x 76.2 cm). The Norton Simon Foundation, Pasadena, Calif.*

then purchased by Mrs. Thomas J. Emery in 1911 and remained in her home, "Edgecliffe," in Walnut Hills, Cincinnati, until her death, when her collection was bequeathed to the museum.[3]

The subject of the Cincinnati painting is simple charity: the saint is shown as a child, distributing his own garments to four little beggar boys. In the Munich painting, a crippled "tailor," a mender of old clothes, begs the saint for a cure to his lameness so that he can work for a living.[4]

In northern paintings and prints of the sixteenth century, and into the seventeenth, the poor mendicant, the crippled beggar, was often pictured as a personification of laziness, greed, or dishonesty. In the Protestant north of Europe, faith or predestination were the route to Heaven. In Catholic Spain, however, one's frail tendency to sin could be offset by penance and by good works, and the poor were considered to offer opportunities for personal salvation and, the greater the economic and social distress of Seville from the middle of the seventeeth century, the greater the opportunities for charity. In the late sixteenth century in Seville, there were pious brotherhoods dedicated to the Niño Perdido (the Lost Child).[5] Even before Seville was afflicted by the plague of 1649, Murillo had painted for the Franciscans of Seville scenes of charity to the poor (see figs. 6 and 18 in biographical essay), and after the commission for the Augustinians, his friend Miguel de Mañara would commission the paintings representing good works for the Hospital de la Caridad.

The Cincinnati painting is particularly interesting as an amalgamation of Murillo's depictions of the act of charity and his genre paintings, which so often represent beggar boys at play, or, much more often, eating. In Spanish literature of the period the beggar boy is often turned into a prototypically Spanish type—the *pícaro*. The pícaro is, with the exception of the more sympathetic figure of Lazarillo de Tormes, a swindler, braggart,

and liar. The pícaro is never painted by Murillo, and this painting is not a genre painting, although it was misinterpreted as such in a review of a 1928 exhibition of Spanish paintings at the Metropolitan Museum of Art: "The Young Saint Thomas of Villanueva, from the collection of the late Mrs. Thomas J. Emery, is an exceptional performance, with not a little humor, for the beggar boys are quickly taking advantage of the infant saint's charity and soon he will be left in nothing but his undershirt. The frank sentiment of this work places it in a class far beyond his other *genre* and beggar pictures."[6] A clever assessment of the subject, but untrue. Murillo was simply painting a scene from the life of a saint who was noted, even as a child, for his generosity to the poor, a reminder to the pious viewer of the biblical injunction to charity:

Though I speak with the tongues of men and of angels, and have not charity, I am become as sounding brass or a tinkling cymbal. And though I have the gift of prophecy, and understand all mysteries, and all knowledge, and though I have all faith, so that I could remove mountains, and have not charity, I am nothing. And though I bestow all my goods to feed the poor, and though I give my body to be burned, and have not charity it profiteth me nothing. (1 Corinthians 13:1–3) And now abideth faith, hope, charity, these three, but the greatest of these is charity. (1 Corinthians 12:13)

Notes:
1. Buchanan 1824, vol. 2, 227.
2. Ibid., 221.
3. Cincinnati 1930, 21.
4. Moreno 1997, 135.
5. Ibid, 130.
6. McMahon 1928, 176.

20. THE NATIVITY

c. 1665–70. Oil on obsidian. 15 1/16 x 13 7/16 in. (38.3 x 34.2 cm)
Museum of Fine Arts, Houston, The Rienzi Collection, Gift of Mr. and Mrs. Harris Masterson III

Apparent from the sequence of entry numbers in Angulo's monograph cited in the references, all of those entries concern this single picture. Lionel Hervey, Esq. (1784–1843) was a diplomat in the British foreign service in Madrid from 1820 to 1822.[1] He must have acquired this painting, along with others that are known, while in Spain, and he lent it to the British Institution the year after he returned. His pictures, probably including this one, were inherited by his son Felton, who died in 1861, but who had already sold some of them before his death. Curtis knew from the catalogues of the British Institution that Hervey had owned a painting entitled *The Holy Family*, said to be painted on stone. Therefore, Angulo, writing a century later, included an entry (no. 1207) for this apparently lost picture, which he had no way of knowing was authentic or not. What he did not realize was that this was the same painting, which he believed to be a canvas, that he knew only from a photograph taken when it belonged in the 1950s to the Sabin Galleries in London, where it was called *The Nativity* (Angulo 1981, cat. no. 221).[2] Nor did he realize that it was the same painting, said to be painted on marble, that had been bought by the Paris dealer Sedelmeyer at the 1899 London sale of the collection of Jean Louis Miéville; thus he recorded that picture as well in yet another entry in his catalogue (no. 1413). But Angulo failed to note that the Miéville catalogue gave an earlier provenance for the painting, describing it as: "The Nativity: The Infant Saviour lying in the centre, with St. Joseph and the Virgin on either side; cherubs holding a scroll above—on marble—from the Collection of W. Delafield, Esq., 1870."[3] In the catalogue of the sale of William Delafield, who may have bought the picture from Felton Hervey only a decade or so earlier, the painting is more specifically said to be painted on black marble.[4] Sedelmeyer sold the painting to C. T. D. Crews, who lent it in 1901 to the *Exhibition of the Works of Spanish Painters,* at Guildhall Gallery, where, although exhibited with the title *The Virgin and Child,* it was described in the catalogue with sufficient detail to be sure it was the same picture. Angulo included Crews's painting in yet another entry (no. 1037), but failed to note that it was painted on stone or to connect it to any of the others. Upon the sale of Crews's collection

in 1915, the painting was purchased by a buyer or agent identified only as Hughes.[5]

By the time the painting was offered for sale in the 1950s by the Sabin Galleries—the time at which the photograph known to Angulo was made—the polished black stone surface upon which the figures were painted, evidently still visible at the time of the Delafield sale in 1870, had been completely overpainted in a skillful imitation of Murillo's manner (fig. 84). The thickly applied pigment, deftly manipulated by the restorer's brush, had filled in distant hills and a clouded, crepuscular sky where none had existed originally. When the painting was recently cleaned at the Kimbell Art Museum, these later additions were found to be very soluble, unlike the figures, the animals, the manger, and the stone wall, all of which were painted by Murillo himself. It was further determined that the support is not black marble, as claimed in 1870, but rather obsidian, a volcanic glass most readily available to a Sevillian painter in the seventeenth century through importation from Mexico [see essay by Jordan in this catalogue]. The slab of stone, seen from the back (fig. 1), has almost identical properties as those of Murillo's *Penitent Saint Peter Kneeling before Christ at the Column* and *Agony in the Garden* [see fig. 61 in the essay by Jordan], both in the Louvre, which had belonged successively to Justino de Neve and Nicolás Omazur, the two most important seventeenth-century collectors of the artist's work.

Not knowing that the four entries in his catalogue related to the small *Nativity* that he knew from a photograph, and that the picture was painted on a stone support, Angulo was also not able to connect it, as he possibly would have done, to yet a fifth of his entries, that inspired by the documentary reference he had found in the death inventory of Murillo's friend and patron Justino de Neve to a lost *Nativity* described as a *lámina de piedra*.[6] In his testament, Neve bequeathed the painting to the Carthusian monastery of Seville, as a token of his great affection and goodwill toward the institution. The painting may have remained there until French troops gathered the artistic treasures of the various churches and monasteries of Seville in 1810. In the chaotic aftermath of the war, some were returned, but many were dispersed

PROVENANCE: [Justino de Neve, Seville?; Carthusian monastery, Seville?]; Lionel Charles Hervey, England; [his son, Felton William Hervey?]; William Delafield, London; Jean Louis Miéville, London; Galerie Sedelmeyer, Paris; C. T. D. Crews, London; Sabin Galleries, London; Harris Masterson, Houston

EXHIBITIONS: London, British Institution, 1823, no. 173; London, British Institution, 1835, no. 102; London 1901, no. 76.

SELECTED REFERENCES: Curtis 1883, 177, no. 146i; Angulo 1981, vol. 2, 204, no. 221; 206, no. 224 (?); 400, no. 1037; 416, no. 1207; and 436, no. 1413; vol. 3, pl. 178.

INSCRIPTION: On the banderole carried by angels: *GLORIA IN EXCELSIS DE / ET IN TERRA PAX HOMINI*

1. *The unpolished back of the obsidian slab upon which* The Nativity *is painted, with chips, in places, revealing the vitreous quality of the stone.*

on the market. It would have been easy for Lionel Hervey to have acquired the painting in Seville after 1820, and it is very likely that the present painting is the one that belonged to Neve.

Now that it has been cleaned and the later additions removed, *The Nativity* is seen to be stylistically very close to the pair of paintings on obsidian in the Louvre (figs. 62 and 63), which had also belonged to Neve. As in those pictures, Murillo has left large parts of the stone in reserve around the figures as a suggestion of the night sky, and, as he did in the Louvre *Agony in the Garden*, he has capitalized on the naturally occurring, lighter streaks in the stone, which fall vertically at a slightly oblique angle, to lend the further suggestion of rays of light falling from heaven. The contrast of the richly modeled figures and the polished surface of the jet black stone is striking, as it is in the Paris pair. And within the nocturnal quietude of this artful composition, the radiance of Christ's infant form and the brilliant white linens of the manger take on a meaning to which all other forms and hues are, by design, subservient. The modeling of the figures and draperies is particularly close to that in *Penitent Saint Peter Kneeling before Christ at the Column*—especially similar are the golden mantle of Saint Joseph, in this painting, and that of Saint Peter, in the other. The model for the figure of the Virgin appears to be the same as that in *Christ on the Cross with the Virgin, Saint John, and Mary Magdalene*, in the Meadows Museum (cat. no. 21), suggesting the likelihood that all of these pictures were painted around the same time; that is, around 1665–70.

WBJ

NOTES
1. He was not a member of the Bristol or Bathurst families, as Angulo sought to investigate.
2. In the bill of sale provided by Sabin to Harris Masterson in 1958, the only provenance given for the painting was "from the collection of Sir Lionel Hervey." Hervey was never knighted.
3. Christie's, London, April 29, 1899, lot 99.
4. Christie's, London, April 30, 1870, lot 36. The painting was purchased for £70 by the dealer John Lewis Rutley, from whom it apparently passed to Miéville.
5. Christie's, London, July 1, 1915, lot 133.
6. Angulo 1981, vol 2, 206, no. 224.

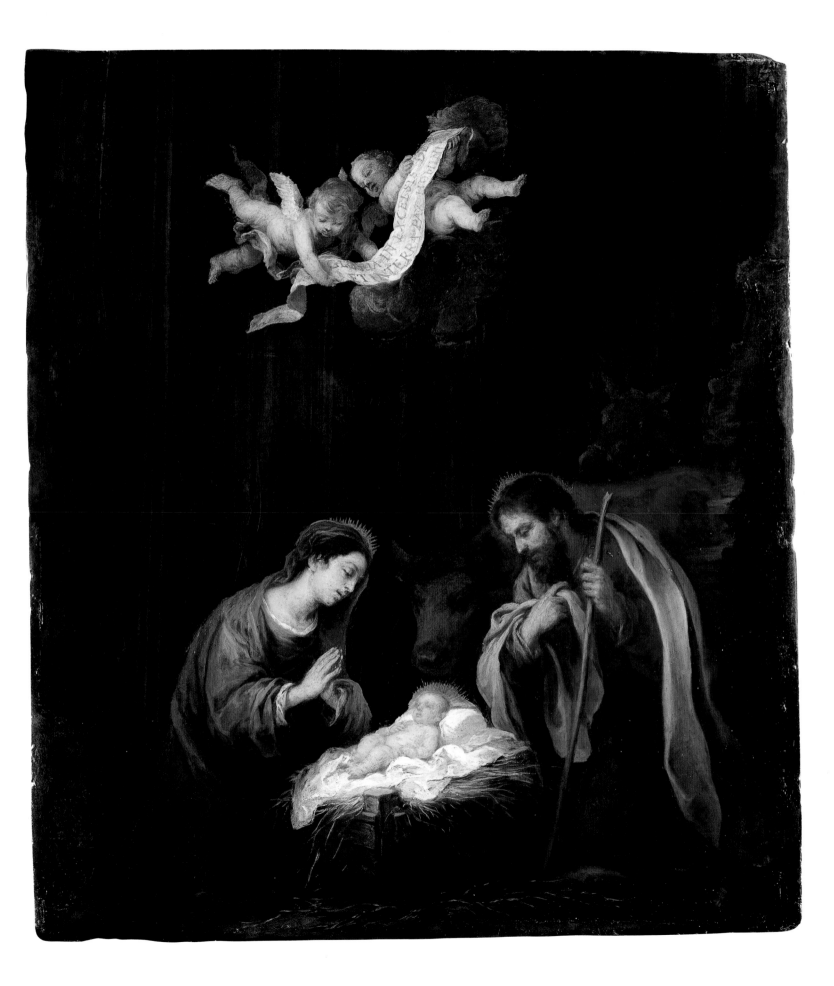

21. Christ on the Cross with the Virgin, Saint John, and Mary Magdalene

c. 1665–70. Oil on copper. 24 x 16 ½ in. (60.8 x 42.1 cm)
Algur H. Meadows Collection, Meadows Museum, Southern Methodist University, Dallas

PROVENANCE: Marqués de Rodríguez de Evora y Vega; comte d'Hane de Steenhuyse et de Leuwerghem, Ghent; Pierre Maisoneuve, Paris

EXHIBITIONS: Brown 1976, no. 56; *Masterpieces from the Meadows Museum*, Wildenstein and Co., New York, September 29–October 30, 1987; Duke University Museum of Art, Durham, N. C., November 20, 1987–January 10, 1988; Lowe Art Museum, University of Miami, Coral Gables, Fla., January 26–April 24, 1988 Phoenix 1998, no. 40

SELECTED REFERENCES: Curtis 1883, 202, no. 214c [with wrong dimensions and no indication that the work is on copper]; Jordan 1967, 14–15; Angulo 1974, 104; Brown 1976, 138, fig. 63; Angulo 1981, vol. 2, 454, no. 1620; vol. 3, pl. 571 [not 572, with which the plate is reversed]; Young 1981, 257; Madrid and London 1982, 210; Kagané 1995, 136; Kagané 1997, 143

The anonymous author who prepared the 1860 Paris auction catalogue of the collection of the comte d'Hane de Steenhuyse et de Leuwerghem gives the provenance of this painting in the 150-year-old collection as having been brought to Flanders by the marqués de Evora y Vega, who married into the Hane de Steenhuyse family at the turn of the eighteenth century.[1] If this unconfirmed statement is true, it would mean that the painting was among the first Murillos to be taken to northern Europe. The author further wrote of the painting that "jamais la génie n'a mieux résolu le dificile problème que consista à faire grand en petit" [never has imagination better solved the difficult challenge of making something small

Fig. 1. Bartolomé Esteban Murillo. CHRIST ON THE CROSS WITH THE VIRGIN, SAINT JOHN, AND MARY MAGDALENE. *c. 1675. Oil on canvas, 38½ x 23¾" (98 x 60.2 cm). The State Hermitage Museum, Saint Petersburg.*

appear large].[2] Indeed, Murillo has succeeded in giving this small, highly finished painting on copper a sense of monumentality entirely lacking in his oil sketches, which were, after all, only rough compositional notations.

A drawing by Murillo in the collection of the late Sir Brinsley Ford (fig. 50) illustrates how carefully the artist prepared for the composition. The drawing bears the following inscription on the verso of the mount: "This magnificent and almost unique study by Murillo belonged to the celebrated Conde de Aguila. His collection of Spanish drawings afterwards passed into the hands of Julian B. Williams, our vice consul at Seville, and who was by far the best judge of Spanish art in Europe: it was given to me at Seville by him in 1831, Rich[d]. Ford."[3] Angulo was the first to identify this drawing as a preparatory study for the Meadows *Christ on the Cross*.[4] Nevertheless, after he finally saw the painting in the original, in the late 1970s, he decided that it must be by a disciple of Murillo.[5] What was unknown at the time, and was impossible to tell by looking at the painting with either natural or ultraviolet light, was that it had been extensively and very skillfully repainted to conceal the fact that it was, indeed, quite damaged. This only became apparent when the painting was cleaned in 1998. The scrupulous restoration undertaken then does not now conceal that the painting has suffered and is in places abraded, but it has removed the overpaint that had obscured many original passages of drapery and flesh.[6] What we can see today, while it surely does not reveal the full subtlety of Murillo's paintings on copper, shows the unmistakable hand of the master himself.

Jonathan Brown, who has also explored the relationship of the preparatory drawing to this painting, has proposed a date of the 1670s for the drawing, and, by extension, for the painting. It seems, however, that this may be slightly too late a date for both.[7] The picture's style relates most closely to Murillo's *Penitent Saint Peter Kneeling before Christ at the Column*, in the Louvre, one of the artist's few paintings on obsidian (see fig. 63 and discussion in the essay by Jordan), which seems plausibly datable to the mid- to late 1660s.[8] Angulo, of course, had rejected this painting

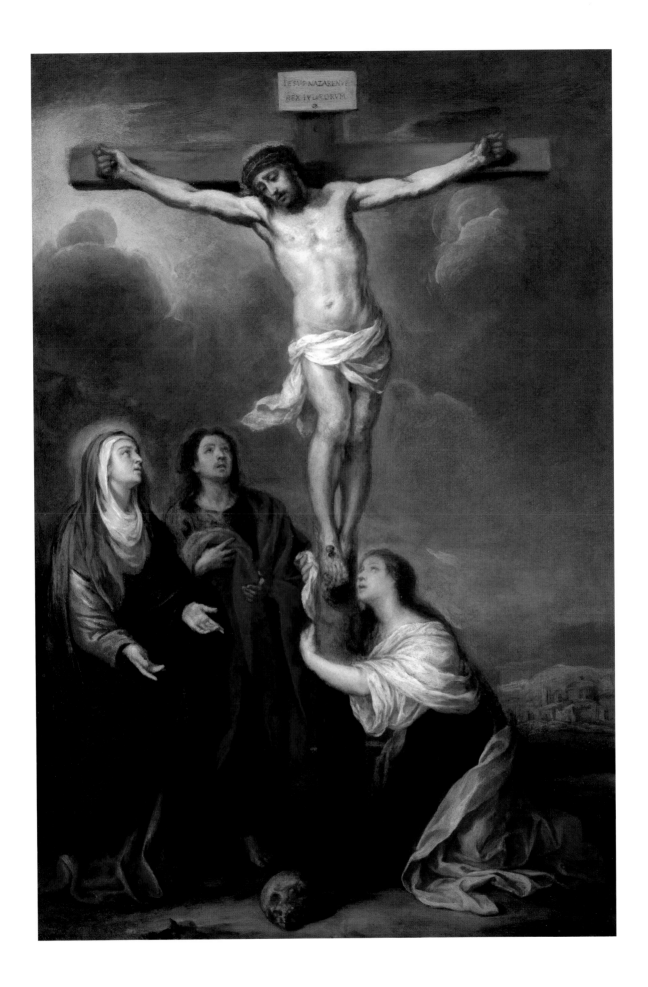

as well, despite incontrovertible evidence now known to the contrary.

A somewhat larger and later treatment of the same subject on canvas, acquired by Catherine the Great from the Walpole collection in 1779 and now in the Hermitage, is sometimes described as a variant of this composition (fig. 1).[9] Although it is unusual in Murillo's oeuvre, like the Meadows picture, for including the three witnesses in the scene of Christ's crucifixion, it is, in fact, an entirely different composition, in which the figure of Christ depends in no way on the Ford drawing and the other figures are arranged in a completely different way.[10] The Hermitage picture probably dates from a bit later in the artist's career. Although Angulo rejected it, too, a definitive determination of its authorship is complicated by the painting's considerable damage and need of cleaning.

A copy of the Meadows painting, said to be executed on canvas and to be approximately the same size as the copper, was once in the collection of the marqués de Remisa, Madrid. Photographed during the Spanish Civil War, it may still be in a Spanish private collection (Angulo 1981, no. 1633). A larger, derivative *Christ on the Cross with Mary Magdalene*, although a different composition, copies the figure of Christ almost exactly from this painting (Angulo 1981, no. 1642).

WBJ

NOTES:

1. Paris, *Vente le Cabinet de feu M. le Comte d'Hane de Steenhuyse et de Leuverghem, à Gand*, March 27, 1860, 2. Three wax seals on the back of the painting's original frame confirm its descent through successive generations in this family. The introduction to the catalogue also states that in 1815 King Louis XVIII of France stayed with the family in Ghent. While there, he asked that the Murillo *Crucifixion* be placed in the oratory of his quarters, and, when he left, he tried to buy the painting. At the 1860 auction it was sold for 8,800 francs.

2. Ibid., 16–17, no. 17.

3. Transcribed in Brown 1976, 138, no. 56.

4. Angulo 1974, 104.

5. Angulo 1981, vol. 2, 454, no. 1620. See Young 1981, who, in this review of Angulo's monograph, expressed surprise at the unexpected downgrading of this work.

6. The cleaning and restoration of the painting were carried out by Claire Barry, chief conservator of paintings at the Kimbell Art Museum. The most extensive damage was found in the drapery of the Virgin and Saint John and at the foot of the cross. The Virgin's blue mantle, however, was only slightly damaged; nevertheless, it was entirely repainted, with the creation of folds that had nothing to do with those that were intact underneath.

7. A drawing in the Hamburg Kunsthalle, *Putti for a Virgin of the Immaculate Conception*, which bears the autograph date October 17, 1660, is executed in a similar technique. The somewhat softer handling noted by Brown in the Ford drawing, particularly in the face, may be due to rubbing of the chalk rather than to a later style.

8. In writing about the Meadows *Christ on the Cross* in Phoenix 1998, I proposed a somewhat earlier date for the picture, 1655–60, which I now believe is too early.

9. Manuela Mena in London and Madrid 1982, 210; see also Kagané 1995, 136–41, no. 16.

10. Kagané, *loc. cit.*, correctly relates the body of Christ in the Hermitage painting to the type found in the small *Crucifixion* in the Prado (Angulo 1981, no. 266).

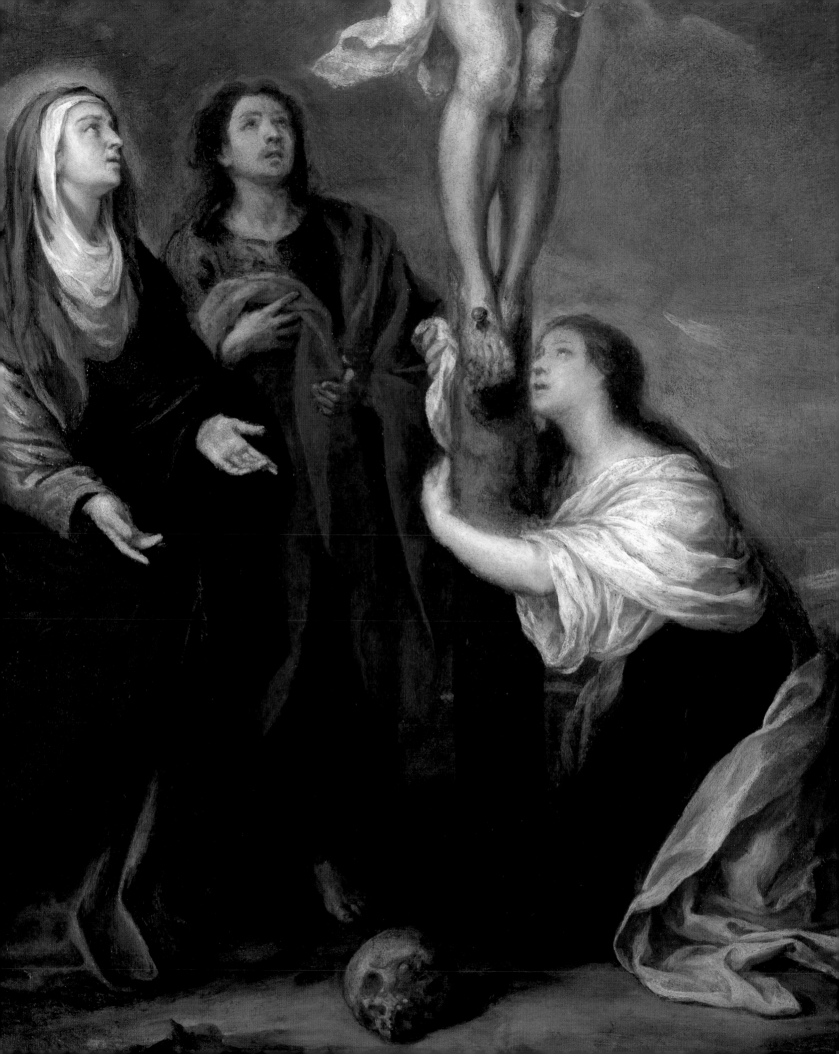

22. Christ after the Flagellation.

c. 1670. Oil on canvas. 50⅛ x 57½ in. (127.3 x 146.1 cm)
Krannert Art Museum, University of Illinois at Urbana-Champaign, Gift of Mrs. Herman C. Krannert

PROVENANCE: Frank
Hall Standish, Spain;
King Louis-Philippe,
Paris; Lord Carew, Castle-
ton, Kildare, Ireland; Mrs.
Herman C. Krannert

EXHIBITIONS: Paris,
Musée du Louvre, 1842;
[Dublin Exhibition
Palace, 1853?]; Minneapo-
lis Institute of Arts, *Vene-
tian Tradition*, 1957; Dallas
Museum of Fine Arts,
*Religious Art of the Western
World*, 1958; Indianapolis
and Providence 1963, no.
54; The Arts Club,
Chicago, November
4–October 3, 1968;
Princeton 1982, no. 32

SELECTED REFERENCES:
T. T. [Théophile Thoré?]
1842, 212–13; Curtis 1883,
201, no. 212b; Gilbert
1960, 16, ill.; Angulo 1961,
14, pl. 18, fig. 30; Wethey
1963, 208; Muller 1963,
100, fig. 3; Eisler 1977,
221; Gaya Nuño 1978,
101, no. 161; Angulo 1981,
vol. 2, 217, no. 246; vol. 3,
pl. 328; Paris 1983, 61, fig.
117; González de Zárate
1994, 55–60 [as in
Boston, Museum of Fine
Arts]; Navarrete Prieto
1998, 173

In the church of Santa Prassede in Rome is a low column, brought in fragments from Jerusalem after the Sixth Crusade in 1228, and said to be the column at which Christ was scourged. This low column first appears in seventeenth-century paintings of the flagellation of Christ, and Murillo's composition may have been informed by a print, such as the one by the Antwerp engraver Johannes van Merlen, which would have reflected the orthodox reference to the relic in Santa Prassede.[1]

There are only two versions of this subject, which is relatively rare, by Murillo. This painting differs from the earlier version of the subject in the Museum of Fine Arts, Boston (see cat. no. 12) in that the figure of Christ faces in the opposite direction and, most notably, he is not accompanied by angels, so that our concentration on him is total. Other differences are more subtle. Nina Áyala Mallory has noted that, in comparison to the Boston picture:

> Here Christ's posture is more erect as he pulls his garments toward himself, and a different, softened pathos is attained. The facial expression, meditative and sorrow-ful, plays a greater role in dictating the emotional response of the beholder. . . . The response that Murillo tried to evoke from the pious viewer here is of respect for the forbearance and endurance of the tor-tured God-made-flesh, rather than of out-rage at the indignity of his human fate.[2]

The painting is striking in its overall dark tonali-ties. The dark gray-brown background provides a foil against which play the soft grays and violet tones of the robes, the silvery white of the loin-cloth, and the brilliant red flashes of blood on luminous flesh and on the flail in the background. When the painting was installed at the Louvre in 1842, part of the bequest of Frank Hall Standish to King Louis-Philippe, a critic identified as "T. T." (probably the writer Théophile Thoré, who wrote quite a bit about Spanish painting) wisely warned the viewer not to underestimate the apparent simplicity of Murillo's composition and execution: "It is not unusual to sink into insipid-ity, ineptitude, and insignificance in an effort to imitate this dangerous technique; but it is above all to this delicate touch of the brush, to this del-icate harmony of color, that Murillo owes some of his masterpieces."[3] In lesser hands, a painting of this subject might have resulted in an image displaying at best a naturalistic treatment of the forms, at worst the allure of sentimental pathos. Murillo's "dangerous technique" yields instead a profoundly spiritual invitation to prayer.

NOTES:
1. González de Zárate 1994, 55–60.
2. Princeton 1982, 94.
3. "Il n'est pas rare qu'on tombe dans la fadeur, l'incorrection et l'insignificance, en voulant imiter cette exécution dan-geureuse; mais c'est pourtant à cette tendresse de pinceau, à cette délicat harmonie de couleur, que Murillo doit une par-tie de ses chefs-d'oeuvre." T. T. [Théophile Thoré?] 1842, 212–13.

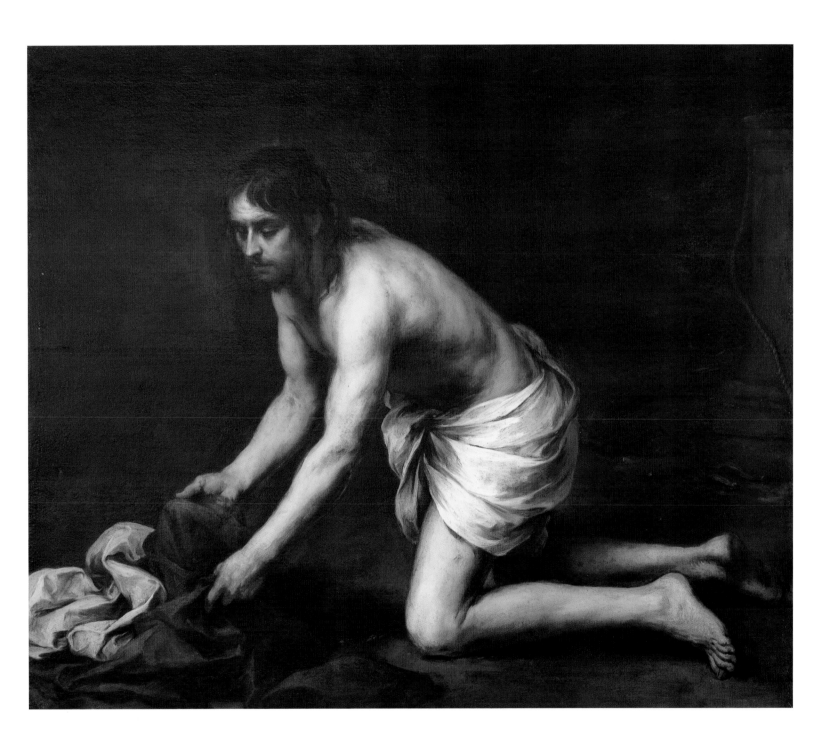

23. VIRGIN AND CHILD ("SANTIAGO MADONNA")

c. 1670. Oil on canvas. 65¼ x 43 in. (165.7 x 109.2 cm)
Lent by The Metropolitan Museum of Art, New York, Rogers Fund, 1943

PROVENANCE: Marqués de Santiago, Madrid; [William Buchanan]; Thomas Noel-Hill, 2nd baron Berwick, Attingham Park, Shrewsbury, Salop; Samuel Jones Loyd, later 1st baron Overstone, London; to his daughter Harriet Sarah Loyd-Lindsay, baroness Wantage, Carlton Gardens, London; Sir David Alexander Edward Lindsay, 27th earl of Crawford, Fife, Scotland; Sir David Alexander Robert Lindsay, 28th earl of Crawford, Fife, Scotland

EXHIBITIONS: London 1844, no. 48; London 1851, no. 97; Manchester 1857, no. 642; London 1871, no. 193; London 1888, no. 131; London 1895, no. 72; London 1901, no. 80; London 1913–14, no. 76 and pl. 35; Boston 1970, 57

SELECTED REFERENCES: Palomino 1724, 421; Cumberland 1787, vol. 2, 125; Davies 1819, xxvi; Buchanan 1824, vol. 2, 221 and 234; Waagen 1857, vol. 4, 141–42; Bürger [T. Thoré] 1860, 127; Tubino 1864, 196–97; Scott 1813, 103; Curtis 1883, 154, no. 95; Stirling-Maxwell 1891, vol. 4, 1611; Lefort 1892, 75, no. 93; Temple 1905, 107–8, no. 153; Mayer 1913A, xviii, 286, ill. 65; Mayer 1913B, vol. 2, 97; Mayer 1922, 340; Burroughs 1943, 261–65; Gaya Nuño 1958, 247, no. 1914; Richards 1968, 235–39; Brown 1976, 165–66, fig. 69; Gaya Nuño 1978, 105, no. 217; Sutton 1979, 38, fig. 6; Angulo 1981, vol. 2, 164; vol. 3, pl. 382; Paris 1983, 24; Brown 1991, 383, fig. 269; Brown 1998, 231, fig. 300

The *Virgin and Child* in the Metropolitan Museum of Art is one of the loveliest of all Murillo's versions of a subject closely associated with his fame. The Virgin is shown seated, with the child on her lap. She wears a gown of rusty red, with a bit of olive green scarf draped over her shoulder and a blue mantle across her lap. The brightness of that blue and the bright white of the animated brushstrokes sketching out the baby's swaddling bring attention to him. He seems to have been distracted from his interest in his mother's breast by the viewer's intrusion on the intimate scene. Momentarily interrupted, he looks directly at us. In 1728, when the painting was inventoried in the collection of the marqués de Santiago (hence its sobriquet "the Santiago Madonna") it was called "Nuestra Señora de la Leche con el Niño" (Our Lady of the Milk with the Child),[1] a matter-of-fact description of the subject long since forgotten.

Don Francisco Esteban Rodríguez de los Ríos, first marqués de Santiago, had acquired a number of particularly fine paintings by Murillo, including the *Virgin and Child*, the Jacob series (see cat. nos. 13 and 14), and a representation of Saint Francis Xavier. Remarkably, four works by Murillo from the Santiago collection eventually found their way into American museums—the two paintings from the Jacob series in the present exhibition, the Saint Francis Xavier (fig. 1),[2] and the "Santiago Madonna." The latter was obtained from the Santiago family by G. Augustus Wallis, acting as agent for the art dealer William Buchanan, and evidently was shipped to England with some difficulty via France and Antwerp, "being detained at the latter place during the siege by the English."[3] The "Santiago Madonna" remained in English collections until it was purchased by the Metropolitan Museum of Art in 1943.

The acquisition of the "Santiago Madonna" by the Metropolitan Museum was greeted with considerable fanfare. The *New York Times* (April 19, 1943) printed a large illustration of the work, informed readers that the painting could be seen in the gallery at the head of the grand staircase, and added: "During the week a full-color reproduction of the painting will be seen on car cards in the subways." Louise Burroughs, then assistant curator of paintings, wrote that "There are remarkably few paintings by Murillo in the museums of this country, and up to 1927 the Metropolitan Museum owned none at all. The splendid Don Andrés de Andrade, bought in that year, admirably represents the artist's work in the field of portraiture. But the lack of a religious composition continued to be keenly felt. It is a great satisfaction, therefore, to be able now to show Murillo in his most familiar and best-loved aspect. . . ."[4] Royal Cortissoz, in an article in the *New York Herald Tribune* (Sunday, April 25, 1943) welcomed the painting to New York as a work of

Fig. 1. Bartolomé Esteban Murillo. SAINT FRANCIS XAVIER. c. 1670. Oil on canvas, 7'1¼" x 63⅞" (216.5 x 162.2 cm). Wadsworth Atheneum, Hartford. The Ella Gallup Sumner and Mary Catlin Sumner Collection

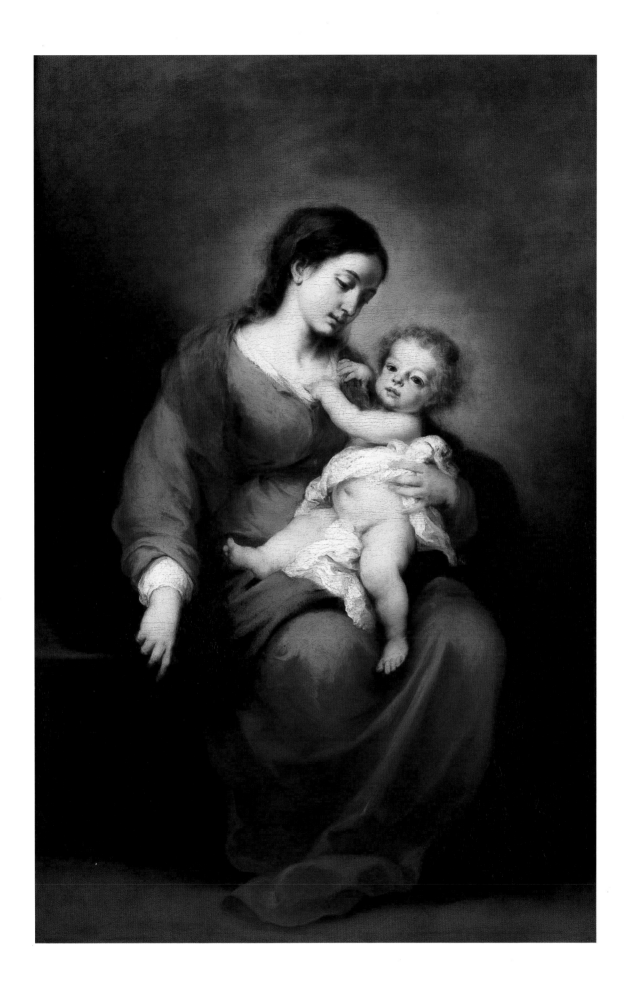

Art (fig. 2) is a delightfully animated example of Murillo's work as a draftsman, in this instance combining lines drawn with ink and a light brown wash over black chalk with added touches of red. Comparison of the sketch with the finished painting reveals how Murillo carefully fine-tuned the composition, turning the head of the Christ child toward the viewer rather than toward the Virgin, a simple change with the considerable effect of drawing the spectator into the painting. Murillo's indefatigable attention to such subtleties in the relationships between the figures in his composition and the audience partially explains the particular success of his devotional paintings.

In July 1857 Nathaniel Hawthorne, who considered Murillo "about the noblest and purest painter that ever lived,"[6] visited several times the vast exhibition of paintings at Manchester, England, where the "Santiago Madonna" was on display. He described a painting, which he did not identify, that he saw at the exhibition:

> I saw . . . a Virgin and Child, which appeared to me to have an expression more adequate to the subject than most of the innumerable virgins and children in which we see only repetitions of simple maternity; indeed, any mother, with her first child, would serve an artist for one of them. But in this picture the Virgin had a look as if she were loving the infant as her own child, and at the same time rendering him an awful worship, as to her Creator.[7]

Surely, Hawthorne was describing the "Santiago Madonna."

Fig. 2. *Bartolomé Esteban Murillo.* VIRGIN AND CHILD. *c. 1670. Pen and brown ink, 8½ x 6″ (21.4 x 15.4 cm). The Cleveland Museum of Art, Mr. and Mrs. Charles G. Prasse Collection, 1968.66*

"unforced tenderness," one with "not a trace of sentimentality." He added: "It has been given the place of honor in the gallery at the head of the grand staircase and it shines there resplendently, especially welcome at this time, when thoughts of religion are so much to the fore." The headline on the front page of the *Herald Tribune* that day read "Americans Open Tunisia Attack, Advance 5 Miles Toward Bizerte; Sweden Gives Germany Warning." Evidently, the power of Murillo's religious images to offer comfort in trying times worked on the modern critic as well as it did on the seventeenth-century worshiper.

In 1968 it came to light that the drawing for the composition of the Metropolitan Museum of Art *Virgin and Child* was also in an American collection.[5] The sketch in the Cleveland Museum of

NOTES:
1. Glendinning 1986, 149.
2. See Cadogan 1991, 302–5.
3. London 1913–14, 80.
4. Burroughs 1943, 265.
5. Richards 1968, 235.
6. Hawthorne 1883–84, 537.
7. Ibid., 532.

24. SAINT JOSEPH AND THE CHRIST CHILD

c. 1670–75. Oil on canvas. 42¾ x 33¾ in. (108.6 x 85.7 cm)
Bequest of John Ringling, Collection of The John and Mable Ringling Museum of Art,
The State Art Museum of Florida, Sarasota

In the archives of the Musée du Louvre is a receipt signed by Serafino García de la Huerta, dated Madrid, March 19, 1837, recording the purchase by Baron Isidore Taylor of a Murillo painting of *Saint Joseph and the Christ Child* for the collection of King Louis-Philippe.[1] The catalogue of his collection, shown at the Louvre as the "Galerie Espagnole," lists three paintings of this subject. Of the three, the painting in the John and Mable Ringling Museum of Art is the only one now considered to be by Murillo's hand,[2] but we cannot be sure that it was the same one purchased by Baron Taylor. Except for that question, the history of the painting since it was sold by Louis-Philippe is well documented. At the auction of the royal collection of Spanish paintings in 1853, Richard Ford described no. 168, "Saint Joseph and the Child . . . painted in his [Murillo's] third and most popular manner, and full of tender sentiment and melting tones, was bought, we believe, by Mr. Lyne Stephens, for £440. Once a gem,— it has suffered even worse than the preceding lot from sea water and ill usage; yet, as a relic it is most precious,—and not, we suspect, utterly irreclaimable."[3] The Ringling Museum painting, as we can see, proved to be not at all "irreclaimable."

Saint Joseph, hardly mentioned in the New Testament, was more fully described in the Apocrypha as an old man, a widower with children. He won the hand of the Virgin Mary in competition with other suitors when his staff burst into bloom—hence his attribute, the "flowering rod," seen in the painting. The cult of Saint Joseph was promoted by the Franciscans, his feast day was established in 1271, and, as a model of rectitude, piety, and devotion to God and family, his cult continued to grow. As Saint Joseph's popularity spread, so did his age decrease until he was pictured in art no longer as a doddering oldster (presumably ensuring the "virginity" of his marriage to Mary), but as a man in the full strength of his maturity, up to the task of serving as earthly father—"nutritoris domini"—to the son of God. The cult of Saint Joseph was fervently promoted

in sixteenth-century Spain. In his *Spiritual Exercises* (1548) Ignatius Loyola emphasized the role of Joseph in Christ's childhood, and the attention paid to him by the Council of Trent may have inspired writers such as Gracián de la Madre de Dios, whose *Grandezas y excelencias del glorioso San José* (1597) was widely read. Teresa of Avila, who was elevated to sainthood in the seventeenth century, established seventeen churches and made Joseph the titular saint of twelve of them. The feast of Saint Joseph was firmly established *de precepto* by Pope Gregory XV in 1621, just a few years following Murillo's birth.

In the Sarasota painting, the Christ child is shown standing next to Saint Joseph, his earthly father. Saint Joseph, like a good parent, encircles the boy protectively with his arms, but in a loose embrace that allows him a sense of independence. The child seems ready to step out confidently into his future; Joseph's expression is concerned, his slightly knitted brow suggesting an apprehension of the future, a sense of the sacrifice God will demand of the son they share.

We may surmise that this painting was extremely popular, for a number of replicas by various hands among Murillo's disciples and, perhaps, the Sevillian followers of his example who created "Murillesque" paintings well into the eighteenth century, are known. In the catalogue raisonné of the artist's oeuvre there are thirteen related painted versions,[4] and Curtis, in 1883, listed nineteen different print reproductions. The artists who were trained in Murillo's workshop, with the possible exception of Francisco Meneses Osorio, have not been well studied and so their different hands have not been identified. A replica of the *Saint Joseph and the Christ Child* in Glasgow (fig. 1) has been attributed to Alonso Miguel de Tovar (1678–1758), as was the Murillo painting now in the Hispanic Society (cat. no. 17) before restoration revealed its true author.

Although not many of Tovar's works have been identified, his career is fairly well documented. He was appointed court painter in 1729 when the Spanish court moved to Seville and he

PROVENANCE: King Louis-Philippe, Paris; Mr. Lyne Stephens; Mrs. Lyne Stephens, Lynford Hall, Brandon, Norfolk

EXHIBITIONS: Paris 1838–48, no. 157; Paris 1874, no. 359; Cummer Gallery of Art, Jacksonville, Fla., *Loans from the Collection of the Ringling Museum of Art,* January– May 1962; South Florida Museum, March 17–27, 1971

SELECTED REFERENCES: Ford 1853A, 594; Curtis 1883, 252, no. 344; Mayer 1923, ill. 185; Suida 1949, 287, no. 349, ill. p. 290; Gaya Nuño 1958, 254, no. 1987; Angulo 1961, 11; Gaya Nuño 1978, no. 232; Angulo 1981, vol. 2, 266, no. 328; vol. 3, pl. 403; Baticle and Marinas 1981, 114–15, no. 157; Paris 1983, 61, fig. 118

traveled with the court when it returned to Madrid. Did Tovar, as a young artist, make copies of paintings by Murillo for the continued insatiable market for works by the seventeenth-century master? We can only be sure that some artists did so, carefully creating many versions of iconic images such as the Sarasota *Saint Joseph and the Christ Child*. These numerous replicas have, over the years, both unintentionally veiled Murillo's true legacy and attested to the great popularity of his art.

NOTES:
1. Baticle and Marinas 1981, 115.
2. The other two are now ascribed to Murillo's workshop (London, private collection) and to a follower (Chantilly, Musée Condé). Ibid., 114–15.
3. Ford 1853A, 594.
4. Angulo 1981, vol. 2, 266–67.

1. *Attributed to Alonso Miguel de Tovar (1678–1752).* SAINT JOSEPH AND THE CHRIST CHILD. *Oil on canvas, 48½ x 36½″ (123 x 92.7 cm). Glasgow Museums: Art Gallery and Museum, Kelvingrove*

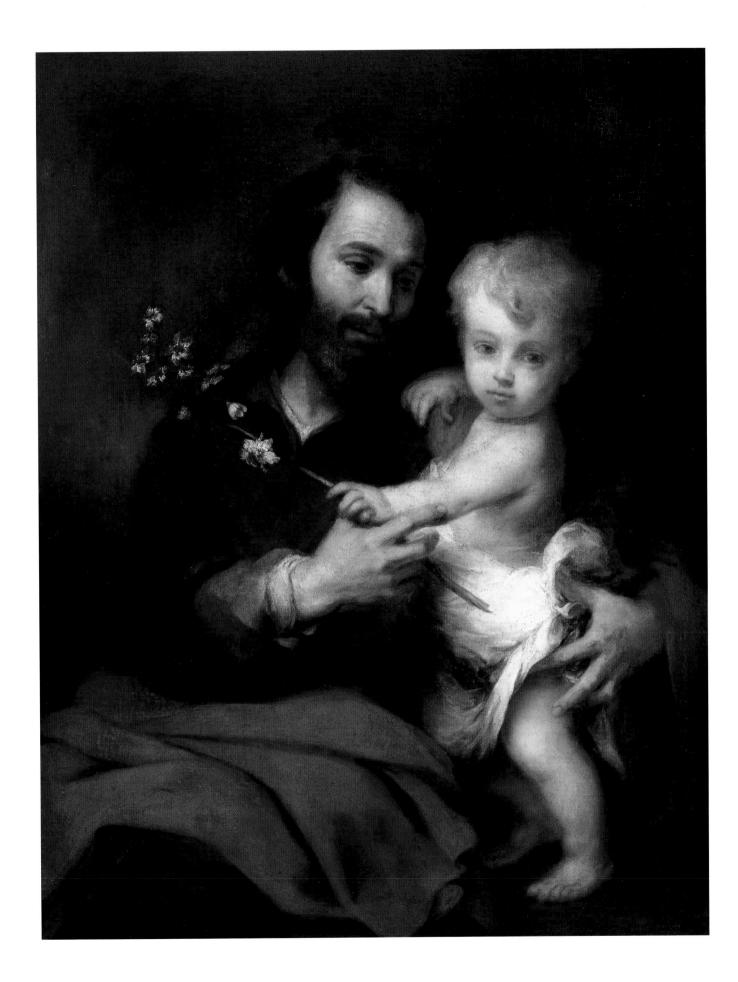

25. HOLY FAMILY WITH THE INFANT SAINT JOHN

c. 1670–75. Oil on canvas. 47¼ x 43½ in. (120 x 110.5 cm)
Fogg Art Museum, Harvard University Art Museums, Cambridge, Massachusetts, Bequest of Nettie G. Naumburg

PROVENANCE: [Marshal-General Nicolas Soult, duke of Dalmatia?]; Admiral Sir Eliab Harvey, M.P., Rolls Park, Chigwell, Essex; his daughter, Lady Louisa Nugent; Lord Nugent; Sir William Eustace, Bart.; Edmund Foster, Clewer Manor, Berkshire; Alfred Beit, London; Maurice Kann, Paris; Sir Ernest Cassel, London; Mrs. Herbert (Margot) Asquith, countess of Oxford and Asquith, London; Aaron and Nettie G. Naumburg, New York

EXHIBITIONS: London 1819, no. 85; Fogg Art Museum, Cambridge, Mass., *Master Paintings from the Fogg Collections,* April 13–August 1977

SELECTED REFERENCES: Waagen 1857, 228; Curtis 1883, 179, no. 153; Lefort 1892, 79, no. 151; Bode 1904, 53, ill. opposite 6; Calvert 1907, 161; New York 1941, no. 233; Gaya Nuño 1958, 247, no. 1913; Freedberg 1978, 397, fig. 15; Gaya Nuño 1978, 105, no. 154; Angulo 1981, vol. 2, 180, no. 198; vol. 3, pl. 311; Mortimer and Klingelhofer 1985, no. 186; Serrera 1988, 184–85; Bowron 1990, 122, ill. 835

INSCRIPTION: On scroll held by the Christ child: *ECCE AGNUS D*

Like many of the paintings by Murillo in American collections, the *Holy Family with Infant Saint John* in the Fogg Art Museum had been, for many decades, in English collections. This painting was owned by Admiral Sir Eliab Harvey in 1819; it was almost certainly brought to England after the Napoleonic Wars. Although we cannot be certain, it seems likely that the earlier provenance of the painting was quite an interesting one.

According to the *Actas Capitulares* of the Cabildo of the cathedral of Seville, in 1810, Marshal-General Soult expressed a desire to have some of the paintings in the cathedral. On July 1, 1810, Soult signed a document thanking the Cabildo for the delivery of five pictures, specifying the *Birth of the Virgin* (Musée du Louvre, Paris), the *Death of Abel,* a *Saint Peter* and a *Saint Paul,* and a *Virgin Resting*—all attributed by Soult to Murillo. The only one of these clearly identifiable today is the painting in the Louvre.

However, it is possible that the Fogg painting is in fact the *Virgin Resting* (*Descanso de la Virgen*) removed from the sacristy of the Capilla de la Antigua in the cathedral, where it was described

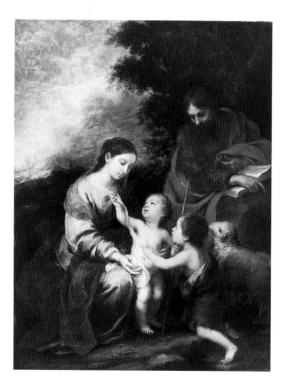

by Ponz and by Ceán Bermúdez. In the inventory of the chapel taken in 1724, the painting was said to have been in the oratory of the canon Gaspar Murillo (son of the painter). This was also noted in an inventory taken in 1760. In 1765, it was described as "una lámina grande con moldura dorada toda, en el lienzo está Ntra. Sra. Con el Niño en los brazos, el Sr. San Joseph y el Sr. Juan." Both Ceán Bermúdez and the cathedral chapter called the painting a *Descanso de la Virgen,* which would imply a moment of respite on the flight into Egypt, a scene that would not include the Infant Saint John the Baptist. However, in the Fogg painting, the Virgin is pictured seated on a large boulder and this may reasonably have suggested the title it was given.[1]

It has always been recognized that the Fogg painting is very close in style and composition to the painting of the same subject in the Wallace Collection in London (fig. 1), which Angulo thought likely to have been the painting in the cathedral of Seville.[2] However, in the Wallace version the Christ child is posed standing in front of the Virgin, while in the Fogg painting he is shown held in her lap—"Ntra. Sra. Con el Niño en los brazos." If this is the painting given to Soult by the cathedral chapter of Seville, we are still missing the link between that moment of its history in 1810 and its appearance in the collection of a military man in Chigwell, Essex, England, nine years later.

Both this painting and the Wallace version are lovely examples of the devotional paintings of Murillo's maturity. The figures are softly, though directly, illuminated, and the serene mood of the scene is enhanced by a palette of pastel tones, soft browns, and silver.

NOTES:
1. This argument is outlined in Serrera 1988, 184–85.
2. Angulo 1981, vol. 2, p. 181.

Fig. 1. Bartolomé Esteban Murillo. HOLY FAMILY WITH SAINT JOHN THE BAPTIST. *c. 1670–75. Oil on canvas, 66⅜ x 51⅛″ (168.6 x 130 cm). The Wallace Collection, London*

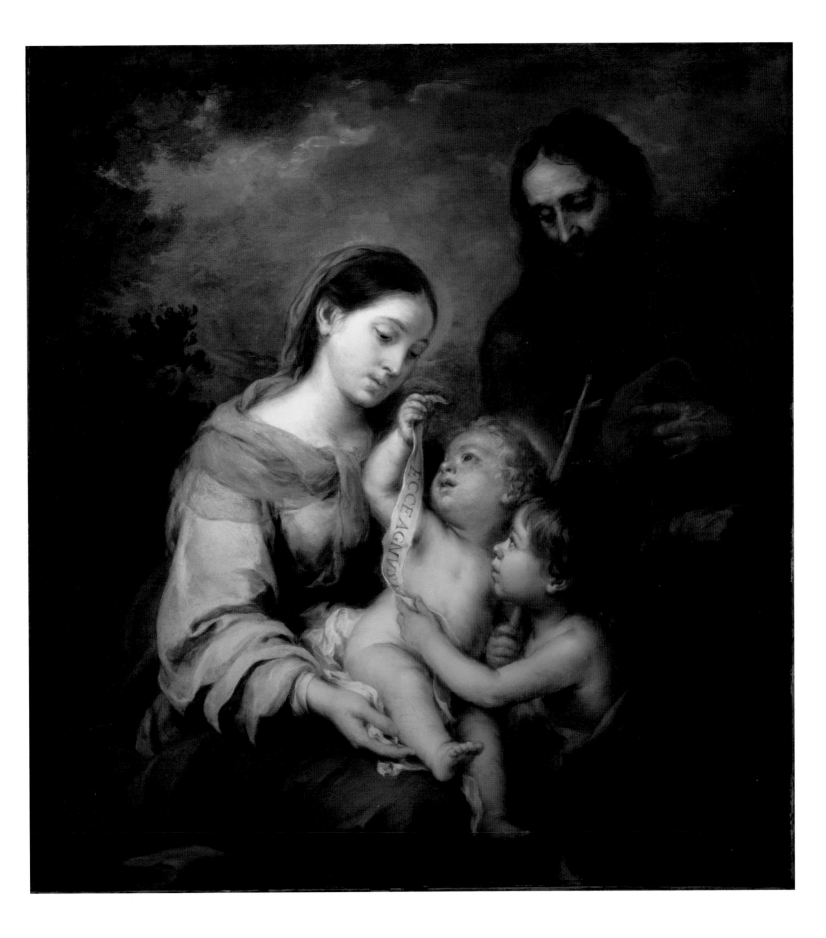

26. CRUCIFIXION

c. 1670—75. Oil on canvas. 20 x 13 in. (50.8 x 33 cm)
Lent by The Metropolitan Museum of Art, New York, Bequest of Harry G. Sperling, 1971

PROVENANCE: Delaval Loftus Astley, 18th baron Hastings, Melton Constable, Norfolk; by descent to Albert Edward Deleval Astley, 21st baron Hastings, Melton Constable, Norfolk; Sir Robert Abdy; Harry G. Sperling

EXHIBITIONS: Jacksonville, Fla. 1965, no. 38; Corpus Christi 1979, no. 4

SELECTED REFERENCES: Brown 1976, 189, no. 14; Young 1980, 88, no. 278; Angulo 1981, vol. 2, 224—25, no. 265; vol. 3, pl. 397; Valdivieso 1990, 142.

This small painting is one of a number of oil sketches that have been attributed to Murillo.[1] For a long time, sketches such as this one, which are clearly related to larger finished works, were considered replicas or copies by other hands. This oil sketch is compositionally very close to a large version in the Museo del Prado, Madrid (fig. 1); in his catalogue raisonné of Murillo's oeuvre, Angulo suggested, too cautiously, that the Metropolitan Museum picture is a replica of the Prado *Christ on the Cross*.[2] Artist's replicas were finished works intended to duplicate admired paintings in their degree of finish, if not in scale. This sketchily painted work is perfectly consistent with what we know of Murillo's oil sketches, which were indeed an integral part of his creative process.

The astute art collector Sebastián Martínez owned, in the late eighteenth century, several oil sketches by Murillo (see cat. no. 29). Among them, Ponz mentioned "un crucifixo en pequeño," which Edward Davies, in 1819, reported "came to England."[3] The English provenance of the Metropolitan Museum picture suggests the possibility (impossible to confirm) that it once belonged to Martínez, a friend of Goya, whose portrait of him belongs to the museum.

Mayer suggested that the inspiration for the two Prado versions of *Christ on the Cross* by Murillo was the painting by Anthony van Dyck in Dendermonde. Angulo agreed that Murillo likely knew "Crucifijos vandiquíanos," but did not think the one in Dendermonde was the most likely model.[4] Indeed that painting, with its flashy Baroque light and movement, has little in common with Murillo's restrained image. If Murillo needed a model for this oft-repeated subject in Spanish art, he undoubtedly found one closer to home: the similarity of his composition to the painting by Alonso Cano in Granada (fig. 2) is certainly suggestive.

Top: *Fig. 1. Bartolomé Esteban Murillo.* CHRIST ON THE CROSS. *c. 1670—75. Oil on canvas, 6' x 42⅛" (183 x 107 cm). Museo Nacional del Prado, Madrid*

Left: *Fig. 2. Alonso Cano.* CHRIST ON THE CROSS. *c. 1652. Oil on canvas, 47⅝ x 32¾" (121 x 83 cm). Academia de Bellas Artes, Granada*

When the American H. Willis Baxley, M.D., visited the Prado in the nineteenth century, he was moved by Murillo's *Crucifixion*:

As an after-death scene, when the face of nature was covered with deep darkness, it is a masterly rendering of the solemn event by Murillo. Lifelessness is shown by relaxation; drawing stands the test of strictest anatomical examination; the flesh tints, pale from stilled blood-streams, and borrowing no colour of surroundings, are convincingly truthful; and the face is not so much hidden in shadow—sometimes done—as to shut out all sign of the soul's repose, but the expression is seen of that submission to sacrifice with which the Savior "bowed his head and died."[5]

Baxley's words apply as aptly to this oil sketch. The dull, greenish-brown sky is not so dark as to obscure the city in the middle distance. The breaking dawn at the horizon is the only light in the picture to compare with the pale flesh-tones, the bright white of the sketchily painted drapery. The single touch of bright color is the blood flowing from the wound in Christ's side, staining the cloth around his waist.

NOTES:
1. See Brown 1976, 34 and 187–90.
2. Angulo 1981, vol. 2, 224–25, no. 265.
3. Davies 1819, lxxiv.
4. Angulo 1981, vol. 2, 224–25, no. 265.
5. Baxley 1875.

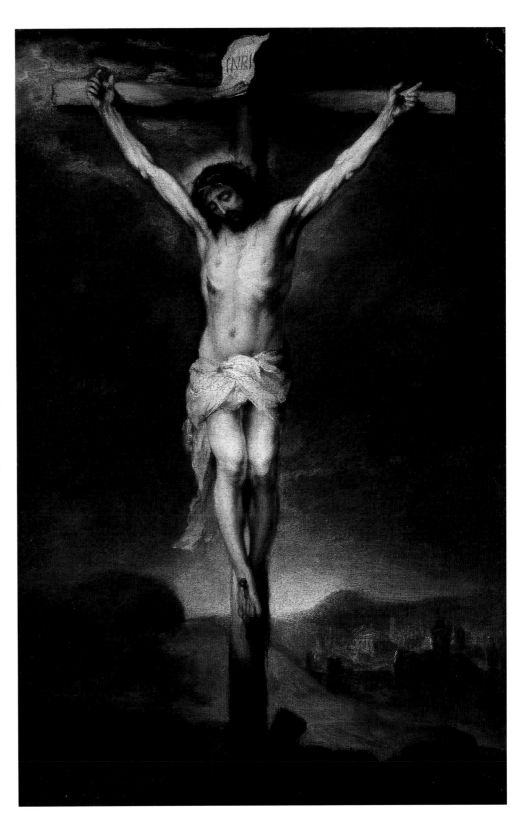

27. Ecce Homo

c. 1675. Oil on panel. 33¾ x 31 in. (85.7 x 78.7 cm)
El Paso Museum of Art, Gift of the Kress Foundation

PROVENANCE: Seville Cathedral, Capilla del Pilar; Seville Cathedral, Capilla de la Virgen del Alcobilla; Seville Cathedral, Sacristía de las Cálices; King Louis-Philippe, Paris; John Campbell, 5th earl of Breadalbane, Taymouth Castle, Perthshire; by descent to the Hon. T. Morgan-Granville-Gavin, London; Samuel H. Kress Collection

EXHIBITIONS: Paris 1838–48, no. 163; London 1881, no. 218; London 1893, no. 112

SELECTED REFERENCES: Ponz 1772–94, vol. 9, 12; Ceán Bermúdez 1804, 72; Standish 1840, 194; Stirling-Maxwell 1848, vol. 3, 1430; Ford 1853B, 623; Latour 1855 [1954 ed.], 66–67; Curtis 1883, 199; Stirling-Maxwell 1891, vol. 3, 1621; Lefort 1892, 82; Mayer 1926, 251, ill.; El Paso 1961, no. 46; Eisler 1977, 219–21 and fig. 209; Angulo 1981, vol. 2, 217–18; vol. 3, pl. 391; Baticle and Marinas 1981, 121–22; Paris 1983, 62, fig. 122; Plazaola 1989, 134–35.

INSCRIPTIONS: Added c. 1839: Upper left: *A LUIS/FELIPE/DE/ORLEANS/REY/DE LOS/FRANCE-SES.* Upper right: *EL CABILDO/DE LA SANTA/METROPOLI-TANA/Y PATRIARCAL/YGLESIA/DE/SEVILLA.*

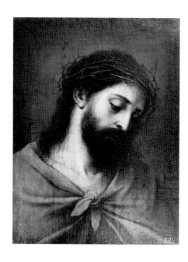

Top left: *Fig. 1. Bartolomé Esteban Murillo.* ECCE HOMO. *c. 1660–70. Oil on canvas, 20½ x 16⅛" (52 x 41 cm). Museo Nacional del Prado, Madrid*

Top right: *Fig. 2. Bartolomé Esteban Murillo.* MATER DOLOROSA. *c. 1660–70. Oil on canvas, 20½ x 16⅛" (52 x 41 cm). Museo Nacional del Prado, Madrid*

Below: *Fig. 3. Pedro Roldán.* CRISTO DE LA CARIDAD. *1674. Polychromed wood. Hospital de la Caridad, Seville*

Then Pilate took Jesus and scourged him. And the soldiers plaited a crown of thorns, and put it on his head, and arrayed him in a purple robe; they came up to him, saying, "Hail, King of the Jews!" and struck him with their hands. Pilate went out again, and said to them "Behold, I am bringing him out to you, that you may know that I find no crime in him." So Jesus came out, wearing the crown of thorns and the purple robe. Pilate said to them, "Here is the man!" And then the cry went up: "Crucify him, crucify him!" (John 19:1-6)

The "Ecce Homo," the Latin version of Pilate's words "Here is the man!," is the image of Christ after the Flagellation, also often called the "Man of Sorrows." Murillo's painting shows Christ wearing the crown of thorns, with a red cloak draped over his left shoulder. His hands are tied together at the waist and the reed of the Flagellation (Matt. 27:30) is held in his left hand as a mock scepter.

Murillo created other versions of this subject, though the one now in El Paso is unique in having been painted on a wood panel. He also painted pairs of portraits of Christ and the Virgin Mary as "Man of Sorrows" (*Ecce Homo*) and "Weeping Virgin" (*Mater Dolorosa*), exemplified by the poignant versions now in the Museo del Prado (figs. 1 and 2). These small devotional paintings are also thematically analogous with the painting of *Christ Carrying the Cross* in this exhibition (cat. no. 10). The *Ecce Homo* was a popular subject in art from the late Middle Ages through the Baroque period and, in Spain, was often depicted in sculptural form. Pedro Roldán's so-called *Cristo de la Caridad* (fig. 3), as an example, shows Christ kneeling, though many sculptured versions present a half-length figure. Murillo would have known Roldán's work, for it was created in 1674, during the years in which both artists were working on the decoration of the church of the Hospital de la Caridad in Seville.

In 1848 Antoine de Latour recorded how this painting was acquired by Baron Isidore Taylor (a Frenchman, despite his name), for the collection of King Louis-Philippe.[1] Taylor, who had come to Seville with the artist Adrien Dauzats, visited the

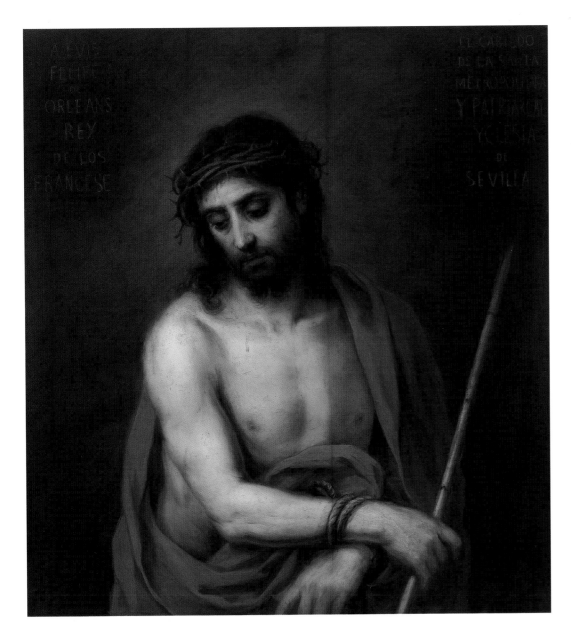

cathedral of Seville in the company of the dean of the Cabildo (the cathedral chapter), Manuel López Cepero, himself a great collector of paintings. Taylor's interest in acquiring a Murillo painting from the cathedral for the French king, López Cepero's ardently Francophile leanings, Taylor's diplomatic charm, and the poverty in which the Cabildo found itself—all these elements conspired to send yet another painting by Murillo to France. When Taylor returned to Paris, he sent as gifts to the Cabildo sets of valuable engravings, a collection of richly decorated prayerbooks, and a full-length portrait of Christopher Columbus. That was just the right touch, for the library of the cathedral chapter, the "Biblioteca Colombina," had been a bequest of Columbus's son. Hence, the

inscription added to the top of the panel, to the left and right: "To Louis Philippe of Orléans, King of the French. The Cabildo of the Holy Metropolitan and Patriarchal Church of Seville."

It is not surprising that Baron Taylor was so determined to acquire this particular painting by Murillo. Not only did it have the cachet of having belonged to the cathedral of Seville, but it is painted in Murillo's late "vaporous" style, the style of his work most prized in the nineteenth century. The soft, loose brushwork reminds us of Titian, whose versions of the *Ecce Homo* were widely known and emulated.

NOTES:
1. See Latour 1855 [1954 ed.], 66–67, quoted also in Plazaola 1989, 134–35.

28. Virgin of the Immaculate Conception

c. 1680. Oil on canvas. 86¾ x 50¼ in. (220.5 x 127.5 cm.)
The Cleveland Museum of Art, Leonard C. Hanna, Jr. Fund 59.189

PROVENANCE: Sir Thomas Sebright, Beechwood near Boxmoor, Hertfordshire

EXHIBITIONS: Indianapolis and Providence 1963, no. 52

SELECTED REFERENCES: Waagen 1857, 328; Curtis 1883, 140, no. 54b; Mayer 1938, 120; Wixon 1960, 163–64, ill. in color on cover; Wethey 1963, 207; Gaya Nuño 1978, 92, fig. 72, and 93, no. 72; Angulo 1981, vol. 2, 121, no. 111; vol. 3, pl. 370; Cleveland 1982, 501–2, ill; Cleveland 1993, 163

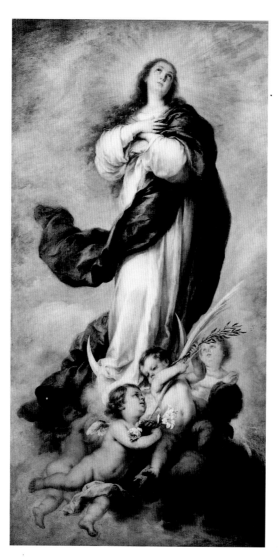

Fig. 1. Bartolomé Esteban Murillo. LA CONCEPCIÓN DE "ARANJUEZ." *c. 1680. Oil on canvas, 7′3½″ x 46½″ (222 x 118 cm). Museo Nacional del Prado, Madrid*

The Virgin of the Immaculate Conception in the Cleveland Museum of Art is a replica, with variations, of the so-called *Concepción de "Aranjuez"* in the Museo del Prado, Madrid (fig. 1). The most important difference between the two is in the arrangement of the putti at the feet of the Virgin, which has been largely reinvented in the Cleveland picture.

We are fortunate to be able to compare, in this exhibition, one of Murillo's very earliest paintings of the Virgin of the Immaculate Conception (cat. no. 8) with this one dating from his last years. The visitor to the exhibition need not be an expert to realize the stylistic differences between the early work, which is compositionally more static and painted with carefully delineated contours, and this painting created during Murillo's last years. The Cleveland painting is a fine example of the loose, painterly brushwork that was characterized in the nineteenth century as "vaporoso."[1]

When the American H. Willis Baxley, M.D., visited the Museo del Prado in the nineteenth century, he was transported by the *Concepión de "Aranjuez,"* so named because it had been in the chapel dedicated to Saint Anthony in the royal palace at Aranjuez until 1818. Baxley's description of the painting spares no effort to capture its impact on the viewer:

> The Virgin . . . stands enthroned on clouds, in loveliness of face and form, chaste and graceful drapery, and transcendent colouring. Atmosphere and infant angels, too, are brightness and beauty; the one, golden hued; the others, lustrous and exultant, making the gazer feel as if he were quaffing gladness, and has flung on him sweetness of peace and purity, as palms, myrtles, lilies, and roses, are waved and tossed abroad by the fluttering throng of innocents. While in recognition of Divine purpose by the heavenward look, in transported sense and soul told alike by a face of yearning submission, and by the folded hands on the breast, there is seen the beautifully tender and gentle; trustful and rapturous, the sublimely spiritual. . . . There is something

about it so expressive of seraphic obedience, so much less of earth than heaven in the pure and pious fervour of the face; something so marvellously happy, yet so humbly passive, in the folded hands stilling the glad tumult of the heart; something so exquisitely spiritual about this revelation; that one lingers long at the art-shrine; and the longer, the stronger he clings to—blending lines, and tints, and tones, which make a thing of truth and beauty. Presented as the Virgin here is, if a knowledge of the Passion and its pangs was hers, she looked beyond them at the Glory of God, and the Grace of his Redemption.[2]

Baxley's unabashed extravagance of expression seems fulsome in comparison with the far drier language used by art historians and critics of today. What has been lost, perhaps, is more than an old-fashioned literary style, but as well a willingness to let oneself be swept away by the power of Murillo's religious art, as did this North American Protestant tourist in Spain.

NOTES:
1. The French critic Louis Viardot seems to have been the first to refer to Murillo's style in terms he attributed to the Spaniards—frío, cálido, vaporoso [cold, warm, vaporous]. See López Rey 1987, 8.
2. Baxley 1875, 276–77.

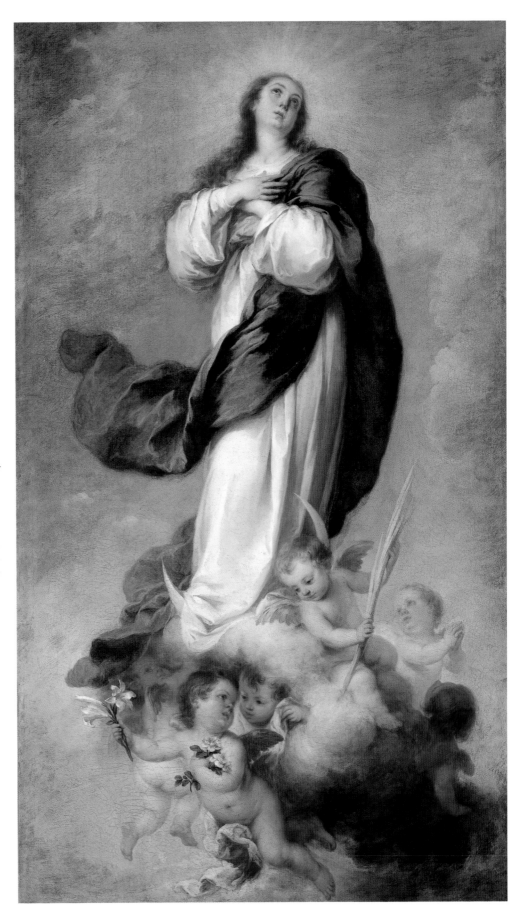

29. THE ARCHANGEL RAPHAEL

c. 1680. Oil on canvas. 12 x 8⅝ in. (30.5 x 22 cm)
Private collection

PROVENANCE: Marqués
de la Cañada, Puerto de
Santa María, Spain;
Sebastián Martínez,
Cádiz; Manuel de Leyra,
Cádiz; Edward Davies,
England; Hastings; Sir
Hamilton Seymour;
Sturzenegger collection,
Switzerland; Museum of
Saint Gall; Tomás Harris,
London; Böhler, Lucerne

EXHIBITION: Spanish
Gallery, London, 1938B

SELECTED REFERENCES:
Curtis 1883, 266, no. 385c;
Malitskaya 1947, ill. 178;
Brown 1976, 189, no. 20;
Angulo 1981, vol. 2, 289,
cat. no. 367; vol. 3, pl. 417;
Young 1982, no. 181

This small oil sketch is very likely a study for the painting of *The Archangel Raphael and Bishop Francisco Domonte* (fig. 1). Domonte, a native of Seville, entered the Mercedarian order in the Casa Grande de la Merced there in 1633. In 1676, while serving as vicar general of the order in Peru he sent 50,000 pesos to his home monastery for "alajas y culto." In 1680 Domonte was named titular bishop of Arjona and auxiliary bishop of Seville. He died the following year, in 1681.[1] According to the chroniclers of the period, Domonte commissioned an altarpiece dedicated to Saint Raphael Archangel and had his own portrait painted at the feet of the angel. The painting remained in the Merced Calzada until 1810, when the French taken it to the Alcázar for safekeeping. Like many other paintings removed there from the monasteries of Seville, it soon left the peninsula. Sometime after 1822 it was in the collection of Josephine Beauharnais at Malmaison, in 1851 it was in Munich in the collection of the duke of Leuchtenberg, and in 1883 it was in the Leuchtenberg Gallery, Saint Petersburg.

The oil sketch is identified by Edward Davies in his *Life of Bartolomé E. Murillo* (London, 1819) as "San Rafael with the Fish," a *baroncillo* [sketch] for the "San Rafael with Bishop Domonte."[2] The sketch, he reported, belonged to the marqués de la Cañada, then to Sebastián Martínez, then Manuel de Leyra, finally arriving in England. Davies's book was characterized by Curtis as "a confused, slovenly, ill-arranged work, but valuable nevertheless."[3] Although no scholar (Davies describes himself as "Esq. late Captain in the first regiment of Life Guards"), he was himself purchasing Spanish paintings for export to England, and his knowlege of the ownership of the works he mentions is likely quite accurate. Indeed, the picture was sold at Christie's on April 26, 1817, by "Major Davis" for £2.2 to Hastings.

Curiously, although Angulo accepts this oil sketch as a study for the portrait of Bishop Domonte, he suggests a date of c. 1670. It is unlikely, however that this painting was executed a full ten years before Murillo turned to the altarpiece commissioned by Domonte; it more likely dates from the end of Murillo's life, c. 1680. Stylistically, it is impossible to compare the two. The oil sketch is in fine condition, demonstrating the delicate, loose brushwork of Murillo's late style. The completed portrait is so abraded and evidently repainted that, except for the still powerful representation of Domonte's gaunt features, little of Murillo's work is to be seen.

In the oil sketch, the Archangel Raphael is pictured in a tunic of golden hue with a pink drape gathered around his body and over his right arm, walking through a sketchily suggested landscape. The fish (Raphael's symbol based on his travels with Tobias) that he bears in his left hand is replaced in the portrait painting with the mitre and staff of a bishop on the ground at the far left of the picture. The staff Raphael holds, however, is the same in both the sketch and the portrait.

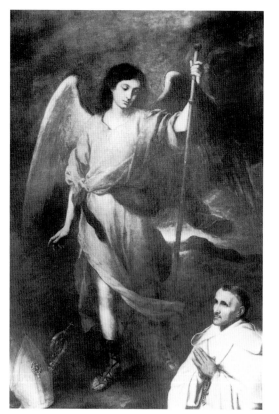

Fig. 1. Bartolomé Esteban Murillo. THE ARCHANGEL RAPHAEL AND BISHOP FRANCISCO DOMONTE. *After 1680. Oil on canvas, 6'11⅛" x 59" (211 x 150 cm). State Pushkin Museum of Fine Arts, Moscow*

NOTES:
1. Angulo 1981, vol. 2, 290, no. 368.
2. Davies 1819, 94 and lxxxiv.
3. Curtis 1883, 359.

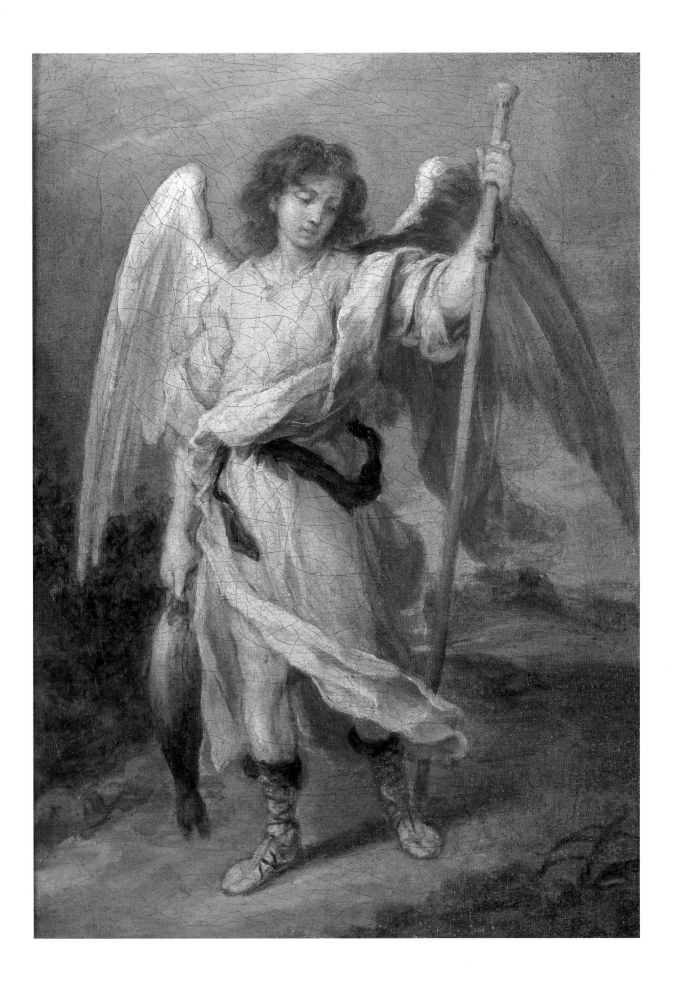

30. THE MYSTIC MARRIAGE OF SAINT CATHERINE

1680–82. Oil on canvas. 28 x 20½ in. (71.1 x 52.1 cm)
Los Angeles County Museum of Art, Gift of The Ahmanson Foundation, M.83.168

PROVENANCE: Marqués de la Cañada, Puerto de Santa María, Spain; Sebastián Martínez, Cádiz; Manuel de Leyra [Llera], Cádiz; Captain Edward Davies, London; Major de Blacquiere; Otto Bernel, The Netherlands; W. Hekking, The Netherlands; Irving M. Scott, San Francisco; heirs of Irving M. Scott, San Francisco

SELECTED REFERENCES: Ponz 1772–94, vol. 18, 48; Twiss 1775, 316; Davies 1819, xcv and 94; Curtis 1883, 222; Brown 1976, 189–90, appendix 2, no. 33; Angulo 1981, vol. 2, 243, no. 291a; vol. 3, pl. 427; Ahmanson 1991, 115–18, ill.

This oil sketch is the *modello* for the central painting of the altarpiece of the Capuchin church of Santa Catalina in Cádiz. Murillo died in Seville on April 2, 1682, of injuries sustained when he fell from a scaffold while he was working on the painting. The huge canvas (fig. 1), nearly fifteen feet high, was completed by one of his followers, Francisco Meneses Osorio, who faithfully followed the composition envisioned by his master, though in a much harder, drier style.

According to a medieval legend, the fourth-century Saint Catherine of Alexandria was praying to an image of the Virgin and the Christ child when he miraculously turned to her and placed a ring on her finger symbolizing her connection to the church as a "bride of Christ." Images of the Marriage of Saint Catherine were important in a Catholic culture like Spain's, in which enormous numbers of unmarried young women decided to dedicate their lives to the church. Murillo placed the scene, witnessed by angels, before the altar of a great church. In the foreground are the symbols of Saint Catherine's martyrdom, ordered by the emperor Maxentius for her attempts to convert his subjects to Christianity. Because lightning sent from heaven destroyed the spiked wheel upon which she was supposed to die, she was beheaded instead.

This oil sketch was mentioned by Richard Twiss in his memoirs of travels in Spain during 1772 and 1773 as being in the collection of the marqués de la Cañada, "a gentleman of Irish extraction; his surname is Tyrry. . . ."[1] Twiss described the painting as "The original small sketch, by Murillo, of the picture which he painted in the Capuchin Church at Cadiz."[2] By 1794, it was in the collection of Sebastián Martínez in Cádiz, where it was described by Ponz as "*el borron* [sketch] by Murillo, which I saw some years ago in Puerto de Santa María owned by someone else [presumably the marqués de la Cañada], and that is the invention of said artist for the painting of the Betrothal of Saint Catherine with the Child. . . ."[3] Martínez was a great art collector (and a friend of Francisco de Goya, whose portrait of him is in the Metropolitan Museum of Art, New York); his several hundred prints and paintings were sold after his death. In 1813, the conde de Maule (who had acquired a *Self-Portrait* by Murillo, see cat. no. 33, fig. 1) reported that "This collection was divided when Don Sebastián Martínez died. Half was taken away by Casado de Torres and the other half went to Don Francisco Viola which sold it to the English."[4] Some of these paintings were purchased by Manuel de

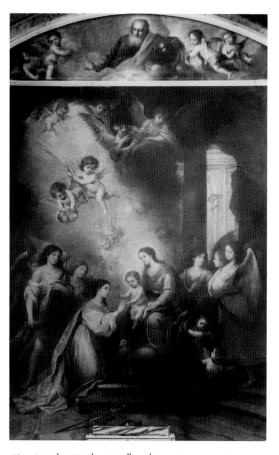

Fig. 1. Bartolomé Esteban Murillo and Francisco Meneses Osorio. THE MYSTIC MARRIAGE OF SAINT CATHERINE. *c. 1682. Oil on canvas, 14'8¾" x 10'8" (449 x 325 cm). Museo de Cádiz, formerly in the Convento de Capuchinos, Cádiz*

Leyra (or Llera), from whom several were acquired by one of "the English," Edward Davies, who brought this and other oil sketches by Murillo home to England with him after his military service in Spain: a "Baroncillo" by Murillo for his portrait of Bishop Domonte with the archangel Raphael (see cat. no. 29), a study for the *Saint John of God* (Church of the Hospital de la Caridad, Seville), a small Crucifix, a small Saint Sebastian, and this oil sketch for the Capuchin church in Cádiz.

All of this information yields an interesting aspect of the history of Murillo's "critical fortunes": in the late eighteenth and early nineteenth centuries, the artist's oil sketches attracted the special interest of some extremely knowledgeable art connoisseurs. By its very nature, an oil sketch is painted in a "sketchier" manner than the finished, large-scale painting. The brushwork is more fluid, the touch lighter, the contours less well defined, the result a more intimate relationship between the artist's hand and the eye of the beholder. Such works were obviously esteemed by late eighteenth-century connoisseurs schooled in the "academic" method that valued the oil sketch as an important part of the creative process.

NOTES:
1. Twiss 1775, 315.
2. Ibid.
3. Ponz 1772–94, vol. 18, 48.
4. Maule 1813, 339. Quoted by Pemán 1978, 62, n. 38.

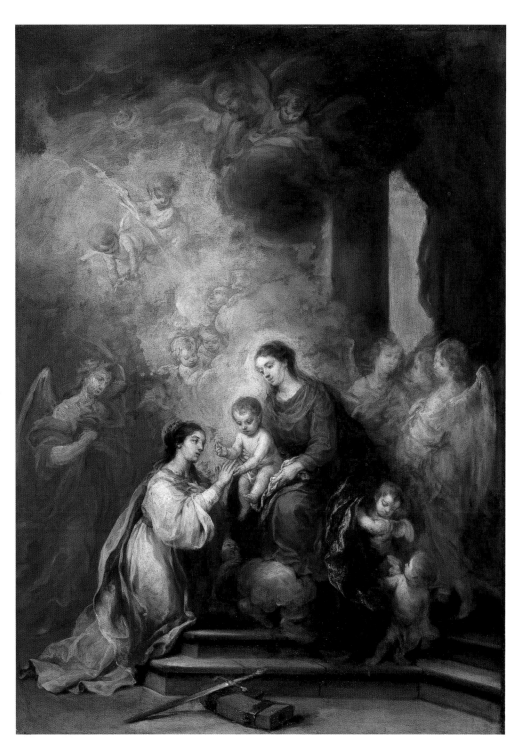

31. FOUR FIGURES ON A STEP

c. 1655–60. Oil on canvas. 43¼ x 56½ in. (109.9 x 143.5 cm)
Kimbell Art Museum, Fort Worth

PROVENANCE: Charles
B. Plestow, England; Mr.
Richard Abraham, Lon-
don; Sir Charles Henry
Coote, Bart., Ballyfin
House, Ireland; Sir Ralph
Algernon Coote, Bart.,
Ballyfin House, Ireland;
purchased by Kendall;
A. L. Nicholson; S. F.
Aram, New York; Erik
Bergmann, Monroe,
Mich.; C. Russell Feld-
mann; private collection,
Greenwich, Conn.

EXHIBITIONS: New York
1830, no. 9; London 1838,
no. 8; Ehrich Galleries,
New York, 1925; The Art
Institute, Chicago, 1925;
Kölnischer Kunstverein,
Cologne (Cologne Trade
Fair), May 11–June 5,
1930, no. 60; New York
1989–90, n.p., no. 10, ill.;
Pabellón de España,
Exposición Universal de
Sevilla, Seville, *Tesoros del
arte español*, August
15–October 12, 1992;
Musée des Beaux-Arts,
Nantes, France, October
6, 1996–May 10, 1997;
New York, 2000–2001,
no. 44, ill. color 403; Lon-
don 2001A, 24, 36–37, no.
11

SELECTED REFERENCES:
Curtis 1883, 292, no.
456b; Mayer 1924–25,
25–26; Yarnall and
Gerdts 1976, vol. 4, 2539;
Angulo 1981, vol. 2, 310,
no. 401; vol. 3, pl. 434;
Brown 1982, 35–42, pl. 4;
Pillsbury and Jordan 1995,
413, ill. 412; Brown 1991,
279, fig. 264; Sutton 1992,
212; Tomlinson and
Welles 1996, 66–85, ill.
67; Brown 1998, 227–28,
fig. 296

This painting was one of the first works by Murillo to arrive in America. It was exhibited under the title "A Spanish Peasant Family" in 1830 at the American Academy of Fine Arts in New York, and it was the public's favorite work in the show. A critic for the *New York Mirror* admired "Murillo's force and vigour . . . the features of humanity so truly and vividly stamped upon the canvas." Another, writing in the *New York American*, praised the work as inimitable in "its beauty of coloring, fine drawing, characteristic expression, [and] ease of spirit. . . ."[1] The American portraitist Thomas Sully considered Murillo's painting quite simply the best thing in the exhibition.

When *Four Figures on a Step* visited New York again in 1925, it was exhibited at Ehrich Galleries as "A Family Group [Presumed to be Doña Beatriz, wife of Murillo, and their three children]."[2] August L. Mayer, writing about the painting in an art journal published 1924–25, called the work a "Genreszene," noting that although it had been called a family portrait, it seemed unlikely that Murillo would portray his loved ones in this very odd way.[3] Similarly, when the painting appeared on the art market in Germany in 1930, it was generically dubbed a "Volksszene." The curiously enigmatic character of the image has prompted quite varied interpretations: that it is an allegory of the senses,[4] or a secularized variation on the "Heilige Sippe" (the Holy Kinship, an iconographic type long out of style in Murillo's time).[5] When the painting was purchased by the Kimbell Art Museum in 1984 it was referred to as "The Threshold,"[6] and it now goes by the neutral title, "Four Figures on a Step."

The four figures arranged on this "threshold" are, from left to right: a handsome, smiling youth in foppish dress; a young woman lifting her scarf over her head and engaging the viewer's attention with a rather unattractive wink; and a mature woman wearing glasses, whose hands rest on the head of a sleeping boy turned so that we see the tear in the seat of his pants. That tear was painted over sometime before 1930, uncovered by 1941, painted over again before the Kimbell purchased the painting, and again removed. The whole composition is, in fact, rather unsettling, and it seems that the ripped seat of the pants provoked real discomfort for some earlier owners, so that it was covered up.

The possibility of a sexually suggestive reading of the painting has been explored by Jonathan Brown, who was the first scholar to connect Murillo's painting with northern genre paintings of an erotic nature that the artist and his patrons could very likely have seen in cosmopolitan Seville.[7] In this interpretation, with which Peter Cherry has recently largely concurred, the figures participate in the business of prostitution.[8]

Four Figures on a Step may be the most overtly erotic of Murillo's twenty or so known genre paintings, but it was perhaps not the only one he created. Murillo's *Girl Lifting Her Veil* (fig. 1) and the *Peasant Boy Leaning on a Sill* (fig. 2), once thought to be pendants, were cut down from larger compositions. In the case of the *Girl*, the gesture of lifting the veil, as in *Four Figures on a Step*, suggests her availablity, as does the décolletage of her dress.[9] The *Peasant Boy*, however, though he might be painted after the same model Murillo used for the standing youth in the Kimbell painting, certainly seems innocent enough. In fact, not all scholars are completely convinced as to the libidinous implications of the *Four Figures*. In the recently published *Dictionary of Art*, the painting is still called the *Family Group*, and, in Arsenio Moreno's 1997 book on painting in golden age Seville, he calls it an "*Escena familiar*" (Family Scene).[10]

The carefully staged arrangement of the figures, so individually characterized and bathed in a clear and unforgiving light, strongly suggests a theatrical interpretation of the subject, much as Murillo's genre paintings of beggar boys have frequently been mentioned in a breath with the Spanish literary tradition of the *pícaro*. Janis A. Tomlinson and Marcia L. Welles, for example, have explored the possible relationship of the painting to one of the very earliest novels in any language, the *Lazarillo de Tormes*, published in 1554.[11]

All of this points to the obvious conclusion: Murillo's composition is so original and populated with such a unique cast of characters that it has as

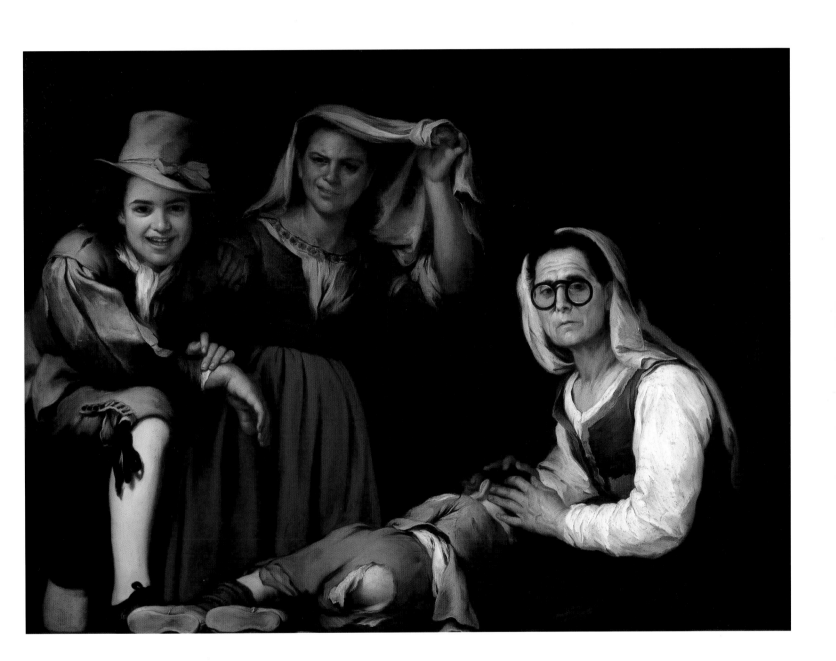

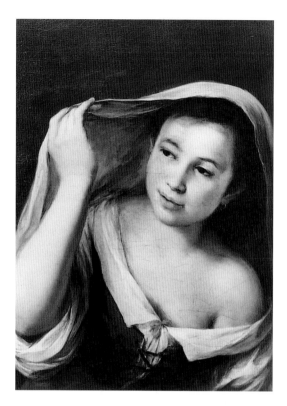

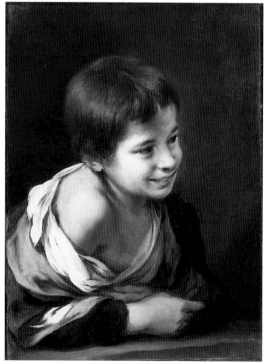

yet to be pinned down by a univerally accepted interpretation. With the exception of the passive figure of the sleeping boy, the smiling gallant, the young woman (wearing a twisted expression like that of the scabies sufferer in Murillo's *Saint Elizabeth of Hungary*, fig. 92), and the older woman whose black eyeglasses are in striking contrast with her pale, paper-dry complexion, form a fascinating trio whose identifications continue to pique our curiosity.

NOTES:
1. New York 2000, 307.
2. New York 1925, n.p.
3. Mayer 1924–25, 25–26.
4. Sutton 1992, 212.
5. Scholz-Hänsel, 57.
6. In an article in the *Dallas Times Herald*, October 19, 1984.
7. Brown 1982, 38.
8. Brown 1998, 228, goes so far as to suggest that the "glimpse of the little boy's backside is suggestive of forbidden sexual practices. . . ," but Peter Cherry, pointing to the protective gesture of the old woman as well as her defiant gaze, cautions not to go too far with this interpretation. He has recently countered that "What we know of gay subculture in seventeenth-century Seville suggests that gay taste was not titillated by scruffy, dirty, flea-ridden street urchins. It is unlikely, moreover, that such a meaning would have been allowed to exist in a painting from such a prominent artist as Murillo, presumably anxious to avoid the unwanted attentions of the Inquisition." (London 2001A, 102).
9. Brown 1982, 38, points to the similar motif of the displaced mantle or veil in Michael Sweerts's *Street Scene* (Accademia de San Luca, Rome).
10. See Manuela Mena Marqués's entry on Murillo in *The Dictionary of Art*, ed. Jane Turner, vol. 22, 346, and Moreno 1997, 121.
11. Tomlinson and Welles 1996, 66.

Above: *Fig. 1. Bartolomé Esteban Murillo,* GIRL LIFTING HER VEIL. *1665–75. Oil on canvas, 20⅝ x 15½″ (52.4 x 39.4 cm). J. C. Carras collection, London*

Left: *Fig. 2. Bartolomé Esteban Murillo.* A PEASANT BOY LEANING ON A SILL. *c. 1670–80. Oil on canvas, 20½ x 15⅛″ (52 x 38.5 cm). National Gallery, London*

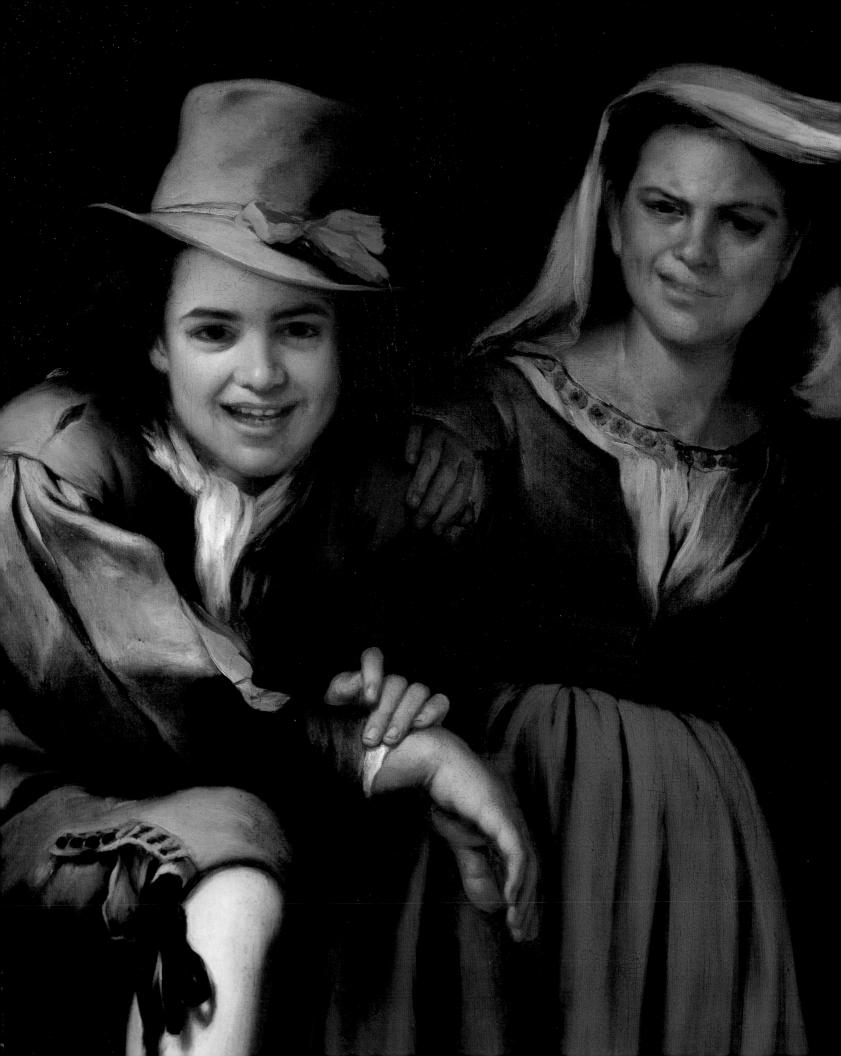

32. TWO WOMEN AT A WINDOW

c. 1655–60. Oil on canvas. 49¼ x 41⅛ in. (125.1 x 104.5 cm)
National Gallery of Art, Washington, Widener Collection

PROVENANCE: Duque de Almodóvar del Río, Madrid; William A'Court, later 1st baron Heytesbury, Heytesbury, Wiltshire; William Henry Ashe, 2nd baron Heytesbury; William Frederick, 3rd baron Heytesbury; P. A. B. Widener, Elkins Park, Pennsylvania; Joseph E. Widener, Elkins Park

EXHIBITIONS: London 1828, no. 2; London 1864, no. 56; London 1887, no. 114; Toledo 1941, 118, no. 77; Madrid 1990, 332, ill.; Pabellón de España, Exposición Universal de Sevilla, Seville, *Tesoros del arte español,* August 15–October 12, 1992; Museo Nacional de Antropología, Mexico City, 1996–97, 84–85, ill. color; London 2001, 24 and 36, no. 10

SELECTED REFERENCES: Stirling-Maxwell 1848, vol. 2, 920–21, ill. 920; vol. 3, 1442; Stirling-Maxwell 1891, vol. 3, 1091–93, ill. 1092; vol. 4, 1635; Waagen 1857, 388–89; Curtis 1883, 288, no. 444; Mayer 1913, 215, ill.; Mayer 1923, 215, ill.; Gaya Nuño 1978, 103, no. 197, color ill. front cover; Angulo 1979, 148–50 and 211–13, ill. 210; Angulo 1981, vol. 1, 452–55, vol. 2, 307–8, no. 399; vol. 3, pl. 435; Brown 1982, 40–41, fig. 7; Brown and Mann 1989, 105–8, ill. 107; Karge 1991, 172–74, ill. 173; Cornette and Mérot 1999, 73, ill.

When Stirling-Maxwell described this painting in the nineteenth century, he called it "Las Gallegas":

> It represents two women at a window, one still in the bloom of her teens, and leaning on the sill, the other declining into the "sere and yellow leaf" and half concealed by a shutter. These fair Galicians, says the tradition, were famous amencebadas [courtesans] of Seville; and the gallants who were lured to their dwelling by the beauty of the younger frail one, frequently became victims of that sort of deception which made the shepherd-patriarch the unwilling husband of the elder daughter of his maternal uncle.[1]

Although Stirling-Maxwell's description of the painting embellishes upon its meaning, even referring to the biblical story told in the book of Genesis, the painting has always been understood to have, at least, amorous connotations. When it was still in the collection of the duque de Almodóvar del Río in Madrid, an engraved copy of this painting was made that bears the title "Las Gallegas," and when the painting was in the collection of Lord Heytesbury and was exhibited in 1828, it was called "Spanish Courtesan." In the 1746 inventory of Murillo's paintings in the royal palace at La Granja, belonging to Queen Isabel de Farnesio, was "una gallega con toca blanca en la cabeza y una moneda en la mano" (a Galician woman with a white scarf on her head and a coin

1. *Follower of Murillo.* TWO WOMEN AT A BARRED WINDOW. *Oil on canvas, 16⅛ x 23⅛" (41 x 58.6 cm). The State Hermitage Museum, Saint Petersburg*

in her hand), which Enrique Valdivieso has interpreted to mean that, at least in the eighteenth century, a "gallega" was a Sevillian sobriquet for a "loose woman."[2]

In Curtis's 1883 catalogue of Murillo's paintings, he described this as "A Girl and her Duenna. *Las Gallegas.*" A *dueña* would be an older woman who accompanies and looks after the reputation of a younger one, but the evidence in the painting suggests that her identity is closer to Stirling-Maxwell's observation that she is simply an older "sister" to the lovely young woman who faces the viewer directly with a slight smile playing about her lips. If the painting represents a scene of prostitution, then the older woman might be a *celestína,* a procuress, but there is no clear indication of this implicit in the painting. Does she cover her mouth because she is toothless—the toothless hag of early literature and art? If this painting represents two prostitutes, or a prostitute and her procuress, it is so subtly treated by Murillo that we cannot be sure. Certainly, the young woman who smiles at us from her window sill may be casually garbed, but her bosom is quite decently covered. And, her posture and smile are open and friendly, not come-hither.

What we can be sure of is that the painting demonstrates Murillo's familiarity with the art of the north, imported to Seville by merchants who found there a clientele among both the Dutch businessmen established there and the Spanish connoisseurs who purchased northern as well as Spanish paintings. The composition of the painting, showing figures at a window, is certainly indebted to Dutch paintings of the period, which Murillo could have seen in Sevillian collections.[3] Unlike the other genre painting by Murillo in this exhibition, the *Four Figures on a Step* (cat. no. 31), this may not have been considered sexually suggestive in its time, for there are several copies of it dating from early times, and those were not necessarily called "Las Gallegas." The copy in the collection of Marshal-General Soult, for example, was simply described as "Servante à sa croisée" (Servant at Her Window).[4] One version of the composition, apparently painted by a follower of Murillo, shows the two figures, one much older and one younger, at a barred window (fig. 1). Following the most

negative possible interpretation of the general theme, it has been called "A Procuress and Her Daughter in Jail," though such bars are actually typical of homes in urban seventeenth-century Seville.

Nothing in the National Gallery painting suggests that we need imagine this scene as representing anything other than gentle flirtation. The dewy beauty of the young woman nearest the window is painted with a controlled brush, creating firm outlines and forms bathed in the clear light of day. This style is consonant with that found in other paintings of around the same date, about 1655–50, such as the *Four Figures on a Step* (cat. no. 31), but also religious paintings such as the *Adoration of the Magi* (cat. no. 7).

NOTES:
1. Stirling-Maxwell 1891, 1092–93.
2. Seville 1996, 27.
3. Brown and Mann 1989, 106.
4. See Thoré 1853, vol. 22, 54.

33. Self-Portrait

c. 1655–60. Oíl on canvas. 42⅛ x 30½ in. (107 x 77.5 cm)
Private collection

Provenance: Gaspar
Murillo, Seville; Bernardo
Iriarte, Madrid; Francisco
de la Barrera Enguídanos;
Julian Williams, Seville;
King Louis-Philippe,
Paris; John Nieuwenhuys;
Baron de Seillière; Paris;
his daughter, Princess
Sagan; private collection,
United States

Exhibitions: Paris
1838–48, no. 187

Selected references:
Palomino 1724, 173; Ceán
Bermúdez 1806, 104;
Burckhardt 1843, 481–82;
Ford 1853B, 623; Stirling-
Maxwell 1848, vol. 2,
397–98, ill.; vol. 4, 1638;
Bürger 1865, 130; Blanc
1869, ill. 1; Curtis 1883,
295, no. 465; Lefort 1892,
94, no. 47; Calvert 1907,
185; Mayer 1923, xxxiii;
MacLaren and Braham
1970, 73, n. 3[1]; Bédat 1973,
144; Angulo 1981, vol. 2,
320–22, no. 413; vol. 3, pl.
451; Baticle and Marinas
1981, 133–34; Princeton
1982, fig. 49, 169; Harris
1987, 159; Schiff 1988,
111–12; Karge 1991, ill.
167

Inscription: Added
after Murillo's death:
VERA EFIGIES
BARTHOLOMAEI
STEPHANI A MORILLO
MAXIMI PICTORIS, /
HISPALI NATI ANNO
1618 OBIJT ANNO 1682
TERTIA DIE MENSIS
APRILIS

Top: *Fig. 1. Bartolomé Esteban Murillo. Self-Portrait.
c. 1650–60. Oil on canvas, 30 x 25″ (76.2 x 63.5 cm). Private
collection*

Above: *Fig. 2. Bartolomé Esteban Murillo. Self-Portrait.
c. 1668. Oil on canvas, 48 x 42⅛″ (122 x 107 cm). © National Gallery,
London*

This portrait of Murillo as a young man wearing the stiff collar called a *golilla* must be the one mentioned in the inventory of the estate of Gaspar Murillo, the painter's son, and which Ceán Bermúdez later saw in the collection of Bernardo Iriarte. Murillo appears to be about forty years old, suggesting that the work can be dated sometime in the decade of the 1650s. He is pictured close-up, painted on a fictive block of stone carved into a framework around the bust of the artist and at the top, but otherwise left with unfinished edges. This block of stone rests at an angle on top of a console or table. (This is suggestive of the fact that Murillo actually did paint on stone: see the essay by Jordan in this catalogue.) A similar self-portrait (fig. 1), which had belonged to the conde de Maule in Cádiz, is also placed within a simulated stone cartouche, but the portrait is more conservatively, more directly, presented.[2] In a later self-portrait that belonged to Nicolás Omazur (fig. 2), Murillo also toyed with illusions of reality, depicting his own hand coming out of the painting to grab the cartouche that enframes it, a device often used in portrait engravings: it is this painting after which William Hogarth modeled his own *Self-Portrait with a Pug* (Tate Britain, London), in 1745.

The earlier self-portrait in the present exhibition had been admired by the painter Sir David Wilkie, who had made a copy of it while he was in Seville, and it became quite well known while on public view in the Galerie Espagnole of Louis-Philippe in Paris during the decade 1838–48, having been acquired in Seville for the king by Baron Isidore Taylor. The painting became even better known as a result of several engravings made after it. It was engraved by H. Adlard for Stirling-Maxwell's *Annals of the Artists of Spain* (1848), and by Carbonneau for Charles Blanc's 1869 *Histoire des peintres de toutes les Ecoles* (Ecole espagnole). Later the image appeared as the frontispiece to the popular books about Murillo by Ellen Minor (1882) and A. F. Calvert (1907).

The young Swiss historian and art historian Jacob Burckhardt was a frequent visitor to the Galerie Espagnole, which inspired him to write an essay, "On Murillo," in August 1943. Burckhardt was passionately taken with this *Self Portrait*:

Murillo is still one of the greatest who ever lived. Here hangs his portrait (by his own hand). It is the key to all his works. Compare it with all the beautiful cavalieros from the court of Don Philip IV, which, by no means badly painted by Velazquez, shine forth here from every wall, and you will comprehend what it was that elevated Murillo above his own time—it is the physical and intellectual power still wielded by this force of nature, while around him his magnificent fatherland and its noble people sank lower and lower.

Look at these splendid, slightly pouting lips! Do they not reveal the man of action! These slightly retracted nostrils, these flashing eyes under the splendid, wrathfully arching eyebrows, this whole face, is it not an arsenal of passions? Yet above it there reigns supreme an imperious forehead, which ennobles, controls, spiritualizes everything; and by its sides, the most beautiful jet-black locks flow down. Happy the woman who has been loved by this man! His mouth has kissed a lot, I believe.[3]

It would be impossible to praise Murillo's *Self-Portrait* more extravagantly.

NOTES:
1. The painting is erroneously described as a version "now, much cut down, in the Collection of Elizabeth, Lady Musker."
2. Seghers 1982–83, 199–201.
3. Schiff 1988, 111–12.

34. Portrait of Don Andrés de Andrade y la Cal

c. 1665–72. Oil on canvas. 79 x 47 in. (200.7 x 119.4 cm)
Lent by The Metropolitan Museum of Art, Bequest of Collis P. Huntington, by exchange, 1927

PROVENANCE: Antonio Bravo, Seville; Sir John Brackenbury, Cádiz; King Louis Philippe, Paris; Thomas Baring, London; Thomas George Baring, 1st earl of Northbrook, Stratton Park, Hampshire and London; Francis George Baring, 2nd earl of Northbrook, Stratton Park, Hampshire

EXHIBITIONS: London 1836, no. 109; Paris 1838–48, no. 182; London 1853, no. 64; London 1870, no. 86; London 1895–96, no. 36; New York 1928, no. 42; Detroit, October 1–29, 1951; Toronto, November 14–December 12, 1951; Saint Louis, January 6–February 4, 1952; Seattle, March 1–June 30, 1952; New York 1970, no. 272, ill. 34; Leningrad 1975, no. 34

SELECTED REFERENCES: Ford 1845, vol. 1, 397; Stirling-Maxwell 1848, vol. 2, 91; vol. 3, 1444; Ford 1853B, 623; Kugler 1854, 178; Waagen 1854, vol. 2, 180–81; Gower 1881–85, vol. 5, 10–11, pl. VII; Curtis 1883, 292; Alfonso 1886, 188, n. 5; Weale and Richter 1889, 173–74, ill.; Stirling-Maxwell 1891, vol. 3, 1090; vol. 4, 1637; Justi 1892, 36, fig. 36; Mayer 1913a, 289, ill. 222; Mayer 1922, 346, fig. 258; Montoto 1923, 120; Burroughs 1928, 44, ill. 41; MacMahon 1928, 177–78; Malitskaya 1947, ill. 185; Gaya Nuño 1958, no. 1868; Gaya Nuño, 1978, 92, no. 68; Young 1980, 32, no. 71; Angulo 1981, vol. 2, no. 405; vol. 3, pl. 458; Baticle and Marinas 1981, 132–33, no. 186; López Rey 1987, 29, ill. 30; Karge 1991, 169, ill. color 168; Pérez Sánchez 1992, 360; Tromans 1998, 68, ill. color 66.

Murillo did not paint many portraits, but those he did create are superb. When this painting was auctioned at the London sale of the collection of King Louis-Philippe, an article in the *Illustrated London News* (May 21, 1853) noted:

> The portraits by Murillo are not numerous, but what exist of them are of great beauty and interest, making one believe that this would have been the field in which he would have been even more preeminently at home than in historical art, had he condescended to adopt it as the field of his operations. The portrait now in question is very forcible and true in character: in this respect very much after the style of Velasquez; but with more richness of colouring and softness of finish than he bestowed.

The subject of this portrait is identified by the inscription and the family coat of arms on the pedestal as the *pertiguero*, or marshal of the processions in the cathedral of Seville.[1] He is shown dressed in Spanish fashion, all in black except for his white collar and stockings, wearing a black hat and sporting a beard and moustache and remarkably full head of black hair. His right hand rests on the head of a white and brown mastiff. The portrait, with the figure posed in much the way made famous by Velázquez's portraits of members of the Spanish royal family as hunters, and with just a touch of swagger, has been well known since it was sold early in the nineteenth century by the descendants of Andrés de Andrade y la Cal.

The interesting nineteenth-century history of the portrait was recounted by the Hispanophile Richard Ford in his articles in the *Athenaeum* documenting the sales of the Galerie Espagnole of Louis Philippe in London. On May 21, 1953, Ford wrote:

> This picture was purchased some twenty years ago, at Seville, by the late Sir John Brackenbury, Consul at Cadiz,—who obtained it from the very heirs of Andrade for less than 400£. Some dispute arose between the agent employed and Sir John, who refused him the usual fee; thereupon

the broker gave information to the authorities,—the old law of Charles the Third against the exportation of paintings was put in force,—and the picture was embargoed. Some time after, a poor copy of the portrait was picked up,—leave was obtained to compare it with the original,—and the copy was substituted in its place. Sir John subsequently would have sold his picture to the Government here for some 500£—the offer was declined,—and it was snapped up by Louis-Philippe at 2,000£.[2]

Ford hoped that Thomas Baring, who bought the portrait when it was auctioned in 1853, would give it to the National Gallery in London, for he was distressed that Spanish art was not being acquired by "our so-called National Gallery." When Baring then purchased Murillo's small version of *Saint Thomas of Villanueva Giving Alms to the Poor* (see cat. no. 19, fig. 2), Ford expressed his pleasure that both the *Saint Thomas* and the portrait of Andrade would be remaining in England, going so far as to call Baring "one of the most munificent of our merchant-princes."[3] All Ford's praise came to naught. The portrait remained in the collection of the earls of Northbrook until 1927, when it was purchased by the Metropolitan Museum of Art.

When the eminent Scottish painter Sir David Wilkie saw the portrait in Seville in 1828, he wrote in his journal: "It seems to see you while you look at it."[4] One hundred years later, when the painting was shown at the Metropolitan Museum, Bryson Burroughs evidently felt that the public would expect the Murillo associated in the popular mind with sweetly sentimental images: he noted in the exhibition catalogue that "The portrait . . . like other portraits by him is free of any sentimentality." Burroughs continued: "But the real vitality of the portrait remains the foundation for the various interpretations each epoch may give it."[5]

A year later, the Metropolitan Museum exhibited another portrait by Murillo, the *Portrait of a Man with a Hat* (fig. 1), then in the collection of Eugen Boross.[6] This portrait, too, had been in English collections from the late nineteenth cen-

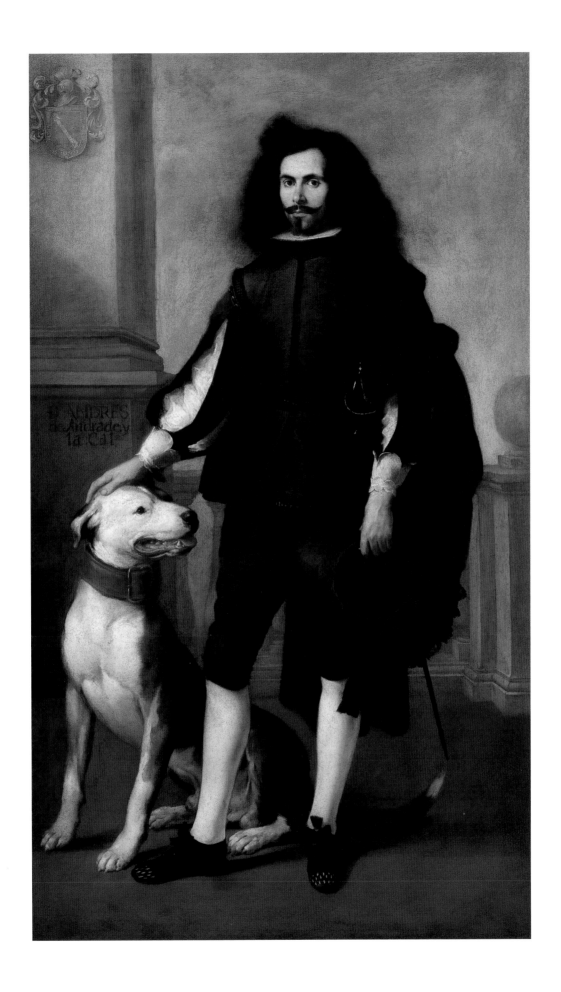

Left: *Fig. 1. Bartolomé Esteban Murillo.* PORTRAIT OF A MAN WITH A HAT. *c. 1670. Oil on canvas, 6′8⅛″ x 42⅝″ (203.5 x 108.3 cm). Extended loan from the Cintas Foundation, Lowe Art Museum, Coral Gables, Fla.*

Right: *Fig. 2. Bartolomé Esteban Murillo.* PORTRAIT OF PEDRO NÚÑEZ DE VILLAVENCIO? (A KNIGHT OF ALCÁNTARA OR CALATRAVA). *c. 1650–60. Oil on canvas, 6′5″ x 38½″ (195.6 x 97.8 cm). The Metropolitan Museum of Art, New York, Gift of Rudolf J. Heinemann, 1954*

tury until 1923. The sitter can be identified as a northerner, from Flanders or the Netherlands, because of his costume: the slashed sleeves of his black doublet reveal the generous yardage of crisp white stuffs of his blouse. It is tempting to think he might be one of Murillo's merchant patrons. Others of the few portraits by Murillo have also made their way into American collections. The Metropolitan Museum owns, besides the portrait of Don Andrés de Andrade, another full-length portrait of a knight of Alcántara, traditionally identified as *Pedro Núñez de Villavicencio* (fig. 2), Murillo's aristocratic friend and disciple. Another full-length portrait, representing Don Diego Félix de Esquivel y Aldama, is in the Denver Art Museum (deposited there by the Samuel H. Kress Foundation).

All of Murillo's full-length portraits suggest a familiarity with the portraits of Van Dyck and are similar, in the poses of the sitters, to those by Velázquez. A remarkable aspect of Murillo's portraits of these gentlemen, especially Don Andrés de Andrade y la Cal, is the complete amalgam of both elegance and virility.

NOTES:
1. For more about the family, see Angulo 1981, vol. 2, 313.
2. Ford 1853B, 623. Ford exaggerated the amount paid by Baron Isidore Taylor for the painting. It was 1,025£ sterling, still making it one of the most expensive paintings in the Galerie Espagnole. See Tromans 1998, 68. A copy of the painting by Juan Simón Gutiérrez is in the Academia de Bellas Artes de San Fernando, Madrid. Another copy, sold at Sotheby's, London, October 18, 1995 (lot 62), might be the one made in order that the original could be spirited out of Spain.
3. Ibid., 67.
4. Burroughs 1928, 44.
5. New York 1928, xxi.
6. Eugen [Jenö] Boross was an American colonel of Hungarian descent. He gave Murillo's *Holy Family* to the Basilica of Saint Stephen's in Budapest. The portrait was acquired by the Cuban industrialist Oscar Cintas in 1929.

NOTES

CHAPTER ONE NOTES

1. Torre Farfán 1666.

2. Ortiz de Zúñiga, *Anales eclesiásticos y seculares de la más noble y muy leal ciudad de Sevilla . . . desde el año de 1246 hasta el de 1671* (Seville, 1677), 806.

3. Asisclo Antonio Palomino de Castro y Velasco, a painter, wrote a treatise on art entitled *El Museo pictórico y escala óptica*. The biographical section, "El Parnaso español pintoresco laureado," contains information about 226 artists. Palomino's work is still a useful resource, particularly in the edition translated into English and edited by Nina Ayala Mallory (Cambridge, 1987), cited here, 281.

4. Ibid.

5. Ibid.

6. *Carta de D. Agustín Ceán Bermúdez a un amigo suyo sobre el estilo y gusto en la pintura de la Escuela Sevillana y sobre el grado de perfección a que se elevó Bartolomé Esteban Murillo cuya vida se inserta, y se describen sus obras en Sevilla* (Cádiz, 1806; reprint, Seville, 1968). This was published by E. Davies in his *Life of B. Esteban Murillo: Compiled from the Writings of Various Authors* (London, 1819) and thus almost immediately available to English-language writers about Murillo.

7. *The New York Times Book Review* (August 23, 1998), 9.

8. Palomino 1987, 283.

9. "La amabilidad de Bartolomé Esteban Murillo convenia perfectamente con la dulzura y estilo de sus pinturas. Manifestó esta virtud y otras prendas en la enseñanza que daba a sus discipulos, dirigiendolos con blandura por el buen camino que va a la imitacion de la naturaleza . . ." Ceán Bermúdez 1800, vol. 2, 55–56.

10. Edmondo de Amicis, *Spain and the Spaniards*, trans. Wilhelmina W. Cady (New York, 1880), 140. De Amicis's book was often quoted by popular writers on Murillo. The same lines cited here, for example, are found on the first page of Jennie Ellis Keysor's *Murillo and Spanish Art: A Sketch* (Boston, 1899), a book written for young people, which includes all the most charming anecdotes about the artist.

11. Published in *Alhambra* 1, no. 3 (August 1919).

12. Diego Angulo Iñiguez, "Murillo, His Life and Work," in the catalogue of the exhibition *Bartolomé Esteban Murillo, 1617–1682*, Museo del Prado, Madrid, and Royal Academy of Arts, London, 1982–83 (London, 1982), 11.

13. Hoppin 1892, 133.

14. "Murillo's Boys," *The Christian Science Monitor* (November 14, 1930), 9, reprinted from Estelle M. Hurll, *The Child-Life in Art*.

15. Ceán Bermúdez noted that *pintura de feria* (that is, pictures sold in the marketplace of Seville) meant "bad paintings" (Ceán Bermúdez 1806, 35–36). Early in the nineteenth century, Allan Cunningham interpreted Palomino's use of the term to mean that Murillo painted banners, and added that "the emblazoning of banners was in the earliest days of art a part of the profession, and honorable too and profitable . . ." (*The cabinet gallery of pictures by the first masters of the English and foreign schools, in seventy-three line engravings: with biographical and critical dissertations by A. Cunningham*, London, 1836), 158. Manuela Mena Marqués recently settled on the term "festal painter" as a reasonable interpretation of *pintando de feria*, in: "Bartolomé Esteban Murillo," *The Dictionary of Art*, ed. Jane Turner, vol. 22 (London and New York, 1996), 342.

16. Ceán Bermúdez 1806, 35.

17. See Alfonso Pérez Sánchez, *Tomás Yepes*, exh. cat. (Centre Cultural Bancaixa, Valencia, 1995) for documentation related to the business transacted at the Medina del Campo fair by the still-life painter also called Tomás Hiepes (pages 18 and 21–24). I am grateful to William B. Jordan for bringing this result of recent research to my attention. In the case of Yepes, trips to Medina del Campo help explain the artist's familiarity with Castilian still-life painting.

18. Pilkington 1770, 410–11.

19. Ibid. Palomino could not entirely resist a good story, but is judicious: "When I had just arrived in this Court, I learned that around the year 1670, on the day of Corpus Christi, a picture by Murillo had been exhibited publicly and had amazed all of Madrid. When King Charles II saw it and learned by whose hand it was, he insinuated that he wished to employ that artist for his service. . . . the only thing that makes it hard to believe is that King Charles II was still only a minor then, being hardly ten years old. . . ." Palomino 1987, 284.

20. O'Neil 1833, 246.

21. Ibid., 246.

22. Ibid., 251–52.

23. Ernest Beulé, *Causeries sur l'art* (Paris, 1867), 305. The street of La Feria then also encompassed shops that sold works of art, especially prints from Flanders and Italy, which Murillo and the other painters of the time certainly purchased for their own use.

24. Charles H. Caffin, *How to Study Pictures* (London, 1906), 222.

25. Washburn 1884, 140–41.

26. The basic study of Murillo is Angulo Iñiguez's three-volume biography and catalogue raisonné, which includes a complete list of references to that date: *Murillo:Su vida, su arte, su obra* (Madrid, 1981). More recently, Jonathan Brown, in *Painting in Spain, 1500–1700* (New Haven and London, 1998) has added significantly to the barebones facts about Murillo's life by careful consideration of the sources for and influences on his work and by bringing into relief Murillo's relationship with his lay patrons. Also useful for English-speaking readers is the catalogue of the exhibition *Bartolomé Esteban Murillo, 1617–1682*, Madrid and London, 1982–83, and Mena Marqués 1996.

27. Washburn 1884, 129.

28. For a sense of the working lives of artists in Murillo's time, see Moreno 1997.

29. See John H. Elliott, "The Seville of Velázquez," in the catalogue of the exhibition *Velázquez in Seville* (National Gallery of Scotland, 1996). This and other essays in the catalogue offer a glimpse into the intellectual, religious, and artistic milieu into which Murillo was born.

30. The basic reference for this time and place is Antonio Domínguez Ortiz, *La Sevilla del siglo XVII*, 3rd ed. (Seville, 1984). For an abbreviated history of the time in English, see Domínguez Ortiz, "Murillo's Seville," in Madrid and London 1982–83.

31. The *Mary Magdalene* was shown at Ehrich Galleries in New York. See "In the Galleries," *The International Studio* (April 1909), where it is illustrated on page LVIII, and the description in "A Fine Murillo," *Academy Notes*, 3 (January 1908), 132, illustrated opposite, noting that when the painting was engraved in 1801 it was said to be in the Bracciano Palace in Rome, "now the property of the banker Torlonia. Later, for a time, it was in the possession of Robert Westall, painter and engraver. It is described in C. B. Curtis's volume on 'Velasquez and Murillo.'"

32. Palomino 1987, 280.

33. "Nadie acertaba como y con quien habia aprendido aquel nuevo, magistral y desconocido estilo, pues no hallaban allí ni modelo ni maestro que pudiese habérsele enseñado. Manifestó desde luego en estos quadros los tres profesores á quien se propuso imitar en Madrid; porque en los ángeles del que representa á un venerable estático en la cocina [*The Angels' Kitchen*, Musée du Louvre], se vé todo el estilo del Spagnoleto: el de Wan-Dick en el perfil de la cabeza y manos de la santa Clara en su tránsito [fig. 7]; y el de Velázquez en todo el lienzo de S. Diego con los Pobres [fig. 6]." Ceán Bermúdez 1800, 50.

34. Palomino 1987, 281. Interestingly, a similar independence on the part of a young painter was attributed to Alonso Cano: "Cano left this master [Francisco Pacheco], and, retiring to his father's house, he gave himself virtuously to the hard work of studying symmetry, anatomy, and the variety of movements which nature designed for the human body." Lázaro Díaz del Valle, *Orígen e yllustración del nobilísimo y real arte de la pintura y dibuxo con un epílogo y nomenclatura de sus más yllustres más ynsignes y más afamados profesores*, in Francisco Calvo Serraller, ed., *Teoría de la pintura del siglo de oro* (Madrid, 1981), 459–78.

35. Not all writers, it should be noted, discredit Palomino's story about Murillo's early trip to Madrid. See, for example, Mallory 1983, 27.

36. Brown, 1991, 177.

37. As quoted by Mena Marqués 1996, 342.

38. Hans Christian Andersen, *In Spain, and A Visit to Portugal* (Boston, 1881), 197.

39. [August L. Mayer], *The Works of Murillo reproduced in two hundred and sixty-seven illustrations* (New York, 1913), 11.

40. Sir Charles Holmes, "Spanish Painting and the Spanish Temper," in *Burlington Magazine Monograph II: Spanish Art* (New York, 1927), 25.

41. See Brown 1998, 203–4 and 213–31, where much information about Murillo's private patrons has been gathered.

42. Quoted from Mena Marqués 1996, 343.

43. Ceán Bermúdez 1800, 52.

44. Brown 1991, 276.

45. Palomino 1987, 281–82.

46. Salomon Reinach, *Apollo: An Illustrated Manual of the History of Art Throughout the Ages* (rev. English-language edition, New York and London, 1908), 257.

47. See Jonathan Brown, *Murillo and His Drawings*, exh. cat., The Art Museum, Princeton University (Princeton, 1976).

48. "También fué el fundador del estilo sevillano, que se conserva todavía, aunque muy desfigurado: estilo de suavidad, que le caracteriza entre los primeros naturalistas, y que se distingue entre todos por un acorde general de tintas y colores; por una indecision de perfiles sabia y dulcemente perdidos; por los cielos opacos que dan el tono á la escena; por las actitudes sencillas y decorosamente expresivas; por los semblantes de amabilidad y virtud; por los pliegues de paños francos y bien trazados; por la fuerza de luz en los objetos principales; y sobre todo por el verdadero color de las carnes." Ceán Bermúdez 1800, 56.

49. As quoted by Mena Marqués 1996, 345.

50. Stratton 1994, 108–10.

51. All described in detail in the invaluable eyewitness account in Torre Farfán 1666.

52. The *Virgin of the Immaculate Conception* painted for the temporary altar in the plaza has disappeared. The *Good Shepherd* has been thought to be the painting in the Lane Collection, London, and the *Infant Saint John* the painting in the National Gallery, London, because they belonged to Justino de Neve, who sponsored the redecoration of Santa María la Blanca (Angulo 1981, vol. 2, 195–96, no. 213). However, the painting of the Virgin was reportedly enormous, about 20 by 14 *pies* (18 feet 4 inches by 12 feet 9 inches; 560 by 390 centimeters), suggesting an overall scale apropos to the out-of-doors setting. Since the altar was an ephemeral installation, it is possible that the three paintings were quickly executed on unprimed cloth (*sarga*), put in place during the festivities, and then, as is normal with ephemeral decorations, destroyed or simply allowed to deteriorate over time. In his description of the "altar del plaza," Torre Farfán did not describe the paintings other than to mention their subjects, while he dwelt on the frame, richly decorated with immaculist attributes, "toda dorada de costísimos cuidados de la escultura" (see Angulo 1981, vol. 1, 345–46).

53. "Los pintó el año de 55 por encargo del arcediano de Carmona D. Juan Federigui, quien los regaló al cabildo; y consta de un MS. de aquel tiempo, en el que el S. Leandro es retrato del licenciado Alonso de Herrera, apuntador del coro, y el S. Isidóro del licenciado Juan Lopez Talavan." Ceán Bermúdez 1800, 51.

54. Ponz 1772–94, vol. 9, 138.

55. Murillo's work for the Capuchinos was recorded in the 1805 history of the monastery in Seville by Angel de Léon, and the documents were later reproduced by Ambrosio de Valencina in *Murillo y los capuchinos: estudio histórico* (Seville, 1908). For more about this extensive commission than can be summarized here, see Angulo 1981, vol. 1, 351–75.

56. Mañara's contribution to the program and its meaning are fully discussed in an essay by Jonathan Brown, "Hieroglyphs of Death and Salvation: The Decoration of the Church of the Hermandad de la Caridad, Seville," in Brown 1978, 129–46.

57. Jonathan Brown, "Murillo, pintor de temas eróticos: Una faceta inadvertida de su obra," *Goya* nos. 169–71 (1982), 35–43.

58. O'Neil 1833, 269.

59. See Marianne Haraszti-Takács, "Pedro Núñez de Villavicencio, Disciple of Murillo," *Bulletin des*

Musées Hongrois des Beaux-Arts 48–49 (1977), 129–55. See also R. González Ramos, *Pedro Nuñez de Villavicencio: Caballero pintor* (Seville, 1999) and London 2001A.

CHAPTER TWO NOTES

1. Cited by Eugene Honée, "Image and Imagination in the Medieval Culture of Prayer: A Historical Perspective," in Henk van Os, ed., *The Art of Devotion in the Late Middle Ages, 1300–1500* (Princeton, 1994), 157–74, especially 157. For an introduction to image-assisted prayer, see Honée, *op. cit.*, and David Freedberg, *The Power of Images: Studies in the History and Theory of Response* (Chicago and London, 1989), 161–91.
2. For this term, see Freedberg 1989, 164.
3. Cited by Freedberg 1989, 164.
4. A useful definition of a devotional image is provided by Sixten Ringbom, *Icon to Narrative: The Rise of the Dramatic Close-up in Fifteenth-Century Devotional Painting,* 2d ed. (Doornspijk, 1984), 53–58.
5. Honée, in Os 1994, 162.
6. For this text, see *Meditations on the Life of Christ: An Illustrated Manuscript of the Fifteenth Century*, eds. Isa Ragusa and Rosalie B. Green, trans. Isa Ragusa (Princeton, 1961).
7. *Meditations on the Life of Christ* 1961, 54–55.
8. For Books of Hours, see Roger S. Wieck, *Time Sanctified: The Book of Hours* (New York, 1988), and *Painted Prayers: The Book of Hours in Medieval and Renaissance Art* (New York, 1997).
9. For this manuscript, see John Plummer, *The Hours of Catherine of Cleves* (New York, 1966), no. 92 [M917, p. 149].
10. Ringbom 1984, 57.
11. For a recent discussion of the Council's position on images, see Pamela Jones, *Federico Borromeo and the Ambrosiana: Art and Patronage in Seventeenth-Century Milan* (New York, 1993), 127–28.
12. Cited by Freedberg 1989, 179, who discusses Ignatius's use of mental imagery in prayer.
13. For a discussion of Morales's devotional paintings, see Lynette M. F. Bosch, "Image and Devotion in Late Fifteenth- and Early Sixteenth-Century Spanish Painting," in Jonathan Brown, ed., *The Word Made Image: Religion, Art, and Architecture in Spain and Spanish America, 1500–1600; Fenway Court*, vol. 28 (Boston, 1998), 30–47.
14. Although the bibliography on El Greco is copious, there is no monographic study of his work as a devotional artist.
15. See the classic study of Emile Mâle, *L'Art Religieux après le Concile de Trente: Etude sur l'iconographie de la fin du XVIe siècle, du XVIIe, du XVIII siècle* (Paris, 1932), 65–69.

16. Francisco M. Martín Morales, "Aproximación al estudio del mercado de cuadros en la Sevilla barroca," *Archivo Hispalense* no. 210 (1966), 137–60.
17. Martín makes the confusing statement that the merchants owned a higher percentage of devotional paintings while the *funcionarios* had more with advocations of the Virgin. The latter, however, should probably be considered as devotional works, too.
18. See the meticulous study of Duncan T. Kinkead, "The Picture Collection of Don Nicolás de Omazur," *Burlington Magazine* 128 (1986), 132–44.
19. See Angulo 1981, vol. 2, 116, no. 108.
20. Angulo 1981, vol. 2, 281, no. 357.
21. Angulo 1981, vol. 2, 215, no. 242, and 216, no. 243, is reluctant to accept the authenticity of these paintings. They are accepted by Jonathan Brown, *Murillo and His Drawings* (Princeton, 1976), 115–16, no. 35, an opinion shared by Claudie Ressort, *Murillo dans les musées français* (Paris, 1983), 34–36, nos. 52–53, and now confirmed by Olivier Meslay in Meslay 2001.
22. Angulo 1981, vol. 2, 124–25, no. 116. For another example, painted on copper and measuring 18½ by 13¼ inches (47 by 33.5 centimeters), see Phoenix 1998, 243, and fig. 69 in this catalogue.
23. Angulo 1981, vol. 2, 174, no. 191.
24. For Neve, see Allan Braham, "Murillo's Portrait of Don Justino de Neve," *Burlington Magazine* 122 (1980), 192–94. His postmortem inventory was in the possession of Angulo, who never published it in its entirety. Angulo cites entries relevant to Murillo's paintings in his catalogue of 1981.
25. See Xanthe Brooke, *Murillo in Focus* (Liverpool, 1990–91).
26. See Duncan T. Kinkead, "Bartolomé Esteban Murillo: New Documentation," *Burlington Magazine* 121 (1979), 35–37, especially 36.
27. For this group, see Angulo 1981, vol. 2, 102–3, no. 93.
28. For the career of this merchant, see Marqués del Saltillo, "La nobleza andaluza de origen flamenco: Los Colarte," *Revista de Genealogía Española* 5 (1916), 495–500 and 529–34; 6 (1917), 1–7.
29. For the document of admission, see Santiago Montoto y Sedas, *Bartolomé Esteban Murillo: Estudio biográfico-crítico* (Seville, 1923), 23. The organization of confraternities is discussed by Isidoro Moreno, *Cofradías y hermandades andaluzas* (Seville, 1985).
30. For an introduction to Rosary devotion, see Franz M. William, *The Rosary: Its History and Meaning,* trans. Edwin Kaiser (New York, 1953).
31. A list of Rosary meditations

published in Spanish and Catalan in the sixteenth and seventeenth century is found in *La Dictionnaire de la spiritualité, ascetique et mystique: Doctrine et histoire*, fasicules 86–88 (Paris, 1987), cols. 967–68.
32. Baltasar de Salas, *Devocionario y contemplaciones, sobre los Quinze Misterios del Rosario de Nuestra Señora,* 1st ed. (cited here) (Madrid, 1588); 2d ed. (Seville, 1589).
33. Salas 1588, p. 30 v.
34. Salas 1588, pp. 110v-111r.
35. Francisco Pacheco, *Arte de la pintura,* ed. Bonaventura Bassegoda i Hugas (Madrid, 1990).
36. Pacheco 1990, 623.
37. Pacheco 1990, 623.
38. Pacheco 1990, 624.
39. Pacheco 1990, 625–26.
40. Angulo 1981, vol. 2, 159–60, no. 164.
41. Brown 1976, 165, no. 79.
42. For this phenomenon, see Benito Navarrete Prieto, *La pintura andaluza del siglo XVII y sus fuentes grabadas* (Madrid, 1998).
43. Angulo 1981, vol. 2, 199, no. 216.
44. Angulo 1981, vol. 2, 196–97, no. 215.
45. For the cult of the Christ child, see Mâle 1932, 325–32.
46. For the versions by Reni and his school, see D. Stephen Pepper, *Guido Reni: A Complete Catalogue of His Works* (Oxford, 1984), 296.

CHAPTER THREE NOTES

1. The most important figure in the Seville academy was the president, elected annually to direct the affairs of the academy and supervise the drawing sessions. The provisional statutes and accounts of the academy between 1660 and 1672 are preserved in a manuscript in the Seville Academy of Fine Arts, which is said to have come from the painters' guild chapel of Saint Luke in the Seville church of San Andrés. See the facsimile and transcription published by the Real Academia de Bellas Artes de Santa Isabel de Hungría, *El Manuscrito de la Academia de Murillo* (Seville, 1982), with an introduction by Antonio de la Banda y Vargas (hereafter *MS Academía* 1982). There also exists an eighteenth-century manuscript copy of the statutes notarized on November 5, 1673; see Banda y Vargas 1961. See also Céan Bermúdez 1806, 64–70, 133–54.
2. Gállego 1995.
3. Céan Bermúdez (1806, 64), dated Murillo's idea for the project to 1658, the date of his visit to the court of Madrid. Palomino (1987 ed., 280) claimed Murillo drew in the Madrid academies on an earlier visit to the court. Palomino (ed. 1987, 270) said Herrera studied in the academies in Rome.
4. Members paid a monthly sub-

scription of 6 *reales* toward the costs of lighting, heating, and the model. A number of them made donations of materials and appurtenances to the academy during its early life. In 1663, for instance, Cornelius Schut donated a painting of the Virgin of Solitude for sale on behalf of the academy. *MS Academía* 1982, 31. The academy was also open to freelance artists who wished to draw from the nude, known as "adventurers" ("abentureros"). These paid a small nightly fee (originally 8 *maravedises*, rising later to 18), which appears to have been calculated to allow access.
5. Angulo 1981, vol. 1, 60–61.
6. *MS Academía* 1982, 31.
7. Palomino 1987, 303. The last date noted in the manuscript of the academy is April 1674. After this, the academy's activities are a mystery. Pérez Sánchez 1995, 31, noted that in 1674 the Seville academy asked the royal painter Juan Carreño to represent the body in seeking royal approval for its statutes, without citing a source for this.
8. The statutes of 1673 ordered that no academicians could receive pupils who were not of old Christian stock, and of clean blood, while the parents of these could not have exercised a lowly trade that would have brought dishonor to the art of painting. Banda y Vargas 1961, 120.
9. This pious obligation was formalized in the later statutes. See Banda y Vargas 1961, 120: "todos los que entraren por la puerta de la Academia siempre que lo hagan alaben a nuestro Señor Jesu Christo y a su Santissima Madre por la obligacion de Christianos, y para que les den auxilio, para conseguir sus estudios diziendo, Bendito y Alabado sea el Santisimo Sacramento y la Inmaculada Concepción de la Virgen María nuestra Señora Concebida sin mancha de pecado original en el primer instante de su ser Amen." The painting of the Immaculate Conception was the donation of the *mayordomo* of the academy in 1668, Francisco de Meneses Osorio, a follower of Murillo. See *MS Academía* 1982, 35, "un lienço de Concepcion guarnecidos de una hermosa tarja para adorno de dicha academia." The description suggests that the image was painted on a shield.
10. *MS Academía* 1982, 42, 43, "un lienço con el retrato del señor rey don Felipe Quarto que Dios aya, y trofeos del arte pintados en el mismo lienço." See the detailed study of this portrait by Macartney 1999. This image was, perhaps, a source of inspiration for Murillo's *Self-Portrait* (Cat. 33, fig. 2), painted a few years later.
11. See Gállego 1979, for an anonymous seventeenth-century painting of Philip IV painting a picture of

the Virgin of the Immaculate Conception, in the collection of the Conde de la Unión.
12. Banda y Vargas 1961, 116, "para el estudio y provecho de nuestro Arte."
13. Banda y Vargas 1961, 117. The later statutes, however, recommended that painters could use the academy for their own paintings when this was not in use and with the permission of the president. *Idem.*
14. Banda y Vargas 1961, 118, "Y para mayor grandeza de nuestro Arte, y sus Estudios . . ."
15. Cherry, in Edinburgh 1996, 68–70. The exact terms of the relationship of the academy with the guild remain unclear. It appears to have assumed some authority with regard to the guild; in February 1663, Valdés Leal was substituted as *mayordomo* of the guild by Alonso Pérez, who was nominated by the academy. *MS Academía* 1982, 31.
16. Pevsner 1940, 33.
17. For the distinction between *profesor* and *oficial*, see Gállego 1995, 122. See *MS Academía* 1982,23, for the right of presidents to award academic degrees. From the foundation of the academy, its members were referred to as "académicos," not merely as "artists" ("artífices"). Ibid., 27. In the proposal for a royal academy drawn up in Madrid in 1624 (discussed below), it was decided that members be called by the honorific title of academician ("Académico, nombre reputado por muy honroso"). Calvo Serraller 1981, 168.
18. Hazañas y la Rua 1888.
19. Brown 1978, 21–43; B. Bassegoda in Pacheco 1990, 20–32.
20. Carducho 1979, 66.
21. On the Florentine academy, see Pevsner 1940, 44–55; Goldstein 1988, 78–88; Goldstein 1996, 14–22.
22. Pevsner 1940, 56ff; Goldstein 1996, 30–33. The French academy had been founded in 1648 and its definitive statutes were drawn up in 1663, in which the life class (on which the academy had a monopoly) was the centerpiece of a systematic program of theoretical instruction. Pevsner 1940, 84ff; Duro 1997, 50.
23. An Academia de San Lucas existed in Madrid by 1603, when it petitioned the king for support. As noted by Brown (1989, 178), this petition is probably the one republished by Calvo Serraller (1981, 165–68), in which the academy was envisioned as an arm of the Counter-Reformation church, an institution in which art could be learned scientifically and employed in the service of religion. In 1606 a group of painters, including Vicente Carducho, rented quarters in the

Madrid convent of La Victoria as headquarters for an academy of Saint Luke in which they could "study and draw." Calvo Seraller in Pevsner 1982, 210–12; Brown 1989, 179.

24. Volk 1977, 398–413; Calvo Serraller 1981, 169–77; Brown 1989, 179–81. The date of the petition, April 1624, was established by Brown (1989, 184, n. 11). In 1626, Juan de Butrón directed a letter to King Philip IV asking for royal protection for the proposed academy of painters (Calvo Serraller 1981, 221–33). Pacheco (ed. 1990, 126), gives an account of academic sessions of drawing from the nude model that may reflect this initiative during his stay at the court between 1624 and 1625.

25. Calvo Serraller 1981, 172. This "curso del natural" or "estudio del natural" was to take the form of two-hour nightly drawing sessions "en un aposento decentemente adornado, y abrigado, a donde se desnudará un hombre de buen porporción y músculos, para que todos los que quisieren dibujén de él, o imiten de cera, o barro."

26. Carducho 1979, 61–62, 440–42; Calvo Serraller 1981, 161–62; Calvo Serraller in Pevsner 1982, 212–13. The academy sought to train young artists, grant academic titles, and to examine and issue permits to practicing artists. Also, a drawing of all commissions for public places was to be sent to the academy for authorization. Calvo Serraller 1981, 174–75; Brown 1989, 180–82. Given the degree of authority and control it sought, it is not surprising that the Madrid academy never found sufficient support among the rank and file of guild members.

27. Gállego 1995, 115–39, on Carducho's defense of the liberal status of painting. Carducho (ed. 1979, 61–66) described the Florentine academy and (ibid., 440–42) the projected Madrid academy.

28. Calvo Serraller 1981, 169, 170. The petition for the Madrid academy of 1624 defined the institution as "no es otra cosa que un estudio general, y ejercicio del dibujo," open to all professionals who needed to draw.

29. Pacheco 1990, 274–75, 346. See also the defense of drawing as the foundation and perfection of painting in Pacheco 1990, vol. 2, chapter 5, and Carducho 1979, 236–45.

30. On Italian theories of drawing in Spain, see Pérez Sánchez 1986, 19–23, 29–31.

31. Carducho 1979, 34, 192.

32. Calvo Serraller 1981, 167, 173, 175, 176–77.

33. Goldstein 1988 analyses in detail the gap between theory and practice in Italian art, with particular

reference to the Carracci.

34. Macartney 1999.

35. All of these volumes are identified by Macartney 1999, 52–55.

36. Brown (1976, 45), notes that the Seville academy did not share the pedagogic aims of the Roman academy, despite the resemblance between their administrative structures.

37. Banda y Vargas 1961, 120, "Cobiene a los Estudios desta Academia y mejor usanza del Pintar y que salgan con mas perfección los que en ella estudiaren, exerciten dicha Academia quatro años continuos. . . ."

38. Ceán Bermúdez 1800, vol. 2, 56. Palomino (ed. 1987, 234) claimed that Cornelius Schut gave artistic advice to members of the academy. The original statutes of the academy cited the role of the president as judge in questions about the precepts and practice of painting; see MS Academia 1982, 23. There is, however, no evidence of any such interventions.

39. In the petition concerning the foundation of the Madrid art academy in 1624, it was taken for granted that it would be equipped with a teaching collection of books, prints, pictures, and drawings, as well as globes, spheres, and geometric instruments, among other things. Calvo Serraller 1981, 172.

40. Murillo's studio was not itemized in his postmortem inventory; see Angulo 1981, vol. 1, 166. It was sold to unnamed "diferentes maestros Pintores" for 600 reales. Only a small number of books on art, probably from Murillo's library, were listed in the inventory of his son Gaspar Esteban in 1709. Montoto 1946. This listed Italian editions of the architectural treatises of Vitruvius and Vignola, the latter with illustrations. There were also two works by Samuel Marolois: his illustrated two-volume work on perspective, Opticae sive Perspectivae (Amsterdam, 1633), and an illustrated volume of his work on fortifications, Artis muniendi sive fortificationis (Amsterdam, 1644). There was also a copy of Carducho's Diálogos de la pintura (1633). The studio equipment of Carducho himself included anatomical models, a skeleton, casts of dissected body parts, anatomical drawings and the treatises of Valverde and Dürer. Caturla 1968–69. Palomino (ed. 1987, 248–49) remarked that the painter Jerónimo de Bobadilla, who joined the academy in 1666 and became fiscal in the following year, owned a collection of models and drawings for his own pleasure and instruction. In 1666, Valdés Leal bought models of human figures and hands and feet from the sale of the sculptor José de Arce; see

Cherry, in Edinburgh 1996, 93, n. 97.

41. Students normally learned to draw the figure in progressive stages, preparing themselves by drawing from prints, drawings, and sculptures, before addressing the live model. In the etching of a life class in José García Hidalgo's Principios para estudiar el nobilísimo y real Arte de la Píntura (Madrid, 1693), less advanced pupils study a sculpture of a nude Samson or Cain, while in the foreground room there are sculptures of heads and figures on a shelf.

42. This is in keeping with the life classes described by Pacheco (ed. 1990, 126) and Palomino (ed. 1988, vol. 2, 197–99). Pacheco describes a life academy as a number of artists who gathered for a few hours each night to draw from the nude male model, posed each week by the best master among them. He says that artists would sit around the model, drawing him from different angles and so making from one figure many. This is how the young artists are disposed in José García Hidalgo's etching of a drawing academy published in his Principios para estudiar el nobilísimo y real Arte de la Píntura (Madrid, 1693), although they are too close to the model.

43. The prototype of these academies was the Carracci academy in Bologna, founded c. 1582, in which drawing from the male model was a priority. Pevsner 1940, 71–74; Goldstein 1988, 49–57; Goldstein 1996, 33–36.

44. Palomino 1987, 226, 231, 261 (on the private academy of the painter Francisco de Solís), 275, 298, 304, 361, 374. A number of such drawings by artists at the court survive today. Examples by Juan Carreño and Claudio Coello are reproduced here (figs. 44, 57). For another of a nude seen from the back and the fragment of another figure, possibly by Mateo Cerezo, see Piedra Adarves 2000, figs. 4, 19.

45. Palomino 1987, 304. Valdés Leal was a fiercely individualistic artist and for Palomino the story also provided a valuable example on the way an artist's own temperament allowed him to break with the norm. He also recounts (ibid., 303) Valdés Leal's jealousy of an itinerant painter at the Seville academy who drew two figures a night by means of technical improvization with the charcoal medium. Earlier, José García Hidalgo (1693) had expressed regret over the fact that El Greco followed his own individual style, despite his great study of anatomy. Palomino (ed. 1987, 82–85) also lamented his "extravagant" drawing and nudes despite his great knowledge of the art of painting.

46. Pacheco (ed. 1990, 127) recommended drawing from the nude model over sculpture for

reasons of greater naturalism; he said that this permitted the study of the musculature of the moving body and of flesh tints. As a polychromer of wood sculpture, Pacheco was particularly interested in the vivifying effects of flesh painting. In adding that sculptures were useful models for artists in the absence of the live model, he could have been referring to the the works of the Sevillian school of polychrome sculptors.

47. Ignacio de Iriarte, a landscape specialist, was a founding member of the academy and Juan van Mol, a Flemish landscape painter, was a member since 1663. The still-life and flower painter Pedro de Camprobín was also a founding member of the academy.

48. MS Academia 1982, 42. These individuals, who had drawn their swords in the academy, were banned from it.

49. The duration of the sessions can be deduced from an agreement of November 1660 with Juan, a French model. MS Academia 1982, 47.

50. MS Academia, 46. The first models were paid by the month at two reales a night. In December 1661, a model was dismissed and replaced by Cristobal de los Reyes Estete with a salary of 40 reales a month. MS Academia, 40.

51. Brown 1976, 46–48, suggested that an album of master drawings, copies, and students' work, known as the Jaffé album, came from the Seville academy. However, the absence of life drawings from this collection would suggest otherwise and it is more likely to represent material from an artist's workshop, as noted by Pérez Sánchez 1986, 299–300.

52. Palomino (1988 ed., vol. 2, 114) advises the beginner to copy "figuras de academia de autores de crédito." He also recounts (ed. 1987, 248) that the Seville painter and academician Jerónimo de Bobadilla owned a collection of drawings and sketches by eminent masters for his own pleasure and instruction. Life drawings by Italian painters were also admired in Spain and the collection of the Madrid painter Francisco de Solís included a number of these. For Italian examples, see Mena 1984, nos. 3, 10, 11, 13, 106, 157.

53. Durán 1980, nos. 30–35.

54. The way in which the chalk has caught in marked horizontal creases along the middle of the sheets of most of the drawings (Durán 1980, nos. 30, 31, 33, 34, 35) shows that these were imperfections in the production of the paper. There are also distinctive sagging folds in the top part of the paper of one of these (no. 31). The condition of some of the drawings, such as staining (nos. 30, 33) and tears (no. 31), is probably a consequence of their later use

by artists. Pin holes in the corners of some sheets (nos. 32, 35) and along the top edge of one (no. 32) reveal that the artists drew with the sheets fixed to a drawing board. The sheets (except nos. 30, 33) bear individual prices in reales, later inventory numbers, and the collection mark of Mariano González de Sepúlveda (d. 1842).

55. Durán 1980, nos. 30, 31; Pérez Sánchez, 1995, nos. 70, 71.

56. Two of the drawings (Durán 1980, nos. 32, 35; figs. 45, 46) appear to be by the same hand. The walking figure (Durán no. 34; fig. 51) is by another hand. It is possible that this latter drawing postdates the others catalogued together in this group, judging from the figure's hairstyle, the artist's meticulous technique, and the different color of the paper.

57. The drawings probably came from the extensive drawings collection of the engraver Pedro González de Sepúlveda. This included a drawing of a Virgin Mary by Murillo, which he gave to Ceán Bermúdez in 1797. Durán 1980, 9.

58. The technique of these life studies is broadly in accordance with Palomino's advice on drawing from the nude model in an academy, which evidently derives from conventional practice. Palomino (ed. 1988, vol. 2, 197–99) advises that the artist be at a distance of approximately one and a half times the height of the model, in order that the whole figure can be apprehended and included on the sheet. Brownish gray paper is recommended, since this provides a midtone and facilitates the application of highlights. The drawing itself is created in a series of methodical stages. First, the whole figure is sketched in charcoal, with the contours carefully drawn. Chalk is then used to define the definitive contours and anatomical features, the charcoal being erased with bread crumbs. The figure is shaded with soft, even strokes of the chalk. Further modeling is achieved by rubbing away with a cloth, deepening the shadows with chalk, and adding white highlights.

59. From the outset, artists were taught to draw in stages, beginning with circumscribing forms with their contour and then proceeding to modeling, as can be seen in the prints from seventeenth-century drawing manuals (cartillas de díbujo).

60. A comparative case is an anonymous seventeenth-century life drawing in Córdoba, which shows two studies of a thin, ordinary model. García de la Torre 1997, 120.

61. For Carducho (ed. 1979, 193), too much study had a negative effect on art. For this reason, Palomino (ed. 1988, vol. 2, 91–92)

said the artist should know anatomy in order to forget it. See also Goldstein 1996, 174–76.

62. Cherry, in Pérez Sánchez 1999, 57.

63. Palomino (ed. 1988, vol. 2, 195) emphasized the importance of study from the nude in academies for beginners. He also noted (ibid., 196–97) that a process of improvement of what the artist observed was expected, based on the artist's experience of copying prints after the best Italian artists and sculpture.

64. This was a practice of the French academy in Paris and Rome. Bignamini and Postle, 1991, 67.

65. For comparable drawings of nude models in historical poses by the Valencian painter Juan Conchillos Falcó, see Angulo and Pérez Sánchez 1988, figs. 42, 44, 46, 47. Palomino (ed. 1987, 378) notes that he modified some of these nudes for figures in his subject paintings. A drawing of a *Man of Sorrows*, for instance (Angulo and Pérez Sánchez 1988, fig. 6), could have been based on a number of his life studies of a seated model (ibid., figs. 50, 57).

66. See Brown 1976, nos. 54, 84, 92. One of Murillo's sketches for the Immaculate Conception was drawn on the back of a letter from Zurbarán, perhaps as an unconscious expression of his supremacy in an image which the older artist had previously made his own. See also Murillo's variations on the theme of Saint Joseph with the Christ Child (ibid., nos. 37, 68) or Christ as the Good Shepherd (ibid., nos. 90, 91). Pacheco (ed. 1990, 433–36) saw drawing as the means by which artists progressed from copying the inventions of others to making their own and by which they made "new things."

67. Navarrete Prieto 1998, 131–32 for Murillo copying angels from a print by Cornelis Cort in two early paintings; ibid., 197, for his variation on two airborne cherubs from a print after Rubens's *Adoration of the Kings*.

68. Traditionally, artists learned to draw by first drawing from other images (drawing from the flat) and progressing to three-dimensional forms. A number of seventeenth-century drawing manuals (*cartillas de dibujo*) included prints depicting airborne cherubs in different positions. Palomino (ed. 1988, vol. 2, 115) advises beginners to practice drawing from models of "niños en diferentes actitudes" and (ibid., 439) to practice foreshortening from sculptural models. A sculpture of a winged cherub is shown available for study in José García de Hildago's etching of a drawing academy in his *Principios para estudiar el nobilísimo y real Arte de la Pintura* (Madrid, 1693). The

sculptor Francois Du Quesnoy was particularly well known for his small sculptures of putti. The painter Francesco Albani, for instance, drew from these and others by Alessandro Algardi. Montagu, 1985, 262, n. 49. A sheet of studies of cherubs by the Florentine artist Simone Pignoni (c. 1614–1698), which was at the Instituto Jovellanos, Gijón, represents the same sculpted figure foreshortened from four different positions. Pérez Sánchez, 1969, no. 568. For studies of cherubs from sculpted figures by an anonymous Spanish artist in the collection of drawings of the Casa de la Moneda, Madrid, see Durán 1980, nos. 107–10. For drawings from sculptures of cherubs by the Valencian painter Juan Conchillos, see Angulo and Pérez Sánchez 1988, figs. 16–17.

69. See, for instance, Brown 1976, nos. 15, 17, 22, 76, 89.

70. See Carducho 1979, 242, on sketching, defined as "inventar, o dibujar de fantasía, o esquiciar," and Pacheco 1990, 433–36, on "rasguños." An important Sevillian precedent for Murillo were probably the pen and ink sketches of Francisco de Herrera the Elder and Alonso Cano, a considerable number of which survive today.

71. The sketch of Saint Salvador and the Inquisitor is on the verso of Murillo's study for *Saint Francis of Solano Taming a Wild Bull* (fig. 54). Brown 1976, 62, no. 2. The faint chalk sketch, apparently preceding a larger chalk figure study of Saint Francis of Solano on the same side of the sheet, records Murillo's initial idea for the dramatic exchange between Saint Salvador of Horta and the Inquisitor.

72. On the verso of the sheet is a less detailed, rapid notational chalk sketch for the *Adoration of the Shepherds*, another painting from the same series. Brown 1976, 102.

73. Brown (1976, 103), noted that the drawing represents alternative positions for the globe beneath Saint Francis's feet and the position of the cross.

74. See Brown 1976, nos. 77, 78, 81, 82, 84, 86, 88, 92, 93, for rapid pen-and-ink sketches by Murillo from his later career. Murillo's conception for the composition of his last painting, the *Mystic Marriage of Saint Catherine* (cat. no. 30, fig. 1), exists in a very abstract, rough pen sketch. Brown 1976, no. 94.

75. Brown (1976, 100–103), cites exposed areas of uninked chalk underdrawing in nos. 72 and 90. See also the chalk underdrawing of nos. 5, 34, and 62, from different points in Murillo's career. A drawing of *Christ as the Good Shepherd* (ibid., no. 90) is an informative example of Murillo's radical redrawing of an image on the same sheet. In this

case, the drawing was followed up by a more finished image (ibid., no. 91).

76. The verso of the drawing of *Saint Francis Solano Taming a Wild Bull* (fig. 54) contains a simplified chalk drawing of the same saint walking, in which Murillo has studied the massing of light and shade in the folds of the habit. Brown 1976, 62. This also shows an alternative detail of the habit covering the saint's proper right foot, a solution that had been rejected in the pen and wash study on the recto of the sheet. For other drapery studies for this series of paintings, see Brown 1976, 58 and no. 3.

77. For Murillo's study of angels, see Brown 1976, no. 18. For another of angels, dated 1660, see ibid., no. 22; ibid., no. 18, for the drawing of the Magdalene; ibid., no. 21, for a chalk drawing of *Saint Francis Receiving the Stigmata*, in which Murillo studied closely the ecstatic expression of the saint.

78. Carducho 1979, 202, 204, 242.

79. See, for instance, the drawings in Seville, Fundación Fondo de Cultura de Sevilla 1995, nos. 11–23.

80. Brown 1976, no. 35, in which the reproduction exaggerates the tonal contrast of the washes.

81. It is assumed that the squaring is Murillo's. A small painting, 20⅞ x 15″ (53 x 38 cm) attributed to Murillo is known of this composition. See Olivier Meslay in *Dessins et tableaux de Maîtres anciens et modernes*, Galerie Charles et André Bailly (Paris, 1988), 84–85. It is worth noting, however, that Murillo did make some drawings as independent works. For an autograph chalk *ricordo* of his *Mystic Marriage of Saint Catherine*, see Brown 1976, no. 14. Ibid., no. 75, for another in pen and ink of one of his earlier paintings of the Virgin and Child (Angulo 1981, vol. 2, no. 158).

82. For the painting, see Angulo 1981, vol. 2, no. 315. Minor differences between the drawing and painting include the location of the cart, and the position of limbs and direction of the gazes of the peasant figures.

83. As noted by Brown (1976, 59), the fact that the sheet is numbered—as is the previous drawing of *Brother Juniper and the Beggar*—suggests that they could have acted as models to be shown to Murillo's Franciscan clients. Murillo's later drawing of *Saint Thomas of Villanueva Receiving News of His Impending Death* (Brown 1976, no. 69), which has a frame drawn around it and shows a degree of finish analogous to that of the drawing of *Saint Francis of Solano Taming a Wild Bull*, might also have been presented to a client for approval.

84. Brown 1976, no. 7. Murillo inked a line frame around this drawing.

This appears to have been the basis for the painting of this subject now in the Toledo Museum of Art. Angulo 1981, vol. 2, no. 227. However, significant differences between the drawing and picture suggest that Murillo made further revisions in separate drawings. For the detail of the page boys in the painting, the artist returned to his original source of inspiration in Luc Vosterman's engraving after Rubens's painting of this subject. Another drawing of this type is the *Vision of Saint Clare* in the Musée du Louvre, Paris. Brown 1976, no. 39. Murillo's drawing of *Saint Isidore* (British Museum, London; ibid., no. 12) is a somewhat cursory study that shows unusally little contrast in the wash modeling, but was evidently explicit enough for the artist to use it as a model for his painting of this subject still in Seville cathedral.

85. Brown 1976, no. 66. Murillo also drew a line frame around this composition. The painting is today in Graves Art Gallery, Sheffield. Angulo 1981, vol. 2, cat. no. 215. For another drawing, in chalk, of the same subject, which could also have served as the basis of a self-contained painting, see Brown 1976, no. 23.

86. Brown 1976, no. 61.

87. Brown 1976, no. 62.

88. Studies that could theoretically have been used in this way include Brown 1976, nos. 34, 36, 37, 68, 71, 72, 74, 79.

89. Véliz (1998A, 298, 313), underlined the corollary between sketches and painterly painting in the second half of the seventeenth century. The treatise of Jusepe Martínez, *Discursos practicables del nobilísimo arte de la pintura*, c. 1673, for instance, mentioned the practice of improvising on the canvas from sketches and painting with "valentía" or "a lo valentón," ibid., 309–11. Murillo's possible use of sketchy drawings as a basis for painterly improvisation is analaogous to sixteenth-century Venetian practice and the approach of Titian and Tintoretto.

90. Brown (1976, 32–34, 187–90), drew fresh attention to this neglected aspect of Murillo's practice.

91. See, for instance, Valdés Leal's oil studies on canvas for the altarpieces of the *Assumption of the Virgin* and *Immaculate Conception* for the Sevillian church of San Agustín. Kinkead 1978, 180; 419, no. 99s; 420, no. 100s; Madrid 1991, nos. 65, 66.

92. Brown 1976, 34 and no. 33; Angulo, 1981, vol. 2, no. 352. Other cases where both preparatory drawings and an oil study survive include Murillo's painting of *Roman Charity* (Brown 1976, 34 and no. 70; Angulo 1981, vol. 2, no. 426) and Murillo's last painting, the *Mystic Marriage of Saint Catherine* (see cat. no.

30, fig. 1; Brown 1976, 34 and no. 94; Angulo 1981, vol. 2, no. 291A).

93. Angulo 1981, vol. 2, nos. 235, 363A.

94. For these drawings and oil studies, see Brown 1976, 34 and nos. 77, 94; Angulo 1981, vol. 2, nos. 182, 291A.

95. Pacheco, ed. 1990, 443, 444. He says he drew from the model for most of his career and from nude figures in both charcoal and chalk. Ceán Bermúdez (1800, vol. 4, 12–13) understood, surely correctly, that Pacheco's mention of drawings of hands, arms, feet, and nudes from nature were working drawings for pictures, rather than pure academic studies. His contemporary, Antonio Mohedano (Pacheco, ed. 1990, 440), was also said to have painted nudes, hands, and feet from the model. In this context, see the studies of nude figures and parts of figures in an album of working drawings by the Valencian artist Gregorio Bausá. Angulo and Pérez Sánchez 1988, nos. 14–258; Benito and Galdón 1994.

96. Palomino 1987, 77, for Roelas's academic study of the scientific aspects of painting.

97. Zurbarán's figures do not appear to have been improvised from print sources, as is sometimes claimed in the literature. See, for instance, J. M. Serrera in Madrid 1988, 236–44; Navarrete Prieto 1998, 101, 220–21. Prints, however, seem to have inspired some of the model's poses.

98. Véliz 1998B, 48. However, no academic studies of the nude have been identified by Cano, which suggest that this was an ad hoc practice. Idem., nos. 9, 73, for two of Cano's sketches of figures which may have been drawn from the life.

99. Giulio Bonasone's print of the same subject served as Cano's inspiration. Both Navarrete Prieto 1998, 278–79, and Véliz 1998B, no. 12, independently suggested the source of Cano's figure of Eve in *The Fall* by Jan Saenredam after Abraham Bloemaert. However, the figures in the painting appear to have been restudied from the life. A drawing by Cano for the composition is in the Real Academia de San Fernando, Madrid.

100. Leonardo 1989, 225, "apply yourself first through draughtsmanship to giving a visual embodiment to your intention and the invention which took form first in your imagination. Next set about adding and subtracting until you are satisfied, and then pose models, draped or nude as your work requires them."

101. Palomino (ed. 1988, vol. 2, 192–93) emphasized the importance of life study for Murillo's

painting early in his career. Mena (1982, 79), notes the absence from Murillo's known corpus of working drawings for parts of figures, due to collectors' lack of interest in such studies.

102. Carducho 1979, 271, ". . . sin preceptos, sin doctrina, sin estudio, mas solo con la fuerza de su genio y con el natural delante . . ."

103. In the case of Murillo's painting of *Christ after the Flagellation, Consoled by Angels* (cat. no. 12), Murillo created the figure of the right-hand angel by grafting together the torso and legs of figures from two separate print sources. No graphic source has been found for the beautiful and pathetic nude figure of Christ, however, perhaps because there was not one. See cat. no. 12, figs. 1 and 2, and Benito Navarrete Prieto in Seville, Hospital de los Venerables 1996, 57, for prints by Abraham Bloemaert and Bartholomeus Spranger from which Murillo derived his figure of the angel.

104. A chalk drawing of *Saint Francis Embracing Christ* was proposed by Brown 1976, 29 and no. 28, with some reservations, as a highly finished preparatory study for Murillo's painting. This was rejected by Angulo and Mena (1982, 89, n. 12), among a number of sheets characterized as possible copies after lost original drawings by Murillo. The technique and style of the drawing is close to two other chalk drawings, an *Immaculate Conception* (Brown 1976, no. 24) and *Mary Magdalene* (no. 31). All of these drawings show only the main figures from respective paintings of these subjects by Murillo. They are unlike any other securely attributed drawings by Murillo and their somewhat mechanical hatching suggests a hand other than his, probably copying his paintings.

105. Carducho (ed. 1979, 164–69; 181–84; 196–98), for instance, took a staunchly Neoplatonic view of art and was adamant on the necessity of painting to be more than mere imitation of an imperfect and corrupted nature, but an improvement on the visible world in accordance with the idea of perfection.

106. Pacheco (ed. 1990, 274–75), who insisted on the artist's obligation to idealize and to depict beautiful figures, was equally conscious of the importance of nature in this process, summarized in his comment "que la perfección consiste en pasar de las ideas o a la natural, y de lo natural a las ideas; buscando siempre lo mejor y más seguro y perfecto." Carducho (ed. 1979, chapter 4) also underlined the importance of nature as a reference and the value of color to make represented figures lifelike. He characterized the

sources of representations as images seen, recollected, and perfected in the imagination. Ibid., 188–89.

107. Brown 1976, no. 56, interpreted the smudged effect of the drawing as a late stylistic feature, dating the drawing to the 1670s. However, the drawing is more likely to date from the previous decade.

108. See Goldstein 1996, 167, on this drawing practice.

109. Carducho's drawing of a Crucified Christ, which was at the Instituto Jovellanos, Gijón, shares analogous characteristics. Pérez Sánchez, 1969, no. 347. True to his Italian principles of *disegno*, the flowing contour of the figure is a sharply pronounced line and anatomical details are greatly suppressed.

CHAPTER FOUR NOTES

1. Angulo 1981, vol. 2, 206, no. 224.

2. I wish to express my special thanks to Dr. Burton B. Fredericksen, of the Getty Provenance Index, for his generous assistance during the course of this study.

3. For an excellent and apposite overview of this trend, see Francesca Cappelletti, "The Enticement of the North: Landscape, Myth and Gleaming Metal Supports," in London 2001B,174–205.

4. See the entries on El Greco and Murillo by Jordan, in Phoenix 1998, 197–99; 241–45, for an earlier discussion of this subject.

5. Pacheco 1649, ed. 1990, 490–92.

6. Another example is a tiny pair of paintings on lapis lazuli, a *Salvator Mundi* and *Mater Amabilis*, painted by Antonio Mohedano (c. 1561–1626), which, by 1799, had reached Würzburg, where they were sold (lots 213 and 214) at an undated auction (Getty Provenance Index).

7. Angulo 1981, vol. 2, 204, no. 221.

8. Real Academia Española, *Diccionario de Autoridades* (vol. 4, Madrid, 1734), facsimile ed., 1964, vol. 2, 354: "Plancha de metal de diversas figuras y tamaños, en la qual se suele esculpir alguna cosa. . . . Se llama también la pintura hecha sobre plancha de cobre."

9. Angulo usually catalogued these lost paintings as being on panel. One candid example of his ambivalence, however, is found in no. 243, which he catalogued as a wood panel: "El hecho de registrarlas como láminas obliga a pensar que no son lienzos. Supongo que serán en tabla, aunque más generalmente el término lámina suele aplicarse a las de cobre."

10. Justino de Neve's postmortem inventory (Archivo Histórico de Sevilla, Sección Protocolos Notariales, Prot. 13031) has not been published in its entirety. Angulo published only those entries with specific attributions to Murillo, the

only artist other than Luis de Morales specifically mentioned in the document, but not all Murillo's paintings in the collection were attributed in the inventory. Kinkead (see below) transcribed and published the Neve entries for paintings by the artist acquired by Nicolás Omazur and attributed in his inventories. Both these authors made occasional errors. We have referred to the original document. The verbatim transcriptions provided here were made by María Cruz de Carlos.

11. For the inventory and analysis of the Omazur collection, see Kinkead 1986. Two different inventories are transcribed there: 1) executed following the death of the collector's first wife, in 1690; and 2) executed following his own death, in 1698. Each has slightly different wording. Angulo did not know these documents. According to the documents of the auction sale, or *almoneda*, of Neve's estate, all the paintings that were eventually owned by Omazur were bought by one Juan Salvador Navarro, who was possibly a dealer acting on behalf of the collector.

12. Kinkead 1986, 138 (*Omazur Inventory, 1690*): "2–3. Yten dos piedras de jaspe negro pintadas en la una la oracion de Xpto en el Huerto, y en la otra Nro Sor Jesus Xpto con San Pedro, con sus molduras anchas caladas entalladas y doradas, y son orijinales del dho Murillo"; *Omazur Inventory, 1698*: "13–14. Yten Dos Laminas em piedra de a mas de tercia pintadas en la una la oracion del Huerto, y en la otra nuestro Señor amarrado a la Coluna y San Pedro originales del dho Morillo con molduras anchas entalladas y Doradas."

13. *Neve Inventory*: "Yten dos laminas de piedra Con ssus molduras doradas de mano de morillo la una de la oracion del guertto y la ottra de nro señor atado a la coluna y san Pedro de rrodillas [400 reales cada una]." See also Angulo 1981, vol. 2, 215, for a modernized transcription.

14. Sale: Bonn, May 18, 1764, lots 35 and 36.

15. Neveu, Paris, December 10, 1764, where they were catalogued together, as by Murillo.

16. See Claudie Ressort, *Murillo dan les musées français* [Les dossiers du département des peintures], Musée du Louvre (Paris, 1983), 34–36. As this essay was completed, but before it went to press, Olivier Meslay's important article on these paintings was published in *The Burlington Magazine* (vol. CXLIII [2001], no. 1175, 73–79). Some details of the paintings' provenance have been incorporated from that source; others have been provided by the Getty Provenance Index.

17. Curtis 1883, 196, no. 195.

18. Mayer 1923, nos. 263, 294.

19. One of the copies after Murillo in Omazur's collection was identified as by Meneses Osorio, indicating that the cataloguers were well aware of the distinction between the two hands.

20. Brown 1976, 115.

21. See note 16 above.

22. Kinkead 1986, 138, n. 2.

23. I am grateful to Olivier Meslay, curator of Spanish paintings at the Louvre, for sharing with me the technical report prepared by the Laboratoire de recherche des Musées de France under the direction of Patrick Le Chanu. See also Meslay 2001 for further observations.

24. Meslay 2001.

25. Brown 1976, 114–15, no. 35, publishes a drawing similar in some respects to the Louvre *Agony in the Garden*, which he compares to others datable between 1665 and 1669. That drawing, however, is much more directly related to an *Agony in the Garden* attributed to Murillo (oil on canvas glued on wood, 53 x 38 cm) that appeared on the Paris art market in 1988: see Meslay 2001, 79, fig. 21. This work was bought in at Christie's London on May 24, 1991 (lot 96) and again on April 15, 1992 (lot 50). It was sold at Sotheby's New York on May 23, 2001 (lot 41).

26. Angulo 1981, vol. 2, 204, no. 221.

27. The back of the obsidian block on one of the paintings in Paris shows diagonal lines deeply incised into the stone across each of the four corners. Olivier Meslay, *loc. cit.*, offers two possible explanations for this, but a third is that the painter could have been exploring the idea of turning the block into one of octagonal shape, an idea that could have been abandoned because of the difficulty of working with this material. The painting in Houston was recently cleaned and analyzed by Claire Barry, chief conservator of paintings at the Kimbell Art Museum.

28. Another *Nativity* on marble attributed to Murillo, which measured ½ by ½ *vara*, was in the López Cepero collection in Seville in 1860 (Angulo 1981, vol. 2, 437, no. 1424). By its square format, it was clearly different from the painting now in Houston, which, in any case, was already in London by this date. A Murillo *Virgin and Child* painted on marble (Angulo 1981, vol. 2, 398, no. 1012) was given to Sir Robert Walpole by Benjamin Keene, who had been ambassador in Madrid. Appraised by Benjamin West and Cipriani at £80, it was sold to Catherine the Great, where it was described in the Hermitage catalogue of 1773–83 as: "Petit morceau des plus beau qui se voyent du Maître." Located by 1797 in the Palace of Gatchina, which was

nearly destroyed in World War II, it is not known today.

29. Omazur apparently bought only one of this pair, the *Pietà*. Kinkead 1986, 139, n. 5, transcribed the entry in the Neve inventory as follows: *Neve Inventory*: "Yten dos laminas ochavadas guarnicidas de plata y cantoneras de laton doradas la una del descendimiento de la Cruz y la otra de Nuestra Señora y el Niño y San Joseph . . .1,200 reales"; our own transcription reads: "Yten dos laminas ochavadas Guarneçidas de platta Y cattoneras de latton dorado la Una del descenrimiento [*sic*] de la cruz y la otra de nuestra señora el niño y san Joan [600 reales cada una]," thus differing in the identification of Saint John, rather than Saint Joseph, as the third figure in the second painting; *Omazur Inventory, 1690*: "8. Yten una lamina ochavada pintada Nra Sra y Nro Sor Xpto vajado de la Cruz y unos Angelitos llorando original del dho Murillo con su moldura dorada de plata fina y cavecitas de Angelitos de bronze sobre dorado"; *Omazur Inventory, 1698*: "9. Yten una lamina ochavada de poco mas de media bara de Nuestra Sra de la Piedad pinttada en cobre original del dho Murillo con guarnicion de Latton Dorada."

30. The *Pietà* may have reached France even sooner. On April 22, 1748, the Parisian dealer Gersaint auctioned on behalf of Charles Godefroy a painting described as being on copper and measuring 13 inches in all directions, which represented Christ descended from the cross, accompanied by the Virgin and two angels. Feeling ill-equipped to judge the authenticity of a work by the artist, Gersaint catalogued it as *Un très-beau Tableau . . . dans le goût de Morillos. . . .*"Ce morceau représente un Christ descendu de la Croix, accompagné de la Vierge & deux Anges. Le Dessein y est exact. Il est peint d'un grand goût, avec beaucoup de vigueur et de fermeté. Quoique ce Tableau soit recommandable, il seroit difficile de lui donner un nom sur lequel on pût ne pas craindre de contradiction. Pour éviter cet inconvénient, nous avons crû qu'il étoit plus convenable d'en abandonner la décision aux Connoisseurs, que de la vouloir prendre sur nous-même, afin d'éviter le reproche qu'on pourroit nous faire de vouloir donner par un nom illustre, un plus grand mérite à ce Tableau; mérite cependant réel & reconu, qu'on ne peut lui refuser sans être injuste." The painting was sold for the considerable sum of 200 *livres* to a buyer named Molin.

31. On this sale, see Frederickson 1993, 51. While the Spanish provenance of the pictures in this sale could be true, none of them has been matched with entries in known

inventories of the royal collection. It is not impossible, therefore, that the stated history of this group of works is a fabrication and that they were assembled from various sources to feed the English taste for things Spanish. On the other hand, the Spanish queens —María Luisa and before her Isabel Farnese—were avid collectors, especially of cabinet pictures, many of them bought abroad, and it may be that no inventory will ever accurately reflect their complete holdings. As the auction predated by two months Wellington's victory at the battle of Vitoria, in which the general captured paintings being taken to France by Spanish forces loyal to Joseph Bonaparte, this sale seems to have set a precedent for the more famous episode.

32. The auction entry read: "Dead Christ, supported by his Mother & Angels, in great esteem amongst Connoisseurs, finely composed and colored, exquisitely finished."

33. Stirling (1848, vol. 3, 1431) described the painting as follows: "Our Lady kneeling beside the dead body of the Saviour, and attended by two weeping cherubs. On an octagonal plate of copper. 1 ft. in diameter." The weeping angels conform closely to the description in the Omazur inventory. Curtis describes the same picture as: "The dead Saviour in the lap of the Virgin, attended by two angels." The fact that the one could say that the Virgin was kneeling beside Christ and the other that Christ was in her lap suggests that the figural group must have resembled that in the *Pietà* from the Capilla Mayor of the Capuchinos (Angulo 1981, vol. 2, no. 71; vol. 3, pl. 245), executed in the late 1660s, in which Christ's head rests in the lap of the Virgin, who sits behind him. It is easy to imagine how this grouping, with certain modifications, could be adapted to an octagonal format. Whether this *Pietà* is the same as the one auctioned in Paris in 1748 (see note 28 above) is impossible to know. One of them, of course, could have been a copy or a second version of the other.

34. This was obviously an inadvertent error due to the fact that the very next entry ends with the words "san Josseph."

35. One inconsistency turned up in comparing Omazur's inventories with the original document of the Neve inventory. Omazur's inventory of 1698 makes clear that the *Pietà* that he bought was painted on copper. Neve's inventory describes both this and the *Holy Family* as being simply *láminas*, without specifying the metal. Nevertheless, in Neve's *almoneda*, or estate sale (*loc. cit.*, f. 776v), where both pictures were bought by Juan Salvador Navarro,

they were referred to as being painted on "ojuela de plata," or silver plate. Most likely this was just a notary's error derived from the inventory's reference to the frames as being of silver.

36. Angulo 1981, vol. 2, 179–80, no. 197, vol. 3, pl. 313. Whereas Angulo gives the dimensions of the painting as 13 by 13 inches, the actual measurements are 13 1/2 by 13 1/2 inches (34.5 by 34.5 cm).

37. See the Earl of Ilchester, ed., *The Spanish Journal of Elizabeth Lady Holland* (London, 1910), the entries for late winter and spring of 1809, for an affectionate account of the couple's friendship with Jovellanos and their excursions together to see the paintings of Murillo in the various churches and convents of Seville.

38. Angulo 1981, ibid.

39. Ibid., 180: ". . . el cuadrito original de Murillo que pedí a Gijón para Vm., y es el único original sincero que tengo de aquel autor. Quisiera ser el dueño del Tránsito de Santa Clara o otra de la insignes obras del autor; pero ofrezco lo que tengo y puedo, para que no carezca Vm. de un pieza legitima de su graciosa mano."

40. Ibid., "Quisiera que el cuadro fuese de otro asunto para los melindrosos de Londres; pero no tenía otro." Other letters related to this gift are cited in J. González Santos, *Jovellanos, aficionado y coleccionista* (Gijón, 1994), 133.

41. Davies 1819, 62, note. Jovellanos was, of course, advised in every respect of his collection by his close friend Ceán Bermúdez.

42. W. H. James Weale and J. P. Richter, *A Descriptive Catalogue of the Collection of Pictures belonging to the Earl of Northbrook* (London, 1889), no. 230: "The twelve Apostles are asssembled round a sarcophagus; a woman behind it rests her right hand on a white gravecloth with roses upon it; near her is another woman. On the left, St. Peter kneels holding the keys. Above, the Virgin, with outstretched arms, ascends to heaven, surrounded by eight winged angel heads. An octagon picture of the same class is in the collection of Lord Lansdowne; it was given to Henry, Marquis of Lansdowne, by Lord Holland. Ex-collection: Sir Thomas Baring. Exhibited: British Institution, 1840, No. 92." See also Angulo 1981, vol. 2, 391, no. 954. According to Angulo, the earls of Northbrook know nothing of this painting's current whereabouts.

43. Curtis 1883, 139, no. 51.

44. Stirling 1848, vol. 3, 1419.

45. Waagen 1854, vol. 2, 181.

46. Although it was not then described as being an octagon, this could have been another of the paintings that were auctioned in

1813, in the sale of cabinet pictures purporting to come from the collection of Queen María Luisa, where it was described: "The Assumption of the Virgin, on copper, finely composed and coloured, a very fine cabinet picture, the two women therein are portraits of the Artist's Wife and Daughter" (Angulo 1981, vol. 2, 389, no. 918). On this sale, see note 31 above. On the other hand, the Northbrook painting could have been the small copper *Assumption* (Angulo 1981, vol. 2, no. 947) sold at Christie's on February 23, 1798 (lot 99), together with other cabinet pictures from Paris, via Hamburg.

47. Kinkead 1986, 139, and note 6: *Neve Inventory:* "Yten quatro obalos pequeños dorados el uno del Santo Rey y el otro de San Herminigildo y el otro de Señora Santa Ana y el otro de Señor San Joseph [the first two] en 100 reales y [the second two] en 150 reales." [Our verbatim transcription reads: "Yten quattro óbalos pequeños dorados el uno de el santto Rey el otro de san ermenejildo y el otro de señora santta ana y el otro de san Josseph en 100 reales y en 150 reales."] *Omazur Inventory, 1690:* "9–12. Yten quatro laminitas redondas pintadas en la una el Sr Sn Joseph y en otra señora Santa Ana, en otra el Sr Rey Sn Fernando, y en la otra el Sr Rey Hermenijildo todas originales del dho Murillo."

48. Ibid.: *Omazur Inventory, 1698:* "141–42. Yten dos redondeles de una tercia en redondo, en el uno pintado el Santo Rey Dn Fernando y en el otro San Hermenigildo con molduras doradas."

49. Ibid.: *Omazur Inventory, 1698:* "223?–224?. Yten dos laminas Redondas de obalo de poco mas de media bara con molduras Doradas de diferenttes devoçiones."

50. See Angulo 1981, vol. 2, nos. 174, 226, 243, 257, 258, 270b, 329 (records two works), 330.

51. Ibid., no. 329.

52. It has not been possible as yet to identify this Spanish or Portuguese nobleman, whose name and title have probably been garbled. Three wax seals on the back of the painting's original frame, however, confirm its descent in successive generations of the Steenhuyse family.

53. Brown 1976, 138, dated the picture to the 1670s.

54. Valdivieso 1988, 121–22, pls. 92 and 93.

55. Kagané 1995, 96–99, no. 8.

56. At Tallard's death sale, the paintings (lot 129) were described as *"Le Christ Couronné d'épines: Buste peint sur cuivre, & une Vierge de douleur en regard,"* measuring 16 x 13 inches. Bernard Dorival, "Obras españolas en las colecciones francesas del siglo XVIII," [please set the following in italics:] *Actas del XXIII Congreso Inter-*

national de Historia del Arte, vol. 3, Granada, 1978, 67–94, has equated these with a tiny pair, measuring 13$\frac{1}{2}$ x 9$\frac{1}{2}$ inches (collection William C. Cartwright, Aynhoe), exhibited at the British Institution in 1839 (Curtis 1883, nos. 72 and 200). Cartwright's Murillos were inherited from the collection formed around 1760 by John Blackwood, who is said to have acquired them in Spain. Angulo (1981, vol. 2, 446, nos. 1526–27) considered this pair to be from Murillo's school. A somewhat larger pair of *láminas* of the same subjects by Murillo belonged to the artist's son Gaspar in 1709 (cf. Angulo 1981, vol 2, 222, nos. 257–58).

57. This copy of the catalogue is in the Rijksbureau voor Kunsthistorisches Documentatie, The Hague.

58. This contradicts Mariette's mistaken assertion, repeated by Curtis, that the painting was executed on paper adhered to panel: P. J. Mariette, *Abecedario*, Paris, 1857–58, IV, 24. See Kagané, *loc. cit.*, for clarification.

59. The painting is said to have been in the Standish collection, but this cannot be confirmed. Curtis 1883, 200, no. 210s, documents the sale of a *Christ at the Column*, attributed to Murillo, from the collection of William E. Gladstone, at Christie's, on January 23, 1875, but this is an error. The only painting of this subject in the sale was attributed to Marco d'Oggione.

60. Angulo 1981, vol. 2, 445, no. 1523.

61. See Angulo 1981, vol. 2, nos. 719 [Angulo does not indicate that this was on copper, but it was], 726, 765; see also various other sale references (in London, Paris, Mechelen, and elsewhere) recorded by the Getty Provenance Index.

62. Christie's, London, March 3, 1838, lot 166: "Murillo, The Assumption of the Virgin, attended by infant angels and cherubs: beautifully grouped; the figure of the Virgin full of grace; painted upon black marble." Although it was catalogued as an *Assumption*, English cataloguers frequently mistook the Immaculate Conception for the Assumption, which may have been true in this case. On the other hand, this could be the *Assumption*, described as "small" and painted on marble, sold by the marquis of Bute at Christie's on June 8, 1822, bought by Ludow (Angulo 1981, vol. 2, 391, no. 951). An entry in the inventory of Justino de Neve should also be noted: "Yten otra lamina de la assumpcion de nuestra sseñora de Piedra Con su moldura de evano [en 18 reales]" (*loc. cit.*, f. 248v). Thus, the subject described in the nineteenth century could have been correct.

63. Stratton 1988, 83.

64. With no provenance, the painting was sold at Sotheby's, Amster-

dam, November 18, 1985, catalogued as by a follower of Murillo. It was bought by the present owner in the following year from Harari & Johns Ltd, London. Pérez Sánchez (Seville 1996, 142, no. 50) has pointed out the similarities in size and composition to two works catalogued by Angulo (1981, vol. 2, 378, no. 808), which passed through the New York and London art markets in the 1930s. The reproduction of one of these with a very deficient photograph (pl. 517) suggests subtle differences, however, and neither of these two was said to be on copper. While one cannot rule out that the present painting might have been one of these two, neither can one dismiss the possibility that both were copies of it.

65. Palomino 1724, ed. M. Aguilar (Madrid, 1947), 1034. In the English translation of the same work by Nina Ayala Mallory (Cambridge, 1987), 283, 285, n. 20, the work is said to be no longer extant. See also Angulo 1981, vol. 2, 365, no. 726. J. A. Ceán Bermúdez (1800, vol. 2, 63) records an *Immaculate* measuring 1/2 *vara* (approx. 42 cm) in the sacristy of the same monastery but does not indicate that it is on copper. Angulo (no. 726 and in no. 765) speculates that the two might have been the same work, but properly concludes that this cannot be considered a certainty.

66. D'Argenville, *Abrégé de la vie des plus fameux peintres . . .* (Paris, 1762). Reprinted in Davies 1819, liv.

67. Zarco Cuevas 1934, 25. See also Angulo 1981, vol. 2, 371, no. 765.

68. If the crown prince did buy it from the monastery, this could explain the existence of a copy, since he is known to have offered to substitute copies for paintings by Murillo that he wanted to acquire from religious institutions (see entry for *The Return of the Prodigal Son*, cat. no. 18).

69. Pérez Sánchez in Seville 1996, 142, no. 50.

70. See Angulo 1981, vol. 2, 377, no. 808, for discussion and illustration of the derivative version in the Ringling Museum, Sarasota and, especially the replica in the Oscar Cintas Foundation.

71. The decree is printed verbatim in Ponz, ed. 1947, 843.

72. Ceán Bermúdez, *Letter. . . to a friend upon the style and taste of the School of Seville, and upon the degree of perfection to which Bartolomé Estevan Murillo elevated it* (Cadiz, 1806); quoted here in translation from Davies 1819, 96.

CHAPTER FIVE NOTES

1. Investigations into Murillo's technique include: Hubert von Sonnenburg, *Zur Maltechnik Murillos* (Munich, 1982); Victoria Leanse,

unpublished manuscript: *Easel Painting Materials and Technique in Spain, 1642–1682* (Courtauld Institute of Art, London, January 1984); Viazmenskaïa, "Technical Study of the Paintings by Murillo in the Hermitage Museum," *Bulletin of the Hermitage Museum* 52 (1987), 51–57; Zahira Véliz, "Técnicas de los artistas: Tradición e inovación en la España del siglo XVII,"in *En torno a Velázquez*, exh. cat. (Museo de Bellas Artes de Asturias, Oviedo, 1999); Ana Sánchez-Lassa de los Santos, "*San Pedro en Lágrimas: Aproximación a la técnica de Murillo*," in *Las Lágrimas de San Pedro en la pintura española del Siglo de Oro*, exh. cat., Alfonso E. Pérez Sánchez and Ana Sánchez-Lassa de los Santos (Museo de Bellas Artes de Bilbao, 2000); and an unpublished study by Gwendolyn Fife.

2. See Gridley McKim-Smith, "On Velázquez's Working Method," *Art Bulletin* 61, no. 4 (December 1979), 589–603; Gridley McKim-Smith, Greta Andersen-Bergdoll, and Richard Newman, *Examining Velázquez* (New Haven, 1988); Carmen Garrido Pérez, *Velázquez: Técnica y Evolución* (Madrid, 1992); Zahira Véliz, "Velázquez's Early Technique," in *Velázquez in Seville*, exh. cat. (National Galleries of Scotland, Edinburgh, 1996); Jonathan Brown and Carmen Garrido, *Velázquez: The Technique of Genius* (New Haven, 1998).

3. Brown 1989, 177–85.

4. McKim-Smith, Andersen-Bergdoll, and Newman 1988, 10.

5. Leanse 1984, 62.

6. Zahira Véliz, ed. and trans., *Artists' Techniques in Golden Age Spain: Six Treatises in Translation* (Cambridge, 1986), 32.

7. The cross sections for the Kimbell group were mounted and analyzed by Christopher McGlinchey, while Barbara Berrie analyzed the cross sections for *Two Women at a Window*, which were prepared by Barbara Miller.

8. Thanks to William B. Jordan, Suzanne Stratton-Pruitt, Timothy Potts, Isabelle Tokumaru, and Michael Gallagher for their helpful suggestions and insights. Leslie Ureña and Jacobus Wolf provided valuable assistance in translating articles. Michael Bodycomb photographed several paintings during the course of examination and treatment. Erika Franek assisted with the digital assembly of X-radiographs. Examination of the paintings in this study would not have been possible without the assistance of many other colleagues, including: Anne Adams, Nathan Augustine, Kenneth Bé, Lucy Belloli, Barbara Berrie, Edgar Peters Bowron, Sarah Fisher, Joseph Fronek, Katherine Howe, Timothy Lennon, John Lunsford, Dorothy Mahon, Catherine Metzger, Lawrence Nichols,

Wynne Phelan, Virginia Rasmussen, Elizabeth Schorr, Marcia Steele, William G. Stout, William Thompson, Hubert von Sonnenburg, and Frank Zuccari.

9. Sonnenburg 1982.

10. The *Jacob* canvas, the smaller of the two paintings included here from this series, consists of two panels of equal width, while the *Laban* support includes a third panel at the top measuring approximately 5⅛ inches. Murillo employed a similar construction for *The Return of the Prodigal Son*. The locations of seams for the two lower panels correspond to those found in the Jacob paintings, with the bottom canvas 43⁵⁄₁₆ inches and the center panel 43⅜ inches in height. The top panel measures 6¼ inches. Palomino described methods for sewing invisible seams for pieced canvases using the "sheet" or overcast stitches. Véliz 1986, 148. See also Joyce Plesters and Lorenzo Lazzarini, "Preliminary Observations on the Technique and Materials of Tintoretto," in London 1972, 153–61. Tintoretto and other sixteenth-century Venetian artists first adopted the practice of enlarging canvases in this manner. Velázquez also employed oversized canvases, stitching together three vertical lengths to produce *Las Meninas*.

11. The horizontal seam in *Self Portrait* appears approximately 9 inches from the bottom edge of the painting.

12. Plesters and Lazzarini 1972.

13. See also Sonnenburg 1982, 3. In *Three Boys Playing Dice*, the selvedge remains on both sides; the width of the canvas measures 109.5 cm (approximately 43¼ inches), similar to the width of canvas used for *The Return of the Prodigal Son, Jacob Laying the Peeled Rods before the Flocks of Laban*, and *Laban Searching for His Household Gods in Rachel's Tent*.

14. Plesters and Lazzarini 1972.

15. The thread counts are as follows: *Two Women at a Window*: approximately 10 threads/cm vertically; 8 threads/cm horizontally; *Four Figures on a Step, Saint Justa*, and *Saint Rufina*: approximately 9 threads/cm vertically and horizontally; *Virgin of the Immaculate Conception*: approximately 10 threads/cm vertically and horizontally. The thread count for *Saint John the Baptist Pointing to Christ* is approximately 11 threads/cm in both directions. The X-radiograph reveals that the top edge of the original support was extended by approximately 2½ inches.

16. Brown and Garrido 1998.

17. Murillo sometimes used the "tablecloth" *mantelillo* weave, a damask with a characteristic texture of overlapping diamond patterns. This expensive Venetian canvas was used by several artists working in

Seville, including Zurbarán, Herrera, and Velázquez; see also Leanse 1984, Véliz 1996, and Sánchez-Lassa de los Santos 2000.

18. *The Adoration of the Magi* (cat. no. 7) also showed a patterned linen support. See also Véliz 1996, 79.

19. John Payne, conservator of paintings at the National Gallery of Victoria, Melbourne, personal communication. See also Viazmenskaïa 1987. In the Musée du Louvre, Paris, *The Birth of the Virgin*, 1661, and *The Apparition of the Virgin*, 1665, are both executed on patterned canvas weaves.

20. See also Véliz 1999. Although the type of wood used here was not analyzed, mahogany was found in another relatively late painting: *Two Angels Carrying the Emblem of Saint Augustine*, c. 1660–64. This wood was imported to Seville from the Indies. Pacheco claims walnut and cedar as the usual wooden supports for oil painting.

21. Dr. J. A. van der Graaf, "Development of Oil-Paint and the Use of Metal Plates as a Support," in London 1972, 139–47. See also Francesca Cappelletti in London 2001B, 174–205.

22. Jordan in Phoenix 1998, 241–45.

23. Ibid., 241, "compositions painted on metal (copper as well as other alloys) are known by a surprising number of Spanish painters, including El Greco, Juan Bautista Maino, (1581–1641), Juan Sánchez Cotán (1560–1627), Eugenio Caxés (1575–1634), José de Ribera (1591–1652), Juan van der Hamen y León (1596–1631), Juan de Zurbarán (1620–1649), Alonso Cano (1601–1667), Mateo Cerezo (1637–1666), Claudio Coello (1642–1693) and others."

24. Meslay 2001. The paintings were examined in the Laboratoire de recherche des Musées de France by Patrick Le Chanu. The obsidian was identified by PIXE analysis (AGLAE accelerator), and this analysis was carried out by Jean Claude Dran, Joseph Salomon, and Thomas Calligaro.

25. Meslay 2001.

26. Ibid. The corners on the reverse of *Christ at the Column* are marked by diagonal scarifications. These marks suggest it may have been used for a sacrificial altar, perhaps in an Aztec or Incan temple.

27. *Nativity* measures 1⅛ inches thick; *Agony in the Garden* and *The Penitent Saint Peter Kneeling before Christ at the Column* measure approximately ¹⁵⁄₁₆ inches. See Meslay 2001, 73, n. 4.

28. See Meslay 2001, 73, n. 5.

29. "Metal plates, being cleaned, are primed with only one thin layer of white lead and umber in oil which is put on and spread with the fingers and not with the brush. Stones or slates (although there are few who paint on them in Spain) will be

primed with two layers in oil, the second having more body." Véliz 1986.

30. Meslay 2001, 78.

31. See also Sánchez-Lassa de los Santos 2000. These grounds are similar to the ones she has identified in Murillo's work. The earths are made up of variable composition but essentially consist of argil/clay and oxide of hydroxide or iron, manganese oxide, calcium carbonate and/or magnesium, etc. Its color depends on the above compounds. Red earths contain an elevated quantity of iron oxide; in yellow earths, iron hydroxide predominates, and in the umbers, manganese oxide.

32. Sánchez-Lassa de los Santos 2000.

33. Brown and Garrido 1998, 16. See also Sonnenburg 1982. Murillo also added lead white to some of his primings, but not in any of the paintings examined here.

34. Jill Dunkerton and Marika Spring, "The Development of Painting on Coloured Surfaces in Sixteenth-Century Italy," *Painting Techniques: History, Materials, and Studio Practice, Contributions to the Dublin Congress, 7–11 September 1998*, ed. Ashok Roy and Perry Smith (London, 1998), 120–30.

35. Cross sections were taken from six of the works: five date from c. 1655–60 and include three devotional subjects, *Saint Justa, Saint Rufina*, and *Virgin of the Immaculate Conception* (cat. no. 8), and two genre paintings, *Four Figures on a Step* and *Two Women at a Window*; while the sixth painting, *Virgin of the Immaculate Conception* (cat. no. 28), c. 1680, is a later work.

36. Sánchez-Lassa de los Santos 2000. Also according to John Payne, personal communication, the tacking edges of *Immaculate Conception* (National Gallery of Victoria, Melbourne) were unprimed.

37. Véliz 1986, 150–51.

38. Leanse 1984, 22.

39. Ibid., 24.

40. As Sarah Fisher noted, the use of local *imprimaturas* has also been seen in Zurbarán's work.

41. Sonnenburg 1982. Von Sonnenburg observed an increasing tendency for Murillo to lighten his grounds over time, but middle-toned grounds were identified in the two examples here.

42. He also saved room for specific costume details, including the red and black bows of the young man's costume.

43. For example, the exposed ground in *Four Figures on a Step* can be glimpsed along the upper left edge of the old woman's right sleeve, between her two thumbs, and along the edges of her chemise, face, and eyeglasses.

44. Brown and Garrido 1998. By contrast, it was Velázquez's frequent habit to make adjustments to his paintings as he worked.

45. Leanse 1984, 53.

46. Ibid.

47. Ibid., 57.

48. Ibid. Similar preliminary sketching in black paint was found in the priest's neck in Murillo's *Saint Thomas of Villanueva Healing a Lame Man* (cat. no. 19, fig. 1).

49. In contrast, Velázquez sometimes applied fluid black preparatory outlines, for example in *Las Meninas* (Museo del Prado, Madrid) and *The Toilet of Venus* (National Gallery, London). See also Leanse 1984, 54, 86; Sonnenburg 1982, part 2.

50. Plesters and Lazzarini 1972, 156.

51. Claire Barry, "La Tour and Autoradiography," in *Georges de La Tour and His World*, exh. cat. (National Gallery of Art, Washington, 1996), 292.

52. Leanse 1984, 54, 86.

53. Leanse 1984, 65.

54. Joyce Plesters, "A Preliminary Note on the Incidence of Discoloration of Smalt in Oil Media," *Studies in Conservation* 14 (1969), 62–74.

55. Ibid., 72.

56. Leanse 1984; see also Plesters and Lazzarini 1972, 156. The method was also used by Venetian artists, including Tintoretto.

57. Véliz 1986, 157.

58. Leanse 1984, 35.

59. Sánchez-Lassa de los Santos 2000.

60. See also Sonnenburg 1982. Murillo also used a localized light-gray underpainting in the blue jacket of the lame man in *Saint Thomas of Villanueva Healing a Lame Man* (cat. no. 19, fig. 1).

61. Garrido Pérez 1992, 18. Velázquez also added calcite to his pigments.

62. Peter Cherry, "Artistic Training and the Painter's Guild in Seville," in *Velázquez in Seville* (National Galleries of Scotland, Edinburgh, 1996), 79. There were ordinances separating the roles of painters and sculptors that prohibited wood carvers from accepting commissions for painting.

63. In the seventeenth century, Rubens adopted this unprimed slate for a commission for a church in Rome because its matte surface compensated for adverse lighting conditions. See also Isabel Horowitz, "The Materials and Techniques of European Paintings on Copper Supports," in Phoenix 1998, 64.

64. Mulcahy 1993, 78.

CHAPTER SIX NOTES

1. The English taste for Spanish paintings has received considerable scholarly attention. Among the important contributions are, in order of publication: Enriqueta Har-

ris, "Sir William Stirling-Maxwell and the History of Spanish Art," *Apollo* 79 (1964), 73–77; Francis Haskell, *Rediscoveries in Art: Some Aspects of Taste, Fashion, and Collecting in England and France* (Ithaca, N.Y., 1976); Allan Braham, *El Greco to Goya: The Taste for Spanish Paintings in Britain and Ireland,* exh. cat. (National Gallery, London, 1981); Hugh Brigstocke, *William Buchanan and the 19th Century Art Trade* (London, 1982); Enriqueta Harris, "Velázquez and Murillo in Nineteenth-Century Britain, an Approach through Prints," *Journal of the Warburg and Courtauld Institutes* 50, 148–59; María de los Santos García Felguera, *La fortuna de Murillo, 1681–1900* (Seville, 1989); Kathleen Maclarnon, "William Bankes and His Collection of Spanish Paintings at Kingston Lacy," *Burlington Magazine* 132 (1990), 114–25; Xanthe Brooke, *Murillo in Focus,* exh. cat. (National Museums and Galleries on Merseyside, Liverpool, 1990); Xanthe Brooke, "British Artists Encounter Spain," in Suzanne L. Stratton, ed., *Spain, Espagne, Spanien: Foreign Artists Discover Spain, 1800–1900,* exh. cat. (The Equitable Gallery in association with The Spanish Institute, New York, 1993); Thomas Bean, "Richard Ford as Picture Collector and Patron in Spain," *Burlington Magazine* 137 (February 1995), 96–107; Nigel Glendinning, "Nineteenth-Century British Envoys in Spain and the Taste for Spanish Art in England," *Burlington Magazine* 131 (February 1989), 117–26; Hugh Brigstocke, "El descubrimiento del arte español en Gran Bretaña," in *En torno a Velázquez,* exh. cat. (Museo de Bellas Artes de Asturias, Oviedo), 1999.

2. García Felguera 1989, 50. Cumberland was the author of *Anecdotes of Eminent Painters in Spain during the 16th and 17th Centuries with Cursory Remarks upon the Present State of Arts in that Kingdom* (London, 1782; new ed. 1787). Cumberland relied mostly on Palomino for his information.

3. See Ellis Waterhouse, "Gainsborough's 'Fancy Pictures,'" *Burlington Magazine* 88 (June 1946), 134–40, and, by the same author, "Murillo and Eighteenth-Century Painting Outside Spain," Madrid and London, 1982–83, 70-71.

4. García Felguera 1989, 57.

5. The story of the amassing of Spanish paintings in France during the early decades of the nineteenth century, which can barely be sketched out in this essay, has been the subject of several thorough, and thoroughly fascinating, studies; among the most comprehensive are García Felguera 1989, 97–127; Ilse Hempel Lipschutz, *Spanish Painting and the French Romantics* (Cambridge, Mass., 1972); and Jeannine Baticle and Cristina Marinas, *La Galerie*

Espagnole de Louis-Philippe au Louvre, 1838–1848 (Paris, 1981). The latter is particularly useful for tracing the whereabouts today of works from that dispersed collection, a number of which are in the present exhibition. Baticle and Marinas start their research with the original guide to the Galerie Espagnole: *Notice des tableaux de la Galerie Espagnole exposés dans les salles du Musée au Louvre* (Paris, 1838), which cost the visitor one franc.

6. In the catalogue accompanying the sale of his paintings, Lebrun noted that it had not been easy to obtain them because paintings by some Spanish masters were forbidden export, because "les collections sont presque toutes substituées, et périssent par ignorance," and because, although the monasteries had lots of paintings, "ils s'en détachent difficilement, et les offres immenses qu'on leur a souvent faites rendent les acquisitions presque impossibles." *Choix des tableaux les plus capitaux de la rare et précieuse collection recueillie dans l'Espagne et dans l'Italie par M. Lebrun dans les années 1807 et 1808* (Paris, April 1810).

7. "La République Française par sa force, la supériorité de ses lumières et de ses artistes est le seul pays au monde qui puisse donner un asile inviolable à ces chefs d'oeuvre." Quoted by García Felguera 1989, 98, from: *Instruction sur la manière d'inventorier et de conserver, dans toute l'étendue de la République, tous les objets qui peuvent servir aux arts, aux sciences, et à l'enseignement* (Paris, 1794).

8. Ponz 1772–94 and Ceán Bermúdez 1800.

9. A more kindly assessment of Soult's role in the massive migration of Spanish pictures to France is detailed by Nicole Gotteri, "Deux tableaux offerts au maréchal Soult par le chapître de la cathédral de Séville," *La Revue du Louvre et des Musées de France* 43 (October 1993), 44–52.

10. *The Spectator* 10 (August 12, 1837), 763–64.

11. Contemporary written responses to the Spanish paintings on view in Paris include: Théophile Thoré, "Études sur la peinture espagnole. Galerie du Maréchal Soult," *Revue de Paris* n.s. 21 (1835), 200–220; n.s. 22 (1835), 44–64; Frédéric Mercey, "La Galerie du Maréchal Soult," *Revue des deux mondes* 14 (1852), 807–16; and Théophile Gautier's essay on Murillo, first published in *Le Moniteur universel* (August 3, 1858), republished in *L'Artiste* (December 1, 1867), and translated into English in *The Works of Théophile Gautier,* vol. 9: *The Louvre, Leonardo da Vinci, Esteban Bartolomé Murillo, Sir Joshua Reynolds* (New York, 1901). Modern scholarly studies include Lipschutz 1972; Baticle and Marinas 1981; García

Felguera 1989; and Alisa Luxenberg, "Over the Pyrenees and through the Looking Glass: French Culture Reflected in its Imagery of Spain," in New York 1993.

12. See Soult, [Nicolas Jean-de-Dieu] Duke of Dalmatia, *Catalogue raisonné des tableaux de la galerie de feu M. le maréchal-général Soult duc de Dalmatie: Vente à Paris, mai 1852* (Paris, 1852).

13. See *Catalogue des tableaux, formant la célèbre Galerie Espagnole de S. M. feu le Roi Louis Philippe* (London: Christie & Manson, 1853).

14. See *Catalogue des tableaux, formant la célèbre collection Standish, léguée à S. M. feu Le Roi Louis Philippe par Mr. Frank Hall Standish.* (London: Christie & Manson, 1853).

15. Brigstocke 1982, 98.

16. Ibid., 427.

17. Ibid., 432.

18. Ford 1845, vol. 1, 178. This influential book about Spain, its manners and mores, was published in several editions. It is sometimes referred to as "Murray's Handbook," after the publisher. Ford's key role in educating the public about Spanish painting is summarized in "Richard Ford and Spanish Painting," an editorial in *Burlington Magazine* 100 (August 1958), 263–64.

19. Quoted in: William Dunlap, *History of the Rise and Progress of the Arts of Design in the United States,* vol. 1 (New York, 1834), 137–38.

20. In the *Catalogue of the Valuable Paintings and Statuary: The Collection of the Late Joseph Bonaparte, Count de Survilliers . . . Sept. 17th and 18th, 1845, at the Mansion at Bordentown, N.J.,* there is no mention of Murillo, nor of Titian and Velázquez, all of whose works Sully was supposed to have seen in the collection.

21. The composition of the painting is known from an engraving by Tomás López Enguídanos, dated 1809, and a preparatory drawing by Murillo in the Boymans-van-Beuningen Museum, Rotterdam, identified by Enriqueta Harris, "A 'Caritas Romana' by Murillo," *Journal of the Warburg and Courtauld Institutes* 27 (1964), 337–39. The painting was described in the catalogue of the Pennsylvania Academy of Fine Arts exhibition (May 1816), no. 63, p. 6. Quoted in Yarnall and Gerdts 1976, 2533.

22. *A Catalogue of the Paintings, Statues, Prints, etc. exhibiting at the Pennsylvania Academy of the Fine Arts* (July 1818), 23, no. 46. It is thus clear that Murillo was somewhat known in America very early in the nineteenth century, at least through written sources ("what is chronologed of him"?). The author of this description might have read Ponz or Ceán Bermúdez's books in Spanish. More likely, he could have read the English transla-

tion of Antonio Palomino's biographies of Spanish painters, published in London in 1739 as *An Account of the Lives and Works of the most eminent Spanish Painters.* He might have read Richard Cumberland's *Anecdotes of Eminent Painters in Spain during the 16th and 17th Centuries with Cursory Remarks upon the Present State of Arts in that Kingdom* (1782). By 1800, there were a number of published sources that could have informed Americans about Murillo and his work.

23. *Catalogue of Italian, Flemish, Spanish, Dutch, French and English Pictures; which have been collected in Europe and brought to this country by Mr. Richard Abraham of New Bond Street, London, and are now exhibiting at the American Academy of Fine Arts* (London, 1830), 17.

24. Pilkington 1770, 410–11.

25. Curtis 1883, xxi and xxvi.

26. See Yarnall and Gerdts 1976, 2533–39.

27. See *Catalogue of the very important and extensive collection of Pictures formed by the late Hon. General John Meade, many years Consul General at Madrid* (London: Christie & Manson, March 6, 7, 8, 1851).

28. *Very valuable gallery of paintings & statuary: Catalogue of the very valuable and well known collection of Fine oil paintings, known as "the Meade Gallery," by order of the administrator of Richard W. Meade, Esq. deceased.* At the Academy of Fine Arts, Philadelphia, by M. Thomas & Sons, March 15, 1858.

29. Alfonso 1886, 229–30.

30. The painting is described in Curtis 1883, no. 140. See "Museum Paintings Listed for Auction," *The New York Times* (January 25, 1929), 14.

31. Buffalo Fine Arts Academy, *Albright Art Gallery: Catalogue of the Permanent Collection of Sculpture and Paintings with Some Additions* (Buffalo, 1907), nos. 211 and 228. There was also a *Holy Family* after an unidentified Murillo and a "Head of the Madonna" after a *Virgin of the Immaculate Conception* in the Prado.

32. Miller 1966, 146–47.

33. Spooner 1880, iii.

34. Miller 1966, 198.

35. "In 1867 it [the collection] was placed in the Art School of Yale University as security for a loan to Jarves of twenty thousand dollars. A few years later at public sale the collection went to Yale for two thousand dollars above the debt." Michael Friedsam, *The Significance of Art in America* [A monograph prepared for the *New York Evening Post* and printed in somewhat abridged form in the issue of October 3, 1924] New York, [c. 1924], n.p.

36. Ibid. The Jarves collection included *An Andalusian Girl Gathering Fruit* attributed to Murillo. See Yarnall and Gerdts 1976, 2539.

37. Listed by Alfonso 1886. See also

Yarnall and Gerdts 1976, 2533.

38. It was finally accepted by the New York Historical Society. Miller 1966, n.p.

39. *The Painter's Eye: Notes and Essays on the Pictorial Arts by Henry James,* selected and edited by John L. Sweeney (Cambridge, Mass., 1956), 80.

40. Miller 1966, 6–7.

41. Charles Eliot Norton, *Educational Review* (April 1895), 346.

42. "Americans found no difficulty in rejecting the Old Masters since most of them had never seen a genuine old painting." Miller 1966, 28.

43. E. Durand Gréville, on a tour of private collections in the United States, was surprised to find so many works in United States collections. He found many modern French paintings—Corot, Meissonier, Millet, et al.—but few works by old masters. His lengthy report, "La Peinture aux Etats-Unis: les galeries privées," *Gazette des Beaux-Arts,* deuxième période, vol. 36 (1887), 65–75 and 250–55, was later translated into English and published in Philadelphia in *The Connoisseur: Bailey, Banks and Biddle's Illustrated Quarterly of Art and Decoration* 2 (1888). Another useful guide to American art collecting in the nineteenth century is *Art Treasures of America,* photogravures of selected pictures from public and private collections in the United States, selected by Edward Strahan [pseud. of Earl Shinn] (d. 1886) and continued by William Walton. The portfolio was published in Philadelphia in twenty-five parts, 1880–90.

44. Until 1900 Americans bought works by the modern French school—and by Rembrandt. See Gerald Reitlinger, *The Economics of Taste: The Rise and Fall of Picture Prices, 1760–1960* (London, 1961), 177.

45. Loftie 1876, 48-49.

46. Spooner 1880, 239-240.

47. Loftie 1876, ibid.

48. Quoted from Thomas E. Norton, *100 Years of Collecting in America: The Story of Sotheby Parke Bernet* (New York, 1984), 10.

49. *The Collection made by W. J. Shaw during a continuous foreign travel of nearly seven years, being the greatest and best collection of genuine paintings by the Old Masters . . . etc.* The sale, held by Geo. A. Leavit & Co. in 187?, included "genuine antiquities of ancient Egypt, real 'Cammels' Hair' Stuffs from the Valley of Cashmere" and the like.

50. "Murillo the Artist—Extraordinary Auction-Scene," *The National Magazine, dedicated to Literature, Art, and Religion* 1, no. 1 (July 1852), 80.

51. "Sale of Louis Philippe's Spanish Pictures," *The Atheneum* (May 28, 1853), 655. Three articles in *The Atheneum* detailing the auction of Louis-Philippe's collection appeared on May 14, May 21, and May 28. Although the author is not indi-

cated, as is so often the case in nine-teenth-century periodicals, the style and opinions are inimitably Ford's.

52. Nathaniel Hawthorne, *Our Old Home, and English Note-Books*, vols. 7 and 8 of *The Complete Works* (New York, 1883–84), 205.

53. Ibid., 521.

54. Ibid., 528 and 535.

55. Ibid., 537, 539, and 542.

56. See *Catalogue of the Art Treasures of the United Kingdom collected at Manchester in 1857,* and Gustav Friedrich Waagen, *A walk through the art treasures exhibition at Manchester: a companion to the official catalogue, under the guidance of Dr. Waagen* (London, 1857).

57. A second edition of the *Annals* was published in 1891. Stirling also wrote *Talbotype Illustrations to the Annals of the Artists of Spain* (London, 1847); *The Cloister Life of the Emperor Charles V* (London, 1852, 2d ed. 1891); *Velázquez and his Works; with a Catalogue of the Prints after them* (London, 1855); and *Essay towards a Catalogue of Prints Engraved from the Works of Diego Rodríguez de Silva y Velázquez and Bartolomé Esteban Murillo* (London, 1873). These are listed in the bibliography provided in Brigstocke 1999. Stirling was collecting engravings for a book about Murillo, a project not completed. Head's book was immediately overshadowed by Stirling's *Annals*, but his efforts on behalf of Spanish painting were probably more widely known through his extensive additions to Kugler's *Handbook*. See F. T. Kugler, *Handbook of Painting*, 2 vols. *Vol. 2: The German, Flemish, Dutch, Spanish and French Schools, partly translated from the German of Kugler by a lady [Mrs. Margaret Hutton], edited, with notes by Sir Edmund Head, Bart.* (London, 1854).

58. Alexander Slidell MacKenzie, *A Year in Spain by a Young American* (Boston, 1829), 112.

59. Ibid., 114.

60. Caroline Elizabeth Wilde Cushing, *Letters, Descriptive of Public Monuments, Scenery, and Manners in France and Spain, in Two Volumes* (Newburyport, 1832), vol. 2 (Spain), 71.

61. S. T. Wallis, *Glimpses of Spain; or, Notes of an Unfinished Tour* (New York, 1849), 197.

62. William Cullen Bryant, *Letters of a Traveller: Second Series* (New York, 1859), 134.

63. Quoted by William Bement Lent, *Across the Country of the Little King: A Trip Through Spain* (New York, 1897), 135. There was also the notion that Murillo could best be appreciated in his native city, even though Seville had long ago lost many of its great masterpieces. "It is often asserted that Murillo can be appreciated only in Sevilla . . . and it is an assertion that leads to a good deal of disappointment." John Lomas, *Spain* (London 1908, 2d ed.

1925), 64. The Museo Provincial in Seville was judged to have "the best, but not the very best, Murillos in it," but the tourist was advised not to fail to visit the museum, for "he will be the poorer beyond calculation if he does not; but he will be a beggar if he does not go to the Hospital de la Caridad, where . . . he will find six Murillos out-Murilloing any others excepting always the incomparable 'Vision of Saint Anthony' in the cathedral." W. D. [William Dean] Howells, *Familiar Spanish Travels* (New York and London, 1913), 254. *The Vision of Saint Anthony* was such a revered painting that its damage by a thief was reported at length in "The Mutilated Murillo," *Harper's Weekly* (February 20, 1875).

64. John Hay, *Castilian Days* (Boston, 1872), 142. Another figure in American politics, General Ulysses S. Grant, visited the museums in Madrid and the Escorial in 1878. He was, unfortunately, one of the rare American visitors who did not record his delight with Murillo.

65. H. [Henry] O'Shea, *O'Shea's Guide to Spain and Portugal* was first published in London in 1865; its thirteenth edition, edited by John Lomas, appeared in 1905. Many travelers must have learned about Spanish art from O'Shea's extensive and well-informed discussion of the major movements and artists of Spain, complete with a guide to further reading.

66. Augustus J. C. Hare, *Wanderings in Spain* (New York, 1873), 123.

67. H. Willis Baxley, *Spain: Art-Remains and Art-Realities, Painters, Priests, and Princes. Being notes of things seen, and of opinions formed, during nearly three years residence and travels in that country*, 2 vols. (New York, 1875), vol. 1, 278.

68. George Parsons Lathrop, *Spanish Vistas* (New York, 1883), 117.

69. Ibid., 117–18.

70. Lent 1897, 142.

71. Henry M. Field, *Old Spain and New Spain* (New York, 1888), 275.

72. See Roger B. Stein, *John Ruskin and Aesthetic Thought in America, 1840–1900* (Cambridge, Mass., 1967).

73. John Ruskin, *The Works of John Ruskin*, vol. 3 (London, 1903), 636.

74. Ibid., vol. 3, 672.

75. Ibid., vol. 4 (1903), xxxiv–xxxv.

76. Ibid., vol. 10 (1904), 228–29.

77. Charles L. Eastlake, *Notes on the Principal Pictures in The Old Pinakothek, Munich* (London, 1884), 148–50.

78. Ibid.

79. Charles L. Eastlake, *Notes on the Principal Pictures in the Louvre Gallery* (London, 1883), 154–57.

80. Frederic Leighton, *Addresses Delivered to the Students of The Royal Academy by the late Lord Leighton* (New York, 1896), 188.

81. Carl Justi's magisterial *Velazquez und sein Jahrhundert* (Bonn, 1889) was

translated into English by A. H. Keane as *Velazquez and his Times* (London, 1899).

82. In a letter to Sir Thomas Lawrence. Allan Cunningham, *The Life of Sir David Wilkie*, vol. 2 (London 1843), 472.

83. Curtis 1883, xxi.

84. Ibid., xxi–xxii.

85. Nancy Mowll Mathews, ed., *Cassatt and Her Circle: Selected Letters* (New York, 1984), 103. I am grateful to M. Elizabeth Boone for bringing this reference to my attention. The relationship between U. S. painters and Spain during this period is a large and fascinating subject beyond the focus of this essay. For more information, see: Carol M. Osborne, "Yankee Painters at the Prado," in New York 1993; M. Elizabeth Boone, "Vistas de España: American Views of Art and Life in Spain, 1860–1898" (Ph.D. dissertation, Graduate School and University Center, City University of New York, 1996); and, by the same author, *España: American Artists and the Spanish Experience*, exh. cat. (Hollis Taggart Galleries, New York, and New Britain Museum of American Art, 1999).

86. Havelock Ellis, *The Soul of Spain* (Boston and New York, 1909), 107.

87. Ibid., 125.

88. Arthur Symonds, "The Painters of Seville," *The Fortnightly Review* 75, n.s. 69 (January 1901), 49 and 58–59.

89. Hoppin 1892, 130.

90. C. Gasquoine Hartley [Mrs. Walter Gallichan], *A Record of Spanish Painting* (London and New York, 1904), 211 and 219.

91. Lady Herbert's *Impressions of Spain*, published by the Catholic Publication Society (New York, 1869), 118.

92. Ripley Hitchcock, *Madonnas by Old Masters: 10 new photogravures of masterpieces by Raphael, Murillo, Holbein, Correggio, Guido Reni* (New York, 1888), n.p.

93. Examples include Washburn 1884; Calvert 1903; and Calvert 1907; *Old Spanish Masters engraved by Timothy Cole with historical notes by Charles H. Caffin and comments by the engraver* (New York, 1907) is interesting only for Cole's perceptive analyses of Murillo's use of color. Caffin also published *The Story of Spanish Painting* (New York, 1910), in which he reduces Murillo's power to that of "a great illustrator—like Raphael—who could tell the stories of the Church's teaching in the vernacular." 148.

94. Edmondo De Amicis, *Spain and the Spaniards*, trans. Wilhelmina W. Cady (New York, 1880), 140.

95. Ibid., 141. De Amicis was a favorite source for women writers of inspirational books about art for children. He is quoted directly, for

example, by Jennie Ellis Keysor, *Murillo and Spanish Art: A Sketch* (Boston, 1899), on her opening page: "He [Murillo] was handsome, good and virtuous. Envy knew not where to attack him: around his crown of glory he bore a halo of love." [n.p.] Some authors of popular art books were more clear-headed in their approach. For example, Estelle H. Hurll, *Murillo: A Collection of Pictures with Introduction and Interpretation* (Boston and New York, 1901), vii, tried to place Murillo's art in the religious and economic context of his time: "Money was poured forth freely for the beautifying of churches and convents. There was a great demand for pictures illustrative of sacred history. It was these circumstances which determined the direction of Murillo's energy. His subjects were dictated by his orders; it was a case of supply and demand." Elsewhere, however, Hurll succumbed to the temptation to describe Murillo's paintings of beggar boys as "simple merriment characteristic of a southern race" ("Murillo's Boys," excerpted from Hurll's *Child-Life in Art*, in *The Christian Science Monitor* (November 14, 1930), 9). In a similar vein, Murillo was, according to M. F. Sweetser, the "idol of the masses" because he had "illustrated the lives of the poorest classes on Spanish soil" (excerpted from *Murillo*, Boston 1870 in *The Christian Science Monitor* (September 18, 1932), 7. De Amicis was, however, the most pernicious because the most widely read. Calvert 1903, 253, considered De Amicis "a writer who has comprehended as much of, and expressed more faithfully the charm and soulfulness of Murillo than any living critic."

96. Edward Hutton, *The Cities of Spain* (New York, 1906), 229.

97. C. S. Ricketts, *The Art of the Prado* (Boston, 1907), 104–5.

98. Quoted by Edward Morris in *Victorian and Edwardian Paintings in the Walker Art Gallery and at Sudley House: British artists born after 1810 but before 1861* (London, 1996), 197.

99. Samuel Levy Bensusan, *Murillo* (London and New York, 1910), 17. The cognoscenti knew better, by the turn of the century, than to shop for good Spanish paintings in Spain. Royall Tyler, *Spain: A Study of her Life and Arts* (London, 1909), 538: "It is melancholy fact that Spain, capital and provinces, is now a poor place in which to buy works of art. Everything that grew on the curiosity-tree—except in inaccessible sacred groves—has been plucked. Further shaking of the tree will bring down nothing but green fruit."

100. Frederick S. Robinson, *The Connoisseur: Essays on the Romantic and Picturesque Associations of Art and Artists*

(New York, 1897), 40. Curtis's figures are fully substantiated in George Redford's *Art Sales* (London, 1888), vol. 2.

101. Curtis, xxiv–xxv.

102. Karl Baedeker, *Spain and Portugal: Handbook for Travelers with introductory article on Spanish art by Professor C. Justi of Bonn* (London, 1898), lxxiv–lxxv.

103. Charles L. Eastlake, "Old Masters and Modern Critics," *Nineteenth Century and After* 52 (August 1902), 264.

104. See Wilhelm Bode, "Die amerikanische Konkurrenz im Kunsthandel und ihre Gefahr für Europa," *Kunst und Kunstler*, Jahrg. 1 (1902), 5–12.

105. Eugen Neuhaus, *The Appreciation of Art* (Boston, [1924?]), 230.

106. Keith Clark, *The Spell of Spain* (Boston, 1914), 241.

107. Ibid.

108. Charles H. Caffin, *How to Study Pictures* (London, 1904, 1906 ed.), 227. The book is a series of studies through comparisons, such as the unlikely pairing of Murillo's *Children of the Shell* and Rembrandt's "Sortie of the Banning Cock Company."

109. *American Art News*, 11 (August 16, 1913), 6.

110. L.G.-S., "Good Sales Prices," *American Art News* 15, no. 18 (February 10, 1917), 5.

111. "Berlin Collection Sold," *American Art News* 16, no. 35 (July 13, 1918), 1. In all, 164 pictures from the collection of Gaston von Malmann sold for a total of one million marks.

112. *New York Herald Tribune* (May 28, 1927), 5. See also "Murillo leads in Pallavicini Sale Prices," *The Art News* 25, no. 35 (June 4, 1927), 1–2.

113. Carlyle Burrows, "An Impressive Murillo," *New York Herald Tribune* (August 23, 1931), section 8, 6.

114. Diego Angulo Iñiguez considered the Walters painting a work of one of Murillo's followers, copied from an original of about 1655. See Angulo 1981, vol. 2, no. 708.

115. *Arts and Decoration* 22, no. 2 (December 1924), illus. p. 20, "In the Office," 78 and 85.

116. "Art in Chicago," *The American Magazine of Art* 16, no. 10 (October 1925), 563.

117. In the 1919 Annual Report of the Smithsonian Institution, it was noted that "An Italian [sic] masterpiece, The Immaculate Conception with the Mirror by Murillo, lent to the gallery by Mr. DeWitt V. Hutchins on April 28, 1928, was withdrawn by Mr. Hutchins and shipped by his order to Thomas J. Kerr, New York City, on June 24, 1929."

118. H. W. Janson, *History of Art*, rev. and expanded by Anthony F. Janson, 5th ed. (New York, 1997), 573.

Bibliography

Ahmanson 1991. Conisbee, Philip, Mary L. Levkoff, and Richard Rand. *The Ahmanson Gifts: European Masterpieces in the Collection of the Los Angeles County Museum of Art.* Los Angeles, 1991.

Alfonso 1886. Alfonso, Luis. *Murillo: el hombre, el artista, las obras.* Barcelona, 1886.

Andersen 1881. Andersen, Hans Christian. *In Spain and a Visit to Portugal.* Boston, 1881. First published in 1863.

Andrews 1947. Andrews, Julia Gethman. *A Catalogue of European Paintings, 1300–1870.* Fine Arts Society of San Diego. San Diego, 1947.

Angulo 1961. Angulo, Diego. "Miscelánea Murillesca." *Archivo Español de Arte* 34 (1961): 1–24.

Angulo 1972. Angulo, Diego. "Murillo, La profecía de Fray Julián de San Agustín, de Williamstown." *Archivo Español de Arte* 45 (1972): 55–57.

Angulo 1973. Angulo, Diego. "Los pasajes de Santo Tomás de Villanueva de Murillo en el Museo de Sevilla y en la colección Norton Simon de Los Angeles." *Archivo Español de Arte* 46 (1973): 71–75.

Angulo 1974. Angulo, Diego. "Algunos dibujos de Murillo." *Archivo Español de Arte* 47 (April–June 1974): 97–108.

Angulo 1981. Angulo, Diego. *Murillo: Su vida, su arte, su obra.* 3 vols. Madrid, 1981.

Angulo 1985. Angulo, Diego, and Alfonso E. Pérez Sánchez. *A Corpus of Spanish Drawings: Seville School, 1600–1650.* London, 1985.

Angulo and Pérez Sánchez 1988. Angulo, Diego, and Alfonso E. Pérez Sánchez. *A Corpus of Spanish Drawings: Valencia, 1600–1700.* London, 1988.

Anon. 1953. "Accessions of American and Canadian Museums: January–March, 1953." *Art Quarterly* 16 (Autumn 1953): 248–58.

ap Rhys 1749. ap Rhys, Udal. *An account of the most remarkable places and curiosities in Spain and Portugal.* London, 1749.

Baedeker 1884. Baedeker, Karl, publishers. *L'Allemagne et l'Autriche avec quelques parties des pays limitrophes.* Leipzig and Paris, 1884.

Banda y Vargas 1961. Banda y Vargas, Antonio de la. "Los estatutos de la academia de Murillo." *Anales de la Universidad Hispalense* 22 (1961), 107–20.

Barcelona 1910. *Exposición retrospectiva* [P. Reig]. Barcelona, 1910.

Baticle 1964. Baticle, Jeannine. "Un Tableau de Murillo." *Revue du Louvre et des Musées de France* 14 (1964): 93–96.

Baticle and Marinas 1981. Baticle, Jeannine, and Christina Marinas. *La Galerie Espagnole de Louis-Philippe au Louvre, 1838–1848.* Paris, 1981

Baxley 1875. Baxley, H. Willis. *Spain: Art-Remains and Art-Realities, Painters, Priests, and Princes.* New York, 1875.

Bédat 1973. Bédat, Claude. *L'Académie des Beaux Arts de Madrid.* Toulouse, 1973.

Benito 1994. Benito, Fernando, and José Luis Galdón. "El 'Maestro del Album Lassala' y Gregorio Bausá: Anotaciones al 'Corpus' del dibujo valenciano del siglo XVII." *Archivo Español de Arte* 266 (1994): 105–18.

Bern 1947. *Europäische Barockmalerei aus Wiener Privatgalerien: Czernin, Harrach, Schwarzenberg.* Exh. cat., Berner Kunstmuseum. Bern, 1947.

Blanc 1857. Blanc, Charles. *Le Trésor de la curiosité, tiré des catalogues des ventes.* 2 vols. Paris, 1857.

Blanc 1869. Blanc, Charles, W. Bürger [pseud. of E. J. T. Thoré], Paul Mantz, Louis Viardot, and Paul Lefort. *Histoire des peintres de toutes les écoles: Ecole espagnole.* Paris, 1869.

Bignamini 1991. Bignamini, Ilaria, and Martin Postle. *The Artist's Model: Its Role in British Art from Lely to Etty.* Exh. cat., University Art Gallery, Nottingham, 1991.

Bode 1904. Bode, Wilhem. *The Art Collection of Mr. Alfred Beit at His Residence, 16 Park Lane, London, compiled by Dr. Wilhelm Bode.* London, 1904. *Die Kunst Sammlungen des Heern Alfred Beit.* Berlin, 1904.

Boston 1970. *Masterpieces of Painting in the Metropolitan Museum of Art.* Exh. cat., Museum of Fine Arts, Boston. Boston, 1970.

Bowron 1990. Bowron, Edgar Peters. *European Paintings before 1900 in the Fogg Art Museum: A Summary Catalogue Including Paintings in the Busch-Reisinger Museum.* Cambridge, Mass., 1990.

Braham 1965. Braham, Alan. "The Early Style of Murillo." *Burlington Magazine* 107 (September 1965): 445–51.

Brigstocke 1982. Brigstocke, Hugh. *William Buchanan and the 19th-Century Art Trade.* London, 1982.

Brigstocke 1999. Brigstocke, Hugh. "El descubrimiento del arte español en Gran Bretaña." *En torno a Velázquez.* Exh. cat., Museo de Bellas Artes de Asturias. Oviedo, 1999.

Bristol 1906. *Fifth Loan Collection of Paintings.* Exh. cat., City Art Gallery. Bristol, 1906.

Brockwell 1915. Brockwell, Maurice W. *A Catalogue of the Paintings at Doughty House Richmond & Elsewhere in the Collection of Sir Frederick Cook BT, Visconde de Monserrate.* Vol. 3. *English, French, Early Flemish, German, and Spanish Schools, and Addenda.* London, 1915.

Brown 1970. Brown, Jonathan. "Hieroglyphs of Death and Salvation: The Decoration of the Church of the Hermandad de la Caridad, Seville." *Art Bulletin* 52 (1970): 265–77.

Brown 1976. Brown, Jonathan. *Murillo and His Drawings.* Exh. cat., The Art Museum, Princeton University. Princeton, 1976.

Brown 1978. Brown, Jonathan. *Images and Ideas in Seventeenth-Century Spanish Painting.* Princeton, 1978.

Brown 1982. Brown, Jonathan. "Murillo, pintor de temas eróticos: una faceta inadvertida de su obra." *Goya*, nos. 169–71 (July–December 1982): 35–43.

Brown 1989. Brown, Jonathan. "Academies of Painting in Seventeenth-Century Spain." In *Academies of Art between Renaissance and Romanticism.* Eds. A. W. A. Boschloo et al. The Hague, 1989, 177–85.

Brown 1991. Brown, Jonathan. *The Golden Age of Painting in Spain.* New Haven and London, 1991.

Brown 1998. Brown, Jonathan. *Painting in Spain: 1500–1700.* New Haven and London, 1998.

Brown and Garrido 1998. Brown, Jonathan, and Carmen Garrido. *Velázquez: The Technique of Genius.* New Haven, 1998.

Brown and Mann 1989. Brown, Jonathan, and Richard G. Mann. *Spanish Paintings of the Fifteenth through Nineteenth Centuries.* National Gallery of Art. Washington, 1989.

Buchanan 1824. Buchanan, William. *Memoirs of Painting.* 2 vols. London, 1824.

Burckhardt 1843. Burckhardt, Jacob. "Uber Murillo: Kunststudien aus dem Louvre [1843]." *Atlantis* 9, no. 8 (August 1937): 480–87.

Bürger 1865. Bürger, W. [Théophile Thoré]. *Trésors d'art en Angleterre.* 3d ed. Paris, 1865.

Burke 1986. Burke, Marcus B. *A Selection of Spanish Masterworks from the Meadows Museum.* Dallas, 1986.

Burroughs 1928. Burroughs, Bryson. "Spanish Paintings from El Greco to Goya." *Bulletin of the Metropolitan Museum of Art* 23 (February 1928): 39–44.

Burroughs 1943. "A Painting of the Virgin and Child by Murillo." *Metropolitan Museum of Art, Bulletin*, n.s., 1, no. 9 (May 1943): 261–65.

Butler 1971. Butler, Joseph T. "The American Way with Art: Murillo Acquired by Clark Art Institute." *Connoisseur* 176 (January 1971): 49–53.

Cadogan 1991. *Wadsworth Atheneum Paintings 2: Italy and Spain, Fourteenth through Nineteenth Centuries.* Ed. Jean K. Cadogan. Hartford, 1991.

Calvert 1903. Calvert, Albert F. *Impressions of Spain.* London and Liverpool, 1903.

Calvert 1907. Calvert, Albert F. *Murillo, a Biography and Appreciation.* London and New York, 1907.

Calvo Serraller 1981. Calvo Serraller, Francisco, ed. *La teoría de la pintura en el Siglo de Oro.* Madrid, 1981.

Carducho 1979. Carducho, Vicencio. *Diálogos de la pintura* (1633). Ed. Francisco Calvo Serraller. Madrid, 1979.

Carriazo 1929. Carriazo, Juan de Mata. "Correspondencia de don Antonio Ponz con el Conde del Aguila." *Archivo Español de Arte y Archeología* 5 (1929): 157–83.

Caturla 1968–69. Caturla, María Luisa. "Documentos en torno a Vicencio Carducho." *Arte Español*, 3 (1968–69): 146–231.

Ceán Bermúdez 1800. Ceán Bermúdez, Juan Agustín. *Diccionario histórico de los más ilustres profesores de las Bellas Artes en España.* 6 vols. Madrid, 1800. Facsimile ed., Madrid, 1965.

Ceán Bermúdez 1804. Ceán Bermúdez, Juan Agustín. *Sevilla pintoresca o descripción de sus más célebres monumentos.* Seville, 1804.

Ceán Bermúdez 1806. Ceán Bermúdez, Juan Agustín. *Carta de D. Agustín Ceán Bermudez a un amigo suyo sobre el gusto en la pintura de la Escuela Sevillana y sobre el grado de perfeccion a que elevó Bartolomé Esteban Murillo cuya vida se inserta, y se describen sus obras en Sevilla.* Cádiz, 1806. Reprint, Seville, 1968.

Cherry 1996. Cherry, Peter. "Artistic Training and the Painters' Guild in Seville." In Edinburgh 1996, 67–75.

Cherry 1999. Cherry, Peter. "La formación de los pintores en los talleres sevillanos." In *Zurbarán ante su centenario, 1598–1998.* Ed. Alfonso E. Pérez Sánchez. Seminario de Historia del Arte, Fundación Duques de Soria, 1999, 49–59.

Cincinnati 1930. *A Catalogue of the Edgecliffe Collection of Paintings Assembled by Mrs. Thomas J. Emery at Her Residence, "Edgecliffe," Walnut Hills, Cincinnati, Ohio, and Bequeathed by Her to the Cincinnati Museum Association.* Cincinnati, 1930.

Cleveland 1966. *Golden Anniversary Acquisitions.* Cleveland Museum of Art, 1966.

Cleveland 1982. *The Cleveland Museum of Art Catalogue of Paintings, 3: European Paintings of the 16th, 17th, and 18th Centuries.* Cleveland, 1982.

Cleveland 1993. *European and American Painting in The Cleveland Museum of Art: A Summary Catalogue.* Compiled by Alan Chong. Cleveland, 1993.

Colorado Springs 1947. *Catalogue of an Exhibition of 21 Great Paintings.* Exh. cat., Colorado Springs Fine Arts Center. Colorado Springs, 1947.

Columbus 1941. *Tenth Anniversary Exhibition.* Exh. cat., Gallery of Fine Arts. Columbus, 1941.

Cornette and Mérot 1999. Cornette, Joël, and Alain Mérot. *Histoire artistique de l'Europe: Le XVIIᵉ siècle.* Paris, 1999.

Corpus Christi 1979. *Spain and New Spain: Mexican Colonial Arts in their European Context.* Exh. cat., The Art Museum of South Texas. Corpus Christi, 1979.

Cumberland 1787. Cumberland, Richard. *Anecdotes of Eminent Painters in Spain during the 16th and 17th centuries; with cursory remarks upon the present state of arts in that kingdom.* 2 vols. London, 1787.

Curtis 1883. Curtis, Charles B. *Velázquez and Murillo: A Descriptive and Historical Catalogue of the Works.* London and New York, 1883.

Dallas 1999. *Faith in Conflict: Devotional Images and Forbidden Books from Spain's Counter-Reformation.* Meadows Museum, Southern Methodist University. Dallas, 1999.

Davies 1819. Davies, Edward. *The life of Bartolomé E. Murillo, compiled from the writings of various authors.* London, 1819.

Dorival 1951. Dorival, Bernard. "Callot modèle de Murillo." *Revue des Arts* no. 2 (1951): 94–101.

Dunkerton and Spring 1998. Dunkerton, Jill, and Marika Spring. "The Development of Painting on Coloured Surfaces in Sixteenth-Century Italy." In *Painting Techniques: History, Materials, and Studio Practice, Contributions to the Dublin Congress, 7–11 September 1998.* Ed. Ashok Roy and Perry Smith (London, 1998): 120–30.

Durán 1980. Durán, Reyes. *Catálogo de los dibujos de los siglos XVI y XVII en la colección del Museo de la Casa de la Moneda.* Madrid, 1980.

Durham 1967. *Four Centuries of Spanish Painting.* Exh. cat., Bowes Museum. Durham, England, 1967.

Duro 1997. Duro, Paul. *The Academy and the Limits of Painting in Seventeenth-Century France.* Cambridge, 1997.

Edinburgh 1996. Davies, David, and Enriqueta Harris. *Velázquez in Seville.* Exh. cat., National Gallery of Scotland. Edinburgh, 1996.

Eisler 1977. Eisler, Colin. *Paintings from the Samuel H. Kress Collection: European Schools, Excluding Italian.* Oxford, 1977.

El Paso 1961. *The Samuel H. Kress Collection: El Paso Museum of Art.* El Paso, 1961

Eller 1841. Eller, Rev. Irvin. *The History of Belvoir Castle.* London, 1841.

Ford 1845. Ford, Richard. *A Handbook for Travellers in Spain.* 2 vols. London, 1845.

Ford 1853A. Ford, Richard [attrib.]. "Sale of Louis Philippe's Spanish Pictures." *Athenaeum,* no. 1333 (May 14, 1853): 593–94.

Ford 1853B. Ford, Richard [attrib.]. "Sale of Louis Philippe's Spanish Pictures." *Athenaeum,* no. 1334 (May 21, 1853): 622–23.

Frederickson 1993. *The Index of Paintings Sold in the British Isles during the Nineteenth Century,* vol. 3 (1811–1815), Part I (A–N). Ed. Burton B. Frederickson. Assisted by Julia I. Armstrong. The Provenance Index of the Getty Art History Information Program. Munich, 1993.

Freedberg 1978. Freedberg, S. J. "Lorenzo Lotto to Nicolas Poussin." *Apollo* 107 (May 1978): 387–97.

Freedberg 1989. Freedberg, David. *The Power of Images: Studies in the History and Theory of Response.* Chicago and London, 1989.

Frimmel 1898–1901. Frimmel, Theodor von. *Geschichte der Wiener Gemäldesammlungen.* 1 vol. in 4 parts. Berlin and Leipzig, 1898–1901.

Frimmel 1913–14. Frimmel, Theodor von. "Kaunitz." In *Lexikon der Wiener Gemäldesammlungen,* vols. 1–2. Vienna, 1913–14.

Gállego 1979. Gállego, Julián. "Felipe IV, pintor." *Estudios sobre arte y literatura dedicados al profesor Emilio Orozco Díaz.* Granada, 1979, 537–49.

Gállego 1995. Gállego, Julián. *El pintor de artesano a artista.* Granada, 1995.

García Felguera 1989. García Felguera, María de los Santos. *La fortuna de Murillo, 1681–1900.* Seville, 1989.

García Hidalgo 1965. García Hidalgo, José. *Príncipios para estudiar el nobilísimo y real arte de la Pintura,* 1693. Facsimile ed. Madrid, 1965.

García de la Torre 1997. García de la Torre, Fuensanta. *Dibujos del Museo de Bellas Artes de Córdoba.* Seville, 1997.

Garrido Pérez 1992. Garrido Pérez, Carmen. *Velázquez: Técnica y Evolución.* Madrid, 1992.

Gaya Nuño 1958. Gaya Nuño, Juan Antonio. *La pintura española fuera de España.* Madrid, 1958.

Gaya Nuño 1978. Gaya Nuño, Juan Antonio. *L'opera completa di Murillo.* Milan, 1978.

Gilbert 1960. Gilbert, Creighton. "The Classics." *Arts* 34 (September, 1960): 16–17.

Glendinning 1986. Glendinning, Nigel. "A Footnote to Goya's *Portrait of the Marquesa de Santiago.*" *The J. Paul Getty Museum Journal,* 14 (1986): 149–50.

Goldstein 1988. Goldstein, Carl. *Visual Fact over Verbal Fiction: A Study of the Carracci and the Criticism, Theory, and Practice of Art in Renaissance and Baroque Italy.* Cambridge, 1988.

Goldstein 1996. Goldstein, Carl. *Teaching Art: Academies and Art Schools from Vasari to Albers.* Cambridge, 1996.

Gómez Imaz 1899. Gómez Imaz, Manuel. "El Príncipe de la Paz, la Santa Caridad de Sevilla, y los cuadros de Murillo," vol. 1, 807–827. In *Homenaje a Menéndez y Pelayo en el año vigésimo de su profesorado.* 2 vols. Madrid, 1899.

González de Zárate 1994. González de Zárate, Jesús María, and Paul Vanderbroeck. "Una nota sobre el tema de Murillo 'Cristo recoge las vestiduras.'" *Boletín del Museo e Instituto Camón Aznar* 55 (1994): 55–60.

Gower 1881–85. Gower, Lord Ronald. *Great Historic Galleries of England.* 5 vols. London, 1881–85.

Hanover, N. H., 1991. *The Age of the Marvelous.* Exh cat., Hood Museum of Art, Hanover, N.H.; North Carolina Museum of Art, Raleigh; Museum of Fine Arts, Houston; High Museum of Art, Atlanta, 1991–93.

Harris 1987. Harris, Enriqueta. "Velázquez and Murillo in Nineteenth-Century Britain, an Approach through Prints." *Journal of the Warburg and Courtauld Institutes* 50 (1987): 148–59.

Haskins 1993. Haskins, Susan. *Mary Magdalene: Myth and Metaphor.* London, 1993.

Hawthorne 1883–84. Hawthorne, Nathaniel. *Our Old Home, and English Note-Books.* 2 vols. (vols. 7 and 8 of the *Complete Works*). New York, 1883–84.

Hazañas y la Rua 1888. Hazañas y la Rua, José. *Noticias de las academias literarias, artísticas y científicas de los siglos XVII y XVIII.* Seville, 1888.

Held 1997. Held, Julius S. "Old Masters in the Clark Collection, Part I: Paintings." *Antiques* 152 (October 1997): 504–9.

Hoppin 1892. Hoppin, James W. *The Early Renaissance and Other Essays on Art Subjects.* Boston and New York, 1892.

Horowitz 1999. "The Materials and Techniques of European Paintings on Copper Supports." In Phoenix 1998, 64.

Indianapolis and Providence 1963. *El Greco to Goya.* Exh. cat., John Herron Museum of Art, Indianapolis; Museum of Art, Rhode Island School of Design, Providence, 1963.

Jameson 1844. Jameson, Anna. *Companion to the Most Celebrated Private Galleries of Art in London.* London, 1844.

Jameson 1852. Jameson, Anna. *Legends of the Monastic Orders.* London, 1852.

Jameson 1857. Jameson, Anna. *Legends of the Madonna as Represented in the Fine Arts.* 2d ed. London, 1857.

Jameson 1867. Jameson, Anna. *Legends of Monastic Orders.* London, 1867.

Jordan 1974. Jordan, William B. *The Meadows Museum: A Visitor's Guide to the Collection.* Dallas, 1974.

Jordan 1968A. Jordan, William B. "A Museum of Spanish Painting in Texas." *Art Journal* 27 (Spring 1968): 288–96.

Jordan 1968B. Jordan, William B. "Murillo's 'Jacob Laying the Peeled Rods before the Flocks of Laban.'" *Art News* 67 (Summer 1968), 30–31.

Justi 1892. Justi, Carl. *Murillo.* Leipzig, 1892.

Justi 1904. Justi, Carl. *Murillo.* Leipzig, 1904.

Kagané 1995. Kagané, Ludmila. *Bartolomé Esteban Murillo: The Spanish Master of the 17th Century.* Bournemouth and St. Petersburg, 1995.

Kagané 1997. *The Hermitage Catalogue of Western European Painting: Spanish Painting. Fifteenth to Nineteenth Centuries.* Moscow and Florence, 1997.

Karge 1991. *Vision oder Wirklichkeit: Die Spanische Malerei der Neuzeit.* Ed. Henrik Karge. Munich, 1991.

Kinkead 1978. Kinkead, Duncan. *Juan de Valdés Leal.* New York, 1978.

Kinkead 1986. Kinkead, Duncan. "The Picture Collection of Don Nicholas Omazur." *Burlington Magazine* 128 (February 1986): 132–44.

Kubler 1970. Kubler, George. "El 'San Felipe de Heraclea' de Murillo y los cuadros del Claustro Chico." *Archivo Español de Arte* 169 (1970): 11–31.

Kugler 1854. Kugler, F. T. *Handbook of Painting: The German, Flemish, Dutch, Spanish, and French Schools.* Trans. Mrs. Margaret Hutton. Ed., with notes, Sir Edmund Head. 2 vols. London, 1854.

Latour 1855 [1954 ed.]. Latour, Antoine de. *Etudes sur l'Espagne: Séville et l'Andalousie* (1855 and 1857). *Viaje por Andalucía de Antonio de Latour* (1848). Trans. Ana María Custodio. Valencia, 1954.

Leanse 1984. Leanse, Victoria. Unpublished manuscript: *Easel Painting Materials and Technique in Spain, 1642–1682.* Courtauld Institute of Art. London, 1984.

Lefort 1892. Lefort, Paul. *Murillo et ses élèves, suivi du Catalogue raisonné de ces Principaux ouvrages.* Paris, 1892.

Lehmann 1986. Lehmann, Jurgen M. "Ein umstrittenes Fruhwerk Murillos." *Bruckmanns' Pantheon* 44 (1986): 37–43.

Leningrad 1975. *One Hundred Paintings from the Metropolitan Museum of Art.* The Hermitage, Leningrad, and The Pushkin Museum, Moscow, 1975.

Lent 1897. Lent, William Bement. *Across the Country of the Little King: A Trip through Spain.* New York, 1897.

Leonardo da Vinci 1989. Leonardo da Vinci. *Leonardo on Painting.* Ed. M. Kemp. New Haven, 1989.

Lipschutz 1972. Lipschutz, Ilse Hempel. *Spanish Painting and the French Romantics.* Cambridge, Mass., 1972.

Loftie 1876. Loftie, William J. *A Plea for Art in the House, with special reference to the economy of collecting works of art, and the importance of taste in education and morals.* Philadelphia, 1876.

London 1802. Desenfans, Noel. *A Descriptive Catalogue … of Some Pictures of the Different Schools, purchased for his majesty the late King of Poland, which will be exhibited early in the year 1802 at the Great Room, no. 3 in Berners Street.* 2 vols. London, 1801.

London 1819. *Catalogue of Pictures of the Italian, Spanish, Flemish, and Dutch Schools.* Exh. cat., British Institution. London, 1819.

London 1822. *Catalogue of the Pictures of the Italian, Spanish, Flemish, and Dutch Schools.* Exh. cat., British Institution. London, 1822.

London 1828. *Pictures by Italian, Spanish, Flemish, and Dutch Masters.* Exh. cat., British Institution. London, 1828.

London 1836. *Catalogue of the Pictures by Italian, Spanish, Flemish, Dutch, and French Masters.* Exh. cat., British Institution. London, 1836.

London 1838. *Catalogue of Pictures of the Italian, Spanish, Flemish, and Dutch Schools.* Exh. cat., British Institution. London, 1838.

London 1844. *Catalogue of Pictures of the Italian, Spanish, Flemish, and Dutch Schools.* Exh. cat., British Institution. London, 1844.

London 1845. *Catalogue of Pictures by Italian, Spanish, Dutch, French, and English Masters.* Exh. cat., British Institution. London, 1845.

London 1851. *Catalogue of Pictures of the Italian, Spanish, Flemish, and Dutch Schools.* Exh. cat., British Institution. London, 1851.

London 1853. *Catalogue of Pictures of the Italian, Spanish, Flemish, and Dutch Schools.* Exh. cat., British Institution. London, 1853.

London 1858. *Pictures by Italian, Spanish, Flemish, Dutch, French, and English Masters.* Exh. cat., British Institution. London, 1858.

London 1862. *Catalogue of Pictures by Italian, Spanish, Flemish, Dutch, French, and English Masters.* Exh. cat., British Institution. London, 1862.

London 1864. *Catalogue of Pictures by Italian, Flemish, Dutch, French, and English Masters.* Exh. cat., British Institution. London, 1864.

London 1870. *Exhibition of Old Masters (Winter Exhibition).* Exh. cat., Royal Academy. London, 1870.

London 1871. *Exhibition of Old Masters (Winter Exhibition).* Exh. cat., Royal Academy. London, 1871.

London 1879. *Exhibition of Works by the Old Masters.* Exh. cat., Royal Academy. London, 1879.

London 1881. *Winter Exhibition.* Exh. cat., Royal Academy of Art. London, 1881.

London 1888. *Winter Exhibition.* Exh. cat., Royal Academy. London, 1888.

London 1893. *Winter Exhibition.* Exh. cat., Royal Academy. London, 1893.

London 1895. *Exhibition of Works by the Old Masters.* Exh. cat., Royal Academy. London 1895.

London 1895–96. *Spanish Art.* Exh. cat., New Gallery. London, 1895–96.

London 1901. *Exhibition of the Works of Spanish Painters.* Exh. cat., Guildhall Gallery. London, 1901.

London 1902. *Exhibition of Works by the Old Masters Including a Special Collection of Paintings and Drawings by Claude.* Exh. cat., Royal Academy of Art. London 1902.

London 1913–14. *Illustrated Catalogue of the Exhibition of Spanish Old Masters in support of National Gallery Funds and for the benefit of the Sociedad de Amigos del Arte Español.* Exh. cat., Grafton Galleries. London, 1913–14.

London 1938A. *Exhibition of Seventeenth Century Art in Europe.* Exh. cat., Royal Academy of Art. London, 1938.

London 1938B. *From Greco to Goya.* Exh. cat., Tomás Harris, Ltd. London, 1938.

London 1966. *Forty Paintings and Sculptures.* Exh. cat., Heim Gallery. London, November 1966.

London 1972. *Conservation of Paintings and the Graphic Arts: Preprints of Contributions to the Lisbon Congress 1972, 9–12 October.* The International Institute for Conservation of Historic and Artistic Works, London, 1972.

London 2001A. Cherry, Peter, and Xanthe Brooke. *Murillo: Scenes of Childhood.* Exh. cat., Dulwich Picture Gallery. London, 2001.

London 2001B. *The Genius of Rome, 1592–1623.* Ed. Beverly Louise Brown. Exh cat., Royal Academy of Arts. London, 2001.

López Rey 1987. López Rey, José. "Views and Reflections on Murillo." *Gazette des Beaux-Arts* VI période, vol. 109 (January 1987): 1–34.

Los Angeles 1960. *Spanish Masters.* Exh. cat., Los Angeles Art Galleries, University of California, and San Diego, Fine Arts Gallery of San Diego (San Diego Museum of Art), 1960.

Macartney 1999. Macartney, Hilary. "The Nobility of Art: The Seville Academy Founded by Murillo and a Portrait of Philip IV at Pollok House." *Journal of the Scottish Society for Art History* 4 (1999): 49–56.

MacLaren and Braham 1970. Neil MacLaren. *National Gallery Catalogue: The Spanish School.* 2d. ed. rev. by Allan Braham. London, 1970.

Madrid 1988. *Zurbarán.* Exh. cat., Museo del Prado. Madrid, 1988.

Madrid 1990. *El espacio privado: cinco siglos en veinte palabras.* Exh. cat., Museo Español de Arte Contemporáneo. Madrid, 1990–91.

Madrid 1991. Valdivieso, Enrique. *Valdés Leal.* Exh. cat., Museo del Prado. Madrid, 1991.

Madrid 1996. *Obras maestras de la Nacional Gallery of Art de Washington.* Exh. cat., Museo Nacional de Antropología. Mexico City, 1996–97.

Madrid 2000. *Pintura española de la Colección Meadows.* Exh. cat., Museo Thyssen-Bornemisza. Madrid, 2000.

Madrid and London 1982–83. *Bartolomé Esteban Murillo, 1617–1682.* Exh. cat., Museo del Prado and Royal Academy of Arts. Madrid and London 1982–83.

Mâle 1932. Mâle, Emile. *L'Art Religieux après le Concile de Trente: Etude sur l'iconographie de la fin du XVIe siècle, du XVIIe, du XVIIIe siècle.* Paris, 1932.

Malitskaya 1947. Malitskaya, K. M. *The Spanish Painting of 16th–17th Centuries* [in Russian]. Moscow, 1947.

Mallory 1982–83. Mallory, Nina. "Rubens y van Dick en el arte de Murillo." *Goya* no. 169–74 (July 1982–June 1983): 92–104.

Mallory 1983. Mallory, Nina. *Bartolomé Esteban Murillo.* Trans. María Luisa Balseiro. Madrid, 1983.

Manchester 1857. *Catalogue of the Art Treasures of the United Kingdom Collected at Manchester in 1857.* Manchester, 1857.

Manners 1903. Manners, Lady Victoria. "Notes on the Pictures at Belvoir Castle, Part 2." *Connoisseur* 6 (May–August 1903): 131–36.

Martínez 1988. Martínez, Juan. *Discursos practicables del nobilísimo arte de la pintura.* Ed. J. Gállego. Madrid, 1988.

Martyn 1766. [Thomas Martyn]. *The English Connoisseur.* 2 vols. London, 1766.

Maule 1813. Maule, Nicolás de la Cruz Bahamonde, Conde de. *Viaje de España, Francia e Italia.* 14 vols in 10. Cádiz, 1806–13. [*De Cádiz y su comercio* (Tomo XIII del *Viaje de España, Francia e Italia*). Ed. Manuel Ravina Martín. Cadiz, 1997.]

Mayer 1913. *Geschichte der Spanischen Malerei.* 2 vols. Leipzig, 1913 (ed. in 1 vol, 1922).

Mayer 1923. Mayer, August L. *Murillo [Klassiker der Kunst].* Stuttgart and Berlin, 1913. 2d. ed., 1923.

Mayer 1924. Mayer, August L. "Zum Werke von Velázquez und Murillo." *Zeitschrift für bildende Kunst* 58 (1924–25): 24–26.

Mayer 1927. Mayer, August-Liebmann. *Laban à la recherche de ses dieux domestiques par Murillo: Etude August-L. Mayer.* Paris, [1927].

Mayer 1929. Mayer, August L. "Laban in Search of His Household Gods." *Apollo* 9 (February 1929): 79–80.

Mayer 1930. Mayer, August L. "Zur Austellung der Spanischen Gemälde des Grafen Contini in Rom," *Pantheon* 5 (May 1930): 203–8.

Mayer 1938. Mayer, August L. "Murillo und seine Italianischen Barockvorbilder." *La Crítica d'Arte* 15 (June 1958): 120.

McKim-Smith, Anderson-Bergdoll, and Newman 1988. McKim-Smith, Gridley, Greta Anderson-Bergdoll, and Richard Newman. *Examining Velázquez.* New Haven, 1988.

McMahon 1928. McMahon, A. Philip. "Spanish Painting: Greco to Goya." *Arts* 13 (March 1928): 172–83.

Meditations on the Life of Christ 1961. *Meditations on the Life of Christ: An Illustrated Manuscript of the Fifteenth Century.* Eds. Isa Ragusa and Rosalie B. Green. Trans. Isa Ragusa. Princeton, 1961.

Mena 1982. Mena, Manuela. "Murillo as a Draughtsman." In Madrid and London 1982–83, 53–63.

Mena 1984. Mena, Manuela. *Dibujos italianos de los siglos XVII y XVIII en la Biblioteca Nacional.* Madrid, 1984.

Mena Marqués 1996. Mena Marqués, Manuela. "Bartolomé Esteban Murillo." In *The Dictionary of Art*, vol. 22. Ed. Jane Turner. London and New York, 1996, 342–48.

Meslay 2001. Meslay, Olivier. "Murillo and 'smoking mirrors.'" *Burlington Magazine* (February 2001): 73–79.

Miller 1966. Miller, Lillian B. *Painters and Patriotism: The Encouragement of the Fine Arts in the United States, 1790–1860.* Chicago and London, 1966.

Minor 1882. Minor, Ellen E. *Murillo.* London, 1882.

Mongan 1969. Mongan, Agnes, and Elizabeth Mongan. *European Painting in the Timken Art Gallery.* San Diego, 1969.

Montagu 1985. Montagu, Jennifer. *Roman Baroque Sculpture: The Industry of Art.* New Haven, 1985.

Montoto 1932. Montoto, Santiago. *Murillo.* Barcelona, 1932.

Montoto 1946. Montoto, Santiago. "La biblioteca de Murillo." *Bibliografía Hispánica* (July 1946): 464–79.

Moreno 1997. Moreno, Arsenio. *Mentalidad y pintura en la Sevilla del Siglo de Oro.* Madrid, 1997.

Morse 1955. Morse, John D. *Old Masters in America.* New York, 1955.

Morse 1979. Morse, John D. *Old Master Paintings in North America*. New York, 1979.

Mortimer and Klingelhofer 1985. Mortimer, Kristin A., and William G. Klingelhofer. *Harvard University Art Museums: A Guide to the Collections*. New York, 1985.

MS Academia 1982. Real Academia de Bellas Artes de Santa Isabel de Hungría. *El Manuscrito de la Academia de Murillo*. With an introduction by Antonio de la Banda y Vargas. Seville, 1982.

Mulcahy 1988. Mulcahy, Rosemarie. *Spanish Paintings in The National Gallery of Ireland*. Dublin, 1988.

Mulcahy 1993. Mulcahy, Rosemarie. " 'The Meeting of Jacob and Rachel': Murillo's 'Jacob' Cycle Complete." *Burlington Magazine* 135 (February 1993): 73–80.

Mullaly 1966. Mullaly, Terence. "A Major Early Murillo and Other Works." *Connoisseur* 163 (November 1966): 166–67.

Muller 1963. Muller, Priscilla. "Paintings from Spain's Past at Indianapolis and Providence." *Art Quarterly* 16 (Spring 1963): 101–6.

Navarrete Prieto 1998. Navarrete Prieto, Benito. *La pintura andaluza del siglo XVII y sus fuentes grabados*. Madrid, 1998.

New York 1830. *A Catalogue of Italian, Flemish, Spanish, Dutch, French, and English Pictures*. Exh. cat., American Academy of Fine Arts. New York, 1830.

New York 1925. *Exhibition of Paintings by Velasquez and Murillo, Never before shown in this country, Given for the benefit of the Building Fund of the Cathedral of St. John the Divine*. Exh. cat., Ehrich Galleries. New York, 1925.

New York 1928. *Catalogue of an Exhibition of Spanish Painting from El Greco to Goya*. Exh. cat., Metropolitan Museum of Art. New York, 1928.

New York 1939. *Catalogue of European Paintings and Sculpture from 1300 to 1800*. Exh. cat, Masterpieces of Art, New York World's Fair. New York, 1939.

New York 1941. *Duveen Pictures in Public Collections of America*. New York, 1941.

New York 1970. *Masterpieces of Fifty Centuries*. Exh. cat., Metropolitan Museum of Art. New York, 1970.

New York 1989–90. *In Pursuit of Quality: Twenty-five Years of Collecting Old Masters (Paintings from the Kimbell Art Museum, Fort Worth)*. Exh. guide, The Frick Collection. New York, 1989.

New York 1993. *Spain, Espagne, Spanien: Foreign Artists Discover Spain, 1800–1900*. Ed. Suzanne L. Stratton. Exh. cat., The Equitable Gallery in association with the Spanish Institute. New York, 1993.

New York 2000–2001. *New York, 1825–1861: Art and the Empire City*. Exh.cat., Metropolitan Museum of Art. New York, 2000.

O'Neil 1833. O'Neil, A. *A Dictionary of Spanish Painters: comprehending simply that part of their biography immediately connected with the arts, from the fourteenth century to the eighteenth*. London, 1833.

Os 1994. *The Art of Devotion in the Late Middle Ages, 1300–1500*. Ed. Hank van Os. Princeton, 1994.

Pacheco 1990. Pacheco, Francisco. *El arte de la pintura*. Ed. B. Bassegoda i Hugas. Madrid, 1990.

Palomino 1724. Palomino, Antonio Acisclo de Castro y Velasco. *El museo pictórico, y escala óptica*, 3 vols. in 2. Madrid 1715–24. Vol. 3: *El Parnasso español pintoresco laureado*. Madrid, 1724.

Palomino 1986. Palomino, Antonio. *Vidas*. Ed. N. Ayala Mallory. Madrid, 1986.

Palomino 1987. Palomino, Antonio. *Lives of the Eminent Spanish Painters and Sculptors*. Trans. N. Ayala Mallory. Cambridge, 1987.

Palomino 1988. Palomino, Antonio. *El Museo pictórico y escala óptica*. Madrid, 1988.

Paris 1963. Laclotte, Michel, and Jeannine Baticle. *Trésors de la peinture espagnole: Eglises et musées de France*. Exh. cat., Palais du Louvre, Musée des Arts Décoratifs. Paris, 1963.

Paris 1983. Ressort, Claudie. *Murillo dans les musées français*. Exh. cat., Musée du Louvre. Paris, 1983.

Pemán 1978. Pemán, María. "La colección artística de Don Sebastián Martínez, el amigo de Goya, en Cádiz." *Archivo Español de Arte* 51 (1978): 53–62.

Pérez Delgado 1972. Pérez Delgado, Rafael. *Bartolomé Esteban Murillo*. Madrid, 1972.

Pérez Sánchez 1969. Pérez Sánchez, Alfonso E. *Catálogo de la colección de dibujos del Instituto Jovellanos de Gijón*. Madrid, 1969.

Pérez Sánchez 1986. Pérez Sánchez, Alfonso E. *Historia del dibujo en España de la Edad Média a Goya*. Madrid, 1986.

Pérez Sánchez 1992. Pérez Sánchez, Alfonso E. *Pintura barroca en España (1600–1750)*. Madrid 1992.

Pérez Sánchez 1993. Pérez Sánchez, Alfonso E. *De pintura y pintores: La configuración de los modelos visuales en la pintura española*. Madrid, 1993.

Pérez Sánchez 1995. Pérez Sánchez, Alfonso E., with B. Navarrete Prieto. *Tres siglos de dibujo sevillano*. Seville, 1995.

Pérez Sánchez 1999A. *Zurbarán ante su centenario, 1598–1998*. Ed. Alfonso E. Pérez Sánchez. Seminario de Historia del Arte, Fundación Duques de Soria, 1999.

Pérez Sánchez 1999B. Pérez Sánchez, Alfonso E. "La práctica del dibujo en la España barroca." In *Figuras e imágenes del barroco: Estudios sobre el barroco español y sobre la obra de Alonso Cano*. Madrid, 1999, 113–42.

Petersen 1968. Petersen, M. *Masterworks from the Collection of the Fine Arts Gallery of San Diego*. San Diego, 1968.

Pevsner 1940. Pevsner, N. *Academies of Art Past and Present*. Cambridge, 1940.

Pevsner 1982. Pevsner, N. *Academias de arte: pasado y presente*, with epilogue by F. Calvo Serraller. Madrid, 1982.

Phoenix 1998. *Copper as Canvas: Two Centuries of Masterpiece Paintings on Copper, 1575–1775*. Exh. cat., Phoenix Art Museum; Nelson-Atkins Museum of Art, Kansas City; Royal Cabinet of Paintings, The Hague. New York and Oxford, 1999.

Piedra Adarves 2000. Piedra Adarves, Álvaro. "Mateo Cerezo, dibujante." *Archivo Español de Arte*, 290, 2000, 97–115.

Pilkington 1770. Pilkington, Matthew. *The Gentleman's and connoisseur's dictionary of painters*. London, 1770.

Pillsbury and Jordan 1985. Pillsbury, Edmund P., and William B. Jordan. "Recent Acquisitions–2: The Kimbell Art Museum." *Burlington Magazine* 127 (June 1985): 409–18.

Pittsburgh 1954. *Pictures of Everyday Life*. Exh. cat., Carnegie Institute. Pittsburgh, 1954.

Plazaola 1989. Plazaola, Juan. *Le Baron Taylor: Portrait d'un homme d'avenir*. Paris, 1989.

Plesters 1969. Plesters, Joyce. "A Preliminary Note on the Incidence of Discoloration of Smalt in Oil Media." *Studies in Conservation* 14 (1969): 62–74.

Poland 1931. R. P. [Reginal Poland]. "Murillo, Given by Mr. and Mrs. Henry H. Timken." *Bulletin of the Fine Arts Gallery of San Diego, California* 5 (June 1931): 2–3.

Ponz 1772–94. Ponz, Antonio. *Viaje de España, en que se da noticia de las cosas mas apreciables, y dignas de saberse, que hay en ella*. 18 vols. Madrid, 1772–94.

Princeton 1982. Sullivan, Edward J., and Nina Ayala Mallory. *Painting in Spain, 1650–1700, from North American Collections*. Exh. cat., Princeton University, Art Museum. Princeton, 1982.

Proske 1967. Proske, Beatrice Gilman. *Martínez Montañés, Sevillian Sculptor*. New York, 1967.

Raleigh 1956. *Catalogue of Paintings, Including Three Sets of Tapestries*. North Carolina Museum of Art, Raleigh, 1956.

Réveil 1828–34. Réveil, Etienne. *Musée de Peinture et de Sculpture*. 16 vols. Paris, 1828–34.

Richards 1968. Richards, Louise S. "Bartolomé Esteban Murillo: A Drawing Study for a Virgin and Child." *Bulletin of the Cleveland Museum of Art* 15 (September 1968): 235–39.

Richardson 1948A. Richardson. E. P. "Murillo's *Flight into Egypt*." *Detroit Institute of Arts Bulletin* 27 (1948): 78–80.

Richardson 1948B. Richardson., E. P. "Recent Acquisitions: Murillo's *Flight into Egypt*." *Art Quarterly* 14 (Autumn 1948), 362–67.

Ringbom 1984. Ringbom, Sixten. *Icon to Narrative: The Rise of the Dramatic Close-up in Fifteenth-Century Devotional Painting*. 2d ed. Doornspijk, 1984.

Robinson 1868. Robinson, J. C. *Memoranda on Fifty Pictures*. London, 1868.

Rogers 1978. Rogers, Millard F., Jr. *Spanish Paintings in the Cincinnati Art Museum*. Cincinnati, 1978.

Rome 1930. Longhi, Roberto, and August L. Mayer. *The Old Spanish Masters from the Contini-Bonacossi Collection*. Exh. cat., Galleria Nazionale d'Arte Moderna. Rome, 1930. [Also published in Italian and Spanish editions.]

Salas 1588. Salas, Baltasar de. *Devocionario y contemplaciones, sobre los Quinze Misterios del Rosario de Nuestra Señora*. 1st ed. Madrid, 1588.

San Diego 1931. *Three Old Master Paintings*. Fine Arts Gallery of San Diego (San Diego Museum of Art). San Diego, 1931.

San Diego 1935. *Illustrated Catalogue of the Official Art Exhibition of the California Pacific International Exposition*. Exh. cat., Fine Arts Gallery of San Diego (San Diego Museum of Art). San Diego, 1935.

San Diego 1936. *Illustrated Catalogue of the Official Art Exhibition of the California Pacific International Exposition*. Exh. cat., Fine Arts Gallery of San Diego (San Diego Museum of Art). San Diego, 1936.

San Diego 1960. *Catalogue*. Fine Arts Gallery of San Diego (San Diego Museum of Art). San Diego, 1960.

San Diego 1983. *Timken Art Gallery: European and American Works of Art in the Putman Foundation Collection*. San Diego, 1983.

San Diego 1996. *Timken Museum of Art: European Works of Art, American Paintings, and Russian Icons in the Putnam Foundation Collection*. San Diego, 1996.

Sánchez-Lassa de los Santos 2000. Sánchez-Lassa de los Santos, Ana. "San Pedro en Lágrimas: Aproximación a la técnica de Murillo." In *Las Lágrimas de San Pedro en la pintura española del Siglo de Oro*. Exh. cat., Museo de Bellas Artes de Bilbao. Bilbao, 2000.

Schiff 1988. *German Essays on Art History*. Ed. Gert Schiff. New York, 1988.

Scholz-Hänsel 1991. Scholz-Hänsel, Michael. *El Greco:*

Der Grossinquisitor: Neues Licht auf die Schwarze Legende. Frankfurt am Main, 1991.

Scott 1813. Scott, William Bell. *Murillo and the Spanish School of Painting.* London, 1813.

Seghers 1982–83. Seghers, Lode. "Mercados de las Artes." *Goya,* nos. 169–74 (July 1982–June 1983): 199–201.

Seligman 1961. *Merchants of Art: 1880–1950.* New York, 1961.

Serrera 1988. Serrera, Juan Miguel. "Varia Murillesca: Expolios y Restauraciones." *Archivo Hispalense,* no. 218 (1988): 179–85.

Seville 1996. *Murillo: pinturas de la colección de Isabel de Farnesio en el Museo del Prado.* Exh. cat., Hospital de los Venerables. Seville, 1996.

Sion 1951. *La Collection Czernin de Vienne.* Exh. cat., Musée de la Majorie. Sion, Switzerland, 1951.

Siple 1932. Siple, Ella S. "Recent Acquisitions in America." *Burlington Magazine* 60 (February 1932): 109–16.

Sonnenburg 1982. Sonnenburg, Hubert von. "Zur Maltechnik Murillos, 2 Teil." *Maltechnik 1: Restauro,* Jahrgang 88 (January 1982): 15–34.

Soria 1960. Soria, Martin. "Murillo's Christ and St. John the Baptist." *Art Quarterly* 2 (1960): 12–14.

Spooner 1880. Spooner, Shearjashub. *Anecdotes of painters, engravers, sculptors, and architects, and curiosities of art.* 3 vols. in 1. New York, 1853. 2d ed., 1880.

Staël [1805]. *Madame de Staël: Correspondance Générale. Tome 5, Deuxième Partie: Le Léman et l'Italie, 19 mai 1804-9 novembre 1805.* Paris, 1985.

Staël 1998. Madame de Staël. *Corinne, or Italy.* Trans. and ed. Sylvia Raphael. Oxford, 1998.

Standish 1840. Standish, Frank Hall. *Seville and Its Environs.* London, 1840.

Stechow 1966. Stechow, Wolfgang. "Bartolomé Esteban Murillo: Laban Searching for His Stolen Household Gods in Rachel's Tent." *Bulletin of the Cleveland Museum of Art* 53 (December 1966): 367–77.

Stirling-Maxwell 1848. Stirling-Maxwell, William. *Annals of the Artists of Spain,* 3 vols. London, 1848.

Stirling-Maxwell 1891. *Annals of the Artists of Spain.* 2d. ed., 4 vols. London, 1891.

Stratton 1988. Stratton, Suzanne L. *The Inmaculada en el arte español.* Madrid, 1988.

Stratton 1994. Stratton, Suzanne L. *The Immaculate Conception in Spanish Art.* Cambridge, 1994.

Suida 1930. Suida, Wilhelm. "Spanische Gemälde der Sammlung Contini-Bonacossi." *Belvedere* 9 (July–December 1930): 142–45.

Suida 1949. Suida, William E. *A Catalogue of Paintings in the John and Mable Ringling Museum of Art.* Sarasota, 1949.

Sullivan 1986. Sullivan, Edward J. *Catalogue of Spanish Paintings.* North Carolina Museum of Art, Raleigh, 1986.

Sutton 1992. Sutton, Peter C. *Prized Possessions: European Paintings from Private Collections of Friends of the Museum of Fine Arts, Boston.* Exh. cat., Museum of Fine Arts, Boston, 1992.

Szeged 1917. *Szegedi Múbarátok Körenek Kialli tasa.* Exh. cat. Szeged, 1917.

T. T. [Théophile Thoré?] 1842. "Musée Standish." *Le Cabinet de l'amateur et de l'antiquaire* 1 (1842): 209–14.

Taggard 1992. Taggard, Mindy Nancarrow. *Murillo's Allegories of Salvation and Triumph: The Parable of the Prodigal Son and the Life of Jacob.* Columbia, Mo., 1992.

Takács 1975. Takács, Marianne Haraszti. "Goya à la vente Kaunitz, 1820." *Bulletin du Musée Hongrois des Beaux-Arts,* no. 44 (1975): 107–21.

Temple 1905. Temple, Sir Alfred George. *A Catalogue of Pictures Forming the Collection of Lord and Lady Wantage at 2 Carlton Gardens, London, Lockinge House, Berks, and Overstone Park and Ardington House.* London, 1905.

Thomas 1766. [Martyn Thomas.] *The English Connoisseur.* 2 vols. London, 1766.

Thoré 1835. Thoré, Théophile. "Etudes sur la peinture espagnole: Galerie du Maréchal Soult." *Revue de Paris* 21 (1835): 201–20; vol. 22 (1835): 44–64.

Timken 1969. *Legacy of Spain: Collection of the Fine Arts Society, 15th–20th Centuries.* Exh. cat., Fine Arts Gallery of San Diego, and Putnam Foundation, Timken Gallery, Balboa Park. San Diego, 1969.

Toledo 1941. *Spanish Painting.* Exh. cat., Toledo Museum of Art, 1941.

Toledo 1976. *The Toledo Museum of Art: European Paintings.* Toledo, 1976.

Tomlinson 1997. Tomlinson, Janis. *From El Greco to Goya: Painting in Spain, 1561–1828.* New York, 1997.

Tomlinson and Welles 1996. Tomlinson, Janis A., and Marcia L. Welles. "Picturing the Picaresque: 'Lazarillo' and Murillo's 'Four Figures on a Step.'" In *The Picaresque: Tradition and Displacement,* Hispanic Issues Series, vol. 12. Minneapolis and London 1996, 66–85.

Tormo y Monzó 1915. Tormo y Monzó, Elías. *La Inmaculada en el arte español.* Madrid, 1915.

Torre Farfán 1666. Torre Farfán, Fernando de la. *Fiestas que celebró la iglesia parroquial de Santa María la Blanca, Capilla de la Santa Iglesia Metropolitana , y patriarchal de Sevilla: en obsequio del nuevo breve concedido por N. S.* Seville, 1666.

Trivas 1941. Trivas, N. S. "Lesser Known American Art Collections, 2: The Fine Arts Gallery of San Diego, California." *Apollo* 33 (June 1941): 137–39.

Tromans 1998. Tromans, Nicholas. "Le Baron Taylor à Londres en 1837." *Revue du Louvre et des Musées de France* no. 3 (1998): 66–69.

Tubino 1864. Tubino, Francisco M. *Murillo, su época, su vida, sus cuadros.* Seville, 1864.

Twiss 1775. *Travels through Portugal and Spain in 1772 and 1773.* London, 1775.

Valdivieso 1988. Valdivieso, Enrique. *Juan de Valdés Leal.* Seville, 1988.

Valdivieso 1990. Valdivieso, Enrique. *Murillo: sombras de la tierra, luces del cielo.* Seville [?], 1990.

Véliz 1986. Véliz, Zahira. *Artists' Techniques in Golden Age Spain: Six Treatises in Translation.* Cambridge, 1986.

Véliz 1996. Véliz, Zahira. "Velázquez's Early Technique." *Velázquez in Seville.* Exh cat., National Galleries of Scotland. Edinburgh, 1996

Véliz 1998A. Véliz, Zahira. "Aspects of Drawing and Painting in Seventeenth-Century Spanish Treatises." In *Looking Through Paintings.* Ed. E. Hermens. *Leids Kunsthistorisch Jaarboek,* vol. 11, 1998, 295–317.

Véliz 1998B. Véliz, Zahira. *Alonso Cano's Drawings and Related Works,* Ph.D. thesis. Courtauld Institute of Art, London, 1998.

Véliz 1999. Véliz, Zahira. "Técnicas de los artistas: Tradición e inovación en la España del siglo XVII." *En torno a Velázquez.* Exh. cat., Museo de Bellas Artes de Asturias. Oviedo, 1999.

Viardot 1844. *Les Musées d'Allemagne et de Russie.* Paris, 1844.

Viñaza 1889–94. Viñaza, Conde de la. *Adiciones al diccionario histórico de los más ilustres profesores de las bellas artes en España de D. Juan Agustín Ceán Bermúdez.* 4 vols. Madrid, 1889–94.

Virginia 1966. *European Art in the Virginia Museum of Fine Arts: A Catalogue.* Richmond, 1966.

Volk 1977. Volk, Mary Crawford. *Vicencio Carducho and Seventeenth Century Castilian Painting.* London and New York, 1977.

Waagen 1838. Waagen, Gustave F. *Works of Art and Artists in England.* 3 vols. London, 1838.

Waagen 1854. Waagen, Gustave F. *Treasures of Art in Great Britain.* 3 vols. London 1854.

Waagen 1857. Waagen, Gustave F. *Galleries and Cabinets of Art in Great Britain* [supplementary volume]. London, 1857.

Waagen 1866. Waagen, Gustave F., *Die vornehmsten Kunstdenkmäler in Wien.* Vienna, 1866.

Washburn 1884. Washburn, Emlyn W. *The Spanish Masters: An Outline of the History of Painting in Spain.* New York and London, 1884.

Weale and Richter 1889. Weale, W. H. James, and Jean Paul Richter. *A Descriptive Catalogue of the Collections of Pictures Belonging to the Earl of Northbrook.* London, 1889.

Webster 1998. Webster, Susan Verdi. *Art and Ritual in Golden-Age Spain.* Princeton, 1998.

Wethey 1955. Wethey, Harold E. *Alonso Cano: Painter, Sculptor, Architect.* Princeton, 1955.

Wethey 1963. Wethey, Harold E. "Spanish Painting at Indianapolis and Providence." *Burlington Magazine* 105 (May 1963): 207–8.

Wethey 1983. Wethey, Harold E. *Alonso Cano: Pintor, escultor, y arquitecto.* Rev. ed. Madrid, 1983.

Wilczek 1936. Wilczek, Karl. *Katalog der Graf Czernin'schen Gemäldegalerie in Wien.* Vienna, 1936.

Williamstown 1984. *List of Paintings in the Sterling and Francine Clark Art Institute.* Williamstown, Mass., 1984.

Williamstown 1992. *List of Paintings in the Sterling and Francine Clark Art Institute.* Williamstown, Mass., 1992.

Wilson 1984. Wilson, William. *California Museums.* New York, 1984.

Wilstach 1904. *Catalogue of the W. P. Wilstach Collection.* Memorial Hall, Fairmont Park, Philadelphia, 1904.

Winter Park 1946. *An Exhibition of Spanish Art of Six Centuries.* Exh. cat., Morse Gallery, Rollins College. Winter Park, Fla., 1946.

Wixon 1960. Wixon, Nancy Coe. "Bartolomé Esteban Murillo: The Immaculate Conception." *Bulletin of the Cleveland Museum of Art* 47 (September 1960): 163–65.

Yarnall and Gerdts 1976. Yarnall, James L., and William H. Gerdts. *Index to American Art Exhibition Catalogues from the Beginning through the 1876 Centennial Year.* 6 vols. Boston, 1976.

Young 1977. Young, Eric. Review of *Murillo and His Drawings* by Jonathan Brown. *Burlington Magazine* 119 (June 1977): 448.

Young 1980. Young, Eric. *Die Großen Meister der Malerei: Bartolomé Murillo.* Frankfurt, Berlin, and Vienna, 1980.

Young 1981. Young, Eric. "Murillo: The Definitive Monograph." *Apollo* 114 (October 1981): 255–57.

Young 1820. Young, John. *Catalogue of the Pictures at Grosvenor House.* London, 1820.

Zarco Cuevas 1934. Zarco Cuevas, Fr. Julián. "Cuadros reunidos por Carlos IV, siendo principe en su Casa de Campo de El Escorial." In *Religión y cultura.* El Escorial, 1934.

INDEX

Note: Page numbers in *italics* refer to illustrations. All artworks are by Murillo unless otherwise noted.

PHOTOGRAPH CREDITS